*Myth & Religion
in European Painting
1270–1700*

Myth & Religion in European Painting 1270 - 1700

The stories as the artists knew them

Satia & Robert Bernen

George Braziller · New York

Published in the United States in 1973 by George Braziller, Inc.
Copyright © 1973 by Satia and Robert Bernen
Originally published in England by Constable and Company, Ltd.

Standard Book Number: 0-8076-0683-9, cloth
 0-8076-0682-0, paper
Library of Congress Catalog Number: 72-96070
Printed in the U.S.A.
First Printing

Preface

The stories of 850 common subjects of museum painting are presented here in dictionary form: mythology, ancient history, Italian poetry, saints' lives, the Bible – themes that were once commonplace to artists and their audience and universally understood. The book is meant for use while looking at paintings, and gathers together in a brief space information that is otherwise scattered throughout many volumes. Quotations and summaries from the Bible and from ancient, medieval and Renaissance writers tell the stories as the painters themselves might have known them, the basic raw materials from which they composed their works, each according to his own genius.

Many of these stories are not readily available to modern readers, and even with a substantial library at hand they are often difficult to find. Modern handbooks of mythology replace 'late' versions of the Greek myths with earlier ones not always known to the painters of the Renaissance. The colourful moral anecdotes from ancient history that were once well known are out of favour with modern historians and are no longer found in reference books. And the fabulously embroidered retellings of the Bible and the lives of the saints that were popular in the Middle Ages are irrelevant to modern theology. Leaving aside modern versions, we have looked for those – Biblical, classical, medieval or Renaissance – that the artists seem to have known. Often considered erroneous now, they were once thought true, and were sources of inspiration for many centuries.

The subjects are arranged alphabetically according to the titles by which they are most commonly known. The authors used are identified in each article and are listed and briefly described at the end of the book.

*Myth & Religion
in European Painting
1270–1700*

Abdolonymus After Alexander the Great defeated Darius at the battle of Issus he wanted to appoint a new king for the city of Sidon. Two noble brothers of the city refused the crown because they did not have royal blood, and they nominated Abdolonymus instead, who was distantly related to the royal family, but who then made his meagre living raising vegetables. 'The cause of his poverty – as is so often the case – was his integrity: intent on his daily work he did not hear the clash of armies which had shaken all of Asia.' They found him weeding his garden in old clothes and covered with dirt. Putting the royal robes on him they brought him to Alexander, who asked him 'how he had so patiently borne his poverty'. Abdolonymus replied, 'When I had nothing, I lacked nothing.' Alexander was so impressed by this example of continence that he not only made Abdolonymus king but greatly increased the size of his realm. (Quintus Curtius Rufus).

Abigail, *see* David and Abigail.

Abraham and the Angels God appeared to Abraham in the form of three angels and prophesied the birth of Isaac: 'And the Lord appeared unto him in the plains of Mamre: and he sat in the tent door in the heat of the day; and he lift up his eyes and looked, and, lo, three men stood by him: and when he saw them, he ran to meet them from the tent door, and bowed himself toward the ground, and said, My Lord, if now I have found favour in thy sight, pass not away, I pray thee, from thy servant: let a little water, I pray you, be fetched, and wash your feet, and rest yourselves under the tree: and I will fetch a morsel of bread, and comfort ye your hearts; after that ye shall pass on: for therefore are ye come to your servant.'

Abraham and his wife Sarah prepared them a meal. The angels prophesied that Sarah, although 'old and well stricken in age', would bear a son. Sarah, standing in the tent door, laughed when she heard the prophecy, for which God reproved Abraham, and added: 'Is anything too hard for the Lord?' Sarah did bear a son, Isaac – so named from the Hebrew word for laughter – who became Abraham's heir to God's promise,

'in thee shall all families of the earth be blessed' (Genesis, 18 and 12).

Abraham and Melchizedek After Abraham – still called by his old name, Abram – had defeated the kings who had taken his nephew Lot prisoner and rescued Lot from them, he was met on his return by Melchizedek, king of Salem. 'And Melchizedek king of Salem brought out bread and wine; he was priest of God Most High. And he blessed him and said, Blessed be Abram by God Most High, maker of heaven and earth; and blessed be God Most High, who has delivered your enemies into your hand. And Abram gave him a tenth of everything' (Genesis, 14 (RSV)).

Melchizedek later symbolized the ideal priest. St Paul refers to Christ, who gave bread and wine to his disciples at the Last Supper, as 'an high priest after the order of Melchizedec'. Abraham's present of a tithe was a precedent for Christian practice. (Hebrews, 5).

Abraham's Sacrifice, *see* Sacrifice of Isaac.

Absalom, *see* Death of Absalom.

Achilles, *see also* Wrath of Achilles, Death of Achilles, *and* Immolation of Polyxena.

Achilles and Chiron 'It was the centaur Chiron, famed for his sense of justice, who brought Achilles up . . . and taught him how to play the lute, and the use of herbs, and the arts of hunting and war, medicine, riding, and wisdom' (Natale Conti).

Achilles and the Daughters of Lycomedes 'When Thetis learned that her son Achilles was going to be killed if he went to the siege of Troy, she entrusted him to King Lycomedes, who kept him among his virgin daughters dressed like a woman and under a different name – the girls called him Pyrrha because he was blond. But when the Greeks found out he was hiding

8

there they sent spokesmen to Lycomedes to ask him to send Achilles along to help them with the siege. The king denied that Achilles was there and allowed them to search the palace. As they could not tell which one was Achilles, Ulysses brought the kind of presents women like into the palace hall, putting a shield and spear in with them, and then arranged for a trumpet to be sounded and the noise and clash of armour heard. Achilles, thinking the enemy was at hand, tore off his woman's dress and seized the shield and spear. So he was recognized and offered to help the Greeks' (Hyginus).

Actaeon, *see* Diana and Actaeon.

Adam and Eve, *see also* Garden of Eden.

Adam and Eve Mourning Abel *The Mirror of Man's Salvation* says that 'Adam and Eve were so grieved by Abel's death that they mourned him for a hundred years'.

Adonis, *see* Venus and Adonis.

Adoration of the Kings, *see* Adoration of the Magi.

Adoration of the Lamb The symbolism by which the lamb represented Christ was established by the words of John the Baptist, 'Behold the Lamb of God, which taketh away the sin of the world'.

In a vision of heaven, St John the Evangelist saw God seated on a throne and holding a sealed book, surrounded by 24 elders and four beasts, one like an eagle, one like a calf, one like a lion and one with the face of a man. With them a lamb, which stood as though it had been killed, took the sealed book that God held and opened it.

'And when he had taken the book, the four beasts and four and twenty elders fell down before the Lamb, having every one of them harps, and golden vials full of odours, which are the prayers of saints. And they sung a new song, saying, Thou art worthy to take the book, and to open the

seals thereof: for thou wast slain, and hast redeemed us to God by thy blood.'

Then a great number of people from different nations, wearing white robes and carrying palms, stood before God and the lamb, and worshipped them. 'These are they which came out of great tribulation, and have washed their robes, and made them white in the blood of the Lamb' (*Revelation*, 5 and 7).

Adoration of the Magi 'Now when Jesus was born in Bethlehem of Judaea in the days of Herod the king, behold, there came wise men from the east to Jerusalem, saying, Where is he that is born King of the Jews? for we have seen his star in the east, and are come to worship him. . . . And, lo, the star, which they saw in the east, went before them, till it came and stood over where the young child was. When they saw the star, they rejoiced with exceeding great joy. And when they were come into the house, they saw the young child with Mary his mother, and fell down, and worshipped him: and when they had opened their treasures, they presented unto him gifts; gold, and frankincense, and myrrh' (Matthew, 2).

The *Golden Legend* says the gifts refer to special attributes of Christ: gold for royalty, incense for divinity, and myrrh, used in burying the dead, for his humanity. In contrast to the Shepherds, Jews who came the very night of the Nativity, the Magi were foreigners coming from different parts of the world. They arrived in Bethlehem some time later, and symbolized the future conversion of non-Hebrews to Christianity.

John of Hildesheim adds that the Magi were named Malchiar, Balthazar and Jaspar, and that Jaspar was an Ethiopian, fulfilling the words of the seventy-second Psalm, 'Before him the Ethiopians will fall down'. Malchiar brought the gold, Balthazar the incense and Jaspar the myrrh, and the manger where they found Christ was in the place where the house of Jesse, the father of David, had once stood; and Christ was born on the very spot where David himself had been anointed king of Israel.

10

Adoration of the Shepherds According to the *Golden Legend,* the Shepherds were Jews who came to adore Christ on the night of his birth.

'And there were in the same country shepherds abiding in the field, keeping watch over their flock by night. And, lo, the angel of the Lord came upon them, and the glory of the Lord shone round about them: and they were sore afraid. And the angel said unto them, Fear not: for, behold, I bring you good tidings of great joy, which shall be to all people. For unto you is born this day in the city of David a Saviour, which is Christ the Lord. And this shall be a sign unto you; Ye shall find the babe wrapped in swaddling clothes, lying in a manger. And suddenly there was with the angel a multitude of the heavenly host praising God, and saying, Glory to God in the highest, and on earth peace, good will toward men.

'And it came to pass, as the angels were gone away from them into heaven, the shepherds said one to another, Let us now go even unto Bethlehem, and see this thing which is come to pass, which the Lord hath made known unto us. And they came with haste, and found Mary, and Joseph, and the babe lying in a manger. And when they had seen it, they made known abroad the saying which was told them concerning this child. . . . And the shepherds returned, glorifying and praising God for all the things that they had heard and seen, as it was told unto them' (Luke, 2).

Adulteress, *see* Woman Taken in Adultery.

Aeneas When the Greeks had captured Troy and were sacking the city, the Trojan hero Aeneas escaped with his family from the burning city at night. Lifting his father Anchises on to his shoulders and taking his young son by the hand, Aeneas told his wife to follow at a safe distance behind. When he realized later that she was lost and there was no hope of rescue, he continued with his father and son and prepared to lead the exiled survivors to find a new home.

They came first to the island of Delos where Aeneas, Anchises and the local priest entered the temple of Apollo. A

11

voice was heard telling the Trojans to return to Italy, the land of their origin, and there found a new kingdom. The goddess Juno – long hostile to Troy – kept them wandering for years, trying to prevent them from reaching Italy. At length, after barely surviving a terrible storm, they landed on the coast of Carthage. When Aeneas and his friend Achates went out to explore the coast, they were met by Aeneas' mother Venus, disguised as a virgin huntress. She told them that the country was ruled by the Phoenicians, whose queen was Dido, also an exile. She was in the process of building the city of Carthage. Venus directed Aeneas to the city, and Dido gave him a friendly reception there. (Virgil).

See also **Dido and Aeneas.**

Aeneas, the Sibyl and Charon, *see* Aeneas in the Under-world.

Aeneas in the Underworld When Aeneas finally arrived in Italy he went to the Sibyl, the prophetess priestess of Apollo, whose shrine was at the entrance to the underworld. She granted his request to visit his dead father Anchises, warning him that the descent into the underworld was easy, but that his great labour would be to find his way upward again along the same road. She told him about a golden bough he would need as an offering to Proserpine, queen of the underworld.

When he had found and plucked the golden bough, Aeneas approached the yawning cave that led to Hades and, drawing his sword, followed the Sibyl in her descent into the darkness. They passed the bodiless forms of monstrous hybrid beasts and the giant elm tree with its spreading branches, the home of false dreams. Finally they reached the river Styx where Charon, ragged and unkempt, ferried the souls of the dead across the river. He accepted Aeneas as a passenger when he saw the golden bough the Sibyl had kept hidden in her dress and, punting his small boat with a pole, ferried them across the Styx. The Sibyl silenced the three-headed monster Cerberus, guardian of the underworld, and passing by the road to Tartarus where the wicked were punished they chose the road

to Elysium, the land of the blessed. There they saw spirits playing games and feasting and singing as they danced in meadows or along the banks of the river Eridanus. There Aeneas found his father, who showed him the men who were to be his descendants in Italy, and told him of the glory that would be their destiny, and the wars they would have to fight. Then Aeneas and the Sibyl left the underworld and Aeneas rejoined his comrades. (Virgil).

Aesop A slave in Asia Minor at the time of King Croesus of Lydia. 'Aesop, the well-known teller of fables, was rightly considered a wise man. When philosophers want to impress some valuable idea on us they usually command us sternly to pay attention. But Aesop made up pleasant merry little stories, and that way he got his point across in the most agreeable and far-sighted way, charming us into remembering them' (Aulus Gellius).

Saint Agatha Agatha was a well-born virgin of Catania in Sicily. The governor of the island fell in love with her and wanted her to sacrifice to the pagan gods. When she refused he sent her to the brothel of Aphrodisia and her nine daughters, who tried to persuade her to change her mind. But Agatha was steadfast in her faith.

The governor had her breasts cut off, but Agatha said, 'My soul has within it whole breasts, and with them I nourish all my senses, which I have consecrated to the Lord from infancy.' That night, in prison, St Peter appeared to her, healed her wounds, and restored her breasts. Such a brilliant light appeared in her cell that her jailors were terrified and wanted to release her, but Agatha insisted on accepting her martyrdom. Finally the governor had her roasted over live coals and she died. (*Golden Legend*).

Saint Agnes When Agnes was only thirteen the prefect of Rome ordered her to sacrifice to pagan idols. When she refused, knowing that Christ and her guardian angel would protect her, he ordered her to be sent nude into a brothel. 'But as she stood

naked her hair loosed itself and fell by divine grace so densely around her that she seemed better dressed in it than in her clothes.' Her angel brought her a brilliant white robe of such a perfect fit that no one could doubt it had been prepared by angelic hands. She was put over live coals, but her prayers cooled the flames, and to put her to death the prefect finally had to have her stabbed in the throat with a sword. (*Acta Sanctorum*).

The *Golden Legend* said of her that 'in years she was a child but in mind she was old, bodily a girl but white-haired in spirit, beautiful of face but more beautiful in faith'. Her name, as well as her innocence, reminded men of the Latin word *agnus*, a lamb, the symbol of Christ.

Agony in the Garden Following the Last Supper, Christ went to pray in a garden nearby, anticipating his approaching trial and death. 'And when they had sung an hymn, they went out into the mount of Olives.... And they came to a place which was named Gethsemane: and he saith to his disciples, Sit ye here, while I shall pray. And he taketh with him Peter and James and John, and began to be sore amazed, and to be very heavy; and saith unto them, My soul is exceeding sorrowful unto death: tarry ye here, and watch' (Mark, 14).

'And he went a little farther, and fell on his face, and prayed, saying, O my Father, if it be possible, let this cup pass from me: nevertheless not as I will, but as thou wilt' (Matthew, 26).

'And there appeared an angel unto him from heaven, strengthening him. And being in an agony he prayed more earnestly: and his sweat was as it were great drops of blood falling down to the ground' (Luke, 22).

'And he cometh unto the disciples, and findeth them asleep, and saith unto Peter, What, could ye not watch with me one hour? Watch and pray, that ye enter not into temptation: the spirit indeed is willing, but the flesh is weak. He went away again the second time, and prayed, saying, O my Father, if this cup may not pass away from me, except I drink it, thy will be done. And he came and found them asleep again: for their eyes were heavy. And he left them, and went away again, and prayed the third time, saying the same words. Then cometh he

to his disciples, and saith unto them, Sleep on now, and take your rest: behold, the hour is at hand, and the Son of man is betrayed into the hands of sinners. Rise, let us be going: behold, he is at hand that doth betray me.

'And while he yet spake, lo, Judas, one of the twelve, came, and with him a great multitude with swords and staves, from the chief priests and elders of the people' (Matthew, 26).

Agrippina with the Ashes of Germanicus Agrippina was the daughter of the Roman emperor Augustus, and a model of the Roman woman: chaste, faithful, and fecund, a good wife and mother. Her husband Germanicus was a nephew of Augustus' successor, the emperor Tiberius, and commanded the Roman legions in Germany, where he became so popular with the troops that he excited his uncle's jealousy. When Germanicus died, poisoned perhaps by Tiberius' men, Agrippina returned to Italy and made a dramatic debarkation with two of her children, holding the urn with Germanicus' ashes in her arms. She was received in Rome by admiring crowds, but was sent into exile by Tiberius. (Tacitus).

Ahasuerus, *see* Feast of Ahasuerus.

Ajax 'Next to Achilles, the strongest of the Greeks. After Achilles' death, Ajax wanted his armour, but Ulysses persuaded the judges to give it to him instead. Ajax went mad with rage and killed a flock of sheep, thinking they were Ulysses and his men. Then he killed himself. Ovid says a flower called Hyacinth grew from his blood.

'Another Ajax, contemporary with the first, was the son of the king of Locris. He was a fast runner and skillful at brandishing the spear. When Troy had been captured, he violated Cassandra, a virgin and a prophetess, in the temple of Minerva. Because of this, on his way back to Locris he and his ship were burned up by a thunderbolt at sea' (Torrentinus).

Alexander the Great 'Son of the king of Macedonia . . . and a pupil of Aristotle. He conquered Asia and a large part of

India and was the founder of many cities called Alexandria after himself. Because of the extent of his conquests, men called him Alexander the Great. When he was on his way back from India to Macedonia, he was carried off to the waters of the Styx, the river of the underworld, at the age of 32; for Antipater, the prefect of Macedonia, poisoned him in Babylon at a banquet' (Calepinus).

Amazons The Amazons were a Scythian tribe who lived by plundering. As the men were gradually killed off, the women began joining them in their raiding expeditions. 'Finally, considering that women were good enough for war and weapons', they killed off the remaining men and exposed all male children as they were born. 'The girls they carefully saved for military service, burning or cutting off the right breast so it would not impede their archery when they grew up, but leaving the left one intact for suckling infants. Hence their name A-mazon, which means without a breast' (Jacopo da Bergamo).
 See also **Battle of the Amazons.**

Saint Ambrose When Ambrose was in his cradle a swarm of bees gathered around his mouth and then flew high into the air, an omen which his father interpreted as a sign of his future greatness. When, after completing his studies at Rome, he was passing through Milan on an imperial mission, he tried to settle a noisy dispute 'between Arians and Catholics' over the election of a new bishop. 'Suddenly a child's voice was heard saying, Ambrose Bishop' and, though he had not even been baptized, the people unanimously elected him. After several attempts to avoid the responsibility, including pretending to be a philosopher and being seen in the company of 'public women', Ambrose was baptized and raised to the episcopal seat.
 He became famous for his firm and eloquent defense of the Church against heretics and governments alike. When, after an uprising in Salonica, the Emperor Theodosius had five thousand people – 'guilty and innocent alike' – slaughtered, Ambrose refused him entry to the church, and turned him away

16

with a severe speech admonishing him to do proper penance. Theodosius realized that 'Ambrose will not be intimidated by the power of the emperor'. When Theodosius was finally readmitted to church, Ambrose rebuked him again for wanting to enter the chancel. 'The purple made you emperor,' he said, 'not priest' (*Golden Legend*).

The whip Ambrose sometimes carries was later thought to commemorate 'this sincere freedom of speech, which did not yield even to the Emperor Theodosius' (Molanus).

Amor, *see* Cupid.

Amphitrite 'When Neptune wanted to marry Amphitrite, she was overcome with shyness and concern for her virginity and fled for refuge to the islands of Atlas. Neptune sent many to look for her, among them a dolphin who found her whiling away her time on the islands.' The dolphin reconciled Amphitrite to Neptune and persuaded her to accept the god as her husband. (Aratus).

Ananias, *see* Punishment of Ananias.

Anchises, *see* Aeneas.

Saint Andrew One of Christ's twelve apostles. He and his brother Simon Peter were fishermen and were the first apostles to be called by Christ, who made them 'fishers of men'. The Middle Ages expanded the story of his life after Christ's death. Once the men of Nicaea complained to him that seven demons were outside the city killing wayfarers. Andrew confronted the demons and ordered them to take on the form of dogs and go away where they could do no harm. The demons obeyed him at once.

He converted and baptized many in Greece, including the wife of a Roman prefect. Infuriated, the prefect ordered him to sacrifice to the pagan gods. When Andrew refused the prefect had him whipped and tied – instead of being nailed – to the cross, to prolong his suffering. But Andrew rejoiced at the

thought of dying in the manner that Christ had, and when he saw the cross he said, 'I have always adored you and desired to embrace you, Cross, for the limbs of Christ have made you fine and beautiful.' He hung there for two days preaching to the crowds that gathered and dissuaded those who wanted to take him down. After his death the prefect's wife buried his body and the prefect was seized by a demon and died.

Long after St Andrew's death the devil appeared in the form of a beautiful young virgin to a bishop and had almost succeeded in seducing him at dinner when St Andrew, dressed as a pilgrim, came to the door and asked to be let in. The devil suggested he should be admitted only if he could answer three difficult questions. When St Andrew had answered the first two, 'the devil asked, How far is it from heaven to hell? St Andrew replied, You should know better than I, for you measured the distance when you fell through it. At that the ancient adversary disappeared and the bishop was saved from sin' (*Golden Legend*).

Angel Appearing to the Shepherds, *see* Adoration of the Shepherds.

Angelica and the Hermit An episode from Ariosto's *Orlando Furioso*. Angelica, a beautiful princess from Cathay, was fleeing the knights of Charlemagne and was befriended by an old hermit skilled in the arts of magic. When his paternal instincts gave way to lecherous ones he sent a sprite to torment her horse and bring her to a wild and deserted spot. Intercepting her there the hermit put her to sleep with a magic potion and she was defenceless against his – impotent – advances, which Ariosto describes:

> 'Yet oft he kissed her lips, her cheeks, her breast,
> And felt and saw the beauties of the rest,
> The dullard jade still hangeth down his head,
> Stirring or spurring could not make him prance. . . .
> His strength was gone, his courage all was dead,
> His weapon looked like a broken lance:

And while himself in vain he thus doth cumber,
He falleth down by her into a slumber'
 (Orlando Furioso, tr. John Harington, 1634.)

Angelica and Medor An incident from Ariosto's *Orlando Furioso*. After a battle between the pagans and the Christians, Medor, a young Moor, was wounded on his retreat from the enemy camp. Angelica, a princess from Cathay, found him lying as though dead, treated his wounds with special herbs, and took him to a shepherd's hut where he recovered. During Medor's convalescence they fell in love. Ariosto describes the pleasure they took in whiling away the days together as she hung on him with delight, her arms twined around his neck, and adds:

'Amid these joys (as great as joys might be),
Their manner was on every wall within,
Without on every stone or shady tree,
To grave their names with bodkin, knife or pin'
 (Orlando Furioso, tr. John Harington, 1634.)

Angels Bringing Food and Drink to Elijah The prophet Elijah was fleeing from King Ahab, who had threatened to kill him. 'But he himself went a day's journey into the wilderness, and came and sat down under a juniper tree: and he requested for himself that he might die; and said, It is enough; now, O Lord, take away my life; for I am not better than my fathers. And as he lay and slept under a juniper tree, behold, then an angel touched him, and said unto him, Arise and eat. And he looked, and, behold, there was a cake baken on the coals, and a cruse of water at his head. And he did eat and drink, and laid him down again. And the angel of the Lord came again the second time, and touched him, and said, Arise and eat; because the journey is too great for thee. And he arose, and did eat and drink, and went in the strength of that meat forty days and forty nights unto Horeb the mount of God (I Kings, 19).

Angels Carrying Mary Magdalene to Heaven After Christ's death 'Mary Magdalene, desiring to live in contem-

plation of higher things, sought a rugged solitude. She remained for 30 years, unknown to anyone, in a place prepared by angelic hands, where she had neither the solace of flowing water, nor trees, nor grass. From this it was clear that our Redeemer had decided to sustain her not with earthly food, but with celestial banquets. Every day angels carried her to heaven at the seven canonical hours and she heard the glorious choruses of the heavenly hosts with her bodily ears. Then the angels brought her back to her solitude where, satisfied with these sweet feasts, she had no need of bodily food.'

A certain priest, whose cell was in that region, had a vision in which he saw the Magdalene being carried to heaven and back again by the angels. To verify what he had seen he approached her retreat, but as he got nearer to it his legs grew weak with fear. He then heard the voice of the Magdalene speaking to him and assuring him that it was she indeed he had seen in his vision. (*Golden Legend*).

Anne and Joachim Joachim, a rich man of Nazareth, married Anne of Bethlehem. They were a just couple and gave one-third of their wealth to the Temple, one-third to pilgrims and the poor, and kept one-third for themselves. When they were still childless after twenty years of marriage they made a vow that if they had a child they would dedicate it to a life of serving God in the Temple.

Expulsion of Joachim From the Temple. Following their vow Anne and Joachim went to Jerusalem to make an offering to God. But when Joachim wanted to present his offering the priest chased him away with great indignation, scolding him and saying it was not right for a childless man to enter the Temple on equal terms with those who had children.

Joachim Among His Shepherds. 'Therefore, Joachim was ashamed and unwilling to return home, since he was afraid he would hear the same reproach from his own family. Instead, he withdrew and went to live among his shepherds.'

Joachim's Dream. One day an angel appeared to him and told him that Anne would conceive and bear a daughter called Mary, 'to whom the son of the Highest will be born, whose

name will be called Jesus and through whom salvation will come to all mankind'. The angel explained that God 'closes a womb so that he may open it again miraculously, to show that the child born is not the product of bodily desire but of divine favour', and added, 'This will be a sign to you: when you arrive at the Golden Gate of Jerusalem your wife Anne will be there to meet you and she, now troubled by your absence, will rejoice to see you.'

Sacrifice of Joachim. 'And Joachim went down and called his shepherds and said, Bring me ten spotless lambs as a sacrifice for the Lord my God, and twelve tender calves for the priests and elders, and one hundred goats for all the people.'

Annunciation to Saint Anne. 'While Anne was weeping bitterly because she did not know where her husband had gone, the same angel appeared to her and told her the same things he had told Joachim, adding that for confirmation of his words she should go to the Golden Gate in Jerusalem where she would meet her husband returning.'

Meeting at the Golden Gate. 'And Anne stood before the Golden Gate, and saw Joachim coming with his flocks, and ran and hung upon his neck and said, Now I know that the Lord God has blessed me greatly, for the widow is no longer a widow, and the barren will conceive. And Joachim stayed home that first day.'

Birth of the Virgin. 'In the ninth month Anne gave birth, and said to the midwife, What have I borne? And the midwife told her it was a girl. Then Anne said, My soul is magnified this day. And when the proper number of days had passed she washed herself and gave suck to the child, and named her Mary' (*Golden Legend* and *New Testament Apocrypha, Protevangelium of James*).

Saint Anne and the Three Marys, *see* Saint Anne's Kith and Kin.

Saint Anne's Kith and Kin There was a legend that Saint Anne was married three times: to Joachim, Cleophas, and Salome, and bore a daughter named Mary by each husband:

21

the Virgin Mary to Joachim, Mary Cleophas to Cleophas, and Mary Salome to Salome.

The Virgin Mary, who married Joseph, was the mother of Jesus.

Mary Cleophas married Alpheus and was the mother of Joseph the Just and of the Apostles Simon, Judas Thaddaeus, and James the Less.

Mary Salome married Zebedee, and was the mother of the Apostles James the Greater and John the Evangelist, the 'sons of Zebedee' (*Golden Legend*).

Annianus, *see* Healing of Annianus.

Annunciation This was the moment of the conception of Christ: 'The angel Gabriel was sent from God unto a city of Galilee, named Nazareth, to a virgin espoused to a man whose name was Joseph, of the house of David; and the virgin's name was Mary. And the angel came in unto her, and said, Hail, thou that art highly favoured, the Lord is with thee (AVE GRATIA PLENA: DOMINUS TECUM): blessed art thou among women. And when she saw him, she was troubled at his saying, and cast in her mind what manner of salutation this should be. And the angel said unto her, Fear not, Mary: for thou hast found favour with God. And, behold, thou shalt conceive in thy womb, and bring forth a son, and shalt call his name Jesus. . . . Then said Mary unto the angel, How shall this be, seeing I know not a man? And the angel answered and said unto her, The Holy Ghost shall come upon thee, and the power of the Highest shall overshadow thee: therefore also that holy thing which shall be born of thee shall be called the Son of God. . . .

'And Mary said, Behold the handmaid of the Lord; be it unto me according to thy word. And the angel departed from her' (Luke, 1).

A second tradition is found in the apocryphal Book of James: Mary was spinning scarlet thread for the veil of the temple, 'and she took her jug and went out to fill it with water. And she heard a voice, saying, Hail you who are full of grace, the Lord is with you, blessed are you among women. She looked around

her right and left to see where the voice was coming from. Growing afraid she returned to her house and put down the jug, and taking up the scarlet thread she sat down upon her seat and drew it out. And the angel of the Lord stood before her saying, Fear not, Mary, for you have found grace before the Lord of all things, and out of his word you will conceive,' and he prophesied to her the birth of Christ. (*New Testament Apocrypha, Protevangelium of James*).

Anointing of David When Saul was king of Israel, the Lord became dissatisfied with him and sent the priest Samuel to anoint as king one of the sons of Jesse the Bethlehemite. Jesse showed Samuel seven of his sons, but none of them was the one God had chosen. 'And Samuel said unto Jesse, Are here all thy children? And he said, There remaineth yet the youngest, and, behold, he keepeth the sheep. And Samuel said unto Jesse, Send and fetch him: for we will not sit down till he come hither. And he sent, and brought him in. Now he was ruddy, and withal of a beautiful countenance, and goodly to look to. And the Lord said, Arise, anoint him: for this is he. Then Samuel took the horn of oil, and anointed him in the midst of his brethren: and the Spirit of the Lord came upon David from that day forward' (I Samuel, 16).

Anointing of Saul Saul was a handsome young man who stood head and shoulders above all the people of Israel. When he was out looking for his father's lost donkeys he came to a city where the priest Samuel, who had been chosen by God to be a judge of the Israelites, was sacrificing. When Samuel saw Saul, God spoke to him, indicating Saul, and said: 'Behold the man I told you of: he shall reign over my people.' Samuel told Saul the lost donkeys had been found and anointed him first king of Israel. (I Samuel, 9 (Vulgate)).

Antiope, *see* Jupiter and Antiope.

Antipater before Caesar When Antipater was accused of disloyalty to Rome and to Caesar he publicly bared his battle-

scars before him, offering them as his defence, which Caesar accepted.

To the Middle Ages Antipater symbolized Christ 'who stands before his Father on our behalf, showing by his wounds that he was a vigorous and loyal fighter, and carried out his Father's commands' (*Mirror of Man's Salvation*).

See also **Christ Showing His Wounds.**

Saint Antony Abbot A hermit saint, born in Egypt in the third century. When he was twenty he gave his possessions to the poor and went into the desert to lead a life of solitude. He tried to make his existence ever harsher, 'for he said that the strength of the soul was at its greatest when the pleasures of the body were at their least.' The severity of his life attracted other hermits and Antony is therefore considered the founder of monasticism.

When Antony first went into the desert he found a gold disk and a mass of silver, but recognizing the devil's hand he refused to be tempted by them. He tried to lead an ascetic life, fasting daily and wearing a hairshirt under an outer garment of skins. He lived alone inside a mountain, and underwent terrible temptations that took many forms. 'The devil would send him obscene thoughts', and one night 'even went so far as to put on the appearance of a woman and to imitate feminine gestures to deceive Antony, but the saint thought upon the Cross . . . and thus extinguished the glowing coal of that deceit'. Another time 'the devil came with a crowd of demons and inflicted so many blows upon him that he lay speechless with pain upon the ground. He later said that the suffering was greater than any ever caused by humanly inflicted blows.' And he was often attacked by wild beasts and even as an old man was seen 'fighting as if against visible enemies, and praying against them'. Hyenas tried to bite him, 'but he trusted faithfully in the Lord, always with a tranquil and imperturbed spirit, and the demons fled and the wild beasts, as it is written, made peace with him.'

Towards the end of his life St Antony paid his famous visit to St Paul the hermit, and then died at the age of 105. (Athanasius).

Molanus says that St Antony was invoked to protect farm animals from evil, and mentions the medieval practice – in commemoration of this – of keeping a communal pig which was known as St Antony's pig. A bell was tied about its neck to protect it from disease. Molanus thinks the pig may also symbolize the demonic assaults St Antony endured.

Saint Antony and the Mule St Antony of Padua was arguing with a heretic who denied that Christ was bodily present in the bread of the eucharist. Finally the heretic challenged the saint as follows: he would keep a mule confined without food for three days and then put a bucket of fodder before it while the saint offered it the holy eucharist. The saint agreed and at the appointed time, holding the eucharist, he addressed the mule: 'In the name of your Creator, whom I now hold in these unworthy hands, I command you, animal, to come humbly here at once and do fitting reverence.' At the same time the bucket of fodder was offered to the hungry mule. 'Miraculous indeed! For the animal, tortured with hunger, but hearing the words of St Antony and in the presence of Christ, neglected the food and at once inclined its head deeply and kneeled before the life-giving sacrament. The Catholics rejoiced, for the heretics were fittingly refuted; and the heretic who had argued with the saint abjured his heresy and accepted the faith' (*Acta Sanctorum*).

Saint Antony of Padua Embracing the Christ Child While on a preaching tour, St Antony was given hospitality by a local citizen, who caught sight of the saint at prayer with the Christ child in his arms. 'Hence he is painted with a book – in token of his learning – with the Christ child standing on it reaching out to embrace him' (*Acta Sanctorum*).

Saint Antony of Padua Finds a Miser's Heart in his Money Chest Preaching at the funeral of a usurer, St Antony took the text of his sermon from the words of the Gospel, Where your treasure is there is your heart also. And among other things in his sermon 'St Antony said, Even though

this rich man is dead and buried and has gone to hell, go to his treasure and in it you will find his heart. The dead man's family and friends went to the treasure and there they found the heart, still warm, in the midst of his coin' (*Acta Sanctorum*).

Saint Antony of Padua Preaching to the Fishes Discouraged by the obstinacy of a group of heretics of Rimini, St Antony went to a river bank near the sea and began, as though preaching, to call the fishes to him 'to hear the word of the Lord'. At once a multitude of big and little fish, such as was never seen before in those parts, approached, all holding their heads just a little above the water, and the saint began: 'My brother fishes, in your own way you are steadfast in giving thanks to the Creator who has given you such a noble element to live in, and who has provided water which is sweet or salt according to your needs, with innumerable refuges from the dangers of storms. He has made it clear and transparent, so that you can make your way around in it easily and find the food he has provided for you in abundance. At the time of the creation of the world you fishes received God's blessing and his instructions to multiply and fill the seas, and in the great flood, when the other animals who were not in the ark all perished, you were kept from harm. Outfitted with fins and armoured with courage, you flit about in every direction just as you wish.'

Hearing the sermon the fishes 'opened their mouths and bent their heads, praising the highest with such signs as they could The people of the city ran to see the miracle, and the heretics came too ... and were all converted by the saint, who sent them away with his blessing in gladness' (*Acta Sanctorum*).

Apelles Painting Campaspe Campaspe was the favourite mistress of Alexander the Great and Apelles was his favourite painter. As Apelles was famous for his paintings of Venus, Alexander asked him to paint a full-length portrait of Campaspe nude, and when Apelles, carrying out the commission,

fell in love with Campaspe, Alexander gave her to him as a present. (Pliny the Elder).

Apocalyptic Woman A vision of St John on Patmos. 'And there appeared a great wonder in heaven; a woman clothed with the sun, and the moon under her feet, and upon her head a crown of twelve stars.' A seven-headed dragon threatened the woman, but the archangel Michael and his angels fought the dragon, 'and the great dragon was cast out, that old serpent, called the Devil, and Satan, which deceiveth the whole world: he was cast out into the earth, and his angels were cast out with him' (Revelation, 12).

The *Mirror of Man's Salvation* considers this a vision of the Assumption of the Virgin, and explains, 'John saw a wonderful woman in the sky who was girded with the sun because Mary, girded with divinity, was ascending. The moon was under her feet, indicating Mary's perpetual stability, for the moon is changeable and does not long remain full, and signifies this world and all earthly things. Mary, despising this instability, trod it beneath her feet and aspired to heaven, where all things endure. The woman had a crown on her head with twelve stars in it. A crown is a sign of honour and here signifies honour worthy of the glorious Virgin. The twelve stars symbolize the Apostles, who are thought to have been present at her death. The woman is given two wings for flying, by which is understood the assumption of her body as well as her soul.'

See also **Immaculate Conception.**

Apollo 'Son of Jupiter and Latona. Under the name of Phoebus he was considered the god of wisdom, prophecy and song, but he was also a war god and thus is said to carry both the lyre and the bow' (Torrentinus).

Apollo and the Muses. 'He is painted in the form of an adolescent youth, sometimes with a boyish face, sometimes as a young man, but never with a beard. . . . Next to him is a green laurel and, flying above, a black raven, the bird sacred to the god himself. Under the laurel the nine muses do a dance and surround Apollo with the melodious sounds of their playing. At

27

a distance is the huge serpent Python, whom Apollo pierced through the middle with his arrow. Apollo himself sits between the two ridges of Mount Parnassus, from which flows the Castalian spring, sacred to him and the muses' (Albricus).

Apollo was also the god of the sun, as his twin sister Diana was goddess of the moon.

Apollo and Hyacinth Hyacinth 'was a beautiful youth with whom both Apollo and Zephyrus were in love at the same time: but Zephyrus (the west wind) perceiving that the youth's love inclined more to Apollo than to himself, grew angry and whilst he and Apollo were playing at the exercise called Discus, with a sudden blast of wind turned the Discus upon the youth's head and killed him; Apollo being grieved at this loss was comforted by Tellus (the earth), which drank up Hyacinth's blood, and turned it into a flower' (Ross, *Mystagogus Poeticus*, 1647 [shortened]).

Apollo Killing the Cyclops 'Aesculapius, Apollo's son, is said to have brought a dead man back to life, and therefore Jupiter struck him down with a thunderbolt. Apollo, because he could not harm Jupiter himself, killed those who made his thunderbolts, that is the Cyclops. Because of this Apollo was given in slavery to Admetus, king of Thessaly' (Hyginus).

Apollo Killing Python 'Python was an enormous serpent, the son of Earth, who used to prophesy from the Delphic oracle on Mount Parnassus before the time of Apollo. But it was fated that Python should be killed by one of Latona's children. At that time Jupiter slept with Latona ... and when Python saw that she was pregnant he began to follow her in order to kill her. But the North wind, at Jupiter's command, caught her up and bore her to Neptune, who protected her.' Hidden away on the island of Delos, 'Latona bore Apollo and Diana, and Vulcan gave them arrows as gifts. Four days after their birth Apollo avenged his mother. He went to Parnassus and killed Python with his arrows, which is why he is called Pythian Apollo' (Hyginus).

Apollo and Pan, *see* Midas.

Apollo Slaying the Nymph Coronis Coronis was the mother, by Apollo, of Aesculapius, but while she was still pregnant she was unfaithful to Apollo. The god learned the truth from a raven and put Coronis to death. Then, while her body was still on the funeral pyre, he snatched the unborn but living Aesculapius from her womb. (Ovid).

Apollo in Vulcan's Forge, *see* Mars and Venus.

Saint Apollonia A chaste and pious virgin of Alexandria. During a persecution of Christians the pagan mob seized Apollonia and tore out all her teeth. They threatened to cast her alive into a huge bonfire unless she denied her faith. But Apollonia horrified even her persecutors by throwing herself into the fire, where the flames were mild compared to the fire of religious conviction burning inside her. (*Golden Legend*).

The Apostles The twelve apostles were Peter, Andrew, James the Greater, John the Evangelist, Bartholomew, Philip, Matthew, Thomas, James the Less, Simon the Zealot, Judas Thaddaeus and Judas Iscariot, who was later replaced by Matthias. St Paul is sometimes shown among the apostles.

Apotheosis of Hercules When Deianira wanted to regain the affection of her husband Hercules, she sent him a shirt which the centaur Nessus had told her would revive his dying love. But the shirt had been soaked with poison, and when Hercules put it on he was tormented with a consuming fire. His agony became so intense that he built and kindled a funeral pyre and lay down on it. As the gods watched the blaze Jupiter reassured them that only Hercules' human part, derived from his mother, would die. 'The part he takes from me is eternal, exempt from death and immune to it, not to be conquered by the flames. When that part has done its stint on earth I will receive it here in heaven.' When Hercules had been destroyed by the fire, 'his finer part grew powerful and bigger to the sight,

and he became fearful in his august dignity. The omnipotent father seized him into the hollow clouds and carried him in his four-horse chariot into the gleaming stars' (Ovid).

Arachne A young woman of Lydia, whose skill in spinning and weaving was admired even by the nymphs. Convinced of her superior talents, Arachne refused to give credit to Minerva for being her teacher and challenged the goddess to a competition. Minerva and Arachne went to different parts of the room, set up the threads on their looms, and speedily began to weave their skilful tapestries. Then Minerva, outraged at being able to find no flaw in her rival's work, hit her with her shuttle. Unable to endure such treatment Arachne tried to hang herself, but as she hung in the air she was turned by Minerva into a spider, spinning thread from her belly. (Ovid).

Argonauts, *see* Jason and the Golden Fleece.

Ariadne 'Daughter of Minos, king of Crete, who helped Theseus find his way in the Labyrinth, and followed him on his way back to Greece. But he abandoned her on the island of Chios, or Naxos. Then Bacchus took her as his wife. When Venus gave her a crown, Bacchus decorated it with nine stars and put it in the heavens. Whence the celestial constellation called Ariadne's Crown' (Torrentinus).

Arion 'A lyre player and lyric poet from the Greek island of Lesbos. . . . He went to Italy where he earned great sums by his art. When he was sailing back to Lesbos and saw that the sailors were plotting against him on account of the money he had with him, he asked them to let him sing one more song before his death. His request was granted and after strumming his lyre and singing for a while he threw himself into the sea, where a dolphin, attracted by his song, took him up on its back and bore him safely to shore' (Stephanus).

Ark, *see* Offering of the Jews for the Building of the Ark; *and* Return of the Ark from Captivity.

30

Artemisia A warrior queen 'renowned for her chastity and love to her husband, Mausolus, whose bones (after he was dead) she preserved in ashes, and drunk in wine, making her self his tomb; yet built to his memory a Monument deserving a place among the seven wonders of the world, which could not be done by less than a wonder of women' (Ben Jonson).

Ascension After Christ's death and resurrection he came back to be with his apostles for 40 days, telling them that they should now preach his name throughout the world. After his instructions to them, 'he led them out as far as to Bethany, and he lifted up his hands, and blessed them. And it came to pass, while he blessed them, he was parted from them, and carried up into heaven' (Luke, 24).

'And while they looked stedfastly toward heaven as he went up, behold, two men stood by them in white apparel; which also said, Ye men of Galilee, why stand ye gazing up into heaven? this same Jesus, which is taken up from you into heaven, shall so come in like manner as ye have seen him go into heaven' (Acts, 1).

Bonaventura described the scene as follows: 'Then the clouds received him from before their eyes. In a moment he was in his kingdom with all the angels and holy fathers.... His mother and the disciples and Mary Magdalene and the other women knelt there and watched him going up to heaven for as long as they could see him.'

Augustine commented, 'He disappeared from our eyes so that we could look for and find him in our hearts' (quoted from the *Golden Legend*).

Ashdod, *see* Return of the Ark from Captivity.

Ass Kneeling before the Consecrated Wafer, *see* Saint Antony and the Mule.

Assumption of the Virgin The death of the Virgin is not mentioned in the Bible. The idea that her body was assumed into heaven is a medieval one. After her death, the apostles

gathered at the tomb where she had been buried to wait for her assumption. 'They noticed a sweet smell emanating from the tomb, and loud voices nearby. Flashes of light and fire passed before them and they heard the blast of a multitude of trumpets. Then they saw that the door of the tomb was open' (*New Testament Apocrypha, Discourse of Theodosius*).

'Suddenly a light from heaven shone round them; they fell to earth, and the holy body was taken up into heaven by angels' (*New Testament Apocrypha, Joseph of Arimathaea*).

The *Golden Legend* mentions the nine choirs of angels who played music and sang songs of praise and thanksgiving during the assumption.

See also **St Thomas.**

Astraea Astraea was the Roman personification of Justice. Ovid tells us that the gods, horrified by the cruelty and violence of men in the iron age, left the earth. 'And when even piety lay vanquished, then the virgin Astraea, last of all the gods, abandoned the bloodstained earth.' Virgil, and later Ariosto, wrote hopefully of Astraea's return as an event that would begin a new age of human justice and peace.

Atalanta, *see* Calydonian Boar Hunt.

Atlas, *see* Fall of the Titans.

Saint Augustine One of the Four Doctors of the western church, Augustine was born in North Africa in the fourth century. Although his mother, St Monica, was a Christian and tried to convert him, Augustine's interest lay in the liberal arts and philosophy. He took a mistress when he was eighteen and had a son by her, and while still quite young went to Milan to teach rhetoric.

The moment of his conversion came when he was thirty. He 'ran into a garden and threw himself down under a fig tree and wept bitterly', full of torments and regrets because he had taken so long to accept Christianity. Suddenly he heard a voice saying, 'Take and read', and opening the Bible at one of the

letters of St Paul he read, 'Clothe yourself in the Lord Jesus Christ'. His doubts vanished at once and, along with his young son and a close friend, he was baptized by St Ambrose, then bishop of Milan, on Easter Day. When Ambrose intoned the words, Te Deum laudamus, Augustine answered with Te Dominum confitemur, and they continued alternately composing the liturgical hymn known as the Te Deum.

Augustine gave up his wordly ambitions and returned to Africa where Valerian, bishop of Hippo, sent for him to preach before him and then made him a priest, and even finally persuaded the reluctant Augustine to replace him as bishop. (*Acta Sanctorum*).

Augustine wrote many works, including *The City of God*, and one on the Trinity. According to Caxton's translation of the *Golden Legend* he was once walking along the sea-shore meditating on the Trinity when he met a child who had dug a hole in the sand and was pouring sea-water into it with a spoon. When Augustine told the child how futile it was to try to put the sea into such a small space, the child replied that it would be easier than explaining the Trinity, 'for the mystery of the Trinity is greater and larger to the comparison of thy wit and brain than is this great sea unto this little pit'. Then the child vanished.

Molanus, writing in the sixteenth century, said that Augustine was painted with his heart pierced with arrows, apparently on account of a passage in his Confessions that reads, 'You have shot our heart through with the arrows of your love'. He also relates the story of the child and the Trinity to a miraculous appearance of the dying St Jerome to Augustine, just as Augustine was writing him a letter. In the vision Jerome tried to moderate Augustine's intellectual ambitions by warning him against trying to put the ocean into a tiny pot.

Augustus and the Sibyl According to the *Golden Legend*, when the Roman senate wanted to worship the emperor Augustus as a god, he was unwilling to accept divine honours before consulting the Sibyl, a prophetess, to find out whether

anyone greater than him would ever be born. 'When he had convoked a council concerning this matter, on the very day of the nativity of the Lord, the Sibyl, alone in the emperor's chamber, consulted her oracles. At midday a golden circle appeared around the sun, and in the middle of the circle a beautiful virgin holding a child in her lap. The Sibyl showed this to Augustus, and when he had stood for some time in admiration of the prophetic vision, he heard a voice saying, This woman is the altar of heaven. The Sibyl added, This child is greater than you, adore him therefore. . . . Recognizing the child's superiority to himself, the emperor offered incense to him and refused to be called a god by the others.'

Babel, *see* Tower of Babel.

Bacchus Son of Jupiter and Semele, and god of wine, which he was the first to discover. His name Bacchus is often used metaphorically for wine itself. 'He had an effeminate appearance, with bared chest, and horns on his head, which was crowned with grape leaves, and he used to ride upon a tiger, holding a wine goblet in one hand and a bunch of grapes in the other' (Albricus).

As an infant 'he was nursed by his foster mother Juno, then she gave him to some nymphs who nourished him. . . . The ass and the goat are sacred to him because, like Bacchus, they resent the spur which does not bother other beasts of burden' (Stephanus).

'Sometimes he is shown in a triumphal procession, riding in a chariot which is draped in vine tendrils and drawn by panthers, or tigers and lynxes. Silenus stands near him with his sway-back ass, while female revellers and satyrs carry rods decorated with vine leaves, and other groups of revellers lead the procession or bring up the rear' (Giraldi).

Balaam When Moses and the Israelites were wandering in the wilderness, they advanced on Moab and the king of Moab called Balaam, a prophet, to curse them. 'And God's anger was kindled because he went: and the angel of the Lord stood in the

way for an adversary against him. Now he was riding upon his ass, and his two servants were with him. And the ass saw the angel of the Lord standing in the way, and his sword drawn in his hand: and the ass turned aside out of the way, and went into the field: and Balaam smote the ass, to turn her into the way. But the angel of the Lord stood in a path of the vineyards, a wall being on this side, and a wall on that side. And when the ass saw the angel of the Lord, she thrust herself unto the wall, and crushed Balaam's foot against the wall: and he smote her again. And the angel of the Lord went further, and stood in a narrow place, where was no way to turn either to the right hand or to the left. And when the ass saw the angel of the Lord, she fell down under Balaam: and Balaam's anger was kindled, and he smote the ass with a staff. And the Lord opened the mouth of the ass, and she said unto Balaam, What have I done unto thee, that thou hast smitten me these three times? . . .

'Then the Lord opened the eyes of Balaam, and he saw the angel of the Lord standing in the way, and his sword drawn in his hand: and he bowed down his head, and fell flat on his face' (Numbers, 22).

In Moab Balaam said, 'How shall I curse, whom God hath not cursed?' and he blessed Israel instead. Part of his blessing, the words: 'A star will rise from Jacob, and a man will come out of Israel', were later interpreted as prophecies of the births of the Virgin Mary (the star) and of Christ. Medieval legend said Balaam's words were preserved in prophetic books. The Magi, as kings descended from him, studied his prophecies, and thus were prepared to recognize the star that led them to Bethlehem when Christ was born. (John of Hildesheim).

Banquet of Herod, *see* Beheading of John the Baptist.

Banquet of Tereus Tereus was king of Thrace and married to Procne, a princess of Athens. 'When he abducted his wife's sister Philomela, on the pretext of taking her to visit Procne, he raped her and then cut out her tongue. This made Procne so furious that she chopped up their son Itys, and served him to his father at a banquet. When the boy's head was brought in at

the end of the feast, Tereus understood what had happened. He drew his sword in a rage but, as he was about to kill his wife, she turned into a swallow before his eyes. Philomela turned into a nightingale, and Itys into a pheasant. Even Tereus himself, standing in wonder at these transformations, was changed into a hoopoe' (Stephanus).

Baptism of Christ John the Baptist had been preaching in Judaea, foretelling the coming of Christ, and calling men to repentance for their sins. 'The next day John seeth Jesus coming unto him, and saith, Behold the Lamb of God, which taketh away the sin of the world' (ECCE AGNUS DEI QUI TOLLIT PECCATA MUNDI) (John, 1).

Then Jesus 'was baptized of John in Jordan. And straightway coming up out of the water, he saw the heavens opened, and the Spirit like a dove descending upon him: and there came a voice from heaven, saying, Thou art my beloved Son, in whom I am well pleased' (Mark, 1).

This was followed by Christ's Temptation in the Wilderness, and was the beginning of his public activity.

Baptism of the Moor, *see* Saint Philip Baptizing the Ethiopian Eunuch.

Saint Barbara Barbara was the daughter of a rich pagan in the third century. 'Her father was exceedingly fond of her because of her great bodily beauty and built a high tower and shut her up in it so that no one would see her. But Barbara's great intelligence even at that young age led her to give up idle thoughts and begin meditating on divine things.' Barbara heard about the theologian Origen of Alexandria and wrote him a letter. He wrote back and also sent a messenger who taught her about Christ and the Trinity, gave her books to study, and baptized her in her tower.

Barbara's father decided to build a pool with two windows. While he was away Barbara came down from her tower and instructed the workmen to put in a third window. When her father returned and was angered at the third window Barbara

explained that 'three windows illuminate the whole man'. At that her father tried to kill her, but the rock near them split open and received her, depositing her on a mountain on which two shepherds were pasturing sheep. When her father came looking for her one of them kept silent, but the other gave her away (and, according to some accounts which the *Golden Legend* rejects, was turned into a marble statue and his sheep into locusts). Just before her death Barbara prayed: 'Lord Jesus Christ, whom all things obey, grant this prayer: if anyone shall be mindful of your name and of the martyrdom of your servant, do not remember his sins in the day of judgement, but be favourable to him, for you know that we are only flesh.' And a voice was heard saying, 'Come, my beloved, rest in the chambers of my Father in heaven: what you ask is granted to you.' Then Barbara was beheaded by her father, who was himself consumed by a bolt of fire from heaven. (*Golden Legend*).

Saint Bartholomew One of Christ's twelve apostles. Medieval legend says he went to India as a pilgrim where he stayed in a temple with a demon who lived in an idol and pretended to cure the sick. When the local priests were offering sacrifices, Bartholomew ordered the demon to leave the idol and break it. The demon not only broke the idol, but all the other idols in the temple crashed to the ground as well.

When the local king tried to make Bartholomew give up his faith and worship pagan gods, the statue of the king's god fell to the ground and turned to dust. For this the king had Bartholomew beaten with clubs and skinned alive. Other accounts say he was crucified, possibly head-down, or beheaded. (*Golden Legend*).

Saint Basil, *see* Mass of Saint Basil.

Bathsheba, *see* David and Bathsheba.

Battle of the Amazons One of the labours of Hercules, whose task it was to bring back the sword-belt of Hippolyta, the

37

queen of the Amazons. When Hercules reached the mouth of the river Thermodon, where the Amazons lived, he and his followers made war against them. 'The most honoured of the women were drawn up against Hercules himself and put up a fierce battle.' Hercules killed their most courageous leaders and 'after taking captive Hippolyta together with her sword-belt completely crushed this nation' (Diodorus Siculus).

Battle of the Giants, *see* Fall of the Titans.

Battle of the Lapiths and the Centaurs Pirithous, king of the Lapiths, invited his cousins the Centaurs to his wedding with Hippodamia. But Eurytus, the wildest of the centaurs, 'his breast burning with wine and the beauty of the virgin bride, gave way to drunkenness twinned with lust. As the overturning tables threw the wedding feast into confusion, Eurytus seized the new bride by her hair and dragged her violently away, and the other centaurs grabbed any woman they wanted or could get. It was like a captured city being sacked.' The hero Theseus, one of the king's guests, rescued the bride. (According to some accounts, Hercules was also there, fighting on the Lapith side.) Goblets, jugs and basins all became weapons, and even sacred objects from the shrine and the altar itself. Finally the Lapiths killed half the Centaurs and the rest fled in darkness. (Ovid).

Saint Bavo Bavo was a seventh century Flemish nobleman and soldier whose early life was spent in dissipation. Then 'he decided to campaign in the service of Christ, and though the king prohibited soldiers from becoming monks, Bavo persisted in his resolve'. Seeking out the missionary bishop Amandus, Bavo was instructed by him in Christianity and baptized. He distributed his wealth to the poor and his lands to the church. His conversion evidently had some effect on Merovingian court life, and his biographer states that 'following his example Gertrude and Biga, the daughters of Pipin the First, also devoted themselves to a purer life' (*Acta Sanctorum* and Molanus, *Belgian Saints*).

Beheading of John the Baptist When King Herod married his sister-in-law, Herodias, John condemned him and said, 'It is not lawful for thee to have thy brother's wife.' Herodias resented John's accusation and sought an occasion to kill him. To please his wife, Herod arrested John and sent him to prison. (Mark, 6).

'But when Herod's birthday was kept, the daughter of Herodias' (that is, Salome) 'danced before them, and pleased Herod. Whereupon he promised with an oath to give her whatsoever she would ask. And she, being before instructed of her mother, said, Give me here John Baptist's head in a charger' (Matthew, 14).

'And immediately the king sent an executioner, and commanded his head to be brought: and he went and beheaded him in the prison, and brought his head in a charger, and gave it to the damsel: and the damsel gave it to her mother' (Mark, 6).

John's disciples buried him, but so many miracles were done at his tomb that Julian the Apostate ordered the bones scattered. When the miracles continued, the bones were gathered again and burnt and the ashes scattered to the winds. But monks from Jerusalem gathered and preserved some relics. (*Golden Legend*).

Bellona 'The Roman goddess of war, and sister of Mars' (Torrentinus).

Belshazzar's Feast 'When Cyrus and Darius were besieging King Belshazzar in Babylon, Belshazzar held a great banquet for a thousand of his nobles, and had the tables set with the goblets his grandfather Nebuchadnezzar had carried off from the Temple of the Lord in Jerusalem. The king and his nobles, his wives and his concubines all drank from the goblets, and gave thanks to all their gods. At that moment a hand appeared opposite the king writing on the wall, and the king saw the hand and the writing, but did not know if any of the others had seen it. And when the hand disappeared, the king was greatly troubled, and his knees beat together, and he cried out for his soothsayers' (*Historia Scholastica*).

When the king's astrologers and soothsayers were unable to interpret the writing, Daniel, a Jew and a prophet, was brought before the king. Daniel condemned the king for praising false gods of silver and gold and prophesied the destruction of his kingdom. He interpreted the writing: 'MENE; God hath numbered thy kingdom, and finished it. TEKEL; Thou art weighed in the balances, and art found wanting. PERES; Thy kingdom is divided, and given to the Medes and Persians.' That night Belshazzar was killed, and Darius the Mede took the kingdom. (Daniel, 5).

Saint Benedict Benedict was a sixth century Italian who went into the wilderness to follow a simple monastic life. The purity of his ways attracted other monks who asked him to govern them. For them he drew up what later became the most famous of monastic rules. The *Golden Legend* says he eventually founded twelve monasteries.

When he went to live in a desert cave a monk lowered his food to him on a rope. The devil came and broke the bell the monk used to call Benedict, but Benedict still received his food anyway. Another monk was divinely instructed to bring his Easter dinner to Benedict, of whose existence he had not been aware, while Benedict, living so far from men, had not known that it was Easter.

The saint performed many miracles. His nurse broke a borrowed flour-sieve and Benedict repaired it with his prayers. One of his monks, Placidus, went to fetch water and fell into the river. Benedict, praying in his cell, was divinely informed of what had happened and sent another monk, Maurus, to the rescue. Maurus 'ran on the water as if it were dry land, catching the lad by the hair and pulling him out'. And when the iron scythe Placidus was using flew off its handle and fell into the water, the saint held the wooden handle in the water and the scythe floated up to meet it.

Benedict's extraordinary insight saved him from a poisoned cup given him by monks who resented the severity of his rule. He made the sign of the cross over the cup and it broke. Similarly he had a raven carry a poisoned loaf to a place where

no one would find it. And when Totila, the king of the Goths, wanting to try 'the man of God' to see whether he really had the spirit of prophecy, sent his bodyguard in his own royal dress to Benedict, 'the saint said, Take off those clothes, young man, they are not your own. At which the bodyguard fell down and died for presuming to fool such a man.' Gregory the Great says that Totila himself then came to see Benedict but 'seeing him at a distance he did not dare approach but knelt down on the ground instead'. Benedict scolded Totila for his evil deeds and 'the frightened king was less cruel from that time on'.

At the hour of his death two of Benedict's monks saw a path of light going from his cell to heaven. (*Golden Legend*).

See also the **Conversation of Saint Scholastica.**

Benjamin, *see* Joseph in Egypt.

Saint Bernard of Clairvaux and the Virgin and Christ

Saint Bernard was praying before a very old and revered image of the Virgin, when suddenly the image held out the Christ child to him 'as if he were his natural brother'. Then, raising her hand to her breast, 'she pressed out from it three drops of milk for the saint'.

Another legend reports him as saying that Christ and the Virgin both appeared to him and 'I fed on the blood of the first and suckled at the breast of the other'.

On another occasion a fellow monk saw Bernard praying alone in church before a crucifix, and the figure of Christ descending from the cross to embrace him. (*Acta Sanctorum*).

Saint Bernardino of Siena A fifteenth century Franciscan. After recovering from a serious illness he gave away his wealth to the poor 'and became an imitator of St Francis. He kept nothing for himself except his habit, underwear and cord, and went off to a lonely monastery which was very suited for meditation.' Bernardino decided to become a preacher 'but as he had a speech impediment he prayed to the Lord, and a fiery globe was let down from heaven which melted the hoarseness of his tongue, and he preached the name of Jesus in the towns and

villages of Italy with great success'. When preaching he would hold up a disk with the Greek initials of the name Jesus – IHS – so that at his death he could literally say, Pater manifestavi nomen tuum hominibus (Father, I have shown your name to men). (*Golden Legend*).

Bethesda, *see* Christ Healing the Paralytic at the Pool of Bethesda.

Betrayal of Christ While Christ was praying in the garden of Gethsemane the disciples that were with him fell asleep. 'Then cometh he to his disciples, and saith unto them, Sleep on now, and take your rest: behold, the hour is at hand, and the Son of man is betrayed into the hands of sinners. Rise, let us be going: behold, he is at hand that doth betray me' (Matthew, 26).

'And immediately, while he yet spake, cometh Judas, one of the twelve, and with him a great multitude with swords and staves' (John adds: 'lanterns and torches'), 'from the chief priests and the scribes and the elders. And he that betrayed him had given them a token, saying, Whomsoever I shall kiss, that same is he; take him, and lead him away safely. And as soon as he was come, he goeth straightway to him, and saith, Master, master; and kissed him. And they laid their hands on him, and took him' (Mark, 14).

'Then Simon Peter having a sword drew it, and smote the high priest's servant, and cut off his right ear. The servant's name was Malchus' (John, 18).

'And Jesus answered and said, Suffer ye thus far. And he touched his ear, and healed him. Then Jesus said unto the chief priests, and captains of the temple, and the elders, which were come to him, Be ye come out, as against a thief, with swords and staves? When I was daily with you in the temple, ye stretched forth no hands against me: but this is your hour, and the power of darkness' (Luke, 22).

'Then all the disciples forsook him, and fled' (Matthew, 26).

Betrothal of the Virgin, *see* Marriage of the Virgin.

Bewailing of Christ, *see* Lamentation for the Dead Christ.

Birth of Apollo and Diana, *see* Apollo Killing Python.

Birth of John the Baptist The birth of John the Baptist and the name he was to be given were foretold to his father Zacharias by an angel. Because Zacharias doubted the words of the angel, he was struck dumb.

'Now Elisabeth's full time came that she should be delivered; and she brought forth a son. And her neighbours and her cousins heard how the Lord had shewed great mercy upon her; and they rejoiced with her. And it came to pass, that on the eighth day they came to circumcise the child; and they called him Zacharias, after the name of his father. And his mother answered and said, Not so; but he shall be called John. And they said unto her, There is none of thy kindred that is called by this name. And they made signs to his father, how he would have him called. And he asked for a writing table, and wrote, saying, His name is John. And they marvelled all. And his mouth was opened immediately, and his tongue loosed, and he spake, and praised God' (Luke, 1).

In describing the birth, Bonaventura mentions the Virgin Mary, who was also there. 'When her time had come, Elisabeth bore a son whom our Lady picked up from the ground and carefully tended as was necessary.'

See also, **Zacharias and the Annunciation of the Birth of John the Baptist.**

Birth of Venus 'The ancients considered Venus the goddess of love, beauty and grace, and of all delights and voluptuous pleasures.... The poets say she was born from the genitals of the sky god Uranus, which his son Saturn cut off and threw into the sea. From them came a sea foam – aphros in Greek – which is why the Greeks called her Aphrodite.... They say she was conceived in an oyster shell and sailed on it to the island of Cyprus' (Stephanus).

At Cyprus Venus rose from the sea and Love and Desire –

or, as others say, the Three Graces – clothed her and led her to Olympus.

Birth of the Virgin, *see* Anne and Joachim.

Blood of the Redeemer The Biblical background of this subject was established by Christ's words to his apostles at the Last Supper, 'This is my blood ... which is shed for the remission of sins', and by the *Coup de Lance* at the Crucifixion, when blood and water came out of his wound. Tertullian says, 'We are called to Christ by the water of baptism, but chosen through his blood. These are the two baptisms he gave us from his pierced side: for whoever believes in his blood will be made clean by the water, and whoever is made clean by the water of baptism will drink of his blood.'

Saint Bonaventura Bonaventura was a thirteenth century Franciscan who wrote theological and mystical works, like the *Lignum Vitae – The Tree of Life*. His name was owing to an incident in early childhood when he became gravely ill and was miraculously cured by St Francis, who then called him Bonaventura, which means Good Luck. As a result his mother vowed that he would become a Franciscan.

Bonaventura's contemporary St Thomas Aquinas admired his mystical writings so highly that he asked to see the library of books 'from which he drew such diverse and rich erudition'. Thereupon Bonaventura took him to his cell and showed him a crucifix.

His authority with his fellow bishops was so great that when they convened to elect a pope and could not come to any decision, they called on Bonaventura for a solution. He designated Gregory X, who two years later made the saint a cardinal. The Council of Lyons, organized by Bonaventura and Thomas, was attended by the Byzantine Emperor Michael Paleologus and was important in that it tried to heal the breach between the Greek and Latin churches, which focused on a disagreement about the Creed. Bonaventura was the first to speak and he did so in such a conciliating manner that he

44

persuaded the Greeks and the Emperor 'to profess as orthodox the faith of the Roman church' and to chant the Creed in unison with the Catholics. His funeral a short time later was attended by the Emperor, Pope Gregory, and many other cardinals and dignitaries. (*Acta Sanctorum*).

Boreas and Orithyia Boreas, god of the north wind, fell in love with Orithyia, the king of Athens' daughter. He tried to win her by persuasion, but when that failed he grew furious and 'shaking out the wings whose beating fills the earth with storms and stirs the seas, and drawing along his robe of dusty darkness, he embraced the trembling Orithyia in his tawny wings and flew away with her' to his northern home. (Ovid).

Brazen Serpent When the Israelites had been led out of Egypt by Moses, they complained about the hardships they had to endure in the wilderness. To punish them 'the Lord sent fiery serpents among the people, and they bit the people; and much people of Israel died.

'Therefore the people came to Moses, and said, We have sinned, for we have spoken against the Lord, and against thee; pray unto the Lord, that he take away the serpents from us. And Moses prayed for the people. And the Lord said unto Moses, Make thee a fiery serpent, and set it upon a pole: and it shall come to pass, that every one that is bitten, when he looketh upon it, shall live. And Moses made a serpent of brass, and put it upon a pole, and it came to pass, that if a serpent had bitten any man, when he beheld the serpent of brass, he lived' (Numbers, 21).

To Christians, the brazen serpent foreshadowed the Crucifixion, through which Christ saved men from that original sin caused by the wiles of the serpent in the garden of Eden. 'And as Moses lifted up the serpent in the wilderness, even so must the Son of man be lifted up: that whosoever believeth in him should not perish, but have eternal life' (John, 3).

Bringing in the Ark of the Covenant, *see* David Dancing Before the Ark of the Covenant.

Briseis Restored to Achilles, *see* Wrath of Achilles.

Brutus An early Roman hero. When Tarquin the Proud was king of Rome, he murdered Brutus' elder brother. Brutus escaped by feigning idiocy. After the Rape of Lucretia by one of Tarquin's sons, Brutus stirred the people up to expel the king and establish a republic. He was later elected to one of the chief public offices himself, and when two of his sons tried to restore the monarchy he ordered them to be put to death. (Livy).

Burial of Christ Those present at Christ's Deposition from the Cross were also present at the Burial, which immediately followed it. 'And after this Joseph of Arimathaea, being a disciple of Jesus, but secretly for fear of the Jews, besought Pilate that he might take away the body of Jesus. . . . And there came also Nicodemus . . . and brought a mixture of myrrh and aloes, about an hundred pound weight. Then took they the body of Jesus, and wound it in linen clothes with the spices, as the manner of the Jews is to bury. Now in the place where he was crucified there was a garden; and in the garden a new sepulchre, wherein was never man yet laid. There laid they Jesus . . . for the sepulchre was nigh at hand' (John, 19).

Joseph of Arimathaea 'rolled a great stone to the door of the sepulchre, and departed' (Matthew, 27).

Bonaventura says that the Virgin Mary wrapped his head in a cloth and that the others anointed him; and Mary Magdalene asked to anoint his feet, and washed them with her tears.

Burial of the Virgin Just before her death an angel gave the Virgin a palm branch which was to be carried before her bier on the way to her burial, to protect her body from unbelievers. After she died, the apostles laid her body on the bier and 'Peter, lifting up the head, began to sing, Israel is come out of Egypt, Halleluia. Paul helped him carry the sacred body of the blessed Virgin, and John carried the palm of light before the bier, while the other apostles sang with very sweet voices.' Some accounts say Peter bore the head and John the feet.

A Jewish priest tried to overthrow the bier but his hands

stuck to it and his arms withered; sudden conversion released his hands and made his arms well again. The apostles carried the body to the field of Jehoshaphat and buried it in a new stone coffin. (*Latin Narrative of Pseudo-Melito, New Testament Apocrypha*).

Burning of the Heretical Books St Dominic had founded his Order of Preachers especially in order to combat heresy. Once, during a disputation, the saint and a heretic each threw one of their books on religion into the fire and 'the heretical book was quickly consumed by the flames and destroyed, but the book of Dominic, the professor of Christ, jumped far out of the fire. Thrown in a second and third time, each time it leapt forth unsinged, verifying the sanctity of its author and the truth of the Christian faith. All were astonished: the pious rejoiced and the impious were repentant' (*Acta Sanctorum*).

Cadmus 'Cadmus was sent by his father, king of Phoenicia, in search of his sister Europa, whom Jupiter had abducted. But when he could not find her and was afraid to go home empty-handed, he founded the city of Thebes in Boeotia. When a huge serpent killed his comrades, Cadmus slew the serpent and buried its teeth in the earth. From them armed men sprang up who fought among themselves and killed each other. But five of them survived and helped Cadmus build the new city, Thebes. It is said that Cadmus, along with his wife Hermione, was changed into a snake' (Torrentinus).

Cain and Abel Cain and Abel were the first sons of Adam and Eve. 'And Abel was a keeper of sheep, but Cain was a tiller of the ground. And in process of time it came to pass, that Cain brought of the fruit of the ground an offering unto the Lord. And Abel, he also brought of the firstlings of his flock and of the fat thereof. And the Lord had respect unto Abel and to his offering: but unto Cain and to his offering he had not respect. And Cain was very wroth, and his countenance fell. . . . And it came to pass, when they were in the field, that Cain rose up against Abel his brother, and slew him.

47

'And the Lord said unto Cain, where is Abel thy brother? And he said, I know not: Am I my brother's keeper? And he said, What hast thou done? the voice of thy brother's blood crieth unto me from the ground. And now art thou cursed from the earth, which hath opened her mouth to receive thy brother's blood from thy hand; when thou tillest the ground, it shall not henceforth yield unto thee her strength; a fugitive and a vagabond shalt thou be in the earth' (Genesis, 4).

Cain, who violated the 'message that ye heard from the beginning, that we should love one another', became the outstanding example of lack of brotherly love. John the Evangelist, thinking of Christ's words, 'If the world hate you, ye know that it hated me before it hated you', said of Cain that he slew Abel 'because his own deeds were evil and his brother's righteous', thus making Abel's death a worldly foreshadowing of Christ's. John added, 'Any one who hates his brother is a murderer' (I John, 3 and John, 15 (RSV)).

Calling of Matthew Matthew, also called Levi, was a publican, or tax collector. 'And as Jesus passed forth from thence, he saw a man, named Matthew, sitting at the receipt of custom: and he saith unto him, Follow me. And he arose, and followed him' (Matthew, 9).

Matthew 'made him a great feast in his own house: and there was a great company of publicans and of others that sat down with them. But their scribes and Pharisees murmured against his disciples, saying, Why do ye eat and drink with publicans and sinners? And Jesus answering said unto them, They that are whole need not a physician; but they that are sick. I came not to call the righteous, but sinners to repentance' (Luke, 5).

Matthew is cited by the *Golden Legend* for his swiftness to obey, 'for as soon as Christ called him, he immediately left his customs house, with his tax accounts unfinished, and followed Christ perfectly'; and for his generosity, because of the feast he made for Christ. He became one of Christ's apostles and later wrote the first Gospel. His symbol 'is a man, because he dwelt principally on Christ's humanity'.

48

Callisto, *see* Diana and Callisto.

Calvary, *see* Carrying of the Cross, *or* Crucifixion.

Calydonian Boar Hunt When the king of Calydon was sacrificing to the gods, he neglected Diana, who punished him by sending a wild boar, bigger than a Sicilian bull, to ravage his land. The monster attacked the crops and herds until the hero Meleager and a band of Greek warriors drove him from his retreat in a dense forest, and killed him.

Among the members of the band was the girl warrior Atalanta, whose boyish features attracted Meleager. In the furious rush to kill the boar, she was the first to wound him with her arrow, putting the men to shame. Finally, after one of the men was gored to death by the tusks of the charging beast, Meleager's spear landed in the middle of the boar's back and killed him. Meleager shared his glory with Atalanta and gave her the boar's hide and head as a trophy.

But when Meleager's uncles grew jealous of Atalanta and took the spoils away from her, Meleager killed them and thus precipitated his own death. For his mother, to avenge the death of her dead brothers, threw into the fire the fatal log which the Fates had prophesied would have the same length of life as Meleager. Concealed until then by her, the log burned away and at the same time Meleager's life was consumed. (Ovid).

Camillus and the Surrender of Falerii Camillus was a Roman general of the fourth century BC. During the siege of the city of Falerii, a schoolmaster of the city came to him and offered to betray the city. Camillus put him in chains and sent him back to his fellow citizens, who were so affected by this instance of Roman justice that they voluntarily surrendered. (Livy).

Campaspe, *see* Apelles Painting Campaspe.

Canaanite Woman, *see* Woman of Canaan.

Cannae, *see* Hannibal.

Captain and Christ, *see* Christ and the Centurion.

Capture of Christ, *see* Betrayal of Christ.

Caritas Romana, *see* Cimon and Pero.

Carrying of the Cross 'And they took Jesus, and led him away. And he bearing his cross went forth into a place called the place of a skull, which is called in the Hebrew Golgotha' (John, 19).

'And as they led him away, they laid hold upon one Simon, a Cyrenian, coming out of the country, and on him they laid the cross, that he might bear it after Jesus. . . . And there were also two other, malefactors, led with him to be put to death' (Luke, 23).

Bonaventura expands this as follows: 'They led him out, no longer to postpone his death, and put upon his shoulders the venerable wood of the cross, long, thick, and very heavy, which the gentle lamb patiently took up and carried. It is thought that the Lord's cross was fifteen feet high. Then he was led along and hurried and heaped with insults, as he was when they mocked him earlier in the day. . . . Because his sorrowing mother could not approach or see him on account of the crowd, she went by another, shorter way with John the Evangelist and those who were with them, so that getting ahead of the others she could draw near him. But when she was waiting for him outside the city gate at the crossroads and saw him coming burdened by such a large piece of wood, which she had not seen before, she was half dead with anguish. She could not say a word to him, nor the Lord to her, because he was hurried along by those who led him to be crucified.'

Saint Casilda Casilda, who was the daughter of a Saracen king of Toledo, used to bring food to Christians held prisoner by her father. Suspicious of his daughter, the king surprised her one night and asked what she was carrying in her apron.

50

'Roses, she answered, and when the king found roses indeed inside her apron he thought his suspicions unwarranted and let her go. Casilda continued on her way, and when she opened her apron to feed the Christians, bread and meat had taken the place of the roses' (*Acta Sanctorum*).

Casting of Lots, *see* Crucifixion.

Castor and Pollux, *see* Rape of the Daughters of Leucippus.

Saint Catherine of Alexandria Catherine was the daughter of a king, educated in the liberal arts and admired for her wisdom. Her father made her promise she would marry no one who was not wealthier, more beautiful and wiser than she was. When none of the princes who courted her came up to that standard, she had a vision of the Virgin with the Christ child in her arms, and realized who her husband was to be. But the child refused her as being poorer, less beautiful and less wise than he was. Learning the meaning of her vision from a Christian hermit, Catherine was instructed in Christianity and baptized. The Virgin and Child appeared to her again, and the Child put a ring on her finger, joining her to him in spiritual marriage.

When the Emperor Maxentius was persecuting Christians who refused to sacrifice to pagan idols, Catherine resorted to philosophical argument and infuriated Maxentius by converting fifty of his wisest orators by her persuasive reasonings. The emperor had them burnt alive in the centre of the city. When Catherine refused to become Maxentius' concubine she was thrown into a dark cell and left for twelve days without food. The empress came to visit her and Catherine converted her and the 200 soldiers who were with her, along with their captain, Porphyrius. This so angered Maxentius that he had them all beheaded. He wanted to torture Catherine on a machine made of four wheels studded with iron saws and nails: the two pairs of wheels were to revolve in opposite directions and crush her. But Catherine prayed that the wheel would fall to pieces and it broke so violently that it killed four thousand pagans. Finally

Catherine was beheaded, but when her head was cut off milk gushed forth instead of blood. Angels took her body by stages to Mount Sinai and gave it an honourable burial there. (*Acta Sanctorum* and *Golden Legend*).

Saint Catherine of Siena A fourteenth century saint who from early childhood dedicated herself and her virginity to Christ. Once when Catherine felt that her sister had been gossiping falsely about her she prayed to Christ for solace. 'Then the Saviour of this world appeared to her with a golden crown in his right hand and a crown of thorns in his left' and told her to choose between them. Catherine chose the crown of thorns. Like St Francis, Catherine received the stigmata, though in her case they were not externally visible. She described the experience herself: 'I saw the Lord above me on the cross descending luminously, and with the impetus of a mind running to meet its creator my small wretched body rose up. Then from the sacred scars of his wounds five rays like blood came down towards my hands and feet and heart. Seeing this great miracle I at once exclaimed: O Lord God, let not, I pray, the wounds appear on the surface of my body. Then, as I spoke, and before the rays had reached me, the red of the blood was turned into a brilliant white.'

Once, during the carnival season which preceded Lent, when others were given up to celebrations, Catherine prayed to God to increase her faith. Christ appeared and told her that the time had come to celebrate the marriage of her soul to him. Then the Virgin, John the Baptist, St Paul, St Dominic and King David with his harp appeared. The Virgin took the saint's right hand and Christ put a gold ring on her finger. (*Acta Sanctorum*).

Saint Cecilia Cecilia was a member of a wealthy Roman family. On her wedding day 'she secretly wore a hair shirt under her gilded wedding dress, and when she heard the musical instruments playing she inwardly sang to the Lord alone, saying: Lord, may my heart and body remain unsoiled'. Then, when she and her husband Valerian were alone, she told him that she had a guardian angel who protected her zealously, and would smite

him if he approached her with impure thoughts. If Valerian would love her with a pure love, the angel would reveal himself to him too. Valerian went to the bishop Urban, hiding in the catacombs, and was baptized by him. When he returned to Cecilia he found her with the angel who gave them each a crown of roses and lilies as symbols of their chastity.

Valerian converted his brother Tiburtius and the two of them began to bury the bodies of Christian martyrs, for which they were arrested and beheaded by the Roman prefect. Cecilia was also arrested, and when she defied the prefect he had her put in boiling oil, but she 'stayed there as in a cool place and felt not the least fatigue'. The prefect had her beheaded, but when the executioner had struck three times Cecilia was still alive. The law prohibited a fourth blow, and Cecilia lingered on 'half alive' for three days, distributing her wealth to the poor, and asking Urban to consecrate her house as a church after her death. Urban did so and buried her body among the bishops of the church. (*Golden Legend*).

The Latin word *organa* – musical instruments – in this legend was sometimes translated as *organ*, the instrument with which Cecilia is often shown.

Celano, *see* Death of the Knight of Celano.

Centaurs 'A people of Thessaly, around Mount Pelion. They are said to have been the first to fight on horseback, whence the myth arose that the centaurs were animals that were half man and half horse' (Torrentinus).
See also **Battle of the Lapiths and the Centaurs.**

Centurion Cornelius, *see* Vision of Saint Peter.

Cephalus and Procris Shortly after Cephalus' marriage to Procris, an Athenian princess, he was snatched away against his will by Aurora, goddess of the dawn. But it was Procris he loved, and he could not stop mentioning her name and talking of his recent marriage, so that finally Aurora grew annoyed and sent him angrily back to his wife.

Uncertain of Procris' loyalty to him, he accused her unjustly of infidelity. She fled in disgust to the mountains where she joined the followers of Diana, goddess of the hunt. Cephalus' confession that he had been wrong brought about their reconciliation, and when Procris returned she presented her husband with a dog, which Diana had given her, and a javelin.

Cephalus used to go hunting in the woods early in the morning, taking only his javelin with him. When tired, he would rest in a shady spot, calling for a cool zephyr to refresh and soothe him. Someone, overhearing his words and thinking the 'zephyr' was a nymph, told Procris of her husband's supposed adultery. Wretched at even the thought of a rival, she still refused to condemn him without visible proof.

The next day she followed Cephalus, and when he was resting from hunting, he called to the zephyr as usual. 'A falling leaf made a slight rustle and thinking it was a wild beast I let fly my javelin. It was Procris! Clutching the wound in her breast she cried, Woe is me! When I recognized the voice of my faithful wife I hurried, mad with grief, in the direction of her cry. I found her half-dead, her clothes spattered with blood, and trying to pull the javelin – her gift to me – from her breast.' Cephalus bound up her wounds and told her the truth about the zephyr, but it was too late and she died in his arms. (Ovid).

Ceres Goddess of crops. Ovid says of her, 'Cères was the first to turn over clods of earth with the curving ploughshare, she first planted grain and cultivated crops, she was the first to give laws: all these are the gift of Ceres.' When Hercules defeated the river-god Achelous, who was in the guise of a bull, he tore off one of his horns, and the naiads filled it with fruit and flowers and gave it to Ceres, the goddess of plenty.

'Sometimes Ceres stands for grain itself, or bread, as Bacchus does for wine, and Venus for love' (Calepinus).

Charon, *see* Aeneas in the Underworld.

Cherubim, *see* Hierarchies of the Angels.

Chiron, *see* Achilles and Chiron.

Christ before Annas After Christ's capture, he was taken to the house of Annas. The *Mirror of Man's Salvation* relates the event as follows: 'They led him first to the house of Annas, who was the father-in-law of the high priest Caiaphas. And when Annas questioned him about his teaching, Jesus told him to ask those who had heard him, for he did not teach in hidden corners, but in the Temple and in the synagogues where all the people came to meet. At once one of Annas' servants raised his hand and slapped him on the cheek. It is thought that this servant was Malchus, whose ear Christ had healed a short while before. But Christ neither defended himself nor struck back, but endured this humbly with all mildness. . . . Hear, then, Christ's teaching: If someone hits you on the cheek, offer him the other.'
 For Malchus *see* **Betrayal of Christ.**

Christ Appearing to the Virgin Mary The *Golden Legend* says that after Christ's resurrection, 'it is thought that he appeared to the Virgin Mary before anyone else, even though the Evangelists make no mention of it'.
 Bonaventura describes their meeting near the tomb. 'While she was praying and quietly weeping, behold suddenly Lord Jesus came in gleaming white garments, serene of face, beautiful, glorious and joyful. Standing to one side, he said to her, Hail, holy parent. . . . I have risen and am still with you. Then she arose and embraced him with tears of joy, pressing her face against his and hugging him closely, and resting with all her weight upon him as he hastened to hold her up. Afterwards they sat down side by side and she looked carefully at his face, at the scars on his hands, and at his whole body to see if all pain had left him. . . . Thus they remained, talking and enjoying each other's company, and celebrating the Passover with gladness and love.'

Christ Appears to the Magdalene, *see* Noli Me Tangere.

Christ Appears to Peter and Paul A medieval legend: Toward the end of Saint Peter's life, when he was in Rome converting pagans to Christianity, Christ appeared to him and warned him that the emperor Nero was plotting to bring about his death. Christ told him not to fear, and promised him the companionship of Paul, who would arrive the next day. Paul joined Peter in Rome the following day, and they worked together preaching the gospel. Later Peter was crucified on the same day that Paul was beheaded. (*Golden Legend*).

See also **Domine Quo Vadis?**

Christ Attended by Angels After Christ's Temptation in the wilderness, 'the devil leaveth him, and, behold, angels came and ministered unto him' (Matthew, 4).

The Middle Ages expanded the story. The angels offered to prepare a meal for Christ because he had fasted for 40 days. 'Christ said, Go to my dear mother, and if she has anything at hand, bring it, for I do not eat any other food as gladly as hers. Then two of them went and were instantly with her. Greeting her with reverence they told her why they had come. Then they gathered up the bit of food which she had prepared for herself and Joseph, the bread, a tablecloth, and anything else that was suitable. Perhaps Our Lady was even able to prepare some small fishes. After they returned, they carried it all to a level spot and solemnly blessed the meal. . . . Watch closely as Christ, dignified and noble, sits on the ground and soberly begins to eat. The angels stand about him ministering to their Lord. One serves him bread, another wine, a third prepares the little fishes, and others sing the songs of Zion' (Bonaventura).

Christ Blessing the Children 'And they brought unto him also infants, that he would touch them: but when his disciples saw it, they rebuked them. But Jesus called them unto him, and said, Suffer little children to come unto me, and forbid them not: for of such is the kingdom of God. Verily I say unto you, Whosoever shall not receive the kingdom of God as a little child shall in no wise enter therein' (Luke, 18).

'And he took a child, and set him in the midst of them: and

56

when he had taken him in his arms, he said unto them, Whosoever shall receive one of such children in my name, receiveth me: and whosoever shall receive me, receiveth not me, but him that sent me' (Mark, 9).

Christ before Caiaphas After being mocked in the house of Annas, Christ was led to the house of Caiaphas, the Jewish high priest. 'Now the chief priests, and elders, and all the council, sought false witness against Jesus, to put him to death; but found none: yea, though many false witnesses came, yet found they none. At the last came two false witnesses, and said, This fellow said, I am able to destroy the temple of God, and to build it in three days. And the high priest arose, and said unto him, Answerest thou nothing? what is it which these witness against thee? But Jesus held his peace. And the high priest answered and said unto him, I adjure thee by the living God, that thou tell us whether thou be the Christ, the Son of God. Jesus saith unto him, Thou hast said: nevertheless I say unto you, Hereafter shall ye see the Son of man sitting on the right hand of power, and coming in the clouds of heaven. Then the high priest rent his clothes, saying, He hath spoken blasphemy; what further need have we of witnesses? behold, now ye have heard his blasphemy. What think ye? They answered and said, He is guilty of death' (Matthew, 26).

The *Mirror of Man's Salvation* modified the Biblical account, saying that when 'Caiaphas challenged Christ to tell them if he was the Messiah, the Son of the living God, Christ acknowledged that he was. All exclaimed that he merited death for this answer. Therefore they bound his eyes with a blindfold and stained his face with their spit and slapped him saying, Prophesy, and say who it was who hit you. These unjust Jews pitilessly inflicted every insult they could on him.'

Christ and the Centurion The centurion in this episode was a Roman officer. Not being a Jew, he would not have studied the Old Testament passages that were thought to foretell the birth of the Messiah to 'the children of the kingdom'.

'And when Jesus was entered into Capernaum, there came

unto him a centurion, beseeching him, and saying, Lord, my servant lieth at home sick of the palsy, grievously tormented. And Jesus saith unto him, I will come and heal him. The centurion answered and said, Lord, I am not worthy that thou shouldest come under my roof: but speak the word only, and my servant shall be healed. . . . When Jesus heard it, he marvelled, and said to them that followed, Verily I say unto you, I have not found so great faith, no, not in Israel. And I say unto you, That many shall come from the east and west, and shall sit down with Abraham, and Isaac, and Jacob, in the kingdom of heaven. But the children of the kingdom shall be cast out into outer darkness: there shall be weeping and gnashing of teeth. And Jesus said unto the centurion, Go thy way; and as thou hast believed, so be it done unto thee. And his servant was healed in the selfsame hour' (Matthew, 8).

Medieval Christians interpreted this incident allegorically as representing Jesus' desire to have his teaching preached not only among the Jews but among other peoples as well. St Augustine said that Jesus' curing the servant 'without going to the centurion's house signified that the Gentiles, to whom he did not come, would be saved by his word'.

Christ Child and John the Baptist, *see* Holy Family and John the Baptist.

Christ at the Column, *see* Flagellation.

Christ in the Desert Served by Angels, *see* Christ Attended by Angels.

Christ among the Doctors, *see* Christ Among the Elders.

Christ among the Elders (Scribes, Doctors) 'Now his parents went to Jerusalem every year at the feast of the passover. And when he was twelve years old, they went up to Jerusalem after the custom of the feast. And when they had fulfilled the days, as they returned, the child Jesus tarried behind in Jerusalem; and Joseph and his mother knew not of it.

But they, supposing him to have been in the company, went a day's journey; and they sought him among their kinsfolk and acquaintance. And when they found him not, they turned back again to Jerusalem, seeking him.

'And it came to pass, that after three days they found him in the temple, sitting in the midst of the doctors, both hearing them, and asking them questions. And all that heard him were astonished at his understanding and answers. And when they saw him, they were amazed: and his mother said unto him, Son, why hast thou thus dealt with us? behold, thy father and I have sought thee sorrowing. And he said unto them, How is it that ye sought me? wist ye not that I must be about my Father's business? And they understood not the saying which he spake unto them. And he went down with them, and came to Nazareth, and was subject unto them: but his mother kept all these sayings in her heart. And Jesus increased in wisdom and stature, and in favour with God and man' (Luke, 2).

Christ Expels the Money Lenders from the Temple 'And the Jews' passover was at hand, and Jesus went up to Jerusalem, and found in the temple those that sold oxen and sheep and doves, and the changers of money sitting: and when he had made a scourge of small cords, he drove them all out of the temple, and the sheep, and the oxen; and poured out the changers' money, and overthrew the tables: and said unto them that sold doves, Take these things hence; make not my Father's house an house of merchandise' (John, 2).

'And he taught, saying unto them, Is it not written, My house shall be called of all nations the house of prayer? but ye have made it a den of thieves' (Mark, 11).

According to the *Mirror of Man's Salvation* the merchants of oxen, sheep and doves were in the temple to provide animals for those who came there to make sacrificial offerings; the money changers lent money for that purpose, accepting gifts of food as interest.

Christ Gives the Keys to Saint Peter 'When Jesus came into the coasts of Caesarea Philippi, he asked his disciples,

saying, Whom do men say that I the Son of man am? And they said, Some say that thou art John the Baptist: some, Elias; and others, Jeremias, or one of the prophets. He saith unto them, But whom say ye that I am? And Simon Peter answered and said, Thou art the Christ, the Son of the living God. And Jesus answered and said unto him, Blessed art thou, Simon Bar-jona: for flesh and blood hath not revealed it unto thee, but my Father which is in heaven. And I say also unto thee, That thou art Peter, and upon this rock I will build my church; and the gates of hell shall not prevail against it. And I will give unto thee the keys of the kingdom of heaven: and whatsoever thou shalt bind on earth shall be bound in heaven: and whatsoever thou shalt loose on earth shall be loosed in heaven' (Matthew, 16).

Christ Glorified in the Court of Heaven, *see* Christ in Glory Sitting in Majesty.

Christ in Glory Sitting in Majesty St John the Evangelist, in a vision, saw Christ seated on a throne in heaven, surrounded by an emerald-like rainbow. Around him were twenty-four elders sitting on thrones and dressed in white, with golden crowns on their heads. On each side of Christ's throne he saw four animals, each with six wings: one of them was like a lion, one like an ox, one had the face of a man, and one was like a flying eagle. The animals praised and glorified Christ, and the twenty-four elders fell down before him and worshipped him, casting their crowns before his throne. (Revelation, 4).

To later Christians the four animals became the symbols of the Four Evangelists.

See also **Last Judgement.**

Christ Healing Augustine allegorized the healing miracles of Christ. 'The mute are those who do not praise Christ, and do not confess the faith. The blind are those who obey without understanding. The deaf are those who understand but fail to obey. And the lame are those who only partially carry out his precepts.'

Christ Healing the Paralytic at the Pool of Bethesda
'Now there is at Jerusalem by the sheep market a pool, which is called in the Hebrew tongue Bethesda, having five porches. In these lay a great multitude of impotent folk, of blind, halt, withered, waiting for the moving of the water. For an angel went down at a certain season into the pool, and troubled the water: whosoever then first after the troubling of the water stepped in was made whole of whatsoever disease he had. And a certain man was there, which had an infirmity thirty and eight years. When Jesus saw him lie, and knew that he had been now a long time in that case, he saith unto him, Wilt thou be made whole? The impotent man answered him, Sir, I have no man, when the water is troubled, to put me into the pool: but while I am coming, another steppeth down before me. Jesus saith unto him, Rise, take up thy bed, and walk. And immediately the man was made whole, and took up his bed, and walked: and on the same day was the sabbath' (John, 5).

When Jesus saw the man later he told him to 'sin no more'. The Pharisees blamed him for healing on the sabbath. Later Christians contrasted the intermittent healing power of the pool with the steady healing offered by baptism.

Christ Heals a Blind Man in Siloam 'And as Jesus passed by, he saw a man which was blind from his birth. And his disciples asked him, saying, Master, who did sin, this man, or his parents, that he was born blind? Jesus answered, Neither hath this man sinned, nor his parents: but that the works of God should be made manifest in him. I must work the works of him that sent me, while it is day: the night cometh, when no man can work. As long as I am in the world, I am the light of the world. When he had thus spoken, he spat on the ground, and made clay of the spittle, and he anointed the eyes of the blind man with the clay, and said unto him, Go, wash in the pool of Siloam. . . . He went his way therefore, and washed, and came seeing.'

The Pharisees blamed Christ for healing on the sabbath, but he said: 'For judgement I am come into this world, that they which see not might see; and that they which see might be

made blind. And some of the Pharisees which were with him heard these words, and said unto him, Are we blind also? Jesus said unto them, If ye were blind, ye should have no sin: but now ye say, We see; therefore your sin remaineth' (John, 9).

Christ before Herod The Jewish high priest Caiaphas delivered Christ for trial to Pilate. After Pilate had questioned Christ, he sent him to Herod, the tetrarch of Galilee. 'And when Herod saw Jesus, he was exceeding glad: for he was desirous to see him of a long season, because he had heard many things of him; and he hoped to have seen some miracle done by him. Then he questioned with him in many words; but he answered him nothing. And the chief priests and scribes stood and vehemently accused him. And Herod with his men of war set him at nought, and mocked him, and arrayed him in a gorgeous robe, and sent him again to Pilate' (Luke, 23).

In the fourteenth century this was told as follows: 'Pilate having heard that he was a Galilean sent him to Herod, because he was under his jurisdiction. . . . Herod had not seen Christ, but had heard much of him, and therefore he was very glad when he came, for he thought he was a magician or a wizard, and hoped to see something miraculous from him. When Herod questioned him about many things and he gave no answer, keeping silent, Herod thought him of unsound mind and dressed him derisively in a white robe, and sent him back to Pilate, saying he found no reason for his death. Herod had no idea of the real meaning of the white robe, but the Holy Ghost was secretly demonstrating Christ's innocence through it' (*Mirror of Man's Salvation*).

Christ at the House of Mary and Martha When Christ and his disciples were journeying together, 'it came to pass, as they went, that he entered into a certain village: and a certain woman named Martha received him into her house. And she had a sister called Mary, which also sat at Jesus' feet, and heard his word. But Martha was cumbered about much serving, and came to him, and said, Lord, dost thou not care that my sister hath left me to serve alone? bid her therefore that

she help me. And Jesus answered and said unto her, Martha, Martha, thou art careful and troubled about many things: but one thing is needful: and Mary hath chosen that good part (OPTIMAM PARTEM ELEGIT), which shall not be taken away from her' (Luke, 10).

This Mary was later associated with Mary Magdalene, who in the Middle Ages sometimes symbolized the contemplative life, as Martha did the active one.

Christ in Limbo Between Christ's death and resurrection, he descended into Hell (or Limbo) to release the souls of the Holy Fathers. 'Then the King of Glory appeared and illuminated the eternal darkness. Putting forth his hand he took the right hand of Adam and said, Peace be with you and with all your sons who are my saints. And the Lord rose up from the lower regions, and all the saints followed him.' Those whom Christ delivered from hell and brought to paradise included Adam, Isaiah, Simeon, who had prophesied at Christ's presentation in the temple, John the Baptist, the good thief who was crucified along with him, and the patriarchs and prophets of the Old Testament. (*Golden Legend*).

Christ and Nicodemus 'There was a man of the Pharisees, named Nicodemus, a ruler of the Jews: the same came to Jesus by night, and said unto him, Rabbi, we know that thou art a teacher come from God: for no man can do these miracles that thou doest, except God be with him.

'Jesus answered and said unto him, Verily, verily, I say unto thee, Except a man be born again, he cannot see the kingdom of God. Nicodemus saith unto him, How can a man be born when he is old? can he enter the second time into his mother's womb, and be born? Jesus answered, Verily, verily, I say unto thee, Except a man be born of water and of the Spirit, he cannot enter into the kingdom of God.... Nicodemus answered and said unto him, How can these things be? Jesus answered, ... If I have told you earthly things, and ye believe not, how shall ye believe, if I tell you of heavenly things?' (John, 3).

63

This same Nicodemus later helped take Christ down from the cross and bury him.

Christ before Pilate Caiaphas, the Jewish high priest, sent Christ to Pilate, the Roman governor of Judaea, to be tried. 'And they began to accuse him, saying, We found this fellow perverting the nation, and forbidding to give tribute to Caesar, saying that he himself is Christ a King' (Luke, 23).

The medieval *Mirror of Man's Salvation* says Pilate thought the first two charges frivolous, but was concerned about the third, which was a political offence against the Roman emperor. The gospel of St John describes the interview this way: 'Then Pilate entered into the judgement hall again, and called Jesus, and said unto him, Art thou the King of the Jews? Jesus answered him, Sayest thou this thing of thyself, or did others tell it thee of me? Pilate answered, Am I a Jew? Thine own nation and the chief priests have delivered thee unto me: what hast thou done? Jesus answered, My kingdom is not of this world: if my kingdom were of this world, then would my servants fight, that I should not be delivered to the Jews: but now is my kingdom not from hence. Pilate therefore said unto him, Art thou a king then? Jesus answered, Thou sayest that I am a king. To this end was I born, and for this cause came I into the world, that I should bear witness unto the truth. Everyone that is of the truth heareth my voice. Pilate saith unto him, What is truth? And when he had said this, he went out again unto the Jews, and saith unto them, I find in him no fault at all' (John, 18).

According to the gospel of St Luke, Pilate had first sent Christ to Herod, who returned him to Pilate's jurisdiction. Pilate wanted to 'chastise him, and release him', and so handed him over to his soldiers to be whipped, apparently in the hope that that would satisfy his accusers, instead of his crucifixion.

See **Christ Before Herod; Flagellation; Ecce Homo.**

Christ in the Praetorium, *see* Mocking of Christ.

Christ Preaching from a Ship This occurred during the period of Christ's preaching in Galilee, about the time when he called his first disciples.

'And it came to pass, that, as the people pressed upon him to hear the word of God, he stood by the lake of Gennesaret, and saw two ships standing by the lake: but the fishermen were gone out of them, and were washing their nets. And he entered into one of the ships, which was Simon's, and prayed him that he would thrust out a little from the land. And he sat down, and taught the people out of the ship' (Luke, 5).

Christ Presented to the People, *see* Ecce Homo.

Christ Showing His Wounds to God the Father John the Evangelist said, 'If any man sin, we have an advocate with the Father, Jesus Christ the righteous: and he is the propitiation for our sins: and not for ours only, but also for the sins of the whole world' (I John, 2).

The Middle Ages expanded the idea. 'Let us hear how Christ shows his wounds to God the Father for our sakes. . . . Christ descended from heaven into hell on our account, and re-ascended into heaven to pray for us for ever. . . . He stands always before his father and shows by his wounds that he was a vigorous fighter and carried out his father's commands as a loyal soldier, wherefore God honours his loyalty and is ready to grant whatever he asks. . . . How could such a merciful father resist the prayers of such a son when he sees the wounds endured at his command?' (*Mirror of Man's Salvation*).

See also **Intercession of the Virgin.**

Christ Taking Leave of His Mother A medieval legend: When Christ was preparing to go to Jerusalem, his mother and Mary Magdalene begged him not to go, but to stay and keep the Passover with them. They anticipated his arrest and crucifixion, which were soon to take place. 'But he replied, It is our Father's will that I should keep the Passover there: for the hour of redemption is at hand, and soon will be fulfilled all things that have been written of me. The women heard what he

said with great sorrow, for they knew he was speaking of his own death. And his mother, scarcely able to articulate the words, said, My son, I am stunned by what you say, and my heart sinks. . . . But the Lord said, softly consoling her, Do not weep, for you know that I must obey our Father: rest assured that I will quickly return to you all, and will rise unharmed on the third day.' Then he took leave of his mother, and Mary Magdalene, and his mother's sisters, Mary Cleophas and Mary Salome, and left for Jerusalem with his disciples. (Bonaventura).

Christ Walks on the Sea Jesus sent his disciples ahead of him by ship while he went up into a mountain alone to pray. 'But the ship was now in the midst of the sea, tossed with waves: for the wind was contrary. And in the fourth watch of the night Jesus went unto them, walking on the sea. And when the disciples saw him walking on the sea, they were troubled, saying, It is a spirit; and they cried out for fear. But straightway Jesus spake unto them, saying, Be of good cheer; it is I; be not afraid. And Peter answered him and said, Lord, if it be thou, bid me come unto thee on the water. And he said, Come. And when Peter was come down out of the ship, he walked on the water, to go to Jesus. But when he saw the wind boisterous, he was afraid; and beginning to sink, he cried, saying, Lord, save me. And immediately Jesus stretched forth his hand, and caught him, and said unto him, O thou of little faith, wherefore didst thou doubt? And when they were come into the ship, the wind ceased' (Matthew, 14).

'And immediately the ship was at the land whither they went' (John, 6).

Christ Washing the Disciples' Feet, *see* Last Supper.

Saint Christopher Christopher was a Canaanite of prodigious size – twelve cubits tall – and of fearful aspect. He wanted to enter the service of the most powerful king on earth. For a while he served the Devil, but discovering that the sign of the cross would put even the Devil to flight, he went in search of

Christ A hermit instructed him to serve Christ by carrying pilgrims across a river. One night Christ himself came as a child, and Christopher, not recognizing him, took him on his shoulders and started across the river, staff in hand; but as he crossed the child became heavier and heavier. Finally Christopher called out in despair, feeling the weight of the whole world on his shoulders, whereupon Christ revealed his identity to him and told him to plant his staff by the side of the river, where it would blossom as a sign of the truth of what he had said. (*Golden Legend*).

Cimon and Ephigenia Cimon was the handsome but moronic son of a Cypriot nobleman. Because he was unfit for any other occupation his father sent him to do farmwork. As he was about his chores one afternoon he came to a meadow with a fountain 'beside which he espied a most beautiful girl lying asleep on the green grass, clad only in a vest of such fine stuff that it scarce in any measure veiled the whiteness of her flesh, and below the waist nought but an apron most white and fine of texture; and likewise at her feet there slept two women and a man, her slaves. No sooner did Cimon catch sight of her, than, as if he had never before seen form of woman, he stopped short, and leaning on his cudgel, regarded her intently, saying never a word, and lost in admiration.' Inspired by love for the beautiful girl, Ephigenia, Cimon lost his boorish qualities, became intelligent and well-mannered, and eventually won her as his wife. (Boccaccio, *Decameron* trans. J. M. Rigg, 1903).

Cimon and Pero 'Consider the filial devotion of Pero: when she and her father were both put into prison, and he was in his extreme old age, she took him to her breast like an infant and gave him suck. Human eyes are astonished when they see this scene painted' (Valerius Maximus).

Circumcision 'And when eight days were accomplished for the circumcising of the child, his name was called JESUS, which was so named of the angel before he was conceived in the womb' (Luke, 2).

For the *Golden Legend* the name Jesus symbolized Christ's dual nature as man and god. The circumcision itself – which the Middle Ages thought of as cruelly painful – indicated his willingness to submit to the old law of Moses so that he could modify it, substituting baptism, which was 'a spiritual circumcision . . . of our vices and carnal desires'. As a symbolic foreshadowing of the Passion 'it was the beginning of our redemption', because 'on this day Jesus first began to shed his blood for us'.

Saint Clare The thirteenth century founder of the Order of the Poor Clares. When she was eighteen, influenced by the piety and preaching of St Francis, she resolved to devote her life to the service of God. Leaving her home during the night following Palm Sunday she walked to the church where St Francis and his friars were waiting for her. Before the altar St Francis cut off her hair and clothed her in the habit of his order. Later Clare was joined by her younger sister Agnes, and St Francis took them both to the church of St Damian, where Clare founded her order and lived in retirement. Next to her skin she wore hog's hair and afflicted her body with continual fasting and penance.

When an army of Saracens approached Assisi 'thirsting for Christian blood' and, terrifying the nuns, was about to scale the walls of the convent, Clare, though ill, had herself carried to the convent gate with the eucharist in a monstrance before her. Kneeling before the eucharist she prayed to God to protect her nuns, and as she prayed a small voice like a child's was heard saying, 'I will protect you forever', and promising to defend the city of Assisi as well. Suddenly the Saracens fled in terror, 'put to flight by the Holy Eucharist and St Clare's prayers'.

During Clare's final illness many came to her bedside: cardinals, prelates, Franciscan friars and the nuns of her own order including her sister Agnes. Just before she died she had a vision of Christ, and then a procession of crowned virgins entered her room dressed in white. With them was the Virgin Mary who embraced Clare and gave

her a robe to wear when she went to join Christ in heaven. (Wadding).

Cleansing of the Temple, *see* Christ Expels the Money Lenders from the Temple.

Saint Clement St Clement was a disciple of St Peter and was one of the early popes. During a persecution of Christians he was exiled to a remote island for refusing to sacrifice to the pagan gods. There he found other Christian exiles, who had been condemned to work in the marble quarries. When he learned from them that they had to carry their water six miles on their shoulders he prayed that a new source would be revealed to them. 'When he had finished his prayer he looked about him and saw a lamb with one foreleg raised as if showing him the place.' Understanding that the lamb, which he alone saw, was Jesus Christ, he struck the indicated spot with a mattock 'and at once a great fountain burst forth and grew into a river'.

The Emperor Trajan sent an inquisitor who 'took Clement and bound an anchor about his neck and hurled him into the sea'. But at the prayers of the other Christians 'the sea receded for three miles and all went on dry land to where they found a marble temple prepared by God, with the body of Clement in a coffin and the anchor next to him' (*Golden Legend*).

Cleopatra 'Queen of Egypt . . . and a most unchaste woman. First she was passionately loved by Caesar and bore him a son. Then she became Antony's mistress, and lived with him as his wife. Finally, when Antony was defeated at Actium, she killed herself by applying vipers to her body' (Calepinus).

Cloelia 'A Roman girl of noble descent. When she and other virgins were given as hostages to the Etruscan king Porsenna, she eluded her guards and swam safely back across the Tiber to Rome. The Romans, thinking this unprecedented act of feminine courage should be rewarded by some equally unprecedented honour, set up an equestrian statue to her at the top of the Sacred Way' (Stephanus).

69

Close of the Silver Age The Greek gods first created 'a golden race of men', who 'lived like gods and without sorrow'. After them came the silver age and a race of men 'not at all like the men of the golden age in mind or body. The children sucked at their mothers' breasts for a hundred years ... and when they finally grew up they led a brief and miserable little life of sorrow and folly. They could not refrain from insane violence against each other, nor would they honour the gods and sacrifice upon their altars, which is the custom among all nations.' In his wrath, Jupiter destroyed them. (Hesiod).

Clotho 'One of the Fates. Her name comes from the Greek word which means "to spin thread" ' (Torrentinus).
 'The poets say she holds a distaff and spins out the length of every human life' (Stephanus).

Coin in the Fish's Mouth, *see* Finding the Coin in the Fish's Mouth.

Conception, *see* Immaculate Conception.

Consignment of the Keys, *see* Christ Gives the Keys to Saint Peter.

Constantine, *see* Invention of the True Cross.

Continence of Scipio Scipio Africanus was the Roman general who defeated Carthage in the Second Punic War. 'When he was twenty-four years old, he captured a large number of hostages who were being held by the Carthaginians. Among them was a virgin of outstanding beauty and of marriageable age. Though Scipio was young, single and a conqueror, when he learned that she came from an illustrious Spanish family and was engaged to a young nobleman there, he sent for her father and fiance and returned her untouched to them, adding to her dowry the gold they had brought for her ransom. Scipio's continence and generosity so impressed the

70

Spaniards that they returned the favour he had done them by inclining the good will of their countrymen towards the Romans' (Valerius Maximus).

Conversation of Saint Scholastica Scholastica was Saint Benedict's sister, he a monk and she a nun. Benedict used to visit Scholastica once every year. During one of these visits she asked him 'not to leave me this night, but remain until morning so that we may converse about the joys of the life in heaven to come'. But he replied indignantly that he could not spend the night outside his cell. Scholastica put her head in her hands as if praying, and suddenly thunder and lightning were heard, and such a heavy rainfall began that neither Benedict nor any of his monks could put a foot outside the door. Seeing Benedict bewildered, Scholastica said, 'I asked you, and you refused. I asked the Lord, and he heard me.' They spent the night conversing, and a few days later, back in his own monastery, Benedict saw Scholastica's soul, in the form of a dove, on the way to heaven. (*Golden Legend*).

Conversion of Saul Saul, an orthodox Jew who was present at the stoning of St Stephen, the first Christian martyr, 'yet breathing out threatenings and slaughter against the disciples of the Lord', went to Damascus to bring back as prisoners any Christians he might find there. 'And as he journeyed, he came near Damascus: and suddenly there shined round about him a light from heaven: and he fell to the earth, and heard a voice saying unto him, Saul, Saul, why persecutest thou me? And he said, Who art thou, Lord? And the Lord said, I am Jesus whom thou persecutest. . . . Arise, and go into the city, and it shall be told thee what thou must do. And the men which journeyed with him stood speechless, hearing a voice, but seeing no man. And Saul arose from the earth; and when his eyes were opened, he saw no man: but they led him by the hand, and brought him into Damascus. And he was three days without sight' (Acts, 9).

After his conversion Saul was called Paul. The *Golden*

Legend says he committed the sin of pride in persecuting the Church. When he repented it was 'so pleasing to the Lord that not only did he forgive him but he also heaped gifts upon him. Of the persecutor he made a faithful preacher.'

Coriolanus A Roman nobleman at the time of the early Roman republic. His father died when he was very young, but he was brought up by his mother in such a way that he became famous for his military courage and valour. Being as haughty as he was brave – he was descended from one of the former kings – his arrogant manner brought him into conflict with the common people, which led to his exile. He fled to another Italian city and led them in a successful war against Rome. All the pleading of the Roman nobles could not deter him, until the noblest of the Roman women, led by his mother and his wife, with her children at her side, induced him to give up the siege of the city and to return, for the rest of his life, into exile. (Livy).

Coronation of the Virgin According to medieval Christians, after her death the Virgin was assumed bodily into heaven, where Christ 'placed her upon his throne at his right hand, and crowned her in perpetual blessedness with the crown of his kingdom . . . taking her to be his wife and mistress, his mother, companion, sister and his queen.'

As the Queen of Heaven, Mary received half of God's kingdom. 'The two parts of the realm are Justice and Mercy. In his Justice God threatens us, through her Mercy Mary comes to our aid' (*Mirror of Man's Salvation*).

This version of the Coronation occurs in a medieval mystery play:

> Jesus: 'Before all other creatures
> I shall give thee both grace and might,
> In heaven and earth to send succour
> To all that serve thee day and night. . . .
> Thou art my life and my delight,
> My mother and my maiden bright.

(Places the crown on Mary's head):

Receive this crown, my dear darling;
Where I am king, thou shalt be queen;
Mine angels bright a song thee sing.'
(York Mystery,
Crowning of the Virgin).

Saints Cosmas and Damian Cosmas and Damian were
brothers born in Asia Minor in the third century. 'They were
skilled in the art of medicine and had received such grace from
the Holy Ghost that they could cure all illnesses, not only of
men but of beasts as well, and their cures were always without
charge.' During the persecution of Christians under Diocletian
the consul Lisias heard of them and ordered them and their
three brothers to come before him and sacrifice to the pagan
idols. When they refused he had them tortured and then bound
with chains and thrown into the sea, 'but an angel freed them
and put them back before the consul'. Thinking them magic-
ians, Lisias asked them to teach him their magic arts. 'And as
he said that, at once two demons appeared and beat him
savagely about the face.' Cosmas and Damian prayed for him
and the demons left. Then, putting their three brothers into
prison, Lisias had Cosmas and Damian stretched on the rack,
crucified, stoned, and shot by archers – all without effect, 'and
the arrows, like the stones before them, turned back and
wounded many, but did not hurt the holy martyrs'. Finally
Lisias had all five brothers beheaded. After their death a camel
came along and gave directions 'in a human voice' for their
burial.

A church was built in their honour at Rome. 'In this church
a certain man served the holy martyrs, whose thigh had been
entirely eaten away by a malignant ulcer. One night while he
was sleeping Saints Cosmas and Damian appeared to him
bringing with them unguents and surgical tools, and one said to
the other, What shall we fill the empty space up with when we
cut away the putrid flesh? The other answered, An Ethiopian
who just died was buried today in the cemetery of St Peter in

73

Chains. Bring part of him to fill up the space. And the other hurried to the cemetery and took the Moor's hip, and cutting away the hip of the sick man he put the Moor's hip in its place and carefully anointed the wound. Then they put the diseased hip on the dead Moor. And when the sick man woke up he felt no pain and could find no lesion.' The reality of the miracle was confirmed when the tomb was opened and the white thigh found on the dead man. (*Golden Legend*).

Creation, *see* Garden of Eden.

Croesus 'A very rich king who was conquered by Cyrus of Persia. He rebelled and was conquered a second time, and was about to be burned at the stake when he cried out, Oh Solon! Solon! Cyrus asked him who Solon was, and Croesus answered, A wise Greek who once warned me that in this life no one is really happy. I now find that he was right. Cyrus, considering the mutability of human fortune, reprieved him. Others write that the fire was put out by a tremendous rainfall' (Torrentinus).

Cross, *see* Invention of the True Cross.

Crowning of the Elect The moment of the Last Judgement when Christ separates the righteous from the damned: 'And then the Son of God will sit on the right hand of his Father, and the Father shall command his angels, and he will minister to those he has chosen, and set them among the choirs of angels, clothing them with incorruptible garments, and giving them crowns that will not fade and seats that will not move. And God will be in their midst' (*New Testament Apocrypha, Book of John the Evangelist*).

Crowning of the Virgin, *see* Coronation of the Virgin.

Crucifixion After his trial, 'they took Jesus, and led him away. And he bearing his cross went forth into a place called the place of a skull, which is called in the Hebrew Golgotha. . . .

And Pilate wrote a title, and put it on the cross. And the writing was, JESUS OF NAZARETH THE KING OF THE JEWS . . . and it was written in Hebrew, and Greek, and Latin' (IESUS NAZARENUS REX IUDAEORUM). (John, 19).

'And there were also two other, malefactors, led with him to be put to death. And when they were come to the place, which is called Calvary, there they crucified him, and the malefactors, one on the right hand, and the other on the left.'

The Good Thief. 'And one of the malefactors which were hanged railed on him, saying, If thou be Christ, save thyself and us. But the other answering rebuked him, saying, Dost not thou fear God, seeing thou art in the same condemnation? And we indeed justly; for we receive the due reward of our deeds: but this man hath done nothing amiss. And he said unto Jesus, Lord, remember me when thou comest into thy kingdom. And Jesus said unto him, Verily I say unto thee, To day shalt thou be with me in paradise' (Luke, 23).

Casting of Lots. 'Then the soldiers, when they had crucified Jesus, took his garments, and made four parts, to every soldier a part; and also his coat: now the coat was without seam, woven from the top throughout. They said therefore among themselves, Let us not rend it, but cast lots for it, whose it shall be' (John, 19).

'And the people stood beholding. And the rulers also with them derided him, saying, He saved others; let him save himself, if he be Christ, the chosen of God' (Luke, 23).

'Now there stood by the cross of Jesus his mother, and his mother's sister, Mary the wife of Cleophas, and Mary Magdalene' (and Mary Salome, the other sister of the Virgin, is usually added; the disciple mentioned here is John the Evangelist). 'When Jesus therefore saw his mother, and the disciple standing by, whom he loved, he saith unto his mother, Woman, behold thy son! Then saith he to the disciple, Behold thy mother!'

The Hyssop. 'After this, Jesus knowing that all things were now accomplished, that the scripture might be fulfilled, saith, I thirst. Now there was set a vessel full of vinegar: and they

75

filled a sponge with vinegar, and put it upon hyssop, and put it to his mouth. When Jesus therefore had received the vinegar, he said, It is finished: and he bowed his head, and gave up the ghost' (John, 19).

The Centurion. 'And when the centurion, which stood over against him, saw that he so cried out, and gave up the ghost, he said, Truly this man was the Son of God' (Mark, 15).

Coup de Lance. Because the next day was the Sabbath and a holy day, the Jews asked Pilate to have the crucified men killed and removed from the cross. 'Then came the soldiers, and brake the legs of the first, and of the other which was crucified with him. But when they came to Jesus, and saw that he was dead already, they brake not his legs: but one of the soldiers with a spear pierced his side, and forthwith came there out blood and water' (John, 19).

The Middle Ages expanded this Biblical account. The soldier who pierced Christ's side was called Longinus and he 'was converted and believed in Christ, because the blood which ran down the lance fell on his face near his eyes, which had been failing from sickness or age, and immediately gave him back his sight. Therefore he gave up soldiering and was instructed by the apostles in the faith' (*Golden Legend*).

According to a medieval tradition, Adam's bones were buried at Calvary 'and therefore it was called The Place of the Skull, because there the skull of the first man was buried. There at length Christ willed to be crucified, that he, as a second Adam, might pour out his blood from the cross and with it wash out the sins of that first Adam lying below.' In the same way, the water that ran out of Christ's side was supposed to have baptized Adam, thus bringing about his salvation. (Jacopo da Bergamo).

When the wound was opened in Christ's side, 'the Virgin, half dead, fell into the arms of Mary Magdalene . . . fulfilling what Simeon had said to her: Your own soul will be transfixed by a sword. For now the sword of that lance pierced the body of the son and the soul of the mother' (Bonaventura).

Cup found in the Sack of Benjamin, *see* Joseph in Egypt.

76

Cupid God of Love and son of Venus. 'The poets say he was armed with a torch and arrows. He was also blind, nude and winged, and held a bow in his hands' (Calepinus).

Cupid and Psyche Psyche (the personification of the Greek word for 'soul') was a king's daughter and was so beautiful that even Venus became jealous of her, and asked Cupid to make her fall in love with the lowest and most miserable of men. But Cupid fell in love with her himself and transferred her to his fabulous palace, where he came to her as her husband every night after dark, requiring of her only that she never try to see what he looked like, thus keeping his identity secret. But one night, stirred by her jealous sisters, Psyche lit a lamp while Cupid was with her. Cupid abandoned her, and Psyche was in despair until, after she had performed many arduous labours at the temple of Venus in the service of the goddess, Cupid returned to her and took her to Olympus, where she drank the cup of immortality before the throne of Jupiter. (Apuleius).

Cyparissus 'A handsome youth from the Greek island of Cea, who was loved by Apollo. When he accidentally killed the tame stag which was his pet he wasted away from sorrow. But Apollo took pity on him and changed him into a cypress', the tree of mourning. (Stephanus).

Danae 'Danae was the daughter of the king of Argos. When an oracle warned the king that he would be killed by Danae's son, he imprisoned her in a fortified tower. But Jupiter was in love with her and, changing himself into a shower of gold, let himself down through the roof tiles into the girl's lap. From this intercourse Danae became pregnant and bore Perseus. In his anger the king put his daughter and new-born grandson out to sea in a small boat, thinking the wind and waves would overwhelm them' (Stephanus).

The boat floated to shore and their lives were saved. Later Perseus returned to Argos and killed the king, not knowing that he was his grandfather.

Dance of Mary Magdalene The worldliness of the Magdalene before her conversion is described in a fifteenth century mystery play. She calls to her male attendants and says, 'Come, musicians, play and sing, for I want to enjoy myself.' One musician rounds up the others with the words, 'Each one to his instrument, with verve, and play with your fine touch, so that paradise itself will seem to appear.' Then the music and the dancing begin, and one of them sings a song in praise of pleasure and the carefree life. (*La conversione di Maria Maddalena,* anonymous Italian).

Daniel in the Lions' Den Daniel was a Hebrew prophet at the time of the Babylonian captivity of the Jews. He was known for his wisdom and holiness. When King Darius wanted to put him in charge of all his kingdom, the Babylonian princes and governors sought a reason to accuse Daniel of disloyalty. Knowing his fidelity to God they tricked Darius into signing a decree that whoever was found praying to anyone except to Darius himself should be cast into the lions' den. Later they saw Daniel praying to God and accused him to Darius, who was forced to cast him to the lions. The next day 'the king arose very early in the morning, and went in haste unto the den of lions. And when he came to the den, he cried with a lamentable voice unto Daniel: and the king spake and said to Daniel, O Daniel, servant of the living God, is thy God, whom thou servest continually, able to deliver thee from the lions?

'Then said Daniel unto the king, O king, live for ever. My God hath sent his angel, and hath shut the lions' mouths, that they have not hurt me: forasmuch as before him innocency was found in me; and also before thee, O king, have I done no hurt. Then was the king exceeding glad for him, and commanded that they should take Daniel up out of the den . . . and no manner of hurt was found upon him, because he believed in his God.'

Darius decreed Daniel's God to be the living and eternal God, the saviour who had delivered Daniel from the lions' den. (Daniel, 6).

See also, **Habakkuk Brings Food and Drink to Daniel in the Lions' Den.**

Daphne When Daphne, a virgin nymph and Apollo's first love, was fleeing the god's amorous advances, she invoked her father, a river-god, to transform her and destroy the beauty which made her so attractive. 'No sooner had she finished this prayer than a deep lethargy seized her limbs, her tender breasts were covered over by a delicate bark, her hair grew out in leafy sprigs, her arms in branches, and her swiftly fleeing feet were held fast by sluggish roots. . . . Apollo felt her heart still beating under the fresh bark, embraced the branches as if they were still limbs, and kissed the tree – but even the tree shrank from his kisses.' As Apollo could not have Daphne as his wife, he adopted her, now a laurel tree, as his emblem, and vowed always to adorn his hair, his lyre and his quiver with laurel leaves. (Ovid).

Darius Warned by Charidemus When the Persian Emperor Darius paraded the enormous Asiatic army he had gathered against Alexander the Great, the Athenian general Charidemus, himself exiled from Greece by Alexander, warned Darius that though his army 'was bright with purple and gold and gleamed with arms and opulence', the 'coarse and rude' Macedonians were far better fighters. Darius, 'unwilling to hear the truth', sent Charidemus to be executed, but before he died Charidemus cried out, 'My avenger is at hand', words soon borne out by Alexander's great victory at Issus. (Quintus Curtius Rufus).

Daughters of Cecrops, *see* Erichthonius.

Daughters of Leucippus, *see* Rape of the Daughters of Leucippus.

David, *see also* Anointing of David.

David and Abigail David went to live in the mountain wilderness to escape King Saul who was trying to kill him. When Nabal, a sheep owner, refused to give David's men food in return for their not having raided his flocks, David went with 400

armed men to take revenge. Abigail, Nabal's wife, intercepted David on the way, offering him gifts, and dissuading him from shedding blood unnecessarily. 'Then Abigail made haste, and took two hundred loaves, and two bottles of wine, and five sheep ready dressed, and five measures of parched corn, and an hundred clusters of raisins, and two hundred cakes of figs, and laid them on asses. And she said unto her servants, Go on before me; behold, I come after you. But she told not her husband Nabal. And it was so, as she rode on the ass, that she came down by the covert of the hill, and, behold, David and his men came down against her; and she met them. . . . And when Abigail saw David, she hasted, and lighted off the ass, and fell before David on her face, and bowed herself to the ground.'

Abigail interceded for Nabal. 'So David received of her hand that which she had brought him, and said unto her, Go up in peace to thine house; see, I have hearkened to thy voice, and have accepted thy person. . . . And it came to pass about ten days after, that the Lord smote Nabal, that he died.' Abigail later became one of David's wives. (I Samuel, 25).

In the Middle Ages Abigail symbolized the Virgin appeasing God's wrath against mankind.

David and Absalom, *see* Reconciliation of David and Absalom.

David and Bathsheba 'And it came to pass in an evening-tide, that David arose from off his bed, and walked upon the roof of the king's house: and from the roof he saw a woman washing herself; and the woman was very beautiful to look upon. And David sent and inquired after the woman. And one said, Is not this Bathsheba, the daughter of Eliam, the wife of Uriah the Hittite? And David sent messengers, and took her; and she came in unto him, and he lay with her . . . and she returned unto her house. And the woman conceived, and sent and told David, and said, I am with child.'

Though God punished the adultery by causing the son that was born to die, Bathsheba later bore David another son, Solomon. (II Samuel, 11).

80

David at the Cave Adullam, *see* David's Three Mighty Men Bring Water from the Well.

David Dancing before the Ark of the Covenant The ark was a portable sanctuary where the Israelites kept the commandments Moses received from God and other historical objects from their forty years in the wilderness. As it was sacred and could not be handled, it was carried on shafts. When David began to reign over Israel, he brought the ark into Jerusalem, the new capital of his kingdom. 'And they set the ark of God upon a new cart. . . . And David and all the house of Israel played before the Lord on all manner of instruments made of fir wood, even on harps, and on psalteries, and on timbrels, and on cornets, and on cymbals.' But when one of the drivers touched the ark to steady it because it was leaning to one side, God killed him. Because of this incident, the ark was left outside Jerusalem for three months, after which David and the Israelites finally brought it into Jerusalem 'with shouting, and with the sound of the trumpet' (II Samuel, 6).

David Entering Jerusalem When King Saul saw David, whom he had never seen before, going out to fight Goliath, he said to Abner, the captain of his army, 'Enquire thou whose son the stripling is.' When David returned after killing Goliath, Abner brought him before Saul with Goliath's head in his hand, and David told the king he was the son of Jesse.

'And David took the head of the Philistine, and brought it to Jerusalem.' As David and Saul were returning to the city together, 'the women came out of all cities of Israel, singing and dancing, to meet King Saul, with tabrets, with joy, and with instruments of musick. And the women answered one another as they played, and said, Saul hath slain his thousands, and David his ten thousands.' Hearing this, Saul grew jealous of David. (I Samuel, 17 and 18).

To the Middle Ages David's triumphal entry into Jerusalem prefigured Christ's entry into Jerusalem, when the people went out to meet and praise him.

David and Goliath 'And there went out a champion out of the camp of the Philistines, named Goliath, of Gath, whose height was six cubits and a span . . . and the staff of his spear was like a weaver's beam . . . and he stood and cried unto the armies of Israel, . . . I defy the armies of Israel this day; give me a man, that we may fight together. When Saul and all Israel heard those words of the Philistine, they were dismayed, and greatly afraid. . . .

'And David said to Saul, Let no man's heart fail because of him; thy servant will go and fight with this Philistine. And Saul said to David, Thou art not able to go against this Philistine to fight with him: for thou art but a youth, and he a man of war from his youth.' But David 'took his staff in his hand, and chose him five smooth stones out of the brook, and put them in a shepherd's bag which he had . . . and his sling was in his hand: and he drew near to the Philistine . . . and when the Philistine looked about, and saw David, he disdained him: for he was but a youth, and ruddy, and of a fair countenance. . . .

'Then said David to the Philistine, Thou comest to me with a sword, and with a spear, and with a shield: but I come to thee in the name of the Lord of hosts, the God of the armies of Israel, whom thou hast defied. This day will the Lord deliver thee into mine hand; and I will smite thee, and take thine head from thee . . . that all the earth may know that there is a God in Israel. . . . And David put his hand in his bag, and took thence a stone, and slang it, and smote the Philistine in his forehead, that the stone sunk into his forehead; and he fell upon his face to the earth. . . . But there was no sword in the hand of David. Therefore David ran, and stood upon the Philistine, and took his sword, and drew it out of the sheath thereof, and slew him, and cut off his head therewith. And when the Philistines saw their champion was dead, they fled' (I Samuel, 17).

Augustine and other Christian commentators emphasized the words, But there was no sword in the hand of David.

David and Jonathan The friendship between David and Jonathan, the son of King Saul, is proverbial. 'The soul of

82

Jonathan was knit with the soul of David, and Jonathan loved him as his own soul' (I Samuel, 18).

When Saul became jealous of David on account of his growing fame, Jonathan warned David of Saul's plan to kill him, and helped him escape. Later, after the death of Saul and his sons, David mourned for Jonathan, saying: 'Thy love to me was wonderful, passing the love of women' (II Samuel, 1).

David Playing before Saul After God had grown dissatisfied with King Saul he sent the priest Samuel to anoint David instead, 'and the Spirit of the Lord came upon David from that day forward'. At the same time 'the Spirit of the Lord departed from Saul, and an evil spirit from the Lord troubled him. . . . And it came to pass, when the evil spirit from God was upon Saul, that David took an harp, and played with his hand: so Saul was refreshed, and was well, and the evil spirit departed from him' (I Samuel, 16).

David Presents the Head of Goliath to Saul, *see* David Entering Jerusalem.

David's Three Mighty Men Bring Water from the Well
During the wars with the Philistines, King David took refuge in the cave of Adullam when the Philistines occupied Bethlehem. 'And David longed, and said, Oh that one would give me drink of the water of the well of Bethlehem, which is by the gate! And the three mighty men brake through the host of the Philistines, and drew water out of the well of Bethlehem, that was by the gate, and took it, and brought it to David: nevertheless he would not drink thereof, but poured it out unto the Lord. And he said, Be it far from me, O Lord, that I should do this: is not this the blood of the men that went in jeopardy of their lives? Therefore he would not drink it' (II Samuel, 23).

The *Mirror of Man's Salvation* makes the Three Mighty Men a prefiguration of the Three Magi and the conversion of the Gentiles to Christianity. 'King David plainly did not thirst

for the water, but for the bravery of his men; so Christ thirsts for our conversion and salvation.'

See **Prefigurations.**

Death of Absalom Absalom rebelled against his father King David, and during the battle that followed he rode on mule-back under an oak and was caught by his hair in its branches. One of the king's officers found him suspended there and pierced him with three lances, and then some of the soldiers killed him. (II Samuel, 18).

Although Absalom was a rebel against his father, the *Mirror of Man's Salvation* considers him a prefiguration of Christ, 'for Absalom was of great beauty and hung on a tree'. So Christ 'was beautiful beyond the sons of men and was fixed to the cross with three nails'.

Death of Achilles Achilles, son of the hero Peleus and the nymph Thetis, was the greatest of the Greek heroes who fought at Troy. 'While he was still an infant his mother dipped him in the waters of the Styx, thus making his body invulnerable except in the part of his foot where she held him' – his heel. (Stephanus).

Years later, during the Trojan War, Achilles killed the Trojan prince Hector. In revenge Hector's mother, Queen Hecuba, contrived to bring about Achilles' death. 'Knowing that Achilles was in love with her daughter Polyxena, she promised he could marry her if he agreed to stop fighting and end the war.' Achilles agreed and came unarmed to the temple of Apollo that night where the marriage was to take place. But Hecuba sent her son Paris instead, and 'when Paris entered the temple he took his bow and arrows and killed Achilles', mortally wounding him in his vulnerable heel. (Jacopo da Bergamo).

According to Ovid, it was Apollo who brought about Achilles' death. Angry at seeing the city he had helped to build so near destruction on account of the Greeks, Apollo turned Paris' bow in Achilles' direction during a battle and then guided the deadly arrow to its goal.

Death of Adam, *see* Invention of the True Cross.

Death of Decius Mus On the eve of a battle between the Romans and the Latins, the generals who were to command the two wings of the Roman army had the same dream: victory would come to whichever general sacrificed himself and the enemy's legions to the gods. The entrails of sacrificed animals confirmed the omen, and the generals agreed that if either wing began to yield, the general there should sacrifice himself on behalf of the Roman people. During the battle when Decius' wing gave way before the Latin army he rushed fully armed into the thick of the enemy, spreading chaos among them and giving courage to the Romans, who won the battle. His body was found the following day in a heap of enemy dead, and was buried by the other general with honours. (Livy).

Death of Joseph The Virgin and Christ were present at the death of Saint Joseph. Mary came to his bedside and Christ stood at his feet. As the moment of death approached Joseph groaned and raised his eyes to heaven. Death came and took his soul at sunrise. Then angels put his soul into a silk napkin and took it away. (*New Testament Apocrypha, History of Joseph the Carpenter*).

Death of the Knight of Celano When St Francis was given hospitality by a knight of Celano, he foresaw his host's approaching death and, calling him aside, urged him to make a final confession of his sins, and added, 'Today the Lord will reward you for having received the poor so devoutly'. The knight followed Francis' advice and prepared for death. Then, as the others began to eat, he died. (Bonaventura).

Death of Saint Peter The Roman prefect Agrippa commanded Peter to be crucified on an accusation of godlessness. Peter asked the executioners to crucify him with his head downward, and said, 'My Lord came down from heaven to earth and was raised upright upon the cross. Now he has called me from earth to heaven, and my cross should show me

85

with my head toward earth and my feet to heaven. For I am not worthy to be upon the cross in the same way my Lord was.'

Angels with crowns of roses and lilies stood by Peter when he was on the cross, and he received a book of the teachings of Christ. *Golden Legend* .

Death of Saul Saul was the first King of Israel. 'Now the Philistines fought against Israel: and the men of Israel fled from before the Philistines, and fell down slain in mount Gilboa. And the Philistines followed hard upon Saul and upon his sons; and the Philistines slew Jonathan, and Abinadab, and Melchi-shua, Saul's sons. And the battle went sore against Saul, and the archers hit him; and he was sore wounded of the archers. Then said Saul unto his armourbearer, Draw thy sword, and thrust me through therewith; lest these uncircumcised come and thrust me through, and abuse me. But his armourbearer would not; for he was sore afraid. Therefore Saul took a sword, and fell upon it. And when his armourbearer saw that Saul was dead, he fell likewise upon his sword, and died with him. So Saul died, and his three sons, and his armourbearer, and all his men, that same day together' (I Samuel, 31).

Death of Seneca The suicide of the Roman philosopher Seneca was the model of a Stoic death. He had been the tutor and guardian of the young emperor Nero, and when Nero later thought that Seneca was implicated in a plot against him, Seneca preferred suicide to execution. Prevented by Nero's officers from making a last will he turned calmly to his friends and told them 'he was leaving to them his finest possession, the example of his life'. His wife Paulina insisted on joining him in death, and with a single stroke of the knife they opened their veins together. Seneca then had Paulina taken to another room so that she would not see his dying agony and dictated his final eloquent thoughts to his secretaries. As death was slow in coming he had himself carried to a hot bath and died there. (Tacitus).

Death of Saint Stephen Stephen, the first Christian martyr, was preaching to the people and accused them of being just as sinful as their forefathers, who persecuted the prophets of the Old Testament. 'When they heard these things, they were cut to the heart, and they gnashed on him with their teeth. But he, being full of the Holy Ghost, looked up stedfastly into heaven, and saw the glory of God, and Jesus standing on the right hand of God, and said, Behold, I see the heavens opened, and the Son of man standing on the right hand of God. Then they cried out with a loud voice, and stopped their ears, and ran upon him with one accord, and cast him out of the city, and stoned him: and the witnesses laid down their clothes at a young man's feet, whose name was Saul. And they stoned Stephen, calling upon God, and saying, Lord Jesus, receive my spirit. And he kneeled down, and cried with a loud voice, Lord, lay not this sin to their charge. And when he had said this, he fell asleep' (Acts, 7).

See also **Conversion of Saul.**

Death of the Virgin An angel appeared to the Virgin just before her death and gave her a palm branch from paradise which she asked John the Evangelist to carry before her bier on the day of her burial. The Apostles were miraculously assembled from the various countries where they had been preaching, to be with the Virgin when she died. The *Golden Legend* tells the story: 'She warned them not to extinguish the tapers until she was dead. . . . Then, putting on her funeral garments, and bidding farewell to all, she settled herself in bed and waited for death. Peter stood at her head and John at her feet, and the other apostles hovered round the bed praising the Mother of God. . . . The Lord descended with a multitude of angels and took up the soul of his mother. And her soul gleamed with such brightness that none of the apostles could look at it.'

Another account says that when Christ appeared, the soul of the Virgin 'leaped from her body into the bosom of her beloved son . . . and he wrapped it in garments of fine linen and gave it to Michael the holy archangel, who bare it on his wings of

light' (*New Testament Apocrypha, Coptic Assumption of the Virgin*).

Decius Mus, *see* Death of Decius Mus.

Deianira, Nessus, and Hercules When Hercules was returning to his city with his bride, Deianira, they came to a river which was so swollen with winter rain they could not cross it. The centaur Nessus offered to carry Deianira across on his back. She 'trembled and was pale in fear of the river and the centaur both'. Hercules swam across, and had just picked up his bow, which he had thrown across first, when he saw Nessus trying to carry off Deianira. 'Hercules' swift arrow pierced his fleeing back.' Nessus died, but first he soaked his shirt in his own blood and gave it to Deianira, telling her it would act as a love potion should she ever lose Hercules' affections. But when Deianira sent the shirt to Hercules some time later, it consumed his body instead with a searing fire. (Ovid).

Deluge, *see* Flood.

Saint Demetrius of Salonica Demetrius was martyred during the persecution of Christians under the Emperor Maximian in the fourth century. When Maximian was visiting Salonica, Demetrius insisted on openly professing his faith and preaching Christian doctrine until he was brought before the emperor himself and put to death. (*Acta Sanctorum*).

Democritus Laughing 'Democritus: A philosopher of Abdera, and a great one too, who used to laugh at the doings of men, as being ridiculous. Finally he blinded himself so that he could investigate the secrets of nature more subtly' (Torrentinus).

Denial of Peter Following the Last Supper, when Christ alluded to his coming trial and crucifixion, Peter said, 'Lord, I am ready to go with thee, both into prison, and to death'. Christ answered, 'I tell thee, Peter, the cock shall not crow

88

this day, before that thou shalt thrice deny that thou knowest me.'

Later that night, after Christ's arrest, his captors 'led him, and brought him into the high priest's house. And Peter followed afar off. And when they' – the servants – 'had kindled a fire in the midst of the hall, and were set down together, Peter sat down among them. But a certain maid beheld him as he sat by the fire, and earnestly looked upon him, and said, This man was also with him. And he denied him, saying, Woman, I know him not. And after a little while another saw him, and said, Thou art also of them. And Peter said, Man, I am not. And about the space of one hour after another confidently affirmed, saying, Of a truth this fellow also was with him: for he is a Galilaean. And Peter said, Man, I know not what thou sayest. And immediately, while he yet spake, the cock crew. And the Lord turned, and looked upon Peter. And Peter remembered the word of the Lord, how he had said unto him, Before the cock crow, thou shalt deny me thrice. And Peter went out, and wept bitterly' (Luke, 22).

Saint Denis, *see* Dionysius the Areopagite.

Departure of the Angel, *see* Tobit.

Deposition Joseph of Arimathaea, a rich man, 'being a disciple of Jesus, but secretly for fear of the Jews, besought Pilate that he might take away the body of Jesus: and Pilate gave him leave. He came therefore, and took the body of Jesus. And there came also Nicodemus, which at the first came to Jesus by night, and brought a mixture of myrrh and aloes, about an hundred pound weight.' The Virgin, John the Evangelist, Mary Magdalene, and the sisters of the Virgin, Mary Cleophas and Mary Salome, were also there. (John, 19).

Bonaventura describes the Deposition as follows: 'They placed two ladders one against either arm of the cross. Joseph went up the ladder at the right side and tried hard to draw the nail from his hand. . . . As soon as it was drawn out, John made

a sign to Joseph that he should hand the nail to him, so that our Lady would not see it. Nicodemus drew out the other nail from the left hand and gave it to John in like manner. Then Nicodemus came down and proceeded to draw out the nail which fastened the feet. Meanwhile, Joseph supported the body of our Lord. . . . Then our Lady reverently took the right hand as it hung down and pressed it to her mouth. She gazed upon it and kissed it with many tears and sighs of pain. As soon as Joseph had drawn out the nail that fastened the feet he came down, and then they all received the body of our Lord and laid it upon the ground.'

Descent from the Cross, *see* Deposition.

Descent of the Holy Ghost (Pentecost) After Christ's Ascension, the apostles returned to Jerusalem to await the coming of the Holy Ghost, whom Christ had promised to send in his place. They were in an upper room praying together with 'the women, and Mary the mother of Jesus, and with his brethren', when 'suddenly there came a sound from heaven as of a rushing mighty wind, and it filled all the house where they were sitting. And there appeared unto them cloven tongues like as of fire, and it sat upon each of them. And they were all filled with the Holy Ghost, and began to speak with other tongues, as the Spirit gave them utterance.'

When the people heard them speaking many different languages they were amazed, and some thought they were drunk. 'But Peter, standing up with the eleven, lifted up his voice, and said unto them, ye men of Judaea, and all ye that dwell at Jerusalem, be this known unto you and hearken to my words: for these are not drunken, as ye suppose, seeing it is but the third hour of the day. But this is that which was spoken by the prophet Joel; And it shall come to pass in the last days, saith God, I will pour out of my Spirit upon all flesh: and your sons and your daughters shall prophesy, and your young men shall see visions, and your old men shall dream dreams: and on my servants and on my handmaidens I will pour out in those days of my Spirit; and they shall prophesy' (Acts, 1 and 2).

Christians later said that as God had confused men's language at the Tower of Babel, here, he gave the apostles the gift of speaking and understanding all tongues.

Destruction of Jerusalem Titus, son of the Roman emperor Vespasian, captured Jerusalem on the 8th of September, AD 70, sacking the city and Solomon's temple, and carrying the Jewish holy objects of worship to Rome for his triumphal procession. This was seen as a fulfilment of Christ's prophecy, 'And when ye shall see Jerusalem compassed with armies, then know that the desolation thereof is nigh. . . . For these be the days of vengeance, that all things which are written may be fulfilled. But woe unto them that are with child, and to them that give suck, in those days! for there shall be great distress in the land, and wrath upon this people. And they shall fall by the edge of the sword, and shall be led away captive into all nations: and Jerusalem shall be trodden down of the Gentiles' (Luke, 21).

Later Christians considered the brutal sack of the city a divine punishment for Christ's crucifixion.

Destruction of Sodom and Gomorrah, *see* Lot.

Destruction of the Temple, *see* Destruction of Jerusalem.

Deucalion and Pyrrha When Jupiter decided to destroy the human race on account of its evil nature, he flooded the earth. Only Deucalion, 'than whom there was no better man, or one more devoted to what is right', and his wife Pyrrha, 'the most pious of all women', survived. Finding themselves alone on earth they consulted the oracle of Themis – the goddess of Justice – who told them to veil their heads and throw behind them 'the bones of their great Mother'. Perplexed at first, Deucalion finally realized the oracle's hidden meaning: their Mother was the earth, her bones were the rocks of the ground. As Deucalion and Pyrrha threw the rocks over their shoulders, they softened and gradually grew into men and women. 'That is why we are such a sturdy race, so fit for hard toil, bearing witness to our origin' (Ovid).

Diana Goddess of the hunt and the moon, 'twin sister of Apollo, the sun god. Because she loved virginity, they say she fled human society and lived as a huntress in the woods, to defend herself from the incitements of lust, accompanied only by a small band of virgins. She carried a bow and quiver, wore hunting boots, and kept her dress tucked up under a belt. Therefore she was also considered the goddess of woods and groves' (Stephanus).

Diana and Actaeon When the goddess Diana was hot and weary from the hunt, she went to a woodland cave to bathe in the clear waters of a pool fed by a spring. Entering the arched grotto, she handed her javelin, quiver and bow to one of her nymphs and her cloak to another. A third nymph bound her long hair into a knot while others drew water in large jars from the spring and poured it over her. At that very moment Actaeon, who had been hunting on a mountain nearby, was making his way through the unfamiliar woods with his hunting dogs and came to the cave where Diana was bathing. The nymphs shrieked at the sight of a man and rushed to shelter their naked and blushing mistress. 'Surrounded by her nymphs, Diana turned aside and looked back over her shoulder. Then, bending as though she wished her arrows were at hand, she scooped up some water, which was at hand, and sprinkled it in Actaeon's face', challenging him to tell others, if he could, how he had seen her without her clothes. Suddenly antlers started growing where the water touched Actaeon's brow and he was changed into a stag. Even his own hunting dogs did not recognize him and, thinking he was a wild animal, chased him and tore him to pieces. (Ovid).

Diana and Callisto Jupiter, king of the gods, fell in love with Callisto, an Arcadian nymph and a favourite among the attendants of Diana, virgin goddess of the hunt. One day Callisto entered a grove to rest: she 'unstrung her supple bow and stretched out on the grass, cushioning her head on her painted quiver'. Jupiter saw her thus, and, assuming the

92

appearance of Diana, chatted with her, and then seduced her, and made her pregnant.

Almost nine months later, Diana and her nymphs, tired and hot from hunting, bathed in a brook they found in a cool grove. As the others undressed, Callisto 'alone tried to delay. When she hesitated, the others pulled off her dress, revealing her nude body and her crime. She stood bewildered, and tried to hide her belly with her hands', but Diana ordered her to leave, and banished her from her company.

When Juno, Jupiter's wife, saw the son that was born to Callisto, she punished her rival by turning her into a bear. Jupiter later turned the boy into a bear too and put mother and son in the sky as neighbouring constellations, the Great and Little Bear. (Ovid).

Diana and Endymion Diana, the chaste goddess who did not like to be seen naked, was so in love with the handsome shepherd Endymion that she sent an eternal sleep upon him in order to be able to kiss him as much as she liked without being observed. 'But, as Pausanias remarks, there must have been more than kisses between them, for some say she had fifty daughters by him' (Cartari).

Dido and Aeneas With different aims in mind Venus and Juno collaborated to bring about the love affair between Dido, the queen of Carthage, and the Trojan exile Aeneas. Juno wanted to divert the Trojans from Italy, where they were destined to found a new kingdom, while Venus wanted Dido to treat Aeneas and the Trojans with kindness. According to the goddesses' plan, Aeneas and Dido went hunting together one early dawn, accompanied by their retinues and hounds. When loud thunder was heard and a downpour began the hunting party scattered in search of shelter, and Dido and Aeneas made their way to the same cave. 'Then Earth and Juno, the goddess of marriage, gave the signal . . . and that day became the origin of destruction and great evil.'

Aeneas forgot his destiny and devoted himself to working on Carthage until Jupiter sent Mercury to prod him from his

self-indulgent passion and remind him of his future. Then Aeneas quickly fitted out a fleet and left Africa. Dido, wretched at his departure, had a tall funeral pyre built in the courtyard of her palace and on it she put the bed they had slept in and the clothes and sword Aeneas had left behind, claiming she wanted to burn all reminders of him. But when it had been set ablaze Dido herself 'raging and pale with her approaching death climbed the high funeral pyre'. There she drew Aeneas' sword and threw herself upon it. As Aeneas sailed away 'he looked back to see the walls of the city resplendent with ill-fated Dido's flames' (Virgil).

Diogenes 'A philosopher and founder of the Cynic school, who despised wealth and would go around begging and openly criticizing those he encountered, doing homage to no one' (Torrentinus).

'When he went to live in a wooden cask, he joked about having a revolving house, and moving with the times. In winter he turned the open end south, and in the summer north, and so Diogenes would orient his residence according to the sun. They say that when Alexander the Great came to see him, he asked him not to block the sun, for he was sunning himself' (Calepinus).

Diogenes reduced his possessions until he had only a drinking cup left. Then, seeing a youth drink from his cupped hand, he realized that even his cup was not necessary, and threw it away. And once 'he lighted a lantern by day and said, I am looking for a man!' (Diogenes Laertius).

Dionysius the Areopagite When St Paul was in Athens preaching on the hill of the Areopagus, Dionysius heard him and was converted. He was baptized by Paul and later made bishop of Athens, and then sent to Paris to convert the Gauls. While he was there a persecution of Christians began and Dionysius and his followers were imprisoned for refusing to sacrifice to the pagan gods. As he was saying mass in prison, Christ appeared to him and, taking up the bread of the eucharist, said, 'Receive this, for with me is your great reward.'

Then Dionysius and his two companions were beheaded beside a statue of Mercury. 'At once the body of the saint arose and picked up his severed head and, led by an angel and preceded by a heavenly light, he carried it two miles' to the place where he chose to be buried. (*Golden Legend*).

Discovery and Proof of the Cross, *see* Invention of the True Cross.

Dives and Lazarus Christ told his disciples the following parable: 'There was a certain rich man, which was clothed in purple and fine linen, and fared sumptuously every day: and there was a certain beggar named Lazarus, which was laid at his gate, full of sores, and desiring to be fed with the crumbs which fell from the rich man's table: moreover the dogs came and licked his sores. And it came to pass, that the beggar died, and was carried by the angels into Abraham's bosom: the rich man also died, and was buried; and in hell he lift up his eyes, being in torments, and seeth Abraham afar off, and Lazarus in his bosom. And he cried and said, Father Abraham, have mercy on me, and send Lazarus, that he may dip the tip of his finger in water, and cool my tongue; for I am tormented in this flame. But Abraham said, Son, remember that thou in thy lifetime receivedst thy good things, and likewise Lazarus evil things: but now he is comforted, and thou art tormented. And beside all this, between us and you there is a great gulf fixed: so that they which would pass from hence to you cannot; neither can they pass to us, that would come from thence.'

At the rich man's request to warn his five brothers, Abraham replied: 'If they hear not Moses and the prophets, neither will they be persuaded, though one rose from the dead' (Luke, 16).

Doctrine of the Three Arrows Honorius of Autun says that during a plague in Rome in the year 590 arrows were seen raining from the sky and mortally wounding anyone they touched.

Saint Dominic later had a vision in which he 'saw God raising his right hand and shaking three lances against the

world with anger in his face. At once the Blessed Mary, our mediator, was there, showing him two vigorous fighters for the conversion of sinners.' These fighters were St Dominic and St Francis. God's three lances were directed against the sins of Pride, Greed and Sensuality, 'of which this world is now full' (*Mirror of Man's Salvation*).

In a medieval French account it is Christ who brandishes the lances. 'Our Lady gently begged him to have pity on the world, and to temper his justice with heavenly mercy.' Christ replied, 'Through loving you, sweet mother, I will spare the world, and withdraw the justice and punishment I planned against it' (from a MS in the French National Library).

See also **Intercession of the Virgin.**

Domine Quo Vadis? (Lord, where are you going?) Just before Christ's crucifixion, Peter had asked him, 'Lord, where are you going? Jesus answered: Where I am going you can not follow me now: but you will later. Peter said to him, Why can I not follow you now? I will lay down my soul for you. Jesus answered him, Will you lay down your soul for me? Amen, amen, I say to you: the cock will not crow before you have denied me three times' (John, 13 (Vulgate)).

Peter did deny Christ, but when he heard the cock crow and realised what he had done 'he went outside and wept bitterly' (Matthew, 26 (Vulgate)).

Years later, when he had just escaped from prison in Rome and was fleeing the city, he saw a vision of Christ going towards it. 'Kneeling down before him, he said, Lord, where are you going? Christ replied, I am going to Rome to be crucified. Peter asked him if he had not already been crucified, and Christ answered, I saw you fleeing death and I want to be crucified for you. Peter said, Lord, let me go and fulfil your bidding. Christ answered, Do not be afraid, for I am with you.'

Peter returned to Rome, where he was arrested and crucified. He told his friends not to be sad, 'but rather rejoice with me, for today I shall receive the fruit of my sorrows' (*New Testament Apocrypha, Acts of Peter*).

Saint Dominic Dominic was the thirteenth century founder of the Order of Preachers, an order founded largely to combat heresy. Pope Innocent III confirmed the order after having a vision of Dominic supporting the crumbling walls of the Lateran Basilica in Rome.

When Dominic's mother was pregnant with him she dreamed that in her womb she had a little dog with a flaming torch in its mouth; when the dog came out of her body it set the world aflame. And the woman who held Dominic at his baptism saw a star on his forehead that brightened the whole world.

Once when he was in St Peter's Basilica in Rome praying for the extension of his order Dominic saw St Peter and St Paul coming towards him. Peter gave him a pilgrim's staff and Paul gave him a book, and then they said, 'Go, preach. God has chosen you for that task.' Dominic understood at once that the members of his order were meant to carry their fight against heresy to all parts of the world. The vision described in the *Doctrine of the Three Arrows* and the subsequent *Meeting of Dominic and Francis* were part of that vocation, as well as the *Burning of the Heretical Books.* In Toulouse when he was presiding at the burning of condemned heretics, Dominic chose one of them out and saved him from the stake, telling him that he was predestined to abandon his heresy and adopt the true faith. Although the heretic persisted in his heresy for twenty years, he finally was converted.

Dominic especially recommended the well-being of his friars to the Virgin. Once, when he was discouraged by his lack of success against the heretics, he withdrew to a cave near Toulouse to pray. There the Virgin appeared to him and gave him a rosary – which, according to legend, was then first introduced into Catholic worship as a new weapon against heresy.

The *Golden Legend* mentions Dominic's ascetic habits and comments, 'His life was nothing but reading and praying day and night' (*Golden Legend* and *Acta Sanctorum*).

See also **Origin of the Dominican Habit; Dominicans at Table Served by Angels.**

Dominicans at Table Served by Angels One evening, after a long day of unsuccessful begging, two Dominicans were returning to their monastery with a single loaf when a poor man approached them and asked for bread. The monks reluctantly gave him their loaf and returned empty-handed. But Saint Dominic said, 'The Lord will feed his servants'. Then he called his monks into the refectory, told them to take their places, and began to pray, after which two handsome youths appeared with baskets full of food and served each of them in turn, disappearing again after they had served the saint. (*Acta Sanctorum*).

Dormition of the Virgin, *see* Death of the Virgin.

Saint Dorothy A fourth century saint. When, having survived many tortures without harm, she was being led out to be beheaded for her faith, a young lawyer named Theophilus made fun of her, telling her to send him a bouquet when she got to heaven. As she was extending her neck for the executioner, she prayed that all who invoked her name would receive divine aid. Suddenly a young man appeared before her in royal dress and offered her three apples and three roses in a basket. At the saint's request he delivered them to Theophilus after her death, and Theophilus converted at once to the Christian faith. (*Acta Sanctorum*).

Dream of Joseph Saint Joseph, the husband of the Virgin, had four dreams. For the first, *see* **Joseph Chiding Mary;** for the second, **Flight into Egypt;** for the third and fourth, **Return from Egypt.** For the dreams of Joseph the Patriarch, *see* **Joseph in Egypt.**

Dream of Pharaoh's Butler, *see* Joseph in Egypt.

Drunkenness of Noah This story from Genesis was re-told with additions in the Middle Ages. Noah, thought of as 'a high priest and great ruler' cultivated the wild grape. At the first wine-harvest 'he held a great feast and, growing drunk on the

wine, fell down like a young lamb and lay shamefully exposed on the ground. When his son Ham, the father of Canaan, saw his father's shameful parts uncovered, he went and told his brothers, laughing at his father and making fun of him, and pointing out his disgrace. But Shem and Japheth showed their filial piety by putting a cloak on their shoulders and walking backward to cover Noah up, and their faces were turned away.' When Noah awoke he blessed Shem and Japheth and, not wanting to curse his own son, cursed the descendants of Ham, the Canaanites, instead. (Jacopo da Bergamo).

Ecce Homo (Behold the Man!) According to a medieval account, Pilate had Christ whipped by Roman soldiers 'hoping that his accusers would be satisfied with his humiliation and afflictions and no longer demand his death' (*Mirror of Man's Salvation*).

According to St John, after they had whipped him, 'the soldiers platted a crown of thorns, and put it on his head, and they put on him a purple robe, and said, Hail, King of the Jews! and they smote him with their hands. Pilate therefore went forth again, and saith unto them, Behold, I bring him forth to you, that ye may know that I find no fault in him. Then came Jesus forth, wearing the crown of thorns, and the purple robe. And Pilate saith unto them, Behold the man! When the chief priests therefore and officers saw him, they cried out, saying, Crucify him, crucify him. Pilate saith unto them, Take ye him, and crucify him: for I find no fault in him' (John, 19).

See also **Flagellation.**

Eliezer and Rebecca (Rebecca at the Well) Abraham sent his servant Eliezer to Mesopotamia, the place of his birth, to find a wife for his son Isaac. One evening Eliezer stopped by a well to water his camels, and Rebecca came out to fetch water with her pitcher on her shoulder. 'And the damsel was very fair to look upon, a virgin, neither had any man known her: and she went down to the well, and filled her pitcher, and came up. And the servant ran to meet her, and said, Let me, I pray thee, drink a little water of thy pitcher. And she said, Drink, my

Lord: and she hasted, and let down her pitcher upon her hand, and gave him drink. And when she had done giving him drink, she said, I will draw water for thy camels also, until they have done drinking' (Genesis, 24).

Her words were the omen Eliezer had hoped for, and he knew that she was to be Isaac's bride. Medieval Christians paralleled Rebecca's willingness to become Isaac's bride to the virgin Mary's words at the time of the Annunciation, 'Behold the handmaid of the Lord; be it unto me according to thy word.'

Elijah, *see also* Angels Bringing Food and Drink to Elijah; *and* Translation of Elijah.

Elijah Fed by Ravens When Elijah prophesied that there would be a drought in Israel, God told him to hide by the brook Cherith, where ravens would feed him. 'So he went and did according unto the word of the Lord: for he went and dwelt by the brook Cherith, that is before Jordan. And the ravens brought him bread and flesh in the morning, and bread and flesh in the evening; and he drank of the brook' (I Kings, 17).

Elijah and the Widow of Sarepta God had brought a drought on Israel, but he told the prophet Elijah to go dwell with a widow of Sarepta (Zarephath in the Old Testament), a city of Sidon which was not part of Israel, and that she would sustain him. 'So he arose and went to Zarephath. And when he came to the gate of the city, behold, the widow woman was there gathering of sticks: and he called to her, and said, Fetch me, I pray thee, a little water in a vessel, that I may drink. And as she was going to fetch it, he called to her, and said, Bring me, I pray thee, a morsel of bread in thine hand. And she said, As the Lord thy God liveth, I have not a cake, but an handful of meal in a barrel, and a little oil in a cruse: and, behold, I am gathering two sticks, that I may go in and dress it for me and my son, that we may eat it, and die.

'And Elijah said unto her, Fear not; go and do as thou hast said: but make me thereof a little cake first, and bring it unto

me, and after make for thee and for thy son. For thus saith the Lord God of Israel, The barrel of meal shall not waste, neither shall the cruse of oil fail, until the day that the Lord sendeth rain upon the earth. And she went and did according to the saying of Elijah: and she, and he, and her house, did eat many days. And the barrel of meal wasted not, neither did the cruse of oil fail, according to the word of the Lord, which he spake by Elijah' (I Kings, 17).

Christ later commented on this episode, 'I tell you of a truth, many widows were in Israel in the days of Elias, when the heaven was shut up three years and six months, when great famine was throughout all the land; but unto none of them was Elias sent, save unto Sarepta, a city of Sidon, unto a woman that was a widow', using it as an example for his proverbial words, 'No prophet is accepted in his own country' (Luke, 4).

Elisha and the Shunamite The prophet Elisha repaid the hospitality given him by a childless woman of Shunem by prophesying that she would bear a son. The son that was born died while still a child, and the woman rushed to Elisha, who was on Mt Carmel. He gave his staff to his servant with instructions to go and lay it upon the dead child's face. But 'the mother of the child said, As the Lord liveth, and as thy soul liveth, I will not leave thee. And he arose, and followed her.' The servant, and the rod, had no effect 'and when Elisha was come into the house, behold, the child was dead, and laid upon his bed. He went in therefore, and shut the door upon them twain, and prayed unto the Lord. And he went up, and lay upon the child, and put his mouth upon his mouth, and his eyes upon his eyes, and his hands upon his hands: and he stretched himself upon the child; and the flesh of the child waxed warm. . . . And the child sneezed seven times, and the child opened his eyes' (II Kings, 4).

Saint Elizabeth of Hungary Though Elizabeth was the daughter of the king of Hungary and wife of a nobleman, her main interest was in ministering to the poor, feeding the hungry, and giving drink to the thirsty. 'When she was a

young girl the cook complained to her father that she was taking meat from the pot and bringing it on the sly to the poor.' Her father intercepted her and asked to see what was hidden in her apron. 'When she opened it, God miraculously transformed the meat she was carrying, and her apron was full of roses and beautiful flowers' (*Revelations of Saint Elizabeth*).

Elizabeth built a large hospital for the sick and tended them through their illnesses and, when her husband was away, she collected all the grain from his granaries and distributed it to the needy. Once she was giving beer to the poor and 'when everyone had had enough it was found that the jug she was pouring from was still full'. After her husband's death on a crusade she became a nun and voluntarily lived in great poverty. Poorly dressed, she would sit among her maids spinning wool, and though her father the king tried to recall her from that life she refused to leave her self-imposed poverty. (*Golden Legend*).

Elymas Struck with Blindness The apostles Paul and Barnabas were preaching in Cyprus during their first missionary journey. When the Roman proconsul Sergius Paulus wanted to hear the word of God, Elymas the sorcerer tried to dissuade him. Then Paul, 'filled with the Holy Ghost', condemned Elymas and predicted that he would become blind. 'And at once there fell on him a mist and a darkness; and he went about seeking some one to take his hand. Then the proconsul, when he saw what had happened, believed, and was astonished at the teaching of the Lord' (Acts, 13 (Vulgate)).

Emmaus After Christ's death and resurrection he appeared to two of his disciples on the way to Emmaus. Not recognizing Christ, they told him how he had been crucified and how the angels at his sepulchre had told the three Marys that he had come back to life, and they added that they did not believe the report. Christ scolded them for not seeing in these events the fulfilment of the words of the Old Testament prophets. 'And beginning at Moses and all the prophets, he expounded unto them in all the scriptures the things concerning himself. And

they drew nigh unto the village, whither they went: and he made as though he would have gone further. But they constrained him, saying, Abide with us: for it is toward evening, and the day is far spent. And he went in to tarry with them. And it came to pass, as he sat at meat with them, he took bread, and blessed it, and brake, and gave to them. And their eyes were opened, and they knew him; and he vanished out of their sight.'

Later they told the other disciples 'what things were done in the way, and how he was known of them in breaking of bread' (Luke, 24).

See **Last Supper.**

Empedocles 'A learned man from Agrigento in Sicily, pupil of Pythagoras, and inventor of rhetoric. He was also a poet and philosopher who wrote about metaphysics in verse. So that people would think he had become a god, he slipped away from his comrades one night, and cast himself into the flaming crater of Mount Aetna. But his iron sandals were vomited up by the flames, and made it plain what Empedocles had done' (Torrentinus).

Entombment, *see* Burial of Christ.

Entry into Jerusalem Christ's entry into Jerusalem marks the beginning of the last week of his life. 'The chief priests and the Pharisees had given a commandment, that, if any man knew where he were, he should shew it, that they might take him,' and bring him to trial.

'On the next day much people that were come to the feast' (of the Passover), 'when they heard that Jesus was coming to Jerusalem, took branches of palm trees, and went forth to meet him, and cried, Hosanna: Blessed is the King of Israel that cometh in the name of the Lord. And Jesus, when he had found a young ass, sat thereon; as it is written, Fear not, daughter of Sion: behold, thy King cometh, sitting on an ass's colt' (John, 11 and 12).

'And a very great multitude spread their garments in the

way; others cut down branches from the trees, and strawed them in the way' (Matthew, 21).

Epiphany, *see* Adoration of the Magi.

Saint Erasmus For refusing to worship pagan idols Erasmus was subjected to a series of tortures by the Roman emperors Diocletian and Maximian. According to Caxton's translation of the *Golden Legend,* Erasmus survived them all 'whole and sound' and continued preaching God's word and baptizing converts. Finally Maximian laid him naked under a windlass 'and cut him upon his belly, and wound out his guts or bowels out of his blessed body'. Erasmus survived even this martyrdom and when he eventually died a natural death, a voice from heaven was heard saying that all who invoked his name for their health's sake would have their prayers answered.

Erichthonius 'Son of Vulcan, the blacksmith of the gods. When Vulcan tried to make love to the virgin goddess Minerva she successfully resisted him and he spilled his sperm on the ground. Minerva, out of modesty, covered it with earth, and from the mixture was born Erichthonius, who is supposed to have had serpent's feet' (Torrentinus).

'Minerva nursed the child in secret, and gave him in a little basket to the three daughters of Cecrops, king of Athens, for safe keeping', warning them not to look inside. 'But they opened it, and a crow told on them. Driven mad by Minerva, they cast themselves headlong into the sea' (Hyginus and Ovid).

Erminia and the Shepherds An episode from Tasso's *Gerusalemme Liberata.* Erminia, a pagan princess, fell in love with the Christian warrior Tancred during one of the crusades to free Jerusalem from the Saracens. Leaving Jerusalem by night disguised in Saracen armour she tried to reach the enemy camp in order to tend Tancred's wounds, but was attacked on the way and fled for refuge to a wooded spot on the Jordan. There, attracted by the sounds of shepherds' pipes, she came

upon an old man weaving willow baskets in the shade. Nearby his flocks were grazing and his three sons sang a rustic song. They were alarmed at the sight of Erminia's armour but she put them at their ease by taking off her helmet, and then listened to the shepherd's praise of the rustic life:

> 'Nor does my peaceful breast one spark enfold
> Of mad ambition, or the lust of gold.
> At the clear brook my modest cup I fill,
> Nor fear lest poison taint the crystal rill.
> My little garden and my flocks afford
> Unpurchased dainties to my frugal board.
> Who lives to Nature and Her dictates true,
> Is soon contented, for his wants are few.'
> (*Gerusalemme Liberata*, trans. J. H. Hunt, 1818).

Eschol, *see* Spies with the Grapes of Eschol.

Esther before Ahasuerus Esther was the Jewish queen of Ahasuerus, king of the Medes and Persians at the time of the Babylonian captivity of the Jews. When Haman, one of the king's ministers, plotted to destroy the Jews, Esther agreed to intercede with the king to save her people. But she knew that in doing so she risked her own life, for, as she said, 'Whosoever, whether man or woman, shall come unto the king into the inner court, who is not called, there is one law of his to put him to death, except such to whom the king shall hold out the golden sceptre, that he may live: but I have not been called to come in unto the king these thirty days.' Nonetheless she promised the Jews that she would 'go in unto the king, which is not according to the law: and if I perish, I perish.'

'And upon the third day, when she had ended her prayer, she laid away her mourning garments, and put on her glorious apparel. And being gloriously adorned, after she had called upon God, who is the beholder and saviour of all things, she took two maids with her: and upon the one she leaned, as carrying herself daintily; and the other followed, bearing up her train. And she was ruddy through the perfection of her

beauty, and her countenance was cheerful and very amiable: but her heart was in anguish for fear. Then having passed through all the doors, she stood before the king, who sat upon his royal throne, and was clothed with all his robes of majesty, all glittering with gold and precious stones; and he was very dreadful. Then lifting up his countenance that shone with majesty, he looked very fiercely upon her: and the queen fell down, and was pale, and fainted, and bowed herself upon the head of the maid that went before her.'

'And it was so, when the king saw Esther the queen standing in the court, that she obtained favour in his sight: and the king held out to Esther the golden sceptre that was in his hand. So Esther drew near, and touched the top of the sceptre. Then said the king unto her, What wilt thou, queen Esther? and what is thy request? it shall be even given thee to the half of the kingdom.' Through Esther's pleading the edict that had gone out against the Jews was revoked.

In a second version, 'God changed the spirit of the king into mildness, who in a fear leaped from his throne, and took her in his arms, till she came to herself again, and comforted her with loving words, and said unto her, Esther, what is the matter? I am thy brother, be of good cheer: thou shalt not die', and 'he held up his golden sceptre, and laid it upon her neck' (Esther, 4 and 5, and the Apocryphal Book of Esther, 15).

For medieval Christians Esther's intercession on behalf of the Jews symbolized the Virgin's intercession with God for mankind. *See* **Intercession of the Virgin.**

Ethopian Eunuch, *see* Saint Philip Baptizing the Ethiopian Eunuch.

Europa and the Bull When Jupiter fell in love with Europa, a king's daughter, he planned to abduct her as she was playing with her maidens beside the sea. Disguising himself as a snow-white bull, he mingled with her father's herd, and leapt and frolicked playfully on the grass. Europa admired him at once but hesitated to approach. 'Little by little putting off her fear she stroked his breast with her virgin hand and hung fresh

garlands on his gleaming horns. Finally she even dared –
unconscious who it was – to mount upon the bull's back.'
Gradually yet swiftly the god moved toward the sea and then
away from the land altogether. 'In her fear Europa looked back
at the receding shore, holding one of the bull's horns in her
right hand, the other hand on his back, her fluttering garments
trembling behind her.' Jupiter carried Europa to Crete and
there, putting off his disguise, fathered the hero king Minos.
(Ovid).

Eurydice, *see* Orpheus.

Saint Eustace Eustace was an officer in the army of the
Emperor Trajan and though he was a pagan he was known for
his works of mercy. Out hunting one day he followed an
especially large and handsome stag which then turned to face
him, and 'when he looked upon it carefully he saw between its
antlers a holy cross that shone more brightly than the sun, and
on it the image of Jesus Christ'. Christ spoke to him through
the mouth of the stag and told him, that as Eustace hunted the
stag, so he had come to hunt Eustace. Then he revealed himself
as the creator of the world.
 Eustace shared this revelation with his wife and two sons,
and they were all baptized together. In a second vision Christ
told him that he would suffer many trials and 'show himself to
be a second Job'. Trajan's successor, the Emperor Hadrian,
angered at their refusal to sacrifice to the idols, had Eustace
and his wife burnt to death in a bronze bull. (*Golden Legend*).

Exaltation of the Cross, *see* Invention of the True Cross.

Exodus *The Passover.* On the eve of the Israelites' escape
from their Egyptian captivity, God sent the last of the Ten
Plagues on Egypt, and killed the first born of every man and
beast. But he gave Moses and Aaron directions prescribing a
ritual by which the Israelites would be spared. Each family
was to kill an unblemished lamb, and mark the door posts of
their house with its blood. God would see the blood and pass

over their houses. Each family was to roast its lamb in one piece, and eat the meat that night with unleavened bread and bitter herbs. God said to Moses: 'And thus shall ye eat it; with your loins girded, your shoes on your feet, and your staff in your hand; and ye shall eat it in haste: it is the Lord's passover.'

Preparing to Leave Egypt. The Israelites left Egypt with their flocks and herds in the middle of the night. They borrowed jewelry and clothing from the Egyptians and took it with them, a way of plundering their captors. 'And the people took their dough before it was leavened, their kneading troughs being bound up in their clothes upon their shoulders. . . . And they baked unleavened cakes of the dough', a sign of their haste in fleeing.

Passage of the Red Sea. The Israelites were guided by God on their way to the Red Sea. 'And the Lord went before them by day in a pillar of a cloud, to lead them the way; and by night in a pillar of fire, to give them light.' Pharaoh and the Egyptians pursued them, but when they approached the Red Sea, God caused the waters to separate so that they could escape. 'And the children of Israel went into the midst of the sea upon the dry ground: and the waters were a wall unto them on their right hand, and on their left. And the Egyptians pursued, and went in after them.' After the Israelites had safely crossed, Moses stretched his hand over the sea, and the waters came together again, 'and the Lord overthrew the Egyptians in the midst of the sea. And the waters returned, and covered the chariots, and the horsemen, and all the host of Pharaoh.'

Then Moses and the Israelites sang a song of thanksgiving which began: 'I will sing unto the Lord, for he hath triumphed gloriously: the horse and his rider hath he thrown into the sea. The Lord is my strength and song, and he is become my salvation' (Exodus, 12–15).

Expulsion from Paradise, *see* Garden of Eden.

Saint Exuperius, *see* Saint Maurice.

Ezekiel, *see also* Vision of Ezekiel.

Ezekiel's Vision of the Dry Bones During the Babylonian captivity of the Jews the prophet Ezekiel had a vision in which he was set down in a valley full of dry bones. God told him to 'prophesy upon these bones, and say unto them, O ye dry bones, hear the word of the Lord'. When Ezekiel prophesied, the bones were clothed in flesh and sinews, and 'breath came into them, and they lived, and stood up upon their feet, an exceeding great army'.

God then told Ezekiel that 'these bones are the whole house of Israel: behold, they say, Our bones are dried, and our hope is lost. . . . Therefore prophesy and say unto them, Thus saith the Lord God; Behold, O my people, I will open your graves, and cause you to come up out of your graves, and bring you into the land of Israel. And ye shall know that I am the Lord' (Ezekiel, 37).

Saint Fabian Fabian 'was divinely designated as Pope by a dove. For when no one had given him a thought, he was chosen by that sign as though by the Holy Ghost, and taken up to the papal throne' (Molanus).

Fall of Jericho Joshua, Moses' successor, led the Israelites at the siege of Jericho. They circled the city once a day for six days: seven priests blew trumpets of rams' horns, followed by the ark of the covenant and by the people, who kept silent. On the seventh time around on the seventh day, Joshua told the people to shout. 'So the people shouted when the priests blew with the trumpets: and it came to pass, when the people heard the sound of the trumpet, and the people shouted with a great shout, that the wall fell down flat, so that the people went up into the city, every man straight before him, and they took the city' (Joshua, 6).

Fall of Man, *see* Garden of Eden.

Fall of the Titans 'When the Titans tried to climb the sky Jupiter, with the help of Minerva, Apollo and Diana sent them

headlong into Tartarus. Then they put the vault of the sky on the shoulders of Atlas, their leader, and it is said he is still holding it up.'

Sometimes the Titans are confused with the Giants, 'an impious race of men who denied the existence of the gods, and therefore are said to have tried to drive the gods from heaven. . . . What else does the battle of the Giants against the gods signify than going against Nature herself?' (Stephanus).

Family of Darius before Alexander When Alexander the Great defeated the Persian emperor Darius at Issus, Darius' mother, wife, six-year-old son and two grown daughters fell into Alexander's hands, along with their attendants. Then an incident occurred which ancient writers cited as an example of the young Alexander's democratic attitude towards his troops and mercy towards his captives. When Alexander went to see Darius' family in their tent he took along with him one of the members of his court, Hephaestion 'by far the closest of all his friends'. The Roman historian Quintus Curtius tells us that 'as Hephaestion was the same age as Alexander, but even more impressive looking, the royal family thought that he was the king and knelt down before him. Then one of the eunuchs who had been captured with them pointed out the real Alexander, and the mother of Darius turned to him and excused her mistake, as she had never seen him before. But the king, helping her to rise, said, You were not mistaken, mother, for he too is Alexander.' He then assured the women that they would be treated according to their royal dignity. Quintus Curtius adds, 'Alexander's behaviour at that time outdid all the kings of history in continence and mercy', and he later recalls this incident when describing the corruption of Alexander's morals that began after his capture of Babylon, with its royal luxuries, vices and courtesans.

Feast of Ahasuerus This is part of the story of Esther. Ahasuerus was king of the Medes and Persians at the time of the Babylonian captivity of the Jews. He gave a lavish feast for all the people of Susa, his capital, in the court of the palace

110

garden. But when Vashti, the queen, refused to obey the royal command to appear before the king and his guests, Ahasuerus, in his anger, gave her royal position to Esther, a Jewess. Esther was specially favoured by the king, and was later able to intercede with him on behalf of the Jews, and to save them from annihilation. (Book of Esther).

Feast in the House of Levi, *see* Calling of Matthew.

Feast of Job's Children, *see* Job.

Feast at Simon's House The woman who anointed Christ's feet while he was eating at the house of Simon the Pharisee was identified by later Christians with Mary Magdalene. 'And, behold, a woman in the city, which was a sinner, when she knew that Jesus sat at meat in the Pharisee's house, brought an alabaster box of ointment, and stood at his feet behind him weeping, and began to wash his feet with tears, and did wipe them with the hairs of her head, and kissed his feet, and anointed them with the ointment. Now when the Pharisee which had bidden him saw it, he spake within himself, saying, This man, if he were a prophet, would have known who and what manner of woman this is that toucheth him: for she is a sinner. And Jesus answering said unto him, Simon, I have somewhat to say unto thee. . . . Seest thou this woman? I entered into thine house, thou gavest me no water for my feet: but she hath washed my feet with tears, and wiped them with the hairs of her head. Thou gavest me no kiss: but this woman since the time I came in hath not ceased to kiss my feet. My head with oil thou didst not anoint: but this woman hath anointed my feet with ointment. Wherefore I say unto thee, Her sins, which are many, are forgiven; for she loved much: but to whom little is forgiven, the same loveth little. And he said unto her, Thy sins are forgiven. . . . Thy faith hath saved thee; go in peace' (Luke, 7).

In the gospel of St John, the meal takes place at the house of Mary and Martha, after Christ had raised their brother Lazarus from the dead. 'There they made him a supper; and

111

Martha served: but Lazarus was one of them that sat at the table with him. Then took Mary a pound of ointment of spikenard, very costly, and anointed the feet of Jesus, and wiped his feet with her hair: and the house was filled with the odour of the ointment. Then saith one of his disciples, Judas Iscariot, Simon's son, which should betray him, Why was not this ointment sold for three hundred pence, and given to the poor? This he said, not that he cared for the poor; but because he was a thief, and had the bag, and bare what was put therein' (that is, he was the group's treasurer). 'Then said Jesus, Let her alone: against the day of my burying hath she kept this. For the poor always ye have with you; but me ye have not always' (John, 12).

Feeding of the Five Thousand, *see* Miracle of the Loaves and the Fishes.

Finding the Coin in the Fish's Mouth The tribute money mentioned in this passage was a temple-tax instituted by Moses as a means of taking the census of the Israelites. 'And when they were come to Capernaum, they that received tribute money came to Peter, and said, Doth not your master pay tribute? He saith, Yes. And when he was come into the house, Jesus prevented him, saying, What thinkest thou, Simon? of whom do the kings of the earth take custom or tribute? of their own children, or of strangers? Peter saith unto him, Of strangers. Jesus saith unto him, Then are the children free. Notwithstanding, lest we should offend them, go thou to the sea, and cast an hook, and take up the fish that first cometh up; and when thou hast opened his mouth, thou shalt find a piece of money: that take, and give unto them for me and thee' (Matthew, 17).

First Disciples 'And Jesus, walking by the sea of Galilee, saw two brethren, Simon called Peter, and Andrew his brother, casting a net into the sea: for they were fishers. And he saith unto them, Follow me, and I will make you fishers of men. And they straightway left their nets, and followed him.

112

'And going on from thence, he saw other two brethren, James the son of Zebedee, and John his brother, in a ship with Zebedee their father, mending their nets; and he called them. And they immediately left the ship and their father, and followed him' (Matthew, 4).

See also, **Miraculous Draft of Fishes.**

Flagellation 'Then Pilate therefore took Jesus, and scourged him' (John, 19).

According to the medieval *Mirror of Man's Salvation*, Pilate had Christ whipped 'hoping that his accusers would be satisfied by his humiliation and afflictions and no longer demand his death', and describes the Flagellation: 'They bound him to a column like a criminal and struck him savagely with rods and whips, so that in his entire body no part was left whole or sound, and his precious blood flowed out in rivulets.'

See also **Mocking of Christ.**

Flight into Egypt After the departure of the Magi, who had brought gifts to the infant Jesus, 'behold, the angel of the Lord appeareth to Joseph in a dream, saying, Arise, and take the young child and his mother, and flee into Egypt, and be thou there until I bring thee word: for Herod will seek the young child to destroy him. When he arose, he took the young child and his mother by night, and departed into Egypt' (Matthew, 2).

See also **Rest on the Flight into Egypt.**

Flight and Fall of Simon Magus Simon Magus was a magician who won the favour of the Emperor Nero. He tried to buy the gift of the Holy Ghost from St Peter and St Paul and was offended when they told him it could not be bought. He claimed to be the son of the True God, but his miracles were accomplished only with the aid of the devil.

When Peter and Paul were in Rome trying to convert Nero and the Roman people to Christianity, Simon announced that he was going to fly off the Capitoline Hill to demonstrate his divine power. Peter and Paul stood by as he successfully took

off. 'Then Peter said, Angels of Satan, who are holding Simon up in flight, I adjure you by Our Lord Jesus Christ to carry him no longer but let him fall'. And at once losing his support Simon fell and died (*Golden Legend*).

Flood 'And God saw that the wickedness of man was great in the earth . . . and it repented the Lord that he had made man on the earth . . . and the Lord said, I will destroy man whom I have created from the face of the earth; both man, and beast, and the creeping thing, and the fowls of the air. . . . But Noah found grace in the eyes of the Lord.'

God told Noah: 'Make thee an ark of gopher wood; rooms shalt thou make in the ark, and shalt pitch it within and without with pitch. . . . The length of the ark shall be three hundred cubits, the breadth of it fifty cubits, and the height of it thirty cubits. A window shalt thou make . . . and the door of the ark shalt thou set in the side thereof; with lower, second, and third stories shalt thou make it. . . . And of every living thing of all flesh, two of every sort shalt thou bring into the ark, to keep them alive with thee; they shall be male and female. Of fowls after their kind, and of cattle after their kind, of every creeping thing of the earth after his kind, two of every sort shall come unto thee, to keep them alive.'

When Noah was six hundred years old, 'were all the fountains of the great deep broken up, and the windows of heaven were opened. . . . In the selfsame day entered Noah, and Shem, and Ham, and Japheth, the sons of Noah,' and their wives, and all the animals, into the ark. 'And the flood was forty days upon the earth . . . the mountains were covered. And all flesh died . . . and Noah only remained alive, and they that were with him in the ark.'

When the flood abated, Noah sent forth first a raven and then a dove 'to see if the waters were abated from off the face of the ground; but the dove found no rest for the sole of her foot, and she returned unto him into the ark, for the waters were on the face of the whole earth: then he put forth his hand, and took her, and pulled her in unto him into the ark. And he stayed yet another seven days; and again he sent forth the dove

out of the ark; and the dove came in to him in the evening; and, lo, in her mouth was an olive leaf pluckt off: so Noah knew that the waters were abated from off the earth. And he stayed yet other seven days; and sent forth the dove; which returned not again.'

Then Noah and his sons and their wives and the animals left the ark. 'And Noah builded an altar unto the Lord; and he took of every clean beast, and of every clean fowl, and offered burnt offerings on the altar. And the Lord smelled a sweet savour; and the Lord said in his heart, I will not again curse the ground any more for man's sake. . . . While the earth remaineth, seedtime and harvest, and cold and heat, and summer and winter, and day and night shall not cease.'

God made a covenant with Noah and his sons, and set the rainbow in the sky as a token of that covenant. 'And it shall come to pass, when I bring a cloud over the earth, that the bow shall be seen in the cloud: and I will remember my covenant, which is between me and you and every living creature of all flesh; and the waters shall no more become a flood to destroy all flesh' (Genesis, 6–9).

Flora 'A goddess honoured by the Romans, who were pleased to put her in charge of flowers. The story goes that she was really a prostitute who made a fortune selling her body, then made the Roman people her heir, and left a certain sum, from the annual interest of which her birthday was to be celebrated with the Floral Games. In the course of time the Senate began to think this a little embarrassing and made up a story from her name to add dignity to a shameful business: they pretended she was the goddess of flowers and had to be propitiated so that the fruit trees and vines would flourish and prosper. Her games were celebrated with all kinds of wanton frolics, as was fitting to her memory' (Stephanus).

Saint Francis Francis was the founder of the Order of Minor Friars at the beginning of the thirteenth century in Assisi. His father was a wealthy merchant and Francis spent his early days in feasting and singing and as a soldier. One day

'dressed in handsome clothing, he met a well-born but impoverished and poorly dressed soldier. Feeling compassion for his poverty, Francis took off his own clothes and dressed the poor man in them.' The following night he had a vision of 'a glorious palace filled with weapons marked with the sign of the cross', and a voice told him they would belong 'to him and his soldiers'. Francis interpreted the vision as foretelling his own prosperity and decided to become a soldier and win military glory. On his way he was stopped by God, who told him that 'the vision you saw foretold a spiritual result to be achieved not by human efforts but by divine favour'.

His call to be a reformer came when he went into the church of San Damiano, which was threatening to collapse on account of its age. While praying before the crucifix 'he heard a voice from the cross saying, Francis, go and repair my house, which as you see is all in ruins'. Francis immediately sold some cloth and his horse in a nearby city and gave the money to the priest of the church, not yet understanding that the voice was referring to the spiritual and not to the material church.

Francis' father objected to his giving away their money and brought him before the bishop of Assisi to disinherit him. Without a moment's delay Francis took off all his clothes and gave them back to his father saying, 'Until now I have called you my father on earth. But now I may truly say, Our Father who art in heaven'. The bishop embraced Francis and put his own cloak around him.

Francis then repaired the abandoned church of St Mary of the Porziuncula, where he founded the order of the Minor Friars and wrote a Rule for their life based on poverty, chastity and obedience. He went to Pope Innocent III to have his Rule sanctioned, but the Pope was reluctant at first because the Rule seemed too severe. But then he had a vision of a poor and feeble man supporting the walls of the crumbling Lateran Basilica, and said, 'This is he who through his work and learning shall sustain the Church of Christ', and sanctioned the Rule.

Francis went to Syria to evangelize the Saracens, and when he was brought before the sultan of Babylon he offered to walk over live coals to prove the truth of his faith. The sultan

116

refused Francis' offer, feeling that none of his own priests would be willing to accept such a challenge.

Towards the end of his life Francis had a vision in which the wounds of Christ were miraculously transferred to his own body. Two years later, much weakened by a series of long and painful illnesses, he asked to be carried to the church of St Mary of the Porziuncula. He called his friars to him to console them for his death and when he died 'many citizens of Assisi came to contemplate the sacred stigmata with their eyes and kiss them with their lips'. One of them, a knight named Hieronymus, was sceptical of the reality of the stigmata and 'touched the saint's hands and feet and side with his own hands, and while he touched and felt those truthful signs of the wounds of Christ, he cut all doubt out of his own heart and everyone else's too'. The next day Francis' body was brought to Assisi and passed the church of San Damiano, where St Clare and her nuns mourned his death and embraced his body. Two years after his burial Francis was declared a saint. (Bonaventura).

Saint Francis Appearing in Arles Once when St Antony of Padua was giving a sermon on the Crucifixion in Arles, one of the monks who was present turned toward the back of the church 'and saw with his own eyes St Francis hovering in the air, with his hands extended as though upon the cross, blessing the brothers ... and confirming the truth of the sermon, especially concerning the cross of Christ, of which he was the bearer and minister' (Bonaventura).

Saint Francis Preaching to the Birds 'On his way to Bevagna St Francis came to a place where a great crowd of different kinds of birds had collected. When God's saint saw them he quickly ran to them and greeted them just as if they were reasonable beings. And when they all turned towards him ... he solemnly urged them to hear the word of God. Brother Birds, he began, you should give great praise to your Creator, who has dressed you in feathers, given you wings for flight, and granted you this pure air to live in. He arranges your life

117

without any worry on your part. And while he was saying these and similar things, the little birds began gesturing in marvellous fashion, stretching out their necks, extending their wings, and watching him attentively.' None of the birds flew away until St Francis had made the sign of the cross and given them permission to leave, and when Francis went back to his waiting companions 'he reproached himself for his negligence in not having sooner preached to the birds' (Bonaventura).

Saint Francis Receiving the Stigmata Near the end of his life, while he was praying on the side of a mountain, St Francis 'saw in a vision a seraph on a cross, and it had six wings, and was above him. And its hands and feet were fixed to the cross. Two wings were raised above its head, and two were extended for flight, and two covered the body completely. Seeing this he was dumbfounded: but he knew not its meaning. Joy and sorrow together rushed into his heart: he rejoiced in the pleasing appearance of the seraph, but the crucifixion terrified him.' The stigmata, which then appeared on Francis' hands and feet and side, later became painfully sensitive and would often bleed. (Celano).

Saint Francis Solaced by an Angel with the Music of the Violin When St Francis was in a weakened state from fasting 'and the attacks of demons' and wanted to comfort his body with spiritual food, he began to think of the glory and joy of the blessed in heaven, and asked God to give him a taste of that joy. Suddenly an angel appeared holding a viol and bow 'and as St Francis stood looking at him in amazement, the angel drew the bow once upwards over the viol, and suddenly such a sweetness of melody touched the soul of the saint that he was lifted beyond all bodily sensation' (*Fioretti*).

Saint Francis and the Wolf of Gubbio A large and ferocious wolf was menacing the town of Gubbio, eating not only the cattle but the people as well. St Francis, visiting the town, went out to confront the wolf, which approached him with gaping jaws. Making the sign of the cross the saint said, 'Come here,

Brother Wolf. I command you in God's name not to attack any man ever again.' Hearing that, the wolf lay down tamely at his feet. Francis declared that the citizens of the town would feed the wolf for the rest of its life if it would refrain from harming them or their animals. To signify its agreement, the wolf bowed its head and put its paw on the saint's hand. (*Fioretti*).

Saint Francis' Marriage to Lady Poverty When St Francis was on his way to Siena he encountered three poor women, very similar to each other in height, age and appearance, who greeted him with the words, 'Welcome to Lady Poverty'. When the women suddenly disappeared the friars who were with the saint realized 'that something mystic was being indicated concerning this holy man'. St Bonaventura explains that the apparition showed that all three evangelical virtues – chastity, obedience and poverty – were equally strong in St Francis, 'even though he took special pride in poverty, which he used to call his Mother, Wife or Mistress' (Bonaventura).

Gabriel, *see* Mission to Gabriel.

Galatea, Polyphemus and Acis Polyphemus was an uncouth cyclops with bristling hair on his body and one eye in the middle of his forehead. He lived in a cave with his sheep. When he fell in love with the beautiful sea-nymph Galatea, he tried to woo her in his rough way from the sea-shore or would follow her alluring conversation as far as he could into the sea. She would attract him as far as he could go and then would disappear under the waves, reappearing farther out. Polyphemus never won her.

Galatea fell in love with Acis, the handsome son of a sea-nymph and only sixteen. Hidden from view, they listened together to Polyphemus' love song. When Polyphemus discovered them he was so jealous he smashed Acis with a boulder from the cliff-side. Galatea used her divine powers to turn Acis' blood into a spring that came out of the cliff, and Acis himself into a river which bore his name. (Ovid).

Ganymede A young Phrygian shepherd boy. 'Because of his handsome looks, he was carried off by Jupiter's eagle, and was made his cupbearer' (Torrentinus).

Garden of Eden God created Adam from the dust of the ground 'and breathed into his nostrils the breath of life; and man became a living soul'. He put Adam in the garden of Eden, in the middle of which grew the tree of life, and the tree of the knowledge of good and evil. God created Eve from Adam's rib while he was sleeping 'and brought her unto the man. And Adam said, This is now bone of my bones, and flesh of my flesh: she shall be called Woman, because she was taken out of Man. . . . And they were both naked, the man and his wife, and were not ashamed.'

The Fall of Man. God allowed Adam to eat from every tree in the garden except the tree of the knowledge of good and evil, 'for in the day that thou eatest thereof thou shalt surely die'. But the serpent – who, according to medieval legend, walked erect at that time and had the head of a virgin – tempted Eve, knowing that she was the weaker of the two, telling her to eat of the fruit of the forbidden tree, 'and ye shall be as gods, knowing good and evil'. Eve ate some of the fruit and gave it to Adam to eat. Then they became aware of their nakedness and made themselves aprons of fig leaves and hid from the presence of God.

Expulsion from Paradise. When God, 'walking in the garden in the cool of the day', discovered that Adam had disobeyed him, he expelled him and Eve from Eden, 'lest he put forth his hand, and take also of the tree of life, and eat, and live for ever: therefore the Lord God sent him forth from the garden of Eden, to till the ground from whence he was taken. . . . And he placed at the east of the garden of Eden Cherubims, and a flaming sword which turned every way, to keep the way of the tree of life' (Genesis, 2 and 3).

Adam and Eve After the Fall. God made coats of skins and dressed Adam and Eve in them. A York mystery play describes them: 'Adam shall have a spade and Eve a hoe, and they shall begin to till the soil and sow corn therein'. Later Eve bore Cain

and Abel, her first two sons. A medieval tradition gave Cain a twin sister, Calmana.

Gathering of Manna When Moses was leading the Jews through the wilderness from Egypt to the promised land, God provided manna and quails for them to eat. 'And the Lord spake unto Moses, saying, I have heard the murmurings of the children of Israel: speak unto them, saying, At even ye shall eat flesh, and in the morning ye shall be filled with bread; and ye shall know that I am the Lord your God. And it came to pass, that at even the quails came up, and covered the camp: and in the morning the dew lay round about the host. And when the dew that lay was gone up, behold, upon the face of the wilderness there lay a small round thing, as small as the hoar frost on the ground. And when the children of Israel saw it, they said to one another, It is manna: for they wist not what it was. And Moses said unto them, This is the bread which the Lord hath given you to eat' (Exodus, 16).

The Jews kept a sample of the manna in the Ark of the Covenant. To medieval Christians, the Ark was symbolic of the Virgin Mary, and the manna was Christ, 'the living bread who descended from heaven' (*Mirror of Man's Salvation*).

Saint Genevieve Genevieve is the patron saint of Paris. She performed many miracles, healing the blind and freeing those possessed of demons. One Easter eve she was on her way to the church of St Denis accompanied by a group of young girls when the candle one of them held went out. The girls were frightened by the darkness of the night, but Genevieve took the candle in her hand 'and at her touch it was lighted again by God's will' (*Golden Legend*).

Saint George George was a knight from Asia Minor who served in the Roman army around the time of Diocletian. When a town in Libya was threatened by a dragon who prowled the city walls 'poisoning everyone with his breath', the citizens appeased the dragon by offering it two sheep every day and, when sheep got scarce, one sheep and one man or woman,

chosen by lot. When it was the turn of the king's daughter to be sacrificed, George happened to be passing by and the princess told him of the dragon and urged him to flee. 'But George, mounting his horse and arming himself with the Cross, daringly attacked the approaching dragon and, smartly brandishing his lance and commending himself to God, wounded him gravely and threw him to the ground.' The princess put her girdle around the monster's neck and led him back to town like a tame dog. After the king and the people agreed to be baptized, George killed the dragon. In another version, George did not capture the dragon, but killed it just as it was about to devour the princess.

When the persecution of Christians began George 'threw off his soldier's uniform and took up the uniform of Christ instead', and coming forth publicly 'he exclaimed that, All pagan gods are demons! The Lord made the heavens'. As a result he was stretched on the rack, lacerated, scorched, and salt was rubbed into his wounds. When, because Christ comforted him in a vision, these tortures failed, he was twice given poison to drink and rendered it harmless with the sign of the cross, was bound on a scythed wheel and thrown into melted lead 'which refreshed him like a warm bath'. When he pretended readiness to sacrifice to the idols, his prayers brought about the destruction of a pagan temple by simultaneous lightning and earthquake. Finally he was beheaded, but a bolt of heavenly fire fell on his persecutors and consumed them.

Centuries later, when the Crusaders were attacking Jerusalem, 'Saint George appeared dressed in white armour with a red cross on it' and led them to victory. (*Golden Legend*).

Gethsemane, *see* Agony in the Garden.

Giacomo, *see* Saint James.

Giants, *see* Fall of the Titans.

Gideon Before the monarchy, Israel was ruled by judges, one of whom was Gideon. After the Midianites had conquered

Israel an angel told Gideon that he would drive them out. The angel had him prepare a sacrifice of bread and meat and then 'the angel of the Lord put forth the end of the staff that was in his hand, and touched the flesh and the unleavened cakes; and there rose up fire out of the rock, and consumed the flesh and the unleavened cakes.' This miracle was meant to confirm the truth of the angel's prophecy.

But Gideon wanted still another sign from God: 'If thou wilt save Israel by mine hand, as thou hast said, Behold, I will put a fleece of wool in the floor; and if the dew be on the fleece only, and it be dry upon all the earth beside, then shall I know that thou wilt save Israel by mine hand, as thou hast said. And it was so: for he rose up early on the morrow, and thrust the fleece together, and wringed the dew out of the fleece, a bowl full of water. And Gideon said unto God, Let not thine anger be hot against me, and I will speak but this once . . . let it now be dry only upon the fleece, and upon all the ground let there be dew. And God did so that night: for it was dry upon the fleece only, and there was dew on all the ground.'

When Gideon had gathered his men, God wished to reduce their number, so that Israel would not take credit for the victory, which belonged to God: 'Bring them down unto the water, and I will try them for thee there. . . . Every one that lappeth of the water with his tongue, as a dog lappeth, him shalt thou set by himself. . . . And the number of them that lapped, putting their hand to their mouth, were three hundred men. . . . And the Lord said unto Gideon, By the three hundred men that lapped will I save you, and deliver the Midianites into thine hand: and let all the other people go every man unto his place.'

Gideon gave each of his men a trumpet and a lamp in a jug, and surprised the Midianites at night in their camp. Shouts, trumpet blasts, and the sudden flashing of the lights fooled the Midianites into thinking that an enormous army was attacking them and they fled. (Judges, 6 and 7).

The *Mirror of Man's Salvation* makes Gideon's fleece a prefiguration of the incarnation of Christ. 'The dew fell only on the fleece and all the surrounding earth stayed dry, so Mary

123

was filled with the divine dew, no other woman being found worthy of it.'

Saint Giles *Saint Giles and the Hind.* Saint Giles was a priest who withdrew into the wilderness to escape the growing fame of his miracles, and lived alone for three years in a well-wooded spot near the Rhône 'on wild fruits and water and the milk of a hind which the Lord sent to feed him'. By chance the king of the Goths, out hunting, caught sight of the hind, which surpassed all others for size and beauty, and pursued it. The hind took refuge at St Giles' feet and he put his arms around it to still its fears, praying God to preserve its life. Though they were hidden from view by the dense foliage, one of the king's archers aimed in their direction and shot an arrow which wounded Giles. When the king and his followers discovered him he refused medical aid and begged to be left in solitude.
The Mass of Saint Giles. At length the king persuaded Giles to give up his retired life. He was invited to the court of Charles Martel, who fervently requested the saint's prayers on his behalf, 'for he had committed a sin so shameful that he did not dare confess it to anyone'. While Giles was celebrating mass the following Sunday an angel appeared and put upon the altar a piece of paper on which was written a description of the king's sin, and a promise of forgiveness if he repented of it. And there was a note added saying that anyone else might find forgiveness for his sins by invoking Saint Giles in the same way. (*Acta Sanctorum*).

Gioacchino, *see* Anne and Joachim.

Girolamo, *see* Saint Jerome.

Giuditta, *see* Judith and Holofernes.

Giuseppe, *see* Joseph.

Glaucus and Scylla 'Glaucus, a god of the sea, was in love with Scylla, daughter of Phorcus. When she spurned him, he

approached the witch Circe, asking her to use her enchantments to make Scylla requite his love. But Circe, who was herself in love with Glaucus, and spurned by him, poisoned the waters Scylla was accustomed to bathe in, and when Scylla entered them she was turned into a monster: a maiden above, a fish below, with the belly of a wolf and a dolphin's tail' (Torrentinus).

Golden Calf The Israelites grew tired of waiting for Moses when he was on the mountain receiving the tablets of the law from God and asked his brother Aaron to make an idol for them which they could worship. This was in defiance of God's commandment, 'Thou shalt have no other gods before me', and, 'Thou shalt not make unto thee any graven image.' Nonetheless Aaron told them to bring him all their gold earrings, and he melted them down and cast the image of a golden calf. After building an altar before it, he 'made proclamation, and said, To morrow is a feast to the Lord. And they rose up early on the morrow, and offered burnt offerings, and brought peace offerings; and the people sat down to eat and to drink, and rose up to play.'

When Moses came down from the mountain with the two stone tablets of the law in his hand 'he saw the calf, and the dancing: and Moses' anger waxed hot, and he cast the tablets out of his hands, and brake them beneath the mount. And he took the calf which they had made, and burnt it in the fire.' Then he commanded the men of the tribe of Levi – the priests of Israel – to slaughter 3,000 of the people to punish them for their sin. (Exodus, 20 and 32).

Golden Gate, *see* Anne and Joachim.

Good Samaritan When Christ agreed that 'Thou shalt love ... thy neighbour as thyself', a lawyer asked him, 'Who is my neighbour?' Christ replied with this parable, which gains point from the fact that 'the Jews have no dealings with the Samaritans'.

'A certain man went down from Jerusalem to Jericho, and

fell among thieves, which stripped him of his raiment, and wounded him, and departed, leaving him half dead. And by chance there came down a certain priest that way: and when he saw him, he passed by on the other side. And likewise a Levite, when he was at the place, came and looked on him, and passed by on the other side. But a certain Samaritan, as he journeyed, came where he was: and when he saw him, he had compassion on him, and went to him, and bound up his wounds, pouring in oil and wine, and set him on his own beast, and brought him to an inn, and took care of him. And on the morrow when he departed, he took out two pence, and gave them to the host, and said unto him, Take care of him; and whatsoever thou spendest more, when I come again, I will repay thee.'

In conclusion Christ asked the lawyer, 'Which now of these three, thinkest thou, was neighbour unto him that fell among the thieves? And he said, He that shewed mercy on him. Then said Jesus unto him, Go, and do thou likewise'(Luke, 10).

The *Mirror of Man's Salvation* comments: 'The man in this parable is mankind, expelled from paradise into the desert of this life, robbed of the grace that God gave him, and wounded with the wound of mortality; for long he lay there half dead, for though his body was alive his soul was not; the Samaritan is Christ, our keeper, and if he had not come into this world, never would men have entered upon life eternal.'

Good Shepherd Jesus said: 'I am the good shepherd: the good shepherd giveth his life for the sheep. But he that is an hireling, and not the shepherd, whose own the sheep are not, seeth the wolf coming, and leaveth the sheep, and fleeth: and the wolf catcheth them, and scattereth the sheep' (John, 10).

Grapes of Eshcol, *see* Spies with the grapes of Eshcol.

Saint Gregory the Great A sixth century saint who was a Benedictine monk and a pope, Gregory is considered one of the four doctors of the western church, along with Ambrose, Jerome and Augustine. His biographer Petrus Diaconus says his name means 'vigilant', 'for he watched over the faithful,

showing them, through the genius of his abundant learning, how they might find the way to heaven'. He adds that 'when Gregory was dictating his books the Holy Ghost in the form of a dove was often seen on his head'.

According to the *Golden Legend,* when some noblemen asked Gregory for holy relics, and he gave them a small part of one of the priestly garments of St John the Evangelist, they returned it indignantly as not being of much value. 'Then St Gregory said a prayer, after which he asked for a knife and stabbed the cloth, and from the punctures blood flowed out, divinely demonstrating the value of the precious relic.'

The Mass of Saint Gregory. According to a sixteenth century writer Gregory is often painted 'celebrating the mass before a picture of the Passion of the Lord, of the kind called the Man of Sorrows, for it is said that when Gregory was celebrating the mass before such a picture the Passion itself appeared to him in a vision' (Molanus).

See also **Symbols of the Passion; Procession of Saint Gregory.**

Guarding the Tomb The day after Christ's burial, the chief priests and the Pharisees came to Pilate saying, 'Sir, we remember that the deceiver said, while he was yet alive, After three days I will rise again. Command therefore that the sepulchre be made sure until the third day, lest his disciples come by night, and steal him away, and say unto the people, He is risen from the dead: so the last error shall be worse than the first. Pilate said unto them, Ye have a watch: go your way, make it as sure as ye can. So they went, and made the sepulchre sure, sealing the stone, and setting a watch' (Matthew, 27).

In a medieval mystery play, the soldiers sit down on either side of the sepulchre to guard it during the night and fall asleep. (York Mystery).

Habakkuk Brings Food and Drink to Daniel in the Lions' Den Daniel was cast into the lions' den by the followers of Cyrus, king of Persia, and he was there 'six days. And in the den there were seven lions, and they had given them every day

two carcases, and two sheep: which then were not given to them, to the intent they might devour Daniel.

'Now there was in Jewry a prophet, called Habbacuc, who had made pottage, and had broken bread in a bowl, and was going into the field, for to bring it to the reapers. But the angel of the Lord said unto Habbacuc, Go, carry the dinner that thou hast into Babylon unto Daniel, who is in the lions' den. And Habbacuc said, Lord, I never saw Babylon: neither do I know where the den is. Then the angel of the Lord took him by the crown, and bare him by the hair of his head, and through the vehemency of his spirit set him in Babylon over the den. And Habbacuc cried, saying, O Daniel, Daniel, take the dinner which God hath sent thee. And Daniel said, Thou hast remembered me, O God: neither hast thou forsaken them that seek thee and love thee. So Daniel arose, and did eat: and the angel of the Lord set Habbacuc in his own place again immediately.

'Upon the seventh day the king went to bewail Daniel: and when he came to the den, he looked in, and behold, Daniel was sitting. Then cried the king with a loud voice, saying, Great art thou, O Lord God of Daniel, and there is none other beside thee. And he drew him out, and cast those that were the cause of his destruction into the den: and they were devoured in a moment before his face' (Bel and the Dragon (Daniel 14)).

Hagar and Ishmael Abraham's wife, Sarah, had borne him no children. Therefore she told Abraham to take her maid, Hagar, and have a child by her. When Hagar conceived by Abraham she became contemptuous of Sarah who, in revenge, treated her harshly. Hagar fled; but an angel of the Lord appeared to her, foretelling the birth of her son Ishmael, and bidding her return to Sarah 'and submit thyself under her hands'.

Hagar did so, but Sarah's jealousy of her continued, and after the birth of her own son, Isaac, she asked Abraham to send Hagar and Ishmael away. 'And Abraham rose up early in the morning, and took bread, and a bottle of water, and gave it unto Hagar, putting it on her shoulder, and the child,

and sent her away: and she departed, and wandered in the wilderness of Beer-sheba. And the water was spent in the bottle, and she cast the child under one of the shrubs. And she went, and sat her down over against him a good way off, as it were a bowshot: for she said, let me not see the death of the child. And she sat over against him, and lift up her voice, and wept. And God heard the voice of the lad; and the angel of God called to Hagar out of heaven, and said unto her, What aileth thee, Hagar? fear not; for God hath heard the voice of the lad where he is. Arise, lift up the lad, and hold him in thine hand; for I will make him a great nation. And God opened her eyes, and she saw a well of water; and she went, and filled the bottle with water, and gave the lad drink. And God was with the lad' (Genesis, 16 and 21).

Hannibal A Carthaginian general. 'His father, Hamilcar, brought him before an altar while he was still a boy and made him swear that, as soon as he was old enough, he would take up arms against the Romans.' Hannibal did so, and his famous crossing of the Alps started the invasion of Italy in which he almost defeated the Romans on their own territory. One of his greatest victories was at Cannae, where the Romans lost 43,000 men. Ultimately he was recalled to Carthage, 'where he joined battle with Publius Scipio at Zama, and 20,000 Carthaginians were killed, and as many more captured'. After that defeat Hannibal went into exile, seeking refuge at the courts of foreign kings, but he was finally forced to take poison to avoid being surrendered to the Romans. (Calepinus).

Harrowing of Hell, *see* Christ in Limbo.

Healing of Annianus A medieval legend. When Saint Mark was entering the city of Alexandria, his boot came apart and he gave it to Annianus, a cobbler. While repairing the boot Annianus hurt his left hand, which Mark miraculously healed by making clay with his saliva and spreading it on the cobbler's wound. Mark later baptized Annianus and his household and made him a bishop. (*Golden Legend*).

Healing of the Lame Man, *see* Peter and John Healing a Cripple at the Temple Gate.

Healing of the Paralytic One of Christ's miracles: 'And they come unto him, bringing one sick of the palsy, which was borne of four. And when they could not come nigh unto him for the press, they uncovered the roof where he was: and when they had broken it up, they let down the bed wherein the sick of the palsy lay. When Jesus saw their faith, he said unto the sick of the palsy, Son, thy sins be forgiven thee. But there were certain of the scribes sitting there, and reasoning in their hearts, Why doth this man thus speak blasphemies? who can forgive sins but God only?' To show them 'that the Son of man hath power on earth to forgive sins', Christ said to the sick man, 'Arise, and take up thy bed, and go thy way into thine house. And immediately he arose, took up the bed, and went forth before them all; insomuch that they were all amazed, and glorified God, saying, We never saw it on this fashion' (Mark, 2).

Saint Helen, *see* Invention of the True Cross.

Helen, *see* Judgement of Paris.

Heliodorus Expelled from the Temple The *Mirror of Man's Salvation* tells how King Seleucus sent Heliodorus with a band of soldiers to despoil the temple in Jerusalem. As Heliodorus entered the temple 'the wrath of God was provoked against him. Suddenly a terrible horse appeared, and on him a rider armed and fearful. The horse attacked Heliodorus furiously with his fore-hooves and hurled him down. And two robust youths were also there, and they whipped Heliodorus until he was almost dead. And then they disappeared.' Revived by the prayers of the high priest, Heliodorus returned to Seleucus and told him that 'if the King has any enemy whose death he desires, send him to despoil the temple in Jerusalem'.

Heraclitus Weeping 'Heraclitus: A disdainful philosopher of Ephesus who wrote a book on theology, but in a very obscure

style, to keep the ordinary man from understanding it. He was always weeping over the vices of mankind' (Torrentinus).

Heraclius, *see* Invention of the True Cross.

Hercules and Achelous Hercules fought against the river god Achelous for the hand of Deianira. When Hercules' strength proved too much for his rival, Achelous changed himself into a long snake and then into a bull. But Hercules seized the bull's head and, forcing its horns into the ground, tore off one of them, which the nymphs filled with fruit and flowers and gave, as the Cornucopia, to the goddess Ceres. Hercules won Deianira, and Achelous returned to his river, hiding his mutilated brow with a wreath of reeds, or willow leaves. (Ovid).

Hercules and Antaeus 'Antaeus was a giant who fought with Hercules in man to man combat. Every time Hercules threw him down and he touched earth, he would get up even stronger, for Mother Earth would give him a fresh supply of strength. Realizing this, Hercules held him off the ground and so brought about his death' (Torrentinus).

Hercules and Cacus Cacus was part man, part monster, belched fire from his mouth and lived off his thefts in a high mountain cave. When Hercules was pasturing his gigantic cattle in the valley below, Cacus stole four of the bulls and four heifers. In his rage Hercules tore off the pinnacle of rock above the cave, exposing Cacus in his den with the stolen cattle. Then, leaping down on Cacus, he clung to him until he had choked him to death. (Virgil).

Hercules and Cerberus This was the twelfth labour of Hercules. 'The poets say Cerberus was a three-headed dog, guardian of the underworld. . . . When Hercules descended there and Cerberus blocked his way, Hercules overcame him and dragged him with chains to the regions above' (Stephanus).

131

Hercules and Geryon One of the labours of Hercules. 'Geryon was a king of Spain who had three bodies. Hercules conquered him in war and stole his cattle' (Stephanus).

Hercules and the Lernaean Hydra One of the twelve labours of Hercules: 'Lerna is a swamp in the Peloponnesus near Argos, inhabited by the many-headed Hydra. Every time Hercules cut off one head, others would grow at once in its place. Finally Hercules set fire to a large pile of wood and burned the Hydra to death' (Torrentinus).

Hercules and Nessus, *see* Deianira, Nessus and Hercules.

Hercules and Omphale Hercules fell in love with Omphale, queen of Lydia, and became her slave. She set him to spinning wool and gave him her distaff and a woman's dress in exchange for his club and lion's skin. 'For a woman's charms are the greatest there are and defeated even him whom the great world could not defeat' (Fulgentius).
Hercules, Omphale and Pan. Even Pan was captivated by Omphale. Planning to seduce her he went one night to the cave where Hercules and Omphale had playfully exchanged clothing and groped his way to Omphale first, but 'feeling the lion's paw, with fear he lifted up his hand, thinking it was Hercules that lay there'. When he came to Hercules 'and felt Omphale's soft and delicate garments, thinking he had found that he sought for, at the bed's feet began to mount up, and lifting up his clothes, in lieu of finding a soft and tender skin, felt a hard flesh and full of hair. Hercules awaked out of his sleep and gave the poor lover such a blow with his fist, that he smote him from the bed to the ground.' The noise awoke Omphale and when the servants came with lights all laughed to see 'the silly god on the ground complaining for the blow he had received' (George of Montemajor, *Diana*, trans. B. Yong, 1598).

Hercules Strangling the Snakes Juno was jealous of Hercules because he was Jupiter's son by a mortal woman. One night when Hercules was only ten months old, Juno sent two

132

monstrous snakes to devour him as he and his younger brother lay sleeping in a bronze shield. His brother screamed when he awoke and caught sight of the snakes, but Hercules gripped them by the throat and strangled them to death, thus presaging his future strength and heroic labours against evil. (Theocritus).

Hercules' Death, *see* Apotheosis of Hercules.

Saint Hermann Joseph This saint's given name was Hermann, but on account of his devotion to the Virgin his fellow monks began calling him Joseph, after the Virgin's earthly husband. The saint felt himself unworthy of the name until, late one night, two angels led him to a mystic marriage with the Virgin, and said, 'From now on your name will be Joseph'. Later the Virgin herself appeared and gave him the Christ child to carry 'as my husband Joseph did when he carried him into Egypt' (*Acta Sanctorum*).

Hermaphroditus, *see* Salmacis and Hermaphroditus.

Hermes, Herse and Aglauros Herse, the king of Athens' daughter, was one of a group of young virgins returning from the festival of Minerva, bearing baskets wreathed in flowers on their heads. Mercury came flying by above them, and as he circled round the Acropolis he caught sight of Herse and fell in love with her. He flew down to earth to make love to her, but on the way was intercepted by her sister Aglauros who tried to sell Herse's chastity for a price. When Mercury returned with the payment, Aglauros sat before Herse's door and still denied him entry. But Mercury opened the door with his magic wand and punished Aglauros by turning her into a stone. (Ovid).

Herminia, *see* Erminia and the Shepherds.

Hero and Leander Hero lived at Sestus in an old tower by the Hellespont. Her lover Leander lived on the opposite shore

133

at Abydus. Every night Leander swam across the Hellespont to make love to Hero, guided by a lamp she put in her window. One stormy winter night, the light from Hero's lamp was blown out by the wind, and Leander was drowned. When Hero saw him lying dead at the foot of her tower, in her grief she flung a woven mantle around herself and plunged headlong to her death in the sea below. (Musaeus).

Herodias, *see* Beheading of John the Baptist.

Hierarchies of the Angels (The Nine Choirs of Angels) According to Isidore of Seville, 'the holy scriptures attest nine orders of angels, that is, Angels, Archangels, Virtues, Powers, Principates, Dominations, Thrones, Cherubim and Seraphim'.

Angels are messengers sent from heaven to bring God's word to men.

Archangels are the highest messengers and announce the most important matters.

Virtues are the workers of portents and miracles. They are subject to the Powers, who repress malignant spirits and keep them from doing as much harm in the world as they would.

Principates lead the heavenly armies.

Dominations have command of the Powers and Principates.

The Thrones are the seat of God and through them he dispenses judgement.

Cherubim have four wings and are blue. They are close to God and shine with the fullness of divine knowledge.

Seraphim have six wings and are red. They are the closest to God and burn with divine love. They cover the face and feet of God with their wings so that they alone among angels can see his full essence. (Isidore, *Etymologies*).

Hieronymus, *see* Saint Jerome.

Saint Hilary A French saint and bishop of Poitiers. He had enemies who belonged to the heretical Arian sect and they had

him removed from his bishopric and exiled. During his exile he came to an island infested with serpents. Putting a staff in the middle of the island, he ordered the serpents not to pass beyond it, and they obeyed.

According to the *Golden Legend* Hilary appeared uninvited at a council of Arian bishops called by a certain Pope Leo, also a heretic. After an exchange of insults the pope withdrew temporarily. As none of the other bishops made room for Hilary to sit down he sat on the ground, quoting the opening words of the twenty-fourth Psalm, 'The earth is the Lord's and the fulness thereof'. At once the earth rose up miraculously, so that he sat as high as the others. When messengers arrived with the news of the pope's sudden death, Hilary brought the other bishops back to the true faith.

Hippodamia, *see* Battle of the Lapiths and the Centaurs.

Hippolyta, *see* Battle of the Amazons.

Hiring of Judas 'Then one of the twelve, called Judas Iscariot, went unto the chief priests, and said unto them, What will ye give me, and I will deliver him' (Christ) 'unto you? And they covenanted with him for thirty pieces of silver.' And Judas 'gave them a sign, saying, Whomsoever I shall kiss, that same is he' (Matthew, 26).
 See **Agony in the Garden,** and **Betrayal of Christ.**

Holofernes, *see* Judith and Holofernes.

Holy Family and John the Baptist A medieval legend relates that after the Presentation of the Christ child in the Temple, 'the holy Virgin left Jerusalem to visit Elisabeth, wishing to see John before they left that region', for the Virgin had been the first to take care of John after he was born. 'When she arrived, they had a great celebration, especially on account of their sons. The children delighted in each other's company, and John, as though understanding, behaved reverently to Jesus' (Bonaventura).

Holy Family with the Sewing Basket After the Holy Family's flight into Egypt 'the Virgin suffered great hunger and poverty, and earned food and clothing for herself and her son with the distaff and needle, enduring this exile and sorrow for seven years' (*Mirror of Man's Salvation*).

Holy Kinship, *see* Saint Anne's Kith and Kin.

Holy Night, *see* Nativity.

Horatius Cocles 'A noble Roman. In the war which Porsenna, king of Etruria, was waging against the Roman republic for the restitution of the Tarquin kings, the enemy was invading the city itself, and everyone had begun their frantic retreat. Seeing this, Horatius remained behind with only two comrades, and delayed the advance of the enemy until the bridge behind him could be destroyed. When he saw that the bridge was down, he leapt fully armed into the Tiber, and swam to safety' (Stephanus).

Saint Hubert Hubert was a Roman officer. Once when he was out hunting on Good Friday a stag he was pursuing turned to confront him. Between its antlers was the crucified Christ, who said, 'Hubert, how long will you go on hunting the beasts of the woods? It is time for you to hunt me, for I am the Lord your God who was crucified this day for you and for all men.' Hubert confessed that he had never believed until then, and was baptized. He studied with a priest named Lambert and then went on a pilgrimage to Rome. As he approached the Vatican, Lambert's death and Hubert's arrival were revealed in a vision to Pope Sergius, who rushed out to meet Hubert. The two went into St Peter's basilica to pray, and the pope urged Hubert to become a priest. 'But as Hubert expressed his reluctance, considering himself unworthy of that honour, he was miraculously dressed in all the clerical garments of the martyred Lambert, and instantly transferred by angels from the place of his death. And when only a stole was lacking,

136

suddenly a white silk one appeared, embroidered with gold and brought by an angel from the Virgin.'

Hubert died from an illness brought on by an accidental wound. His tomb at Liège became the focal point of many miracles. After twelve years the grave was opened and the body was found intact and undecayed, with the appearance of youth, not age. (*Acta Sanctorum*).

Hyacinth, *see* Apollo and Hyacinth.

Icarus When the craftsman Daedalus, held prisoner by king Minos of Crete, fashioned wings of feathers and wax for himself and his son Icarus to escape with, he warned Icarus to fly neither too low near the sea's heavy waves, nor too high near the burning fire of the sun. Then Daedalus took the middle course between heaven and earth, and Icarus followed close behind him. Below them 'someone out fishing with his quivering rod, or a shepherd leaning on his crook, or a farmer bent over his plough looked up, perhaps, and caught sight of them in silent awe, thinking they must be gods.' But Icarus, elated by the thrill of flight, approached too near the sun, which melted the wax that held his wings together. Slipping from their grasp, he plunged into the sea below. Daedalus buried his body on a nearby island, which then received the name Icaria. (Ovid).

Saint Ignatius Ignatius was a disciple of St John the Evangelist and was bishop of Antioch. When the Emperor Trajan 'threatened all Christians with death, Ignatius ran forward and openly professed himself a Christian'. Trajan had him tortured, and when Ignatius was asked why he kept calling out the name of Jesus, he answered, 'That name is inscribed on my heart'. After he had been thrown to the lions 'his heart was torn from his body and split open and there, in golden letters through the middle of it, was found the name Jesus Christ' (*Golden Legend*).

Saint Ildefonso Ildefonso was bishop of Toledo in the seventh century. Among his writings is a work *On the*

Perpetual Virginity of the Virgin Mary, whom he especially revered. One night while he was praying in church, she appeared sitting in his bishop's seat 'surrounded by a group of virgins who were singing her praises'. The Virgin spoke to him and said, 'Because you have remained constant in your praise of me, with pure mind and firm faith', and 'have girt your loins with virginity, I am bringing you this vestment from the vestments of eternal glory'. Then she gave him an alb, an ecclesiastical garment associated with chastity, instructing him that no one but he should ever wear it. (*Acta Sanctorum*).

Immaculate Conception The belief that the Virgin Mary was conceived by her mother Anne without carnal sin is known as the Immaculate Conception. The medieval *Mirror of Man's Salvation* expresses a similar idea in these words: 'While her mother still carried her closed in her womb the Holy Spirit poured sanctity into her and stamped her with the seal of the Holy Trinity, because no pollution ever entered into her.' The representations of the Immaculate Conception are related to those of the Apocalyptic Woman.

Immolation of Polyxena Polyxena was the daughter of Priam and Hecuba, the king and queen of Troy. After the Greeks had captured Troy, the ghost of Achilles appeared and demanded Polyxena's sacrifice to him on his tomb. Polyxena, instead of regretting her death, saw it as an escape from a life of servitude as her captor's concubine. Seeing Achilles' son Neoptolemus with his sword drawn, she called on him to bury it quickly in her breast. 'Polyxena shall never be a slave to anyone. . . . Let me go to the underworld a free woman.' Her steadfast courage moved the onlookers and Neoptolemus himself to tears, and even as she fell she kept her body chastely covered. (Ovid).

Infant Hercules, *see* Hercules Strangling the Snakes.

Intercessio Mariae, *see* Intercession of the Virgin.

138

Intercession of the Virgin The Middle Ages drew a parallel between Christ's passion and Mary's compassion, that is, Christ's trial and crucifixion and Mary's sympathetic suffering with him. Through her compassion Mary became the mediator and defender of mankind – mediator in protecting us from God's wrath and punishment, defender against the temptation of the devil. After her bodily assumption into heaven she was thought to stand before Christ 'showing her son her breasts, that had suckled him', while Christ in turn interceded with God the Father, showing him his wounds, suffered in his battle for human redemption. A medieval author adds, 'There is no doubt that God always listens to their plea' (*Mirror of Man's Salvation*).

See also **Virgin of Mercy; Christ Showing His Wounds; Doctrine of the Three Arrows.**

Invention of the True Cross When Adam was dying his son Seth went to the gates of paradise to ask for the oil of mercy to anoint his father. As the oil of mercy could not be obtained until the crucifixion of Christ, the archangel Michael gave Seth 'some of the wood of the tree in which Adam had sinned, telling him that Adam would be healed when the tree bore fruit'. Seth planted the wood over Adam's grave and it 'grew into a great tree and lasted even until the time of Solomon'.

The Queen of Sheba and her Retinue. Solomon had the tree cut down to use in the building of his house, but it was always too long or too short to fit, and so was thrown across a lake to serve as a bridge. 'But when the Queen of Sheba came to hear the wisdom of Solomon and wanted to pass over the bridge, she saw in a vision that the Saviour of the world would be hung on this tree. She was therefore unwilling to walk over it and adored it instead.' Later the queen told Solomon that someone would hang on the tree through whose death the kingdom of the Jews would be overthrown. Solomon therefore 'had the wood sunk into the deepest bowels of the earth'. But as the time for Christ's Passion approached the tree came to the surface and was used to make his cross. Then it was buried again.

The Dream of Constantine. Almost three centuries later the Emperor Constantine was preparing to fight a battle against his rival Maxentius, when he had a dream in which he saw the cross in the sky, with the motto, 'In hoc signo vinces' – In this sign you will win. Constantine adopted the cross for his banner, the labarum. Maxentius prepared a trap for Constantine in the form of a false pontoon bridge, but then fell into his own trap and was drowned, thus giving Constantine a bloodless victory. As a result Constantine converted to Christianity and was baptized.

Saint Helen. Constantine's mother, St Helen – who had originally been a stable-girl – went to Jerusalem to look for the cross. Finding a Jew named Judas who was supposed to know where the cross was, she put him in a dry well without any food for six days to make him reveal its location. Judas finally led her to a temple of Venus, which Helen destroyed. Deep below it were found three crosses.

The Proving of the Cross. Not knowing which was the true cross, 'they placed them all in the middle of the city to wait for a manifestation from God'. When a dead youth was carried by on the way to be buried, Judas stopped the funeral procession and put the first two crosses on the corpse, but without result. 'But when he put the third cross on him the dead man returned to life at once.' According to another account the cross revived a wealthy woman. Judas himself was baptized and later became bishop of Jerusalem. Helen left part of the cross in Jerusalem and took the rest to Constantinople, along with the nails of the crucifixion.

Death of Chosroes and the Exaltation of the Cross. Several centuries later Chosroes, the king of Persia, was warring against the Christians and the Emperor Heraclius and captured the part of the cross that was in Jerusalem. Later Heraclius defeated Chosroes in single combat and had all his soldiers baptized. When Chosroes alone refused baptism Heraclius had his head cut off. Then Heraclius took the cross back to Jerusalem, 'but when, mounted upon his regal steed and wearing his imperial armour, he approached the gate through which the Lord passed just before his Passion, the stones

140

themselves fell down and blocked his way'. As all stood in astonishment, an angel appeared and told Heraclius that as Christ had entered Jerusalem riding on a humble ass, so he too must give an example of humility to his followers. Barefooted and wearing only his shirt, the emperor took up the cross and carried it to the gate, and the stones that had blocked his way spontaneously moved apart to allow him entry. (*Golden Legend*).

Iphigenia 'Daughter of Agamemnon and Clytemnestra. When the Greeks were on their way to besiege Troy they were held up for lack of a suitable wind. The soothsayers attributed this to the wrath of Diana, whose deer king Agamemnon had killed: the goddess could be appeased only by the sacrifice of Iphigenia. . . . But when the maiden was about to be killed, Diana took pity on her and substituted in her place a deer that had her features. She brought her to the region of Tauris, where she was made one of her priestesses.'

After the Trojan War Iphigenia's brother Orestes was driven mad and in his wanderings he and his faithful friend Pylades came to Tauris 'where it was the custom to sacrifice all foreigners to Diana. Pylades offered to die in Orestes' place, but Iphigenia recognized her brother and set him free. Later Orestes fled with his sister and a statue of Diana to the town of Arezzo in Italy' (Torrentinus).

Isaac, *see also* Sacrifice of Isaac.

Isaac Blessing Jacob Instead of Esau When Isaac felt death approaching he asked his firstborn son, Esau, who was a hunter, to bring him a meal of venison, and so to receive his final blessing. Isaac's wife, Rebecca, favoured their younger son, Jacob, and had him slaughter one of the kids of his flock; then she prepared it to taste like venison, and Jacob gave it to Isaac. Rebecca covered Jacob's arms with the kid's skin and Jacob fooled Isaac, whose eyes were dim with age, into thinking that he was his brother Esau, who was a 'hairy man'. 'The voice is Jacob's voice, but the hands are the hands of Esau,'

141

said Isaac, feeling the skins. 'See, the smell of my son is as the smell of a field which the Lord hath blessed,' and he gave Jacob the blessing meant for Esau, thus giving him the right of primogeniture. When Esau returned, Isaac realized what had happened. 'Hast thou but one blessing, my father? bless me, even me also, O my father,' said Esau, and 'lifted up his voice, and wept.' Isaac had only a lesser blessing left for Esau, and made him inferior to his younger brother. (Genesis, 27).

Ixion 'Ixion tried to seduce Juno, but at Jupiter's command Juno substituted a cloud in the likeness of herself which Ixion thought was Juno. From the cloud were born the centaurs. Then Mercury, also at Jupiter's bidding, bound Ixion to a wheel in the underworld which they say is still going round' (Hyginus).

Jacob, Laban and Leah In return for serving his uncle Laban for seven years, Jacob was to have Laban's daughter Rachel as his wife. On the wedding night, Laban surreptitiously put Leah, the elder but less appealing daughter, in Rachel's place. And Jacob 'went in unto her. . . . And it came to pass, that in the morning, behold, it was Leah.' When Jacob reproached Laban for the deception, Laban agreed to give him Rachel also, but bound him to serve another seven years.

Jacob loved Rachel more than Leah and 'when the Lord saw that Leah was hated, he opened her womb: but Rachel was barren'. Later, however, Rachel did conceive and gave birth to Joseph and Benjamin. (Genesis, 29).

Jacob Comes to Egypt, *see* Joseph in Egypt.

Jacob and Esau, *see* Meeting of Jacob and Esau.

Jacob and Rachel at the Well When Jacob was fleeing from his brother Esau, he went to take refuge with his uncle's family. He first saw Rachel, his cousin and future wife, at the well where she had come to water her father's flocks. Jacob

142

'rolled the stone from the well's mouth, and watered the flock of Laban his mother's brother. And Jacob kissed Rachel, and lifted up his voice, and wept.' Jacob told Rachel that he was her father's nephew, Rebecca's son, 'and she ran and told her father' (Genesis, 29).

Jacob Receiving Joseph's Bloody Coat, *see* Joseph in Egypt.

Jacob Wrestles with an Angel Jacob was returning from his service with his uncle Laban to his father's home in Canaan and sent his family and servants on ahead with all their belongings, by night. 'But Jacob remained there by himself, and an angel fought with him until the morning, and when he saw that he could not prevail against him, he touched the side of his thigh, and the side of Jacob's thigh was benumbed in the fight. And the angel said to him, Let me go, for the morning star is rising. And he said, I will not let you go unless you give me your blessing. The angel said, What is your name? And he replied, Jacob. And the angel said, Your name will no longer be called Jacob, but Israel will be your name, for you have grown strong with God and are a ruler among men. But Jacob asked him, and said, Tell me your name. And he replied, Why do you ask my name? For it is wonderful. And he blessed him there, and Jacob called the name of the place The Face of God, saying, For I have seen the Lord face to face and my soul is saved. And the sun rose upon him, and he passed before The Face of God, but he limped on his thigh' (Genesis, 32 (Old Latin)).

Jacob's Blessing and Death, *see* Joseph in Egypt.

Jacob's Departure When Jacob completed his fourteen years of service with his uncle Laban, he left to return to his paternal home in Canaan. He took with him his wives, Rachel and Leah, and their maidservants by whom he had also had children, his eleven sons, his servants, and all the sheep and goats and other animals from Laban's stock that had been promised to him. (Genesis, 31).

Jacob's Ladder After Jacob had stolen the right of primogeniture from his brother Esau, he fled for his life, 'and when he came to a certain place and wanted to rest there after sundown, he took one of the stones that lay about and put it under his head and slept there. And in his sleep he saw a ladder standing on the earth, and its top touched heaven. And he saw the angels of God going up and down on it, and the Lord leaning on the ladder saying to him: I am the Lord God of your father Abraham, and the God of Isaac. The land you are sleeping on, to you will I give it, and to your seed . . . and all the families of the earth will be blessed in you.' Jacob awoke and, realizing that 'the Lord is in this place' and that it was 'the gate of heaven', named it Bethel – House of God. (Genesis, 28 (Vulgate)).

Jacob's vision was interpreted by Christians in varying terms. The *Mirror of Man's Salvation* saw it as a prefiguration of the Ascension, which reunited heaven and earth, but Isidore of Seville said simply that 'the ladder is Christ, who said Ego sum via – I am the way', and the angels were all who preached Christ's word.

Jael and Sisera Sisera, general of the Canaanite army, had oppressed the Israelites for twenty years. When his army was finally defeated and slaughtered, Sisera fled to the tent of Jael, whose husband Heber lived apart from the other Jews and had been on peaceful terms with the Canaanites. 'And Jael went out to meet Sisera, and said unto him, Turn in, my Lord, turn in to me; fear not. And when he had turned in unto her into the tent, she covered him with a mantle. And he said unto her, Give me, I pray thee, a little water to drink; for I am thirsty. And she opened a bottle of milk, and gave him to drink, and covered him. Again he said unto her, Stand in the door of the tent, and it shall be, when any man doth come and enquire of thee, and say, Is there any man here? that thou shalt say, No. Then Jael Heber's wife took a nail of the tent, and took an hammer in her hand, and went softly unto him, and smote the nail into his temples, and fastened it into the ground: for he was fast asleep and weary. So he died.'

144

Thus the prophecy of Deborah, who judged Israel at that time, was fulfilled: 'For the Lord shall sell Sisera into the hand of a woman' (Judges, 4).

Jairus' Daughter, *see* Resurrection of Jairus' Daughter.

Saint James the Greater One of Christ's twelve apostles, the brother of John the Evangelist. In medieval legend he was called 'the brother of John' not only because he was John's blood relation, but because he was like John in character: both were zealous and had the same desire to learn. He was called the Greater because he was called to be a disciple of Christ earlier than James the Less, and because of his intimacy with Christ. 'For Christ seems to have had a closer familiarity with this James than with the other, as is clear because he admitted him to his secrets. For he was present at the raising of Jairus' daughter, and at the glorious Transfiguration' (*Golden Legend*).

Medieval legend describes his life after Christ's death, when he went to Spain to preach, and later to Judaea where he was martyred. He was dragged by a rope around his neck before Herod Agrippa, who condemned him to be beheaded. The scribe who led James to his martyrdom was converted on the way, and punished for his conversion by being beheaded along with James. James' relics were later transferred to Compostella in Spain, where they attracted pilgrims from vast distances during the Middle Ages.

Saint James the Less One of Christ's twelve apostles and son of Mary Cleophas, who was the Virgin's sister. He is also called James the Brother of Our Lord, for he and Christ were cousins.

According to medieval legend, his features were so like those of Christ that on several occasions James was mistaken for him. At the time of Christ's betrayal, the soldiers were afraid they might take James instead, so told Judas to designate Christ with a kiss.

When James and the other apostles were preaching in the

Temple of Jerusalem, a Jew accused them of being magicians. He hurled James from the platform where he was preaching and lamed him for the rest of his life.

Because he refused to deny Christ, James was martyred by being thrown from the roof of the Temple and stoned. He prayed for the souls of his assailants 'but one of them, taking up a fuller's club, hit him a strong blow on the head and knocked out his brains' (*Golden Legend*).

Janus 'This most ancient king of Italy . . . is supposed to have been the wisest of all the monarchs of his age, knowing the past and foreseeing the future, which is why he is shown with two faces. When he died he was put among the gods and had a temple at Rome which was opened in time of war and closed in peace. . . . Some say the reason is that when Romulus was fighting against the Sabines and was almost defeated, warm water suddenly gushed forth from this place and put the Sabine army to flight. So it became the custom to open the temple when they were going off to war as if in hope of receiving such assistance again' (Stephanus).

Jason and the Golden Fleece When the Greek hero Jason wanted to win renown for himself by accomplishing a difficult task, he set off with a group of followers called the Argonauts on an expedition to bring back the fleece of a golden ram that was kept in the temple of Mars in Colchis. But the king of Colchis had been warned by an oracle that he would die when foreigners carried off the golden fleece, and therefore he had the temple guarded by fire-breathing bulls and a sleepless dragon. When Jason asked for the fleece, the king required him first to yoke and plough with the bulls, and then sow dragon's teeth. The king knew that from the teeth a race of armed men would spring up and attack Jason. But Medea, the king's daughter, had fallen in love with Jason and helped him perform these tasks with the use of magic drugs. When the armed men appeared, Medea told Jason to throw a stone into their midst, and they killed themselves fighting over it. After putting the dragon to sleep with poison, Jason took the golden fleece from

the temple and left with Medea for his own country. (Diodorus Siculus and Hyginus).

Jealousy, *see* Close of the Silver Age.

Jephthah's Daughter Jephthah was a general of Israel who vowed that if he defeated the Ammonites he would sacrifice to God whatever came first from his house to meet him on his return home. He won the battle and 'behold, his daughter came out to meet him with timbrels and with dances'. She was his only child, and a virgin. As the Jews considered childlessness a great misfortune, when she had heard her father's vow, she asked for time to mourn her childless death.

'And she said unto her father, Let this thing be done for me: let me alone two months, that I may go up and down upon the mountains, and bewail my virginity, I and my fellows. And he said, Go. And he sent her away for two months: and she went with her companions, and bewailed her virginity upon the mountains. And it came to pass at the end of two months, that she returned unto her father, who did with her according to his vow which he had vowed: and she knew no man' (Judges, 11).

The Middle Ages condemned the senselessness of this sacrifice, contrasting it to Anne and Joachim's dedication of their daughter Mary to a life of serving God in the Temple. (*Mirror of Man's Salvation*).

Jeremiah Lamenting the Destruction of Jerusalem Jerusalem was sacked twice. The first time the Babylonian king Nebuchadnezzar and his army besieged the city in the sixth century BC, burning the Temple and the houses and carrying away the Temple treasures and many of the Jews to captivity in Babylon. The second time was by the Romans in 70 AD.

The Old Testament prophet Jeremiah mourned the Babylonian destruction of the city in a lament that begins, 'How doth the city sit solitary, that was full of people! How is she become as a widow! She that was great among the nations, and princess among the provinces, how is she become tributary!' (Lamentations, 1).

147

The Roman destruction of Jerusalem was prophetically lamented by Christ before it occurred. *See* **Destruction of Jerusalem.**

Jericho, *see* Fall of Jericho, *and* Two Blind Men from Jericho.

Saint Jerome One of the Four Doctors of the western church, born in Dalmatia in the fourth century. He was sent to Rome as a child and there he studied Greek and Latin and became a voracious reader of ancient literature. Later he went through dreadful spiritual torments trying to give up the classics and read the Bible instead: after the stylistic perfection of Cicero the 'uncouth language' of the prophets horrified him. Seriously ill and worn out by the fever of the conflict he had a vision in which he found himself before a tribunal clothed in such brilliance that he could not raise his eyes to the judge. When he professed himself a Christian the judge replied, 'You are lying, you are a Ciceronian.' Then followed a whipping so severe that when Jerome awoke the next morning his shoulders were livid with bruises. He renounced pagan literature and recovered his health.

Going to the Holy Land he became a hermit and tried to put his intellect and learning wholly at the service of the church. He set himself to the study of Hebrew, and though its 'rough and strident words' gave him trouble, he is now thought of as the translator of the Latin version of the Bible known as the Vulgate. In addition he wrote many Biblical commentaries and kept up an active correspondence with other Christians. Devoting himself to long hours of study, he tried to lead a rude ascetic life in order to subdue the temptations of the flesh. 'And yet how often,' he wrote in one of his letters, 'while I was there in the wilderness, and in that vast solitude which, scorched by the flaming sun, offers a miserable refuge to the monks, did I feel myself among the worldly pleasures of Rome.' Such visions were followed by intensified penance.

According to legend a lion with a thorn in its paw wandered into Jerome's monastery and terrified the monks. Jerome calmly withdrew the thorn, and thus tamed the lion, which was

148

set to work herding the ass that hauled the community's wood. One day while the lion was sleeping the ass was stolen by a passing caravan, and the lion was suspected of having eaten it and was himself made to carry the wood. But when the caravan returned the lion put the merchants to flight, repossessed the ass, and the goods-laden camels as well, and brought them triumphantly back to St Jerome. A short time later the merchants themselves appeared and sought the saint's forgiveness. (*Acta Sanctorum*).

Though there were no cardinals in the fourth century, Molanus explains Jerome's cardinal's hat and robes as signifying the equivalent position he held as ecclesiastical secretary to Pope Damasus.

Jerusalem, *see* Destruction of Jerusalem, *and* Entry into Jerusalem.

Jesus Praying in the Garden, *see* Agony in the Garden.

Joachim, *see* Anne and Joachim.

Job Job was a rich man from the east who had seven sons and three daughters and owned extensive flocks of animals and 'was perfect and upright, and one that feared God, and eschewed evil'.

To test Job's fidelity, God allowed Satan to afflict him with many misfortunes. Thieves carried off his oxen, asses and camels, lightning struck his sheep and the men tending the animals were all killed. His sons and daughters perished when a violent wind blew in the walls of the house where they were eating and drinking wine. 'Then Job arose, and rent his mantle, and shaved his head, and fell down upon the ground, and worshipped, and said, Naked came I out of my mother's womb, and naked shall I return thither: the Lord gave, and the Lord hath taken away; blessed be the name of the Lord. In all this Job sinned not, nor charged God foolishly.'

Job on the Dunghill. 'So went Satan forth from the presence of the Lord, and smote Job with sore boils from the sole of his foot

unto his crown. And he took him a potsherd to scrape himself withal; and he sat down among the ashes' (Vulgate: 'on the dunghill').

Job Tormented by his Wife. 'Then said his wife unto him, Dost thou still retain thine integrity? curse God, and die. But he said unto her, Thou speakest as one of the foolish women speaketh. What? shall we receive good at the hand of God, and shall we not receive evil? In all this did not Job sin with his lips.'

Three of Job's friends, hearing of his misfortune, came to give him sympathy and comfort. They sat with him in silence for seven days, 'for they saw that his grief was very great'. Then Job and his friends debated at length the nature of suffering and the ways of God. Job's friends accused him of having sinned, and explained his suffering as divine retribution. In his misery, Job complained against God. But when God spoke to him from a whirlwind, Job repented, and was finally rewarded by God who 'gave Job twice as much as he had before' and 'blessed the latter end of Job more than his beginning' (The Book of Job).

Molanus mentions the custom of representing Job's three friends 'singing and playing on stringed instruments before him, to soothe his pain'.

John the Baptist John the Baptist prepared the people for the coming of Christ and preached in the wilderness of Judaea. 'And the same John had his raiment of camel's hair, and a leathern girdle about his loins; and his meat was locusts and wild honey. Then went out to him Jerusalem, and all Judaea, and all the region round about Jordan, and were baptized of him in Jordan, confessing their sins' (Matthew, 3).

John's Preaching of Repentance. 'And he came into all the country about Jordan, preaching the baptism of repentance for the remission of sins; as it is written in the book of the words of Esaias the prophet, saying, The voice of one crying in the wilderness, Prepare ye the way of the Lord, make his paths straight' (Luke, 3).

'But when he saw many of the Pharisees and Sadducees come to his baptism, he said unto them, O generation of vipers,

who hath warned you to flee from the wrath to come? Bring forth therefore fruits meet for repentance' (Matthew, 3).

John's Messianic Preaching. When John was baptizing in the river Jordan, he preached the coming of the Messiah, saying, 'I indeed baptize you with water unto repentance: but he that cometh after me is mightier than I, whose shoes I am not worthy to bear: he shall baptize you with the Holy Ghost, and with fire' (Matthew, 3).

When Christ came to John the following day to be baptized by him, John recognized him as the Messiah and said, 'Behold the Lamb of God, which taketh away the sin of the world' (ECCE AGNUS DEI QUI TOLLIT PECCATA MUNDI). (John, 1).

See also **Beheading of John the Baptist; Birth of John the Baptist; Holy Family and John the Baptist; Zacharias and the Annunciation of the Birth of John the Baptist.**

Saint John the Evangelist One of Christ's twelve apostles, author of the fourth Gospel and the Book of Revelation. His symbol is the eagle, 'since he flew higher than the others, in writing of the divinity of Christ'.

John was Christ's favourite apostle, the disciple 'whom Jesus loved'. He sat beside Christ and rested against him at the Last Supper, and Christ on the cross designated him to take his place as the Virgin's son. He and his brother James the Greater and Peter were alone chosen by Christ to be present at the Agony in the Garden, and to witness his Transfiguration and certain of his miracles.

Medieval legend described him as a virgin and expanded the story of his life after Christ's death: the emperor Domitian accused him of refusing to offer sacrifices to pagan gods and had him plunged into a cauldron of boiling oil in public before the Latin Gate of Rome. But John felt no pain and came forth unharmed. So the emperor exiled him to the Greek island of Patmos, where he wrote the book of Revelation.

When the emperor died, John returned triumphantly to his friends in Ephesus, where he came upon the funeral procession of Drusiana, a devoted friend and disciple, and raised her to life again. When the high priest of the temple of Diana poisoned

John's chalice, John drank the poison but felt no ill effects. The priest, seeing that John was able to bring back to life two men who had died of the same poisoned drink, was converted from his pagan worship and baptized by John.

Just before her death, the Virgin gave John a palm branch from paradise and asked him to carry it before her bier on the way to her burial. Before John's own death, he had a grave dug near the altar of the church where he was preaching. He entered the grave in a blinding light, and when the light faded John had vanished. (*Golden Legend*).

John on Patmos, *see* Saint John the Evangelist, *and* Apocalyptic Woman.

Jonah God called on Jonah to go to Nineveh and prophesy the city's imminent destruction on account of its sinfulness, but Jonah tried to escape God's command by taking passage on a ship bound in the opposite direction. When a storm came up and threatened to break the ship in pieces, Jonah admitted that he was the cause of the storm, because he was fleeing from God, and told the sailors to cast him into the sea and so save themselves. Although the sailors tried to bring the ship to land, the sea was too rough for them. 'And they took Jonah, and cast him into the sea: and the sea ceased from its raging.' But 'the Lord had prepared a great fish to swallow Jonah: and Jonah was in the fish's belly three days and three nights. And Jonah prayed to the Lord his God from the fish's belly . . . and the Lord spoke to the fish; and it vomited Jonah out on dry land.'

This time Jonah obeyed God and went to Nineveh, 'and he cried out and said, Forty days more and Nineveh will be overturned. And the men of Nineveh believed in God, and declared a fast, and put on sackcloth, from the greatest to the least'. Even the cattle wore sackcloth. When God saw their repentance he 'was sorry for the evil which he said he would do them, and did not do it'. Jonah, seeing his prophecy turned to falsehood, 'was greatly afflicted and angry'. He went to sit outside the city, waiting to see what its fate would be, and built himself an arbour for shade.

God, pitying him, 'made ivy grow over the arbour to shelter Jonah's head and protect him. And Jonah rejoiced exceedingly because of the ivy.'

Then God sent a worm to destroy the ivy, and when Jonah, bitter at its loss, complained to God and prayed for death, God said to him, 'You are grieved over the ivy which you neither planted nor helped to grow, which was born in a single night and perished in a single night; and should I not spare Nineveh, a great city, in which there are more than 120,000 people who do not know their right hand from their left, and many cattle?' (Jonah (Vulgate)).

In the Middle Ages Jonah became an important Christian symbol, based on Christ's allegorical prediction of his own death and resurrection by an allusion to Jonah: 'As Jonah was three days and three nights in the whale's belly; so shall the Son of man be three days and three nights in the heart of the earth' (Matthew, 12).

Jordan, *see* Passing Over Jordan.

Joseph Chiding Mary After the betrothal of Joseph and Mary but before their marriage, Joseph found that Mary was pregnant. But he, 'being a just man, and not willing to make her a publick example, was minded to put her away privily. But while he thought on these things, behold, the angel of the Lord appeared unto him in a dream, saying, Joseph, thou son of David, fear not to take unto thee Mary thy wife: for that which is conceived in her is of the Holy Ghost. And she shall bring forth a son, and thou shalt call his name Jesus: for he shall save his people from their sins. Now all this was done, that it might be fulfilled which was spoken of the Lord by the prophet, saying, Behold, a virgin shall be with child, and shall bring forth a son, and they shall call his name Emmanuel, which being interpreted is, God with us. Then Joseph being raised from sleep did as the angel of the Lord had bidden him, and took unto him his wife: and knew her not till she had brought forth her firstborn son: and he called his name Jesus' (Matthew, 1).

153

Joseph with the Christ Child on his Lap After the birth of Christ the Virgin nursed him and took care of him. 'Concerning Joseph, St Bernard says he thinks he used to hold the Christ child on his knees and often smiled at him' (Bonaventura).

Joseph (in Egypt) Joseph was one of Jacob's twelve sons, and his favourite 'because he was the son of his old age: and he made him a coat of many colours. And when his brethren saw that their father loved him more than all his brethren, they hated him, and could not speak peaceably unto him.'

Joseph's Dream. Joseph had two dreams. The first foretold his superiority over his brothers. 'Hear, I pray you, this dream which I have dreamed: for, behold, we were binding sheaves in the field, and, lo, my sheaf arose, and also stood upright; and, behold, your sheaves stood round about, and made obeisance to my sheaf. And his brethren said to him, Shalt thou indeed reign over us? or shalt thou indeed have dominion over us? And they hated him yet the more for his dreams, and for his words.'

The second dream foretold his superiority over his entire family. 'And he dreamed yet another dream, and told it his brethren, and said, Behold, I have dreamed a dream more; and, behold, the sun and the moon and the eleven stars made obeisance to me. And he told it to his father, and to his brethren: and his father rebuked him, and said unto him, What is this dream that thou hast dreamed? Shall I and thy mother and thy brethren indeed come to bow down ourselves to thee to the earth? And his brethren envied him; but his father observed the saying.'

Joseph Sold by his Brothers (Joseph lowered into the cistern; Joseph raised out of the cistern). Jacob sent Joseph to bring back news from his brothers, who were tending sheep some distance away. But the brothers had been plotting against Joseph, 'and it came to pass, when Joseph was come unto his brethren, that they stript Joseph out of his coat, his coat of many colours that was on him; and they took him, and cast him into a pit: and the pit was empty, there was no water in it . . .

and, behold, a company of Ishmeelites came from Gilead with their camels bearing spicery and balm and myrrh, going to carry it down to Egypt.' Rather than kill Joseph, as originally planned, his brothers decided to sell him to the Ishmeelites. 'And they drew and lifted up Joseph out of the pit, and sold Joseph to the Ishmeelites for twenty pieces of silver: and they brought Joseph into Egypt.'

Jacob Receiving Joseph's Bloody Coat. 'And they took Joseph's coat, and killed a kid of the goats, and dipped the coat in the blood; and they sent the coat of many colours, and they brought it to their father; and said, This have we found: know now whether it be thy son's coat or no. And he knew it, and said, It is my son's coat; an evil beast hath devoured him; Joseph is without doubt rent in pieces. And Jacob rent his clothes, and put sackcloth upon his loins, and mourned for his son many days ... and he said, For I will go down into the grave unto my son mourning.'

Joseph and Potiphar's Wife. In Egypt, Joseph became overseer of the household of Potiphar, Pharaoh's captain of the guard. Potiphar's wife 'cast her eyes upon Joseph; and she said, Lie with me. But he refused.' As Joseph fled from her, she caught hold of his cloak and snatched it from him and, bitter at his refusal, used it to support her false allegation that he had tried to seduce her. On the basis of her accusation Joseph was thrown into prison.

Joseph in Prison. Pharaoh's butler and baker were sent to the same prison, and each had an enigmatic dream that only Joseph could interpret. The baker's dream foretold his execution, the butler's foretold his reinstatement in his former post. Both prophecies came true within three days.

Joseph remained in prison for two years. Then Pharaoh had a dream that could not be interpreted, and the butler remembered Joseph, who was brought from the prison to Pharaoh.

Pharaoh's dream. Pharaoh had dreamt of seven lean cows which ate up seven fat ones, and of seven withered ears of grain devouring seven full ears, both dreams foretelling seven years of plenty to be followed by seven years of famine. Joseph advised Pharaoh to put aside grain from the good years for use

during the bad ones. Pharaoh approved the plan and chose Joseph to carry it out, making him governor of Egypt.

Joseph Receiving his Brothers. During the years of famine Joseph, as governor of Egypt, sold some of the grain he had stored up during the good years. When his ten half-brothers came to buy grain, they did not recognize him, and he pretended not to recognize them, accusing them of being spies. He kept one brother, Simeon, as a hostage, until the others should return with their youngest brother, Benjamin, who was Joseph's only full brother. Before they left he had their money secretly returned to the sacks full of grain they had bought, and they only discovered it on their way home.

The brothers returned to Egypt with Benjamin and with gifts for Joseph. Joseph was so moved at seeing Benjamin after many years of separation that he retired to his room and wept. Then he entertained all the brothers at a great feast, not yet revealing his identity to them.

Cup Found in the Sack of Benjamin. When Joseph's brothers were leaving Egypt with the second cargo of grain they had bought, he had his silver cup secretly placed in his brother Benjamin's sack. Then he sent his steward to overtake them, accuse them of thievery, find the cup, and bring Benjamin back captive. This was to be Joseph's excuse for keeping Benjamin with him.

Joseph Reveals Himself to his Brothers. Judah pleaded with Joseph to release Benjamin and keep himself as hostage: 'When I come to thy servant my father, and the lad be not with us; seeing that his life is bound up in the lad's life; it shall come to pass, when he seeth that the lad is not with us, that he will die.' Hearing Judah's plea, Joseph realized that his brothers had finally repented of selling him into slavery. Dismissing his stewards, he wept aloud, and then revealed his true identity to his brothers, 'and he said, I am Joseph your brother, whom ye sold into Egypt. Now therefore be not grieved, nor angry with yourselves, that ye sold me hither: for God did send me before you to preserve life.... And he fell upon his brother Benjamin's neck, and wept; and Benjamin wept upon his neck. Moreover he kissed all his

brethren, and wept upon them: and after that his brethren talked with him.'

Jacob Comes to Egypt: his Blessing and Death. Joseph explained to his brothers that there would be five more years of famine, and sent them to bring their father back to Egypt. Then Jacob, with his sons and their families and all their possessions, came to Egypt, where he spent his last years. Before he died, the blind Jacob gave his blessing to Joseph's sons, his grandsons. Joseph placed the boys so that Jacob's right hand would lie on the head of Manasseh, the first-born. But Jacob crossed his arms so that Ephraim, the younger, was under his right hand, and thus designated to be even greater than his older brother. Then he said to Joseph, 'Behold, I die: but God shall be with you, and bring you again unto the land of your fathers.'

Later Jacob called all twelve of his sons to him and blessed them and their descendents, who were to be the twelve tribes of Israel. After that Jacob died, and was embalmed, and his body returned to Israel for burial. (Genesis, 37–48).

Joseph Sold by his Brothers, *see* Joseph in Egypt.

Joseph's Dream, *see* Joseph in Egypt; *or* Dream of Joseph.

Joshua Staying the Sun Joshua led the Israelites in their successful defence of Gibeon against the Amorites. 'Then spake Joshua to the Lord in the day when the Lord delivered up the Amorites before the children of Israel, and he said in the sight of Israel, Sun, stand thou still upon Gibeon; and thou, Moon, in the valley of Ajalon. And the sun stood still, and the moon stayed, until the people had avenged themselves upon their enemies' (Joshua, 10).

Judas, *see* Hiring of Judas.

Judas Maccabaeus Praying for the Dead At the time of the Greek empire in Egypt in the second century BC, Judas Maccabaeus led the Jews of Judaea in their defeat of the

Idumeans. When the Jews were burying their dead they found votive offerings to idols under the coats of some of them. As this was strictly forbidden by Jewish law, Judas and his men prayed that God would deliver them from this sin. 'And in doing so he was mindful of the resurrection: for if he did not hope that those who were fallen would rise again, it would have seemed superfluous and vain to pray for the dead' (II Maccabees, 12 (Vulgate)).

Judas Thaddaeus, *see* Simon the Zealot and Judas Thaddaeus.

Judgement of Cambyses 'Consider the extreme severity of the barbarian king Cambyses. He punished a corrupt judge by having him skinned and then, hanging the skin over the judge's seat, appointed the judge's own son as his successor. Thus he devised a way, with this new and dreadful punishment, of preventing more corruption' (Valerius Maximus).

Judgement of Daniel, *see* Susanna and the Elders.

Judgement of Paris 'When the hero Peleus was celebrating his marriage to the nymph Thetis, Jupiter is said to have invited all the gods to the wedding feast except Discord. But when she came later and was not admitted, she threw an apple onto the banquet table, with the words, For her who is the most beautiful. Juno, Venus and Minerva began to quarrel over it so loudly that Jupiter ordered Mercury to take them to the Trojan shepherd Paris on Mount Ida and let him decide who was the most beautiful. Juno offered to make Paris king over all the earth and richer than anyone; Minerva, if she should win, to make him the most powerful of men and skilled in every craft; but Venus promised him Helen, the most beautiful of women, as his wife. Paris preferred the last offer, and judged Venus the most beautiful. On that account Juno and Minerva became hostile to the Trojans. And Paris, instructed by Venus, carried Helen away from Sparta and the house of his host Menelaus and took her

to Troy as his wife.' The well-known sequel was the Trojan War. (Hyginus).

Judgement of Solomon Two harlots bore children three days apart. When one of them found her son dead, she exchanged him for the living child while the other woman slept. Each claimed the living child, and the case was brought to the newly crowned King Solomon. 'And the king said, Bring me a sword. And they brought a sword before the king. And the king said, Divide the living child in two, and give half to the one, and half to the other. Then spake the woman whose the living child was unto the king, for her bowels yearned upon her son, and she said, O my lord, give her the living child, and in no wise slay it. But the other said, Let it be neither mine nor thine, but divide it. Then the king answered and said, Give her the living child, and in no wise slay it: she is the mother thereof. And all Israel heard of the judgement which the king had judged; and they feared the king: for they saw that the wisdom of God was in him, to do judgement' (I Kings, 3).

Judith and Holofernes When Holofernes, general of the Assyrian army, was besieging the Jewish city of Bethulia, Judith, a chaste but attractive widow of the city, saved it from capitulation to the Assyrians. She 'took off her widow's garments, and bathed her body with water, and anointed herself with precious ointment, and combed her hair and put on a tiara, and arrayed herself in her gayest apparel, which she used to wear while her husband Manasseh was living. And she put sandals on her feet, and put on her anklets and bracelets and rings, and her earrings and all her ornaments. And the Lord also gave her more beauty: because all this dressing-up did not proceed from sensuality, but from virtue: and therefore the Lord increased this her beauty, so that she appeared to all men's eyes incomparably lovely.'

Judith, with her maid, went to Holofernes, pretending to be fleeing from the Israelites, whom she said would be destroyed by him. Attracted by her beauty, Holofernes invited her to drink and be merry with him, hoping to seduce her later. When

Judith saw that the wine had put him to sleep, she told her maid to wait for her outside the bedchamber. 'Then Judith, standing beside his bed, said in her heart, O Lord God of all might, look in this hour upon the work of my hands . . . for the destruction of the enemies who have risen up against us.'

Then 'she went up to the post at the end of the bed, above Holofernes' head, and took down his sword that hung there. She came close to his bed and took hold of the hair of his head, and said, Give me strength this day, O Lord God of Israel! And she struck his neck twice with all her might, and severed his head from his body. Then she tumbled his body off the bed and pulled down the canopy from the posts; after a moment she went out, and gave Holofernes' head to her maid, who placed it in her food bag.'

Judith and her maid returned to Bethulia, and 'all ran together, both small and great, for it was unbelievable that she had returned; they opened the gate and admitted them, and they kindled a fire for light, and gathered round them. Then she said to them with a loud voice, . . . Praise God, who has not withdrawn his mercy from the house of Israel. . . . Then she took the head out of the bag and showed it to them, and said The Lord has struck him down by the hand of a woman. . . . It was my face that tricked him to his destruction, and yet he committed no act of sin with me, to defile and shame me.'

Early the next morning they hung the head on the city-walls. When the Assyrians discovered the headless body of their general, they fled from their camp in consternation and were slaughtered by the Israelites. (Book of Judith (RSVCE)).

Saint Julian Killing his Parents When St Julian the Hospitator was out hunting one day he followed a stag which turned and told him he would kill his own parents. To escape such a fate Julian left home and settled in a distant region where he distinguished himself in the army of the prince and married a noblewoman. His mother and father set out to look for their son and came to Julian's castle while he was away. Julian's wife received them hospitably and, realizing from their conversation

160

who they were, put them in her own bed, sleeping herself that night in another room. But 'when Julian returned and entered the bedchamber to join his wife, he found two people sleeping there instead. Not recognizing them as his parents he thought it was his wife with a lover, and silently drew his sword and killed them both.'

Realizing later what had happened, Julian and his wife became penitents, constructed a hostel for travellers and the poor, and served pilgrims by ferrying them across a river. After many years they received divine forgiveness from an angel and died. (*Acta Sanctorum*).

Juno 'Jupiter's sister and wife' (Virgil).
For Juno's peacock, see **Mercury and Argus.**

Jupiter and Antiope Jupiter fell in love with Antiope and, after turning himself into a satyr, made love to her. (Stephanus).

Jupiter Fed by Amalthea's Goat When Jupiter was born his mother hid him away on the island of Crete to keep his father Saturn from eating him. 'They say the nymph Amalthea hid Jupiter in the woods, where she had the flourishing mother of two kids, a goat that was outstanding among the flocks of Crete. Her high horns curved up and back, her udder was such as Jupiter's nurse should have, and she suckled the god. But one of her horns broke off in a tree, and she lost the half of her adornment. The nymph took it and garlanded it with crops and filled it with fruits, and brought them to Jupiter to eat' (Ovid, *Fasti*).

Jupiter and Io Jupiter, king of the gods, took a fancy to the nymph Io. To hide his conquest from his wife Juno he spread a layer of dark cloud over the area where Io was fleeing from his advances. 'Then the god hid the earth with a thick and widespread fog. He stopped Io's flight and seized her virginity.' Jupiter sensed his wife's suspicions, but before she had time to burst in on them he changed Io into a heifer. 'Even as a cow, Io was appealing and Juno, though against her will, praised its

161

appearance and even asked whose it was, where it came from, and from what herd.' When she asked for the heifer as a gift, Jupiter, hoping to conceal his guilt, handed it over to her.

Juno had Io guarded by Argus, a monster with many eyes. When Jupiter sent his messenger Mercury to kill Argus, Juno retaliated by tormenting Io with a Fury, or gad-fly, which drove her all over the world. When she reached Egypt, Io was allowed to resume her former shape, and was worshipped by the Egyptians as the goddess Isis. (Ovid).

Jupiter and Mnemosyne 'Mnemosyne was the nymph on whom Jupiter begot the nine Muses. We can translate her name as Memory. The poets say she was the mother of the Muses because the treasure house of the arts is acquired and conserved by means of the beneficence of memory' (Stephanus).

Jupiter with Nymphs on Mount Ida, *see* Jupiter Fed by Amalthea's Goat.

Jupiter and Semele 'Semele was the daughter of Cadmus, king of Thebes. When Jupiter made her pregnant, his wife Juno was angry, and wanted to destroy her. Having assumed the guise of the old woman who had been Semele's nurse, Juno went to Semele and pretended to doubt her story that her lover was really the king of the gods. She suggested that Semele ask Jupiter to appear to her in the way he did to Juno. Semele asked Jupiter to grant her a wish, and when he agreed, she made the request Juno had suggested. Jupiter, unable to break his oath, came to her as a thunderbolt and thus destroyed her. But he rescued the unborn infant from her womb, and put it in his own thigh, keeping it there until it was ready to be born. This infant was Bacchus, the god of wine' (Torrentinus).

Jupiter's Infancy, *see* Jupiter Fed by Amalthea's Goat.

Saint Just of Beauvais A child saint. When he was nine years old he saw in a vision that his uncle was being taken prisoner in another town. He and his father went to free the

uncle, and after the rescue the three of them left for home. But the prefect of the town sent his men in pursuit and they cut off Just's head. 'Whereupon his body rose up, took the head in its hands, and prayed to the Lord: God of Heaven and Earth, receive my spirit, for I am innocent and of a pure heart.' The prefect's men fled at this miracle, but the head was taken home to Beauvais, where it illuminated the whole city with its brightness. (*Acta Sanctorum*).

Saint Justina of Padua A virgin martyr, killed during one of the early persecutions of Christians. When she was being chased by her persecutors, Justina thought they were going to rape her, and knelt down to pray on a bridge. The marble softened at once, and kept the imprint of her knees. Finally she was stabbed to death with a sword. (*Acta Sanctorum*).

Kingdom of Heaven like a Pearl Jesus said to his disciples: 'Again, the kingdom of heaven is like unto a merchant man, seeking goodly pearls: who, when he had found one pearl of great price, went and sold all that he had, and bought it' (Matthew, 13).

Kings, *see* Adoration of the Magi.

Korah, *see* Rebellion of Korah.

Laban Looking for the Stolen Household Gods This episode occurred after Jacob's departure from Mesopotamia, with his wives, Rachel and Leah, and all their possessions. Before leaving, Rachel had stolen her father Laban's household gods. When Laban pursued them, Jacob, unaware of the theft, invited Laban to search all his belongings. Rachel deceived her father by concealing the gods in a camel's saddle which she sat upon, and then told her father she could not move because she was menstruating. Old Testament law prohibited a man from touching a menstruating woman, or anything she had touched, until it had been purified, and so Rachel's ruse succeeded. (Genesis, 31).

163

Lamentation for the Dead Christ Joseph of Arimathaea and Nicodemus took Christ down from the cross, handing the nails to John the Evangelist, who was at the foot of the cross with Mary Magdalene and the Virgin and her sisters, Mary Cleophas and Mary Salome. 'After they had drawn the nail from his feet, Joseph descended and they all received the body of the Lord and laid it on the ground. Our Lady took his head and shoulders in her lap, and Mary Magdalene his feet, where she had once found forgiveness. The others stood around them, all raising a great lament over him. They mourned him bitterly, as though he were their only son' (Bonaventura).

Laomedon When Laomedon, the king of Troy, was building the walls of his city, Apollo watched the slow progress of the work from a distance, standing near an altar sacred to Jupiter. He and Neptune, disguising themselves as mortals, offered to complete the work for Laomedon, and received the king's promise of a payment of gold in return. But when the walls of Troy were complete, Laomedon tried to cheat the gods of their wages, and Neptune punished the new city by flooding it and the land around it. He demanded the king's daughter, Hesione, as an offering for a sea-monster. The princess had already been chained to the rocks when Hercules passed by and offered to save her, in exchange for some divine horses Laomedon had. When Laomedon again went back on his promise, Hercules besieged Troy and captured it. (Ovid).

Last Judgement St Matthew describes the Day of Judgement at the end of the world when Christ will separate the wicked from the just. 'When the Son of man shall come in his glory, and all the holy angels with him, then shall he sit upon the throne of his glory: and before him shall be gathered all nations: and he shall separate them one from another. . . . Then shall the King say unto them on his right hand, Come, ye blessed of my Father, inherit the kingdom prepared for you from the foundation of the world. . . . Then shall he say also unto them on the left hand, Depart from me, ye cursed, into everlasting fire, prepared for the devil and his angels. . . . And

these shall go away into everlasting punishment: but the righteous into life eternal' (Matthew, 25).

The apocryphal Book of John the Evangelist describes the 'sounding of the trumpet, in which the voice of the archangel will be heard from heaven unto hell', and the appearance of Christ 'who will set his throne above the clouds; and he will sit on the throne of his majesty, with his twelve apostles upon their twelve seats of glory.' In the book of Revelation John saw Christ judging the dead from the book of life, 'and they were judged every man according to their works. . . . And whosoever was not found written in the book of life was cast into the lake of fire' (Revelation, 20).

See also **Michael with the Scales of the Last Judgement.**

Last Supper The Last Supper took place in a large upper room in a house in Jerusalem the night of Christ's capture. He and his disciples were celebrating the Passover.

'And as they were eating, Jesus took bread, and blessed it, and brake it, and gave it to the disciples, and said, Take, eat; this is my body. And he took the cup, and gave thanks, and gave it to them, saying, Drink ye all of it; for this is my blood of the new testament, which is shed for many for the remission of sins. But I say unto you, I will not drink henceforth of this fruit of the vine, until that day when I drink it new with you in my Father's kingdom' (Matthew, 26).

Then Christ rose from the table 'and laid aside his garments; and took a towel, and girded himself. After that he poureth water into a basin, and began to wash the disciples' feet, and to wipe them with the towel wherewith he was girded. Then cometh he to Simon Peter: and Peter saith unto him, Lord, dost thou wash my feet? Jesus answered and said unto him, What I do thou knowest not now; but thou shalt know hereafter. Peter saith unto him, Thou shalt never wash my feet. Jesus answered him, If I wash thee not, thou hast no part with me.' Then Christ explained to the disciples that as he washed their feet, so they should wash each others' feet, as a symbolic act of humility. (John, 13).

After he was seated again at the table, Christ said 'Verily,

verily, I say unto you, that one of you shall betray me. Then the disciples looked one on another, doubting of whom he spake. Now there was leaning on Jesus' bosom one of his disciples,' – this was John the Evangelist – 'whom Jesus loved. Simon Peter therefore beckoned to him, that he should ask who it should be of whom he spake. He then lying on Jesus' breast saith unto him, Lord, who is it? Jesus answered, He it is, to whom I shall give a sop, when I have dipped it. And when he had dipped the sop, he gave it to Judas Iscariot, the son of Simon. And after the sop Satan entered into him. Then said Jesus unto him, That thou doest, do quickly. Now no man at the table knew for what intent he spake this unto him. For some of them thought, because Judas had the bag,' – that is, was the treasurer of the group – 'that Jesus had said unto him, Buy those things that we have need of against the feast; or, that he should give something to the poor' (John, 13).

Matthew, relating the same event, does not say, 'He it is, to whom I shall give a sop', but, 'He that dippeth his hand with me in the dish, the same shall betray me' (Matthew, 26).

Latona and the Lycian Peasants After the birth of her twins Apollo and Diana, Latona was forced to flee from the wrath of Juno, whose jealousy was aroused because the twins' father was Jupiter. Tired and thirsty from her wanderings Latona, carrying the twins, came to a lake in Lycia where peasants were gathering reeds in the marshes nearby. When the peasants tried to keep her from drinking the cool water, she appealed to them humbly to let her quench her thirst: 'The use of water is a common right. Nature has not made sun or air or flowing water anyone's property.' But they answered with insults and muddied the waters by jumping about in them. In her anger Latona prayed that they would never again leave the marsh they had made, and they were changed into quarrelling gaping frogs, 'neckless, green-spined, and with the greatest part of their body a broad white belly' (Ovid).

Saint Lawrence Lawrence was born in Spain in the third century and brought to Rome by Pope Sixtus. When Sixtus

166

was arrested in the great persecution under the Emperor Decius, he gave the treasures in his possession to Lawrence, telling him to distribute them to the churches and the poor. Lawrence himself was arrested a few days later, and when ordered to produce the treasures he gathered together the poor, the lame, and the blind of Rome and presented them to the emperor. Then, as he refused to sacrifice to the pagan gods, he was put on an iron grill and roasted alive over glowing coals. Just before he died he cried out to Decius, 'Look, wretch, you have grilled one side, now grill the other, and eat!' (*Golden Legend*).

Lazarus, *see* Raising of Lazarus.

Leda and the Swan 'Leda was the wife of Tyndarus, king of Laconia. Jupiter, in the form of a swan, is said to have made love to her, and the story goes that she laid two eggs: from one were born the immortals Pollux and Helen, and from the other the mortals Castor and Clytemnestra.

'When Castor was killed after he and Pollux had abducted the daughters of Leucippus, Pollux shared his immortality with him, and so they spend half their time in the underworld and half above ground' (Torrentinus).

Levi, *see* Calling of Matthew.

Liberation of Saint Peter, *see* Saint Peter in Prison.

Saint Livinus Livinus was born in Scotland in the seventh century, became a priest and then, with three disciples, 'walked across the sea with dry feet' to Belgium. There he preached Christianity with great success until he was beaten almost to death by a group of unbelievers who wanted to discredit him before his hearers. One of them 'fired by the devil's will, thrust an iron tongs into his mouth and cut out his tongue, and threw it out where everyone could see it'. The infidels were consumed by 'a flash of fire which proceeded from the wrath of God'. God gave Livinus back his tongue, and he continued to preach until

167

he was finally beaten to death. (*Acta Sanctorum of the Bene-dictine Order*).

Lost Mite A parable of Christ: 'Either what woman having ten pieces of silver, if she lose one piece, doth not light a candle, and sweep the house, and seek diligently till she find it? And when she hath found it, she calleth her friends and her neighbours together, saying, Rejoice with me; for I have found the piece which I had lost. Likewise, I say unto you, there is joy in the presence of the angels of God over one sinner that repenteth' (Luke, 15).

Lot
Lot and his Family Leaving Sodom. When God decided to destroy the cities of Sodom and Gomorrah because they were given to homosexuality, he sent two angels to save Lot, a Hebrew living as an alien with his family in Sodom. 'And when the morning arose, then the angels hastened Lot' and 'laid hold upon his hand, and upon the hand of his wife, and upon the hand of his two daughters; the Lord being merciful unto him: and they brought him forth, and set him without the city. . . . Then the Lord rained upon Sodom and upon Gomorrah brimstone and fire . . . and, lo, the smoke of the country went up as the smoke of a furnace.' The angels warned them not to look back but to escape to the mountain some distance away, but Lot's wife 'looked back from behind him, and she became a pillar of salt'.
Lot and his Daughters. And Lot 'dwelt in a cave, he and his two daughters. And the firstborn said unto the younger, Our father is old, and there is not a man in the earth to come in unto us after the manner of all the earth: come, let us make our father drink wine, and we will lie with him, that we may preserve seed of our father. And they made their father drink wine that night: and the firstborn went in, and lay with her father; and he perceived not when she lay down, nor when she arose. And it came to pass on the morrow, that the firstborn said unto the younger, Behold, I lay yesternight with my father: let us make him drink wine this night also; and go thou

in, and lie with him, that we may preserve seed of our father. And they made their father drink wine that night also: and the younger arose, and lay with him; and he perceived not when she lay down, nor when she arose.' The daughters conceived and bore sons who became the founders of the nations of Moab and Ammon. (Genesis, 19).

The *Mirror of Man's Salvation* says that 'God foreshadowed the redemption of men from hell when he freed Lot and his family from the destruction of Sodom' and adds, 'The sinner should not look back on the sins he has abandoned, but ascend toward virtue ... and be saved'. Luther, in the sixteenth century, allegorized Lot differently: 'The story of Lot begetting adulterous sons upon his daughters represents those who misuse the seed of God's word. . . . Lot is the law of God, and his daughters are the people of that law who make Lot drunk when they interpret the word of God falsely.'

Saint Louis of France A thirteenth century saint, and king of France. 'When he was fourteen years old he began to reign and continued for forty-one years. As he was ardent and zealous in the faith he never thought, did or spoke anything which did not do honour to God and the Christian faith.' Louis died as a crusader 'and when Pope Boniface reviewed his holy life and the many miracles that Louis had done he put him in the ranks of the other confessor saints' (Jacopo da Bergamo).

Saint Louis of Toulouse Son of the king of Sicily. Through his love for Christ, 'who became a pauper for our sakes, he despised all glory, wealth, and even the powerful kingdom which was his by right'. Therefore he became a monk and was eventually made bishop of Toulouse. (*Acta Sanctorum*).

Lucretia Lucretia was the wife of a Roman nobleman when Tarquin was king of Rome. One night, during a military campaign outside the city, a dispute broke out among some kinsmen of the king as to whose wife was the most virtuous. They decided to ride to Rome at once, surprising their wives at home and thus settling the matter. The other wives were found

banqueting lavishly with various companions, but Lucretia was found sitting quietly among her handmaidens spinning wool. One of the king's sons, inflamed by her beauty and chastity, returned during the night and threatened to kill her if she would not sleep with him, adding a threat to kill a male slave and put both bodies together in Lucretia's bed in a compromising manner. Seeing no way to save both her virtue and her good name, Lucretia yielded, but the next day she sent for her husband, father and brothers and telling them what had happened she called on them to avenge her. Quickly drawing a knife from under her robe, she plunged it into her breast before she could be stopped, saying, 'Never shall an unchaste woman live by Lucretia's example.' This incident resulted in the expulsion of the kings from Rome and the establishment of the Roman republic. (Livy).

Saint Lucy A virgin from a noble family of Syracuse in Sicily. When she sold her dowry and gave the money to the poor, she was suspected of being a Christian. Her pagan fiancé denounced her to the consul Paschasius who ordered her to sacrifice to the pagan idols. Lucy refused and he gave orders for her to be taken to a brothel and violated until she died. But the Holy Ghost intervened and she became so heavy that 1,000 men, and even yokes of oxen, were not able to move her. In desperation Paschasius called for his magicians, but they too were powerless. Finally they built a great fire around her and doused her with pitch, resin and boiling oil, without effect. Last of all they plunged a sword into her throat, but her power of speech remained and before she died she declared herself patroness of Syracuse. Paschasius was tried by the Roman senate and put to death. (*Golden Legend*).

A Renaissance writer says that Lucy was so beautiful that many fell in love with her, and one young man was especially attracted by the brilliance of her eyes. Lucy, 'following the words of the gospel which says, If your eye offends you cast it out, dug out both her eyes with a stake and had them sent on a carving-platter to the young man. By these self-inflicted wounds she wanted to ruin the looks of her body and remain

170

chaste, rather than occasion another's damnation' (Jacopo da Bergamo, *De Claris Mulieribus*).

Saint Luke One of the four evangelists, Luke was a disciple of St Paul and is thought to be the author of the Acts of the Apostles. His symbol is the ox because in his gospel 'he deals with the priesthood of Christ' and, as the ox was formerly a sacrificial animal, so Christ 'was like a calf in his suffering'.

Luke was a physician by profession but medieval legend adds that he was also 'an unusually skilled painter and, according to John of Damascus, painted a picture of the Virgin which is in Rome'. The Virgin favoured him by disclosing many things to him, in particular certain private events in her life, such as the Annunciation and Christ's Nativity, 'for these things are known only from the gospel of St Luke' (*Golden Legend* and *Sermones de Sanctis*).

Lunatic Boy After Christ's Transfiguration, he came down from the mountain with his disciples Peter, James and John. 'And when they were come to the multitude, there came to him a certain man, kneeling down to him, and saying, Lord, have mercy on my son: for he is a lunatick, and sore vexed: for ofttimes he falleth into the fire, and oft into the water. And I brought him to thy disciples, and they could not cure him. Then Jesus answered and said, O faithless and perverse generation, how long shall I be with you? how long shall I suffer you? bring him hither to me. And Jesus rebuked the devil; and he departed out of him: and the child was cured from that very hour.' Later, when the disciples asked Christ why they were unable to cure the boy, he told them it was because of their lack of faith. (Matthew, 17).

Lystra, *see* Paul and Barnabas at Lystra.

Maddalena, *see* Mary Magdalene.

Madonna, *see also* Virgin.

171

Madonna of the Milk

> 'L'enfant prend la mamelle
> Et lacte pascitur.
> C'est du lait de pucelle
> Quod non corrumpitur.
> La chose est bien nouvelle
> Quod virgo mater est.
> Et sans coulpe charnelle
> Hic puer natus est.'

A medieval Christmas carol, with alternating lines of French and Latin, thus expresses the incorruptibility of the milk of the virgin-mother, and Christ's birth free from mortal sin. (The infant takes the breast and feeds on milk that is a virgin's milk and therefore incorruptible. Never before has a virgin been a mother, and a child been born without carnal sin.)

Madonna della Misericordia, *see* Virgin of Mercy.

Madonna of the Rosary, *see* Saint Dominic.

Magi, *see* Adoration of the Magi.

Man of Sorrows These words of Isaiah were applied by medieval Christians to Christ:

> 'He was despised and rejected by men;
> a man of sorrows, and acquainted with grief;
> and as one from whom men hide their faces
> he was despised, and we esteemed him not.
> Surely he has borne our griefs
> and carried our sorrows;
> yet we esteemed him stricken,
> smitten by God, and afflicted.
> But he was wounded for our transgressions,
> he was bruised for our iniquities;
> upon him was the chastisement that made us whole,
> and with his stripes we are healed.'

<div align="right">(Isaiah, 53 (RSV)).</div>

Manna, *see* Gathering of the Manna.

Manoah's Sacrifice, *see* Samson.

Marcia 'The wife of Cato the Younger. After she had borne him some children, Cato gave her to his friend Hortensius, and then took her back again when Hortensius died. His enemies slandered him for doing this, saying that he had sent her away empty-handed and poor, so that he might get her back again wealthy with Hortensius' estate' (Calepinus).

Marcus Curtius 'A noble Roman, who died voluntarily for the sake of the Roman people. For when a terrible fissure opened suddenly in the earth of the Roman forum the soothsayers declared that Pluto, god of the underworld, demanded a sacrifice from the nobility; unless one of the leading nobles hurled himself into the fissure, great danger menaced the city. Wherefore Curtius, in full armour and mounted on horseback, rode into the abyss and the fissure soon closed' (Torrentinus).

Mardocheo, *see* Mordecai.

Saint Margaret Margaret was the daughter of a noble pagan of Antioch. Under her nurse's influence she became a Christian and was baptized, thus becoming odious to her father. Her nurse protected her and set her to tending sheep. When she was just fifteen Margaret's beauty caught the eye of the prefect Olybrius and when she refused his advances he had her tortured and thrown into prison. There 'she prayed the Lord to make visible the enemy who fought against her, and at once an enormous dragon appeared who rushed to devour her, but she made the sign of the cross and he disappeared.' After the prefect's attempts to burn her to death and drown her had failed, she was beheaded.

The *Golden Legend* says of her that she was 'small through humility, white through virginity, and courageous by reason of her miracles'.

173

Saint Mark One of the four evangelists: his symbol is the lion 'because he wrote of the Resurrection. For it is said that lion cubs lie as if dead for two days and are aroused by the lion's roaring on the third.'

According to medieval legend Mark was baptized by St Peter, who instructed him in Christianity and took him to Rome. Mark wrote his gospel for the Christians of Rome, describing Christ's life as it was told him by Peter. From Rome he was sent to Egypt where he preached the word of God and miraculously healed the wound of Annianus, a cobbler. He was consecrated bishop of Alexandria and was eventually martyred there by being dragged through the streets of the city with a rope around his neck. Then he was thrown into prison, where Christ came to him and said, Peace be to thee, Mark, my Evangelist (PAX TIBI MARCE EVANGELISTA MEUS), and offered Mark his protection. The next day he was dragged again through the city and died. His persecutors tried to burn his body, but a sudden hailstorm frightened them away. The body remained intact and was taken by Christians and given a proper burial.

In the fifth century the Venetians brought his body from Alexandria to Venice, where they built the Basilica of St Mark in his honour. His body was placed in a vault under one of the columns of the basilica and he became the patron saint of the city. (*Golden Legend*).

See also **Miracle of the Saracen.**

Saint Mark Rescuing a Slave A slave went on a pilgrimage to St Mark's basilica in Venice, despite his master's refusal to give him leave. When he returned, his master had him tortured in various ways. But when the other slaves tried to gouge out his eyes with wooden stakes, the points broke, and when they tried to break his limbs with a hatchet and smash his teeth with hammers, the iron turned soft. Finally the master repented and apologized to his slave, and they went away to pray together at St Mark's tomb. (*Golden Legend*).

Marriage in Cana Christ and his mother and his first disciples were guests at a marriage in Cana. When the supply of

174

wine ran out, Christ performed his first public miracle. 'And when they wanted wine, the mother of Jesus saith unto him, They have no wine. Jesus saith unto her, Woman, what have I to do with thee? mine hour is not yet come. His mother saith unto the servants, Whatsoever he saith unto you, do it.

'And there were set there six waterpots of stone, after the manner of the purifying of the Jews, containing two or three firkins apiece. Jesus saith unto them, Fill the waterpots with water. And they filled them up to the brim. And he saith unto them, Draw out now, and bear unto the governor of the feast. And they bare it. When the ruler of the feast had tasted the water that was made wine, and knew not whence it was: (but the servants which drew the water knew;) the governor of the feast called the bridegroom, and saith unto him, Every man at the beginning doth set forth good wine; and when men have well drunk, then that which is worse: but thou hast kept the good wine until now. This beginning of miracles did Jesus in Cana of Galilee, and manifested forth his glory; and his disciples believed on him' (John, 2).

In the Middle Ages the bridegroom was said to be John the Evangelist. 'When the feast was over, Jesus called John aside, saying, Leave your wife and follow me, for I will lead you to a higher marriage; and he followed him. By his presence at this wedding, the Lord showed his approval of earthly marriage, as instituted by God; but in that he called John away from the wedding, he gave us clearly to understand that a spiritual matrimony is far more worthy than an earthly one' (Bonaventura).

Marriage of the Virgin The Middle Ages often tried to define the exact relationship of Mary and Joseph. According to some accounts he was only her guardian, but others thought they were really married and that she bore him children who were Jesus' half-brothers. Mary had dedicated herself to a life of serving God in the Temple in Jerusalem. The *Golden Legend* says that when she was fourteen the high priest wanted her to return home to be married, but she felt she could not obey him because of her vow of perpetual virginity. Perplexed, the priest

175

consulted the elders. At the consultation a voice came from the oratory saying that every marriageable man of the house of David was to bring a branch and lay it on the altar: Mary's husband would be the one whose branch flowered. Further, the Holy Ghost would settle on it in the form of a dove.

As Joseph the carpenter was a member of the house of David he also presented himself to the priest, 'but he thought it incongruous for someone of his advanced age to marry a young virgin, and when others presented their branches he alone hid his'. The priest took the branches and went into the temple and prayed. When none of them blossomed the priest again consulted God, who replied that one branch was still missing. 'Thus indicated, Joseph brought forth his branch, and it blossomed at once and a dove from heaven perched on it. Thus it became clear to all that this was he to whom the Virgin would be betrothed.'

The *Golden Legend* does not describe the actual betrothal, but says that 'after he was betrothed to Mary Joseph went home to get his house ready and prepare what was needed for the wedding', while Mary returned to her parents' house in the company of seven virgins who had been brought up with her in the temple. (*Golden Legend* and *New Testament Apocrypha, Protevangelium of James*).

The wedding ceremony itself is described in a Coventry mystery play:

> 'Bishop: Joseph, will ye have this maiden to your wife,
> And her honour and keep as ye know how?
> Joseph: Nay, sir, so may I thrive,
> I have no right nor need of her.
> Bishop: Joseph, it is God's will it should be so.
> Say after me as it is proper.'

Joseph agrees to bow to God's will and the bishop turns to Mary:

> 'Bishop: Mary, will ye have this man
> And keep him as your life?

Mary: In the tenderest wise, father, as I can,
 And with all my wits five.
Bishop: Joseph, with this ring now wed this wife,
 And by her hand now you her take.
Joseph: Sir, with this ring I wed her readily
 And take her now here for my mate.'
 (Coventry Mystery, *The Betrothal of Mary*).

Mars 'Regarded by the ancients as the god of war' (Stephanus).

Mars and Venus Apollo, the Sun-god, was the first to see the shameful behaviour of Venus, the goddess of love, and Mars, the god of war. When Apollo told Vulcan, Venus' husband and blacksmith of the gods, of their affair, Vulcan fashioned a net of such fine bronze chains that, although the net was unbreakable, the eye could not detect it. He set the net around his bed and when Venus and Mars lay down together the chains held them fast in the act of embracing. Then Vulcan called in the other gods to see them shamed. One of them was heard to say he would be happy to be put to shame in just that way with Venus. 'The gods laughed, and this was long the best known tale in all of heaven' (Ovid).

Marsyas 'They say Minerva was the first to make a flute, from deer bone, and went to play it at a banquet of the gods. But when Juno and Venus laughed at her because her cheeks were all puffed up, and she seemed uncouth and ridiculous when she played it, she went to a fountain in the woods and looked at her image in the water as she played. Seeing that she deserved to be laughed at, she threw the flute away, and invoked a curse that whoever picked it up would be afflicted with a grave punishment.

'Marsyas, a Thracian shepherd, and maybe even a satyr, found it. By practising on it steadily he was soon producing a very sweet sound, so that he even challenged Apollo to compete with him on his lyre' (Torrentinus).

But when Marsyas lost the contest, he was punished by

Apollo by being tied to a tree and flayed alive. 'His blood turned into a river which bears his name' (Hyginus).

Martha Reproaches Mary The Middle Ages added many details to the life of Mary Magdalene before her conversion. She was said to have 'offended God in many ways', not only with her eyes, 'by casting them on frivolous things', but also 'with her hair, by arranging it in frivolous ways' (Voragine, *Sermones de Sanctis*).

In a French mystery play, Mary calls to her maids to bring her jewelry boxes 'with my necklaces, rings, precious stones and beautiful trinkets for doing my hair and making myself up'. Later, Martha complains to her sister Mary that her sins are a cause of sorrow to her family, and that there will be only reproaches for her as long as she thinks of worldly pleasures. Mary scornfully replies, 'Mind your own affairs, and don't concern yourself with the dangers of sin.' Martha begs her to turn to Christ the Saviour, but Mary says, 'May you who seek his grace receive it, but don't interfere with my pleasures' (Jean Michel, *Mystère de la Passion*).

Saint Martin Martin was a Roman officer with leanings towards Christianity. One day he encountered a nude beggar and 'dividing his cloak with his sword gave half to the beggar and kept the other half for himself. That night Christ appeared to him surrounded by angels and said, Martin, though not yet baptized, dressed me in this garment.' Therefore Martin 'recognized God's mercy' and was baptized.

When Martin refused the Emperor Julian the Apostate's order to fight the barbarians, the emperor accused him of cowardice. Martin offered to go into battle the next day without armour, protected only by the sign of the cross. But the next day the enemy surrendered without a battle, 'whence there is no doubt that this bloodless victory was granted on account of the merits of the holy man'.

Martin was ordained bishop of Tours, but the tumults of the people drove him to found a monastery outside the city. There he often had visions of St Agnes and St Thecla and the Virgin

coming to visit him. Once, as he was on his way to say mass, a poor man followed him to church. While the deacon went to get the poor man some clothing, Martin gave him his own coat, and put on the old coat the deacon brought under his bishop's cope. During the mass, 'a great light of fire descended upon his head' making him equal to the apostles. When he raised his hands during the service the sleeves of the old coat were seen to come only to his elbows, but angels appeared and brought him sleeves of gold and precious stones to cover his arms. (*Golden Legend*).

Saint Mary of Egypt A certain Abbot Zosimas, going through the desert 'in search of holy fathers', saw 'someone nude and black' walking some distance away and started to follow. It was Mary, who stopped and addressed him by name. She told him she was a woman and nude, and asked for his bishop's cloak 'so that I may look at you without shame'. Astonished at hearing his name, Zosimas gave her his cloak and then asked for her blessing. When she began to pray, he saw her hovering above the ground.

Zosimas asked the story of her life and Mary told him that she was born in Egypt, went to Alexandria at the age of twelve and was a public whore there for seventeen years. She decided to go on a pilgrimage to Jerusalem and paid for her passage by sleeping with the sailors. In Jerusalem she was converted and heard a voice telling her that she would be saved if she crossed the Jordan, which she did, entering the desert and taking three loaves of bread with her. She stayed there for forty-seven years, living on the loaves, though her clothes rotted away. For twelve years she suffered carnal temptations, 'but now through God's grace I have overcome them all'.

She asked Zosimas to return the next Sunday bringing the eucharist with him, as she had not received holy communion since her arrival in the desert. After his second visit, she asked him to return again a year later. He did so and found her dead, with a message written beside her in the sand telling him that she had died just after receiving the eucharist from him. 'Old age prevented him from burying her, but a lion appeared and did it for him' (*Golden Legend*).

179

Mary Magdalene Mary Magdalene was the sister of Martha and Lazarus of Bethany. 'As the Magdalene had abundant wealth, and as sensuousness is comrade to wealth, the more she shone with wealth and beauty, the more she gave her body to pleasure. Whence in time her real name was forgotten and it became customary to call her the Sinner.'

She first found forgiveness for her sins at Christ's feet, which she loved to anoint and be near. 'Christ defended her before the Pharisee who called her unclean, before her sister who said she was lazy, and before Judas who said she was wasteful. Seeing her weep, Christ could not hold back his own tears; through her love he resuscitated her brother Lazarus who had been dead four days; through her love he freed her sister Martha from a flow of blood she had suffered from for twelve years. . . .

'This is she who washed the Lord's feet with her tears, dried them with her hair, and anointed them with unguent; who, when she was forgiven, first did solemn penitence; who, in Christ's words, chose the better part, and sitting at the feet of the Lord heard his word; who anointed his head; who stood beside the cross during the passion of the Lord; who procured unguent and wished to anoint his dead body; who did not leave his tomb even when the disciples did. To her Christ appeared first after his resurrection and made her apostle to the apostles' (*Golden Legend*).

For the words, 'chose the better part', *see* **Christ at the House of Mary and Martha;** and for 'apostle to the apostles', **Noli Me Tangere.** Mary Magdalene also appears in the **Dance of Mary Magdalene, Martha Reproaches Mary,** the **Feast at Simon's House,** the **Raising of Lazarus,** the **Crucifixion,** the **Deposition,** the **Lamentation,** the **Burial of Christ,** the **Three Marys at the Tomb,** the **Penitent Magdalene, Angels Carrying Mary Magdalene to Heaven,** and other religious subjects. The curing of Martha is told in the **Woman with the Issue of Blood.**

Mary Magdalene at the Tomb, *see* Penitent Magdalene.

Mary and Martha, *see* Christ at the House of Mary and Martha.

Mary Queen of Heaven, *see* Coronation of the Virgin.

Marys at the Tomb, *see* Women at the Tomb.

Mass of Saint Basil This incident was connected with the struggle of the Church against the Arian heresy, which disputed the full degree of Christ's divinity. Saint Basil was saying mass one day when suddenly the Emperor Valens – a supporter of the Arians – entered the church with a large body of followers. At the sight of Basil the emperor was struck with a sudden dizzy spell and 'if one of his ministers had not supported the tottering emperor he would have suffered a very bad fall' (*Acta Sanctorum*).

Mass of Saint Gregory, *see* Saint Gregory the Great.

Massacre of the Innocents, *see* Slaughter of the Innocents.

Saint Matthew, *see also* Calling of Matthew.

Saint Matthew Overcomes Two Dragons A medieval legend. When St Matthew was in Ethiopia, he was approached by two magicians with two dragons belching deadly fire from their mouths and nostrils. As soon as the dragons saw Matthew, who armed himself with the sign of the cross, they fell asleep at his feet, no longer able to harm anyone, and leaving the magicians powerless. (*Golden Legend*).

Saint Matthias Matthias was the apostle chosen to replace Judas Iscariot after Christ's death. The other eleven apostles chose by lot between the two men they had appointed, Joseph Barsabas and Matthias. 'And they prayed, and said, Thou, Lord, which knowest the hearts of all men, shew whether of these two thou hast chosen, that he may take part of this ministry and apostleship. . . . And they gave forth their lots; and the lot fell upon Matthias' (Acts, 1).
 According to the *Golden Legend* the lot was a divine radiance descending from heaven onto Matthias to indicate his

election. After preaching the gospel in Judaea Matthias was martyred by being stoned – to comply with Old Testament Law – and by beheading with an axe – in deference to Roman law.

Saint Maurice (Mauritius) A third-century knight from Thebes in Arabia. His Latin name was sometimes shortened to Maurus, the Latin word for a moor, or negro.

When the Emperor Diocletian, known for his persecution of Christians, ordered the Christians of Thebes to send him a legion, they thought of the precept of Christ, Render unto Caesar the things that are Caesar's, and sent the 6,666 men under the command of Maurice later known as the Theban Legion. Diocletian ordered them to sacrifice to the pagan gods and when they refused he had them literally decimated by killing a tenth of them. Maurice, who survived, declared the readiness of them all to die for their faith. Exuperius, the standard-bearer of the legion, said that though they were knights of the Roman empire they were also servants of Christ, and the whole legion was slaughtered. (*Golden Legend*).

Maxentius, *see* Invention of the True Cross.

Medusa One of the Gorgons, monsters of the underworld. Once renowned for her beauty, 'she was raped by Neptune in a temple of Minerva and the goddess, in her wrath, changed Medusa's hair into snakes and declared that all who looked upon her would turn to stone. . . . Later Perseus, having gotten winged sandals from Mercury and a sword and shield from Minerva, cut off Medusa's head while she was asleep and used it to turn his enemies to stone. Eventually Minerva put the head on her own shield' (Torrentinus).

Meeting of Saint Dominic and Saint Francis St Dominic had gone to Rome to seek papal confirmation of his Order. One night he had the vision of the *Three Arrows,* in which he saw St Francis, whom he had never met. In church the next day Dominic saw Francis for the first time and, recognizing him at

once, ran up and embraced and kissed him saying, 'You are the comrade who is to work with me. If we stand together, no adversary can prevail against us. Then Dominic told Francis his vision, and they became one heart and one soul in God' (*Acta Sanctorum*).

Meeting of Jacob and Esau After Jacob's flight from his uncle Laban, in whose service he had been for fourteen years, he was obliged to pass through his older brother Esau's territory on his way home; but he feared the meeting with Esau, because he had stolen their father Isaac's blessing from him fourteen years before. His messengers to Esau returned saying, 'We came to thy brother Esau, and also he cometh to meet thee, and four hundred men with him. Then Jacob was greatly afraid and distressed: and he divided the people that was with him, and the flocks, and herds, and the camels, into two bands; and said, If Esau come to the one company, and smite it, then the other company which is left shall escape.'

But at the meeting 'Esau ran to meet him, and embraced him, and fell on his neck, and kissed him: and they wept.' Jacob showed Esau his wives and children and made him an offering of goats, sheep, camels, bulls and asses. When Esau refused it, Jacob insisted: 'Take, I pray thee, my blessing that is brought to thee; because God hath dealt graciously with me, and because I have enough. And he urged him, and he took it' (Genesis, 32 and 33).

Melchizedek, *see* Abraham and Melchizedek.

Meleager, *see* Calydonian Boar Hunt.

Mercury 'Mercury was the son of Jupiter and Maia; the Greeks called him Hermes. Some think the name comes from the Hebrew word for language or speech, for Mercury was the messenger of the gods. . . . They say he had wings on his head and feet, by that fiction signifying that speech goes swiftly through the air. He is called the messenger of the gods because all thoughts are spoken only by means of language; and god of eloquence because they say he gave the gift of oratory to men.

183

He is also considered the god of merchants, profit, wrestling, and of thieves' (Stephanus).

Mercury and Argus Argus was a monster who had a third eye in the back of his neck; or four eyes, two before and two behind; or a hundred. He was sent by Juno to guard the heifer her husband Jupiter had given her, for she suspected that it was really Io, Jupiter's latest conquest. Jupiter could not bear to watch Io's sufferings as a cow, so sent his messenger Mercury in the guise of a shepherd to kill Argus. 'Mercury sat down beside him, and whiled away the day with talk of many things, and sought to overcome the watchful eyes by playing on his reed pipes. Argus struggled to keep off drowsy sleep.' But finally all the eyes closed and Mercury cut off his head with a sword.

Juno took Argus' eyes and put them in the tail-feathers of the peacock, the bird sacred to her. (Ovid).

Mercury and Battus 'The story goes that Mercury gave a cow to a shepherd named Battus to keep him from revealing one of Mercury's thefts, which no one else knew about. Then, to test Battus, Mercury came back in a different guise, and offered him a second reward to reveal the theft. In that way he found out how two-faced Battus was and changed him into a stone as a monument to his own disloyalty' (Torrentinus).

Mercury and the Dishonest Woodman One of Aesop's fables: A woodcutter was cutting trees beside a river and lost his axe in the water. Mercury appeared and dived into the river to retrieve the axe. First he came up with a golden axe, then a silver one, and finally the lost one, which was the only one the woodcutter recognized and claimed as his own. When the god rewarded his honesty by giving him all three axes, the woodcutter told the story to his comrades, and one of them decided to do the same thing. Deliberately throwing his axe into the water he waited for Mercury to bring up a golden axe and then claimed it. Mercury, disgusted by his dishonesty, not only kept the golden one but the woodcutter's own as well.

184

Mercury Orders Aeneas to Abandon Dido, *see* Dido and Aeneas.

Michael Driving out the Rebel Angels 'When Lucifer sought equality with God, the Archangel Michael, flag-bearer of the celestial army, joined battle with him and expelled him and his followers from heaven, hurling them into darkness until the very Day of Judgement' (*Golden Legend*).

The book of Revelation describes Michael's victory: 'And there was war in heaven: Michael and his angels fought against the dragon; and the dragon fought and his angels, and prevailed not; neither was their place found any more in heaven. And the great dragon was cast out, that old serpent, called the Devil, and Satan, which deceiveth the whole world: he was cast out into the earth, and his angels were cast out with him. And I heard a loud voice saying in heaven, Now is come salvation, and strength, and the kingdom of our God, and the power of his Christ: for the accuser of our brethren is cast down, which accused them before our God day and night' (Revelation, 12).

Michael with the Scales of the Last Judgement Molanus says, 'The Archangel Michael is sometimes painted with a balance: in one scale is a soul, in the other are its good acts. The Devil is shown beside the scale with the soul in it, trying with all his might to press it downward. But Michael opposes the Devil, making the sign of the cross over the scale that holds the good acts, and through the Passion and Cross of Christ he adds weight to that scale.' He quotes Augustine as saying that 'if the number of evil deeds is greater than the good ones they will draw their doer down to hell, but if the good works prevail they will fight against the evil deeds with greater force, and draw their doer up into the region of the living even from the very gates of hell.'

Midas When Bacchus offered Midas, a wealthy Phrygian king, the chance to request whatever he wanted, Midas asked that whatever he touched should turn to gold. Bacchus agreed, but when even his food and drink became gold, Midas realized

that his wish had been a stupid one and begged Bacchus to take back his gift.

Later, when Pan and Apollo were having a music contest, the judge favoured Apollo. 'But Midas, who happened to be present, preferred Pan, as he was a rather dull-witted judge.' The indignant Apollo punished Midas by giving him ass's ears, which he hid under a cap. Only his barber, sworn to secrecy, knew about them. 'But the barber, who could hardly keep such a novel thing to himself, yet dared tell no one about them, dug a hole in which he shouted, King Midas has ass's ears.' He filled the hole with earth, but reeds grew up on the spot, and when the wind blew they whispered the secret to the whole world. (Torrentinus).

Milky Way, *see* Origin of the Milky Way.

Minerva 'Goddess of wisdom, born from the brain of Jupiter. She is also called Pallas. The poets represent her as a woman armed with a breastplate and girded with a sword. Her manly head is protected by a crested helmet. She holds a spear in her right hand and in the left a crystal shield containing the Medusa's head with its monstrous snakes.... Beside her is shown the green olive tree, and above her flies the owl' (Albricus).

'They say that Minerva is immortal and a virgin, for wisdom can neither die nor be corrupted' (Fulgentius).

Ministry of the Angels, *see* Christ Attended by Angels.

Miracle of the Catafalque, *see* Burial of the Virgin.

Miracle of the Loaves and the Fishes Jesus had attracted a great crowd by his preaching and healing. 'When Jesus then lifted up his eyes, and saw a great company come unto him, he saith unto Philip, Whence shall we buy bread, that these may eat? And this he said to prove him: for he himself knew what he would do. Philip answered him, Two hundred pennyworth of bread is not sufficient for them, that every one of them may

take a little. One of his disciples, Andrew, Simon Peter's brother, saith unto him, There is a lad here, which hath five barley loaves, and two small fishes: but what are they among so many? And Jesus said, Make the men sit down.

'Now there was much grass in the place. So the men sat down, in number about five thousand. And Jesus took the loaves; and when he had given thanks, he distributed to the disciples, and the disciples to them that were set down; and likewise of the fishes as much as they would. When they were filled, he said unto his disciples, Gather up the fragments that remain, that nothing be lost. Therefore they gathered them together, and filled twelve baskets with the fragments of the five barley loaves, which remained over and above unto them that had eaten. Then those men, when they had seen the miracle that Jesus did, said, This is of a truth that prophet that should come into the world' (John, 6).

Miracle of the Saracen When some merchants of Venice were sailing to Alexandria in a Saracen ship, a storm arose and the Venetians saved themselves by jumping into a small skiff, but the ship itself sank 'and the ravenous waves overwhelmed the Saracens. One of them invoked St Mark and vowed – in so far as a Saracen could – that if the saint came to his aid he would make a pilgrimage to his basilica in Venice and be baptized. At once a gleaming man appeared to him and, snatching him from the flood, put him in the small boat.' The Saracen had to be reminded of his vow by St Mark in another vision, but finally did make his pilgrimage and was baptized in Venice. (*Golden Legend*).

Miraculous Draft of Fishes This miracle is part of Luke's account of the calling of the first disciples. Christ preached to the people crowding to hear him from Simon Peter's fishing boat, near the shore of the Lake of Gennesaret. 'Now when he had left speaking, he said unto Simon, Launch out into the deep, and let down your nets for a draught. And Simon answering said unto him, Master, we have toiled all the night, and have taken nothing: nevertheless at thy word I will let

down the net. And when they had this done, they enclosed a great multitude of fishes: and their net brake. And they beckoned unto their partners, which were in the other ship, that they should come and help them. And they came, and filled both the ships, so that they began to sink. When Simon Peter saw it, he fell down at Jesus' knees, saying, Depart from me; for I am a sinful man, O Lord. For he was astonished, and all that were with him, at the draught of the fishes which they had taken: and so was also James, and John, the sons of Zebedee, which were partners with Simon. And Jesus said unto Simon, Fear not; from henceforth thou shalt catch men. And when they had brought their ships to land, they forsook all, and followed him' (Luke, 5).

Miraculous Saving of the Apostles After the death and resurrection of Christ, the Jewish high priest and his followers were 'filled with indignation' at the number of miracles the Apostles were performing. They 'laid their hands on the apostles, and put them in the common prison. But the angel of the Lord by night opened the prison doors, and brought them forth, and said, Go, stand and speak in the temple to the people all the words of this life. And when they heard that, they entered into the temple early in the morning, and taught' (Acts, 5).

Miriam After Pharaoh's horsemen had been drowned in the Red Sea trying to catch the Jews on their flight from Egypt, 'Miriam the prophetess, the sister of Aaron, took a timbrel in her hand; and all the women went out after her with timbrels and with dances. And Miriam answered them, Sing ye to the Lord, for he hath triumphed gloriously; the horse and his rider hath he thrown into the sea' (Exodus, 15).

Mission to Gabriel A medieval legend: 'Omnipotent God called the archangel Gabriel and said to him, Go to our beloved daughter Mary . . . and tell her that my son desires her beauty, and has chosen her as his mother. Ask her to accept him gladly, for through her I have resolved to work the salvation of the entire human race. . . .

'Gabriel, with happy face and full of joy, knelt down and, bowing his head in fear and reverence, received attentively the embassy of his Lord.' Then Gabriel announced to the Virgin that she would conceive and bear a son called Jesus. (Bonaventura).

Mocking of Christ The *Golden Legend* says Christ was mocked four times.

The first time was before Caiaphas, the high priest (or before Annas, his father-in-law) where 'they spit in his face, and buffeted him', and 'the men that held Jesus mocked him, and smote him. And when they had blindfolded him, they struck him on the face, and asked him, saying, Prophesy, who is it that smote thee?' (Matthew, 26 and Luke, 22).

The second time was before Herod. 'And Herod with his men of war set him at nought, and mocked him, and arrayed him in a gorgeous robe, and sent him again to Pilate' (Luke, 23).

The third time was by Pilate's soldiers, after the Flagellation. 'Then the soldiers of the governor took Jesus into the common hall, and gathered unto him the whole band of soldiers. And they stripped him, and put on him a scarlet robe. And when they had platted a crown of thorns, they put it upon his head, and a reed in his right hand: and they bowed the knee before him, and mocked him, saying, Hail, King of the Jews! And they spit upon him, and took the reed, and smote him on the head' (Matthew, 27).

A medieval passion-play adds this detail: 'Then four of the soldiers took in their hands two staves, and crossing them over his head, pressed the crown heavily down upon the brow of Jesus, who shuddered in agony' (*Oberammergau Passion Play*).

According to the *Mirror of Man's Salvation,* the robe Herod dressed Christ in was white – an unwitting indication of his innocence – and the robe Pilate's soldiers used was purple, in derision of his supposed royalty.

The fourth mocking was during the Crucifixion. (*Golden Legend*).

For medieval versions of the Mocking, *see* **Christ Before**

Annas; Christ Before Caiaphas; Christ Before Herod; Flagellation.

Saint Monica Saint Monica was the mother of St Augustine, and best known for her tears and prayers for her son's conversion. When she kept urging a certain bishop to pray for Augustine's salvation, 'he was finally overwhelmed by her persistence and replied prophetically, Go assured that it is impossible for the son of so many tears to be lost' (*Golden Legend*).

Mordecai Mordecai was a Jew at the time of the Babylonian captivity of the Jews, whose cousin Esther became the queen of King Ahasuerus.
Mordecai at the Gate of the Palace. When Haman, one of the king's ministers, plotted to annihilate the Jews, 'Mordecai rent his clothes, and put on sackcloth with ashes, and went out into the midst of the city, and cried with a loud and a bitter cry; and came even before the king's gate: for none might enter into the king's gate clothed with sackcloth. . . . But when Haman saw Mordecai in the king's gate, that he stood not up, nor moved for him, he was full of indignation against Mordecai' (Esther, 4 and 5).
Esther and Mordecai. Mordecai persuaded Esther to intercede with Ahasuerus to save the Jews. The king revoked the edict that had gone out against them, hung Haman, and promoted Mordecai to Haman's former position.

Esther and Mordecai wrote letters to the Jews of the provinces telling them that they should celebrate the festival of Purim every year, in memory of the days when they were saved from their enemies. 'They should make them days of feasting and joy. . . . And the decree of Esther confirmed these matters of Purim; and it was written in the book' (Esther, 9).
 See **Esther before Ahasuerus.**

Moses and the Burning Bush After the young Moses had fled a murder charge in Egypt he tended the flocks of his father-in-law Jethro, 'and he came to Horeb the mountain of

God. And the Lord appeared to him in a flame of fire from the midst of a thorn-bush: and he saw that the thorn-bush was on fire, and was not burned up.' Moses turned aside to see 'this great vision, why the thorn-bush is not burned up', but the Lord told him to remove his sandals before he approached, 'for the place on which you stand is holy ground'. God told Moses that he was the God of his ancestors, Abraham, Isaac and Jacob, and that he had come to deliver the Jews from their captivity, and was sending Moses back to Egypt for that purpose. This was the beginning of the Exodus. (Exodus, 3 (Vulgate)).

Medieval Christians interpreted the incident in various ways. In the seventh century Isidore of Seville thought of the thorn-bush as the sinful Jewish people and the flame as the word and law of God that was given to them. Later, the *Mirror of Man's Salvation* saw the bush as symbolic of the Virgin, for as God descended into the bush to redeem the Jews from their Egyptian captivity, so Christ descended into the Virgin to redeem all men. 'And as the bush sustained the fire without losing its greenness, so Mary conceived her Son without losing her virginity.'

Moses Electing the Elders When the Israelites left Egypt and were on their way to the promised land, Moses alone judged the people. His father-in-law, Jethro, the priest of Midian, advised him to lighten his burden by choosing qualified men to help him. 'So Moses hearkened to the voice of his father in law, and did all that he had said. And Moses chose able men out of all Israel, and made them heads over the people, rulers of thousands, rulers of hundreds, rulers of fifties, and rulers of tens. And they judged the people at all seasons: the hard causes they brought unto Moses, but every small matter they judged themselves' (Exodus, 18).

Moses and the Fiery Coal 'Pharaoh's daughter had found and adopted the infant Moses. Later, when she brought him to a feast of Pharaoh's he clutched at Pharaoh's crown and cast it to the ground. The priest of Heliopolis said the child must be

killed, but a test was devised to see whether he had acted in ignorance or willfully. A bowl of hot coals and a bowl of jewels were offered to him and – guided, say the Jews, by the archangel Gabriel – he took one of the coals, put it to his lips, and burned them ... hence becoming slow of speech later on. This convinced Pharaoh of his innocence', and his life was spared. (*Historia Scholastica*).

Moses Found in the Bulrushes Pharaoh feared the growing power of the Israelites in Egypt, and to stop their increase he ordered that every son born to them should be thrown into the river. 'And there went a man of the house of Levi, and took to wife a daughter of Levi. And the woman conceived, and bare a son: and when she saw him that he was a goodly child, she hid him three months. And when she could not longer hide him, she took for him an ark of bulrushes, and daubed it with slime and with pitch, and put the child therein; and she laid it in the flags by the river's brink. And his sister stood afar off, to wit what would be done to him.

'And the daughter of Pharaoh came down to wash herself at the river; and her maidens walked along by the river's side; and when she saw the ark among the flags, she sent her maid to fetch it. And when she had opened it, she saw the child: and, behold, the babe wept. And she had compassion on him, and said, This is one of the Hebrews' children. Then said his sister to Pharaoh's daughter, Shall I go and call to thee a nurse of the Hebrew women, that she may nurse the child for thee? And Pharaoh's daughter said to her, Go. And the maid went and called the child's mother. And Pharaoh's daughter said unto her, Take this child away, and nurse it for me, and I will give thee thy wages. And the woman took the child, and nursed it. And the child grew, and she brought him unto Pharaoh's daughter, and he became her son. And she called his name Moses: and she said, Because I drew him out of the water' (Exodus, 2).

Moses and Jethro's Daughters Moses killed an Egyptian who was molesting the Jews. 'Now when Pharaoh heard this

thing, he sought to slay Moses. But Moses fled from the face of Pharaoh, and dwelt in the land of Midian. And he sat down by a well. Now the priest of Midian had seven daughters: and they came and drew water, and filled the troughs to water their father's flock. And the shepherds came and drove them away: but Moses stood up and helped them, and watered their flock.'

When the priest heard what had occurred he sent for Moses, who agreed to live with him, and took one of his daughters in marriage. 'And she bare him a son, and he called his name Gershom: for he said, I have been a stranger in a strange land. And she bare him another, whom he called Eliezer, saying: The God of my father, my helper, has snatched me out of Pharaoh's hand' (Exodus, 2 (second quotation, Vulgate)).

Moses Receiving the Tablets of the Law When the Israelites were camped in the desert on their way to the promised land, God called Moses to come up to him on Mount Sinai to receive laws for the people written on stone tablets. 'And Moses went up into the mount, and a cloud covered the mount. And the glory of the Lord abode upon Mount Sinai, and the cloud covered it six days: and the seventh day he called unto Moses out of the midst of the cloud. And the sight of the glory of the Lord was like devouring fire on the top of the mount in the eyes of the children of Israel. And Moses went into the midst of the cloud, and gat him up into the mount: and Moses was in the mount forty days and forty nights. . . . And he gave unto Moses, when he had made an end of communing with him upon Mount Sinai, two tables of testimony, tables of stone, written with the finger of God.'

When Moses returned to the camp and saw the people worshipping the Golden Calf, he broke the tablets in his anger, but later God wrote the commandments again for him on two other stone tablets. As Moses came down from Mount Sinai the second time 'when Aaron and all the children of Israel saw Moses, behold, the skin of his face shone . . . and he gave them in commandment all that the Lord had spoken with him in Mount Sinai' (Exodus, 24, 31 and 34).

193

The medieval Latin text of the Bible does not say that Moses' face shone but that Moses' 'face was horned' – for Molanus the symbol of 'royal authority and sovereignty'.

Moses Strikes Water from the Rock The Israelites pitched camp in the wilderness on their way to the promised land, and complained to Moses because there was no water to drink. 'And Moses cried unto the Lord, saying, What shall I do unto this people? They be almost ready to stone me. And the Lord said unto Moses, Go on before the people, and take with thee of the elders of Israel; and thy rod, wherewith thou smotest the river, take in thine hand, and go. Behold, I will stand before thee there upon the rock in Horeb; and thou shalt smite the rock, and there shall come water out of it, that the people may drink. And Moses did so in the sight of the elders of Israel' (Exodus, 17).

According to Jewish legend the rock followed the Israelites through the wilderness. St Paul, describing the flight of the Jews from Egypt and their life in the wilderness, refers to this episode in Christian terms: 'And all of them drank the same spiritual drink, for they drank of the spiritual rock that followed them, and the rock was Christ' (I Corinthians, 10 (Vulgate)).

Mount of Olives, *see* Agony in the Garden.

Mourning for the Dead Christ, *see* Lamentation for the Dead Christ.

Naaman cured by Elisha Naaman, the commander of the king of Syria's army, was also a leper. He heard that there was a prophet in Israel – Elisha – who might be able to cure him. The story, and its medieval interpretation, is retold briefly in the *Mirror of Man's Salvation:* 'Naaman was a pagan and knew nothing of God, yet he went to God's prophet Elisha to be cured. At Elisha's bidding he washed seven times in the Jordan and so was cleansed of all his leprosy. By this sevenfold washing in the Jordan Elisha prefigured the washing away of

the seven mortal sins in baptism. Naaman's flesh was made like the flesh of a child by the Jordan, thus are sinners made as clean as children by baptism.'

Nailing to the Cross Bonaventura relates that when Christ was stripped before being nailed to the cross, the Virgin girded his loins with the veil from her head. Some thought that Christ mounted up to the cross, which had already been set up. Others said that 'laying the cross on the ground, they lifted him up and then fixed the cross in the earth. If it were done in this way, see how roughly they seize him like the lowest scoundrel, and throw him down angrily upon the cross. They take his arms and after stretching them violently fasten them to the cross. They do the same with his feet, which they pull as much as they can. Thus was the Lord Jesus stretched out on the cross, so that all his bones could be counted. . . . Three nails supported the weight of his whole body.'

In a York Mystery play the holes on the cross are bored too far apart and they have to stretch Jesus to make him fit: one soldier says to another, 'Fasten on a cord and tug him to, by top and tail.'

Nain, *see* Raising of the Widow's Son at Nain.

Narcissus 'A very handsome youth and hunter, son of a river god and a nymph. He was loved by many nymphs, and above all by Echo, but he scorned them proudly. Finally he was captivated by his own image, for he saw himself in a pool of water and thought it was a nymph. When he was not able to take possession of the image he gradually wasted away, and was changed into a gleaming flower' (Torrentinus).

Nastagio Boccaccio tells this story as an example of cruelty avenged by divine justice. Nastagio, a wealthy young man of Ravenna, fell in love with the daughter of one of the local nobility, but she, considering him unworthy of her, scorned his love and treated him with contempt. After wasting much of his fortune trying to impress her Nastagio,

in an attempt to forget the unpitying girl, moved to a lonely place near the sea three miles from Ravenna, where he set up tents and pavilions and entertained his friends with banquets and hunting parties.

One day early in May he was taking a solitary and pensive walk in a nearby pine woods, thinking of his cruel loved one, when he was startled by the desperate cries of someone in distress. Running towards him was a beautiful young woman chased by two fierce dogs, who were biting her, and close behind them a knight on horseback, armed with a sword and threatening to kill her. Nastagio tried to defend the woman with a branch, but the knight explained that her punishment was deserved, for he had loved her once, but had been so cruelly rejected that he finally killed himself, and was thus condemned to eternal damnation. When she died unrepentant of her sin, her punishment was to be chased by him and killed by having her cold heart cut out and fed to the dogs, and these agonies were to be repeated every Friday in these woods until her sin was expiated.

The following Friday Nastagio invited the girl he loved and her family and all their female relatives to dine with him, and had a magnificent banquet served in the woods. Towards the end of the meal cries were heard. The guests rose in alarm as the woman appeared, chased by the knight and bitten by the dogs. They were horrified by the knight's story, and Nastagio's loved one was so frightened that she later sent her maid secretly to Nastagio with the message that she would marry him at once. 'And this fear had more than one happy consequence, for all the women of Ravenna were sobered by the experience, and were much more eager to please their men than they had ever been before.'

Nativity 'And it came to pass in those days, that there went out a decree from Caesar Augustus, that all the world should be taxed. . . . And Joseph also went up from Galilee, out of the city of Nazareth, into Judaea, unto the city of David, which is called Bethlehem; (because he was of the house and lineage of David:) to be taxed with Mary his espoused wife, being great

196

with child. And so it was, that, while they were there, the days were accomplished that she should be delivered. And she brought forth her firstborn son, and wrapped him in swaddling clothes, and laid him in a manger; because there was no room for them in the inn' (Luke, 2).

The Middle Ages expanded the story: 'They led with them an ox and an ass, and travelled like poor cattle merchants. When they had arrived in Bethlehem, because their means were limited and many people were there to be taxed, they could not find lodging ... so had to seek shelter in a covered passage where people were accustomed to take refuge from the rain. ...

'When the hour of birth had come, in the middle of the night on Sunday, the Virgin, rising, rested herself against a pillar which was there. Joseph, however, sat sadly, perhaps because he could not provide what was necessary for her. Rising therefore and taking hay from the manger he spread it at the feet of the Virgin and retired elsewhere.

'Then the son of the eternal God came forth from his mother's womb without any trouble or injury to her, transferred in a moment to the hay at her feet. His mother, spontaneously stooping down, took him up gently in her arms, put him in her lap and, with full breast and taught by the Holy Spirit, began to wash him all over in her sacred milk. When she had done this she wrapped him in her kerchief and laid him in the manger. Then the ox and the ass, kneeling down, laid their heads over the manger, breathing through their nostrils as if they were rational beings and knew that the child thus poorly covered needed to be kept warm at such a cold time of year. And his mother knelt down and adored him, and gave thanks to God' (Bonaventura).

The adoration of the ox and the ass was referred to the words of the prophet Isaiah, 'The ox knoweth his owner, and the ass his master's crib', and was taken as a confirmation that Christ was indeed the Messiah.

In another version the birth took place in a dark cave which 'began to gleam when Mary entered it as though the sun itself were there', and angels surrounded the new-born child and adored him saying, 'Glory to God in the highest, and on earth

197

peace, good will to men' (*New Testament Apocrypha, Evangelium of Pseudo-Matthew*).

Nausicaa Daughter of the king of the Phaeacians. 'When she happened to go outside the town walls with her maids in waiting to wash her clothes in a stream, she came upon the shipwrecked Ulysses sitting on the sea shore, naked, and covered only with leafy branches. When he approached her as a suppliant, she gave him clothing and led him back to her father's palace' (Stephanus).

Nebuchadnezzar Before the Golden Image, *see* Three Children in the Furnace.

Saint Nemesius Nemesius was a Roman tribune whose daughter, Lucilla, was born blind. When she grew up they were converted to Christianity and baptized together. As they came up out of the baptismal font, Lucilla cried out that at last she could see. But the Emperor Valerian ordered them to renounce their faith, and when they refused he condemned them to death. Their executioners decided to behead Lucilla first, in front of Nemesius, to torment him, but he 'rejoiced greatly and exclaimed, Accept, O Christ, this sacrifice that I make to you', after which he was beheaded too. (*Acta Sanctorum*).

Neptune 'When the world was being divided up, the kingdom of the sea was given to Neptune, which is why he carries a trident, the sceptre of his particular realm. . . . His wife is Amphitrite, the mother of many nymphs. . . . They say he was the first to tame horses and to institute the art of horseback riding, and others think that men did not even know about horses until they were given to them by Neptune' (Stephanus).

Nessus, *see* Deianira, Nessus and Hercules.

Saint Nicholas Nicholas was born in Asia Minor in the fourth century. He was famous for helping those in distress. Sailors in a storm, innocent men unjustly condemned, even

those already killed, all invoked his aid and received it. On one occasion, knowing that an impoverished nobleman would have to sell his three daughters into prostitution for lack of money, Nicholas secretly threw a lump of gold into their bed chamber by night, thus providing a dowry for the first daughter; and when she was married, he did the same for the second and then the third. Once during a famine he persuaded sailors to unload grain from cargoes that had been previously weighed, and though they unloaded a two-year supply none was found missing when the grain was weighed again at its destination.

When an episcopal council convened to elect a new bishop for the church at Myra, a heavenly voice was heard saying that the first person to come to church in the morning should be chosen. It was Nicholas and 'leading him all reluctant into church they seated him in the bishop's chair'. After his death fountains of healing oil and water flowed from his tomb. When the Turks destroyed Myra in the twelfth century, Christians took his body to Bari in Italy. (*Golden Legend*).

'There is a popular story that a woman killed three boys one night and salted them away in a pot to use as corned beef, but Saint Nicholas brought them back to life again' (Molanus).

Noah, *see* Flood; Drunkenness of Noah.

Noli Me Tangere (Touch Me Not) As Mary Magdalene first found forgiveness for her sins at Christ's feet, which she washed with her tears and dried with her hair, she always liked to be near them. After his resurrection, Christ appeared first to her 'to show that he had died for sinners' (*Golden Legend*).

'But Mary stood without at the sepulchre weeping: and as she wept, she stooped down, and looked into the sepulchre, and seeth two angels in white sitting, the one at the head, and the other at the feet, where the body of Jesus had lain. And they say unto her, Woman, why weepest thou? She saith unto them, Because they have taken away my Lord, and I know not where they have laid him. And when she had thus said, she turned herself back, and saw Jesus standing, and knew not that it was Jesus. Jesus saith unto her, Woman, why weepest thou? Whom

seekest thou? She, supposing him to be the gardener, saith unto him, Sir, if thou have borne him hence, tell me where thou hast laid him, and I will take him away. Jesus saith unto her, Mary. She turned herself, and saith unto him, Rabboni; which is to say, Master. Jesus saith unto her, Touch me not; for I am not yet ascended to my Father: but go to my brethren, and say unto them, I ascend unto my Father, and your Father; and to my God, and your God' (John, 20).

Bonaventura says Mary Magdalene 'ran towards Christ's feet to kiss them: but the Lord said what he did because he wanted to raise her mind to divine things, so that she would never more seek him on earth'.

Nymphs 'Goddesses of water. . . . Some are celestial, others terrestrial, others fluvial or marine, or found in still waters. . . . The terrestrial nymphs are thought by some to have raised Ceres and Bacchus, while the celestial nymphs are heavenly spirits, also called Muses, and personify our more lofty virtues. Some of the terrestrial nymphs are found in woods and are called dryads, and others, called oreads, live in mountains, others, the hamadryads, in individual trees, and yet others in pastures and flowers. Those in rivers are naiads, and in lakes limniads. The nymphs of fountains were called ephydriads, and those of the sea nereids' (Stephanus).

Odysseus Odysseus was the king of Ithaca and one of the warriors in the Trojan War. His Latin name was Ulysses. After fighting at Troy for ten years he took ten more years returning to Ithaca.

See also **Penelope and the Suitors; Nausicaa; Polyphemus and Ulysses.**

Odysseus and Circe When Odysseus was sailing home to Ithaca after the Trojan War, he and his comrades were blown to the island of the enchantress Circe. With herbs and magic spells, Circe used to transform her victims into beasts. She prepared a special concoction for Odysseus' comrades which they drank; then, with the touch of her wand, she transformed

them into pigs. Odysseus, protected by a white flower given him by Mercury, refused to drink from Circe's cup and, frightening her with his sword, won her pledge of good faith. He became her husband and, as a wedding gift from his wife, his comrades were restored to their true shape. (Ovid).

Oedipus and the Sphinx 'The sphinx was a monster with the face of a maiden, a bird's wings, and the feet of a lion. She went to Thebes and asked the following riddle, killing anyone who could not solve it: What is not only biped, but also triped and quadruped? Finally Oedipus solved the riddle, giving the answer: Man, who goes on all fours in infancy, on three feet as an old man with a cane, and on two during the years between.' In despair at having lost, the sphinx flung herself to her death from a rocky precipice. (Torrentinus).

Offering of the Jews for the Building of the Ark When Moses was leading the Israelites through the wilderness to the promised land, God spoke to him and gave him instructions for building the tabernacle and a sanctuary, that is, the ark of the covenant. He told Moses that before the Israelites began to construct the ark, they should make a special offering of 'gold, and silver, and brass, and blue, and purple, and scarlet, and fine linen, and goats' hair, and rams' skins dyed red, and badgers' skins, and shittim wood, oil for the light, spices for anointing oil, and for sweet incense. . . . And they came, every one whose heart stirred him up, and every one whom his spirit made willing, and they brought the Lord's offering to the work of the tabernacle' (Exodus, 25 and 35).

Omphale, *see* Hercules and Omphale.

Orestes and Pylades, *see* Iphigenia.

Origin of the Dominican Habit A certain Reginald, a teacher of canon law, fell ill while desiring to enter the Order of Preachers of St Dominic, and his life was despaired of. Dominic prayed to the Virgin, who appeared to Reginald in a vision as the

Queen of Mercy, and anointed his ears, mouth, hands, loins and feet with a healing ointment. She also showed him a religious habit and said, Here is the habit of your order. Simultaneously, St Dominic had the same vision and, finding Reginald restored to health in the morning, he and his friars assumed the habit the Virgin had shown them. Reginald was cured of his fever and of all carnal temptations as well. (*Golden Legend*).

Origin of the Milky Way In ancient mythology, a mortal could become immortal if he was suckled by Juno, the queen of the gods. When Jupiter wanted his son Hercules, whose mother was a mortal, to have immortality, he had him brought to Olympus by Mercury, the messenger of the gods, who placed him quietly at Juno's breast while she was sleeping. But the infant sucked so vigorously that Juno awoke and pushed him away. Her milk spurted out across the sky, forming the Milky Way. (Hyginus).

Original Sin, *see* Garden of Eden.

Orion 'A hunter and follower of the goddess Diana. . . . Some derive his name from the Greek word *hora*, "season", and make it refer to the different seasons of the year.' The story was that 'a poor and childless man named Oenopeus once gave hospitality to Jupiter, Neptune and Mercury, and when they asked him what he wanted in return he asked for a son. The gods pissed into the hide of a sacrificial ox and told Oenopeus to bury it for nine months. From it Orion was born.'

Orion became a vigorous hunter 'but when he boasted that there was no animal he could not kill, the indignant earth sent a scorpion which bit him and he died. Diana put him among the stars' (Stephanus).

Orpheus Orpheus was a Thracian poet whose wife, Eurydice, died on their wedding day, bitten in the ankle by a viper. Orpheus mourned her loss and descended to the underworld, where the beauty of his singing to the lyre so moved Pluto and Persephone, the king and queen of Hades, that they

granted Orpheus the right to lead Eurydice back to earth with him. But they added the condition that he must not look back at her until they had reached the surface of the earth, or else Eurydice would again be taken from him. As they neared the end of their ascent from the underworld, 'fear that she had been left behind, and eagerness to see her – love, in short – made him turn around to look, and instantly she was gone again. He held out his arms to take hold of her and be held by her, but caught only the yielding air. And she, dying a second time . . . spoke a last farewell which he could scarcely hear, and was recalled again to the world below.'

From then on Orpheus avoided human company and pre-ferred to sit on a hilltop, playing his lyre. His music attracted a grove of different kinds of trees which came and sheltered him from the sun. Sitting among wild animals and flocks of birds that had been charmed by the sounds, he tuned the strings of his lyre and sang. But finally a group of frenzied women who thought the poet had scorned them, attacked him with stones and mattocks and tore him apart. (Ovid).

Pan 'Pan is a rustic god formed in the likeness of Nature, which is why he is called Pan, which means "All". His horns are like the rays of the sun and the horns of the moon; his face is ruddy like morning air; his mule-skin breast plate is covered with stars; his lower parts bristle with hair like thickets and foliage and the fur of animals; his goat's feet reflect the solidity of the earth. He carries a flute with seven reeds for the seven harmonious voices of the heavens, and a shepherd's crook, which revolves back upon itself like the seasons of the year. Because he is the god of all Nature, the poets say he fought with love and lost, because Love conquers All.

'Pan is said to have loved Syrinx, a nymph. When he pursued her she called on mother Earth for help and was turned into a reed, which Pan cut to solace his love, and from which he made the pan-pipes' (Servius).

Parable of the Blind Christ's disciples told him that he had offended the Pharisees by calling them hypocrites, and he

replied: 'Let them alone: they be blind leaders of the blind. And if the blind lead the blind, both shall fall into the ditch' (Matthew, 15).

Parable of the Sabbath, *see* Plucking Grain on the Sabbath.

Parable of the Sower In Christ's parable a sower was sowing seed; some fell by the wayside, some on rock, some among the thorns, and some on good ground. Christ explained: 'The seed is the word of God. Those by the way side are they that hear; then cometh the devil, and taketh away the word out of their hearts, lest they should believe and be saved. They on the rock are they, which, when they hear, receive the word with joy; and these have no root, which for a while believe, and in time of temptation fall away. And that which fell among thorns are they, which, when they have heard, go forth, and are choked with cares and riches and pleasures of this life, and bring no fruit to perfection. But that on the good ground are they, which in an honest and good heart, having heard the word, keep it, and bring forth fruit with patience' (Luke, 8).

Parable of the Tares Christ explained the Last Judgement with the following parable. A man sowed good wheat in his field, but his enemy came during the night and sowed tares in the same field. Instead of removing the tares as soon as they appeared, the man left them until the harvest, for fear of damaging the wheat as well. At harvest time his reapers gathered and saved the wheat but burnt the tares.

Christ explained the parable: the seeds of good wheat were his followers, 'the children of the kingdom'. The tares were 'the children of the wicked one; the enemy that sowed them is the devil; the harvest is the end of the world; and the reapers are the angels' (Matthew, 13).

Parable of the Vineyard Shortly before Christ's arrest, he taught the people in the Temple with the following parable: A man planted a vineyard, then rented it to tenant farmers while he was out of the country. Later he sent his servants to bring

back grapes from the harvest but the farmers stoned some and killed others. Finally the man sent his own son, but even he was killed by the farmers. Christ asked the people how the man would punish the tenants when he returned to his vineyard, and they said, 'He will miserably destroy those wicked men, and will let out his vineyard unto other husbandmen, which shall render him the fruits in their seasons.' This was later regarded as an allegorical prediction that 'the kingdom of God' would be taken away from the Jews and given to the Gentiles, the 'other husbandmen' (Matthew, 21).

Paris, *see* Judgement of Paris.

Parnassus 'A mountain in Greece which has two peaks. . . . It was sacred to Apollo and Bacchus, wherefore the poets are said to frequent it, and the Muses are called the daughters of Parnassus' (Torrentinus).

Passage of the Red Sea, *see* Exodus.

Passing over Jordan Joshua led the Israelites when they crossed the river Jordan into Canaan, the promised land, after forty years of wandering in the wilderness. When the priests who bore the ark of the covenant before the people dipped their feet in the river the water separated. About forty thousand Israelites passed over on dry ground into the plains of Jericho. God told Joshua to choose one man from each of the twelve tribes of Israel to carry twelve stones from the middle of the Jordan, where the priests had stood, and set them up as a memorial to the miraculous crossing. When the priests, who were the last to cross, reached the other side, the waters ran together again as usual. 'And Joshua set up twelve stones . . . and they are there unto this day' (Joshua, 4).

Passover, *see* Exodus.

Saint Paul St Paul and St Peter were called the Princes of the Apostles, though Paul was not one of the original twelve.

His real name was Saul and in his early years he was a fierce persecutor of Christians and witnessed the stoning of St Stephen. His conversion occured on the road to Damascus. From then on he was a dedicated Christian and was called Paul, which the *Golden Legend* interprets to mean 'miraculously chosen'.

Paul was the author of many letters to Christian communities in Greece and Rome, and went on three missionary journeys. Though a Jew, he was also a Roman citizen, and when he was arrested in Jerusalem for his teaching he appealed to be tried before the emperor, and was taken to Rome and kept there under house arrest. The *Golden Legend* describes his martyrdom there when the Emperor Nero accused him of treason and ordered his beheading on the day St Peter was crucified. According to legend first milk and then blood gushed forth from Paul's mutilated body.

See also **Conversion of Saul.**

Paul and Barnabas at Lystra During their first missionary journey, the Apostles Paul and Barnabas came to Lystra in Syria, where they preached the gospel. When the people saw Paul's miraculous curing of a man crippled from birth, they said, 'The gods are come down to us in the likeness of men. And they called Barnabas, Jupiter; and Paul, Mercurius, because he was the chief speaker.

'Then the priest of Jupiter, which was before their city, brought oxen and garlands unto the gates, and would have done sacrifice with the people. Which when the apostles, Barnabas and Paul, heard of, they rent their clothes, and ran in among the people, crying out, and saying, Sirs, why do ye these things? We also are men of like passions with you, and preach unto you that ye should turn from these vanities unto the living God. . . . And with these sayings scarce restrained they the people, that they had not done sacrifice unto them' (Acts, 14).

Saint Paul in Ephesus When Paul was on a missionary journey in Ephesus, many magicians and exorcists were converted, and confessed their practices to him. 'And a number

of those who practised magic arts brought their books together and burned them in the sight of all. . . . So the word of the Lord grew and prevailed mightily' (Acts, 19 (RSV)).

Saint Paul the Hermit 'When the persecution of the Emperor Decius was raging in the third century Paul, the first hermit, went into the vast wilderness and lived there in a cave for sixty years, unknown to men' until his existence was revealed to Saint Antony Abbot, who set out through the woods to find him. Antony was shown the way by 'a hippocentaur, that is, a mixture of man and horse', and then by 'an animal that looked like a man above but had the shape of a she-goat below. And when Saint Antony conjured him by God to tell him who he was he replied that he was the Satyr, the fictitious god of the woodlands. Finally he met a wolf, who led him to Saint Paul.'

The two saints embraced when they met, and a raven appeared bringing them a double portion of bread. Saint Paul explained 'that God ministered to him in that manner every day and had doubled the portion that day on account of his guest'.

As Antony was on his way home he saw Paul's soul being carried to heaven by an angel, and swiftly returning he found Paul's body kneeling in prayer, as though alive. 'Holy spirit,' said Antony, 'in death you make known the way you lived.' Then, 'as he had nothing to bury him with, two lions came along and dug the grave for him' (*Golden Legend*).

Saint Paul Imprisoned at Philippi When Paul and his companion Silas were preaching in Philippi, Paul cured a young girl possessed of the spirit of divination. The men who employed her were angry because their source of profit was gone and brought Paul and Silas before the Roman magistrates of the city, accusing them of disturbing the peace. The magistrates stripped them of their clothes and had them beaten and cast into prison. But at midnight an earthquake opened the prison doors, the prison-keeper was converted and baptized, and Paul and Silas were freed. (Acts, 16).

Saint Paul on Malta When the Apostle Paul was being taken as prisoner from Israel to Rome, the ship ran aground after a storm and he, along with the other prisoners and the Roman soldiers, swam safely to land.

'After we had escaped, we then learned that the island was called Malta. And the natives showed us unusual kindness, for they kindled a fire and welcomed us all, because it had begun to rain and was cold. Paul had gathered a bundle of sticks and put them on the fire, when a viper came out because of the heat and fastened on his hand. When the natives saw the creature hanging from his hand, they said to one another, No doubt this man is a murderer. Though he has escaped from the sea, justice has not allowed him to live. He, however, shook off the creature into the fire and suffered no harm. They waited, expecting him to swell up or suddenly fall down dead; but when they had waited a long time and saw no misfortune come to him, they changed their minds and said that he was a god.' Later Paul put his hands on the father of the chief of Malta, who was sick with fever and dysentery, and healed him. (Acts, 28 (RSV)).

These miracles fulfilled the words of Christ to his disciples concerning their missionary activities after his death: 'They will pick up serpents, and . . . they will lay their hands on the sick, and they will recover' (Mark, 16 (RSVCE)).

Saint Paul Preaching in Athens When Paul was in Athens during his second missionary journey, he was disturbed to see that everyone there worshipped idols. In the synagogue and market place he preached of Christ and the resurrection, but most of the Epicurean and Stoic philosophers were dubious and others called him a babbler. Finally they brought him to the hill called the Areopagus where Paul addressed them saying, 'Ye men of Athens, I perceive that in all things ye are too superstitious. For as I passed by, and beheld your devotions, I found an alter with this inscription, TO THE UNKNOWN GOD. Whom therefore ye ignorantly worship, him declare I unto you.' After his sermon some still mocked him but others, notably Dionysius the Areopagite, believed and were converted. (Acts, 17).

Saint Paul's Ecstasy, *see* Saint Paul's Translation to Heaven.

Saint Paul's Flight from Damascus After Paul's conversion, he stayed with the disciples in Damascus and preached the word of Christ in the synagogues. 'And after that many days were fulfilled, the Jews took counsel to kill him: but their laying await was known of Saul. And they watched the gates day and night to kill him. Then the disciples took him by night, and let him down by the wall in a basket' (Acts, 9).

Saint Paul's Translation to Heaven Paul described one of his visions of God in the third person: 'I knew a man in Christ above fourteen years ago, (whether in the body, I cannot tell; or whether out of the body, I cannot tell: God knoweth;) such an one caught up to the third heaven. And I knew . . . how that he was caught up into paradise, and heard unspeakable words, which it is not lawful for a man to utter.' To prevent him from feeling superior to other men because of his visions, God sent a thorn to torment his flesh. When he asked him to take it away, God replied, 'My grace is sufficient for thee: for my strength is made perfect in weakness.' Paul explained, 'Most gladly therefore will I rather glory in my infirmities, that the power of Christ may rest upon me' (II Corinthians, 12).

Peleus and Thetis, *see* Judgement of Paris.

Penelope and the Suitors During the years it took Odysseus, king of Ithaca, to return home after the Trojan War, his wife Penelope was pestered by the unwanted attention of suitors. Assuming that Odysseus was dead, they insisted she choose a new husband from among them. For nearly four years she postponed a decision, claiming she wanted to wait until she finished weaving a shroud for Odysseus' father. She wove by day but undid her work by night, until finally one of her servants gave her away. Then the suitors caught her unravelling the work and forced her to complete it. (Homer, *Odyssey*).

Penitent Magdalene As a penitent sinner, Mary Magdalene came with a jar of ointment to the Feast at Simon's House, where she anointed Christ's head and feet, and found forgiveness for her sins. After Christ's death and burial she came to his tomb early in the morning with a jar of ointment to anoint his body, and wept because the body was no longer there. During her years of solitude before her death, she lived a life of penance, 'suffering through the tears which she poured out, for tears are the witnesses of the grief with which the sinner's heart is wounded' (Voragine, *Sermones de Sanctis*).

Pentecost, *see* Descent of the Holy Ghost.

Persephone, *see* Rape of Proserpine.

Perseus and Andromeda Because Andromeda's mother boasted that her daughter was more beautiful than the sea nymphs, the nymphs complained to Neptune and he flooded the land and sent a sea-monster to ravage it. To propitiate the god, Andromeda was chained to sharp, craggy rocks on the sea-shore as a sacrifice to the monster.

Perseus, on his way from cutting off the Medusa's head with its growth of snakes that petrified anyone who looked at it, came flying through the air on winged sandals. When he saw Andromeda he fell in love with her at once and offered to rescue her if her parents would give him her hand in marriage. The distraught parents agreed at once.

'The waves resounded, and from the boundless sea came a threatening monster ... making its way through the waters with the force of its breast.' Then Perseus, 'swooping in rapid flight through the sky ... wounded him with his curved sword', avoiding the snapping jaws and striking the shell-covered back. When he had killed the monster he freed Andromeda from her chains and claimed her as his reward and bride. As he went to wash his hands in the sea he laid the Medusa's head on a bed of leaves and sea-weed to protect it from the harsh sand. The sea-weed hardened at its touch and became coral, delighting the

210

sea-nymphs who kept testing the twigs and breaking them off. (Ovid).

Perseus Turns the Wedding Guests to Stone Andromeda had been engaged to her uncle Phineus before Perseus rescued her from the sea-monster and claimed her hand. In his jealousy Phineus, with a riotous mob of followers, broke up their luxurious wedding banquet. The battle was only brought to an end when Perseus held up the Medusa's head. Phineus' men were frozen into stone in various attitudes of assault, but Phineus turned his head aside and begged for mercy. Perseus rewarded his cowardice by swinging the head around so that Phineus unwillingly caught sight of it and he too turned to marble, keeping forever his frightened look. (Ovid).

Saint Peter, *see also* Christ Gives the Keys to Saint Peter, Denial of Peter, Death of Saint Peter, *and* Vision of Saint Peter.

Saint Peter Distributing the Common Goods By their preaching, Peter and John inspired the early Christians to give up their possessions. 'Neither was there any among them that lacked: for as many as were possessors of lands or houses sold them, and brought the prices of the things that were sold, and laid them down at the apostles' feet: and distribution was made unto every man according as he had need' (Acts, 4).

Saint Peter Enthroned A medieval legend. Before Peter was made bishop of Antioch he was imprisoned by Theophilus, the prince of the city and a pagan. When Peter promised to raise Theophilus' son, who had died fourteen years before, from the dead, 'he was led forth from prison and, as he prayed before the open tomb, the son came to life again at once. . . . Then Theophilus and all the people of Antioch and many others believed in the Lord. . . . In the next week more than 10,000 people were baptized, and Theophilus had his palace consecrated as a basilica, with a high throne for Peter from

which he could be seen and heard by all. . . . This holiday is commonly called the Enthronement of Saint Peter, from the raising of Peter to the episcopal seat at that time' (*Golden Legend*).

Saint Peter Healing the Sick with his Shadow 'And by the hands of the apostles were many signs and wonders wrought among the people . . . insomuch that they brought forth the sick into the streets, and laid them on beds and couches, that at the least the shadow of Peter passing by might overshadow some of them. There came also a multitude out of the cities round about unto Jerusalem, bringing sick folks, and them which were vexed with unclean spirits: and they were healed every one' (Acts, 5).

Peter and John Healing a Cripple at the Temple Gate A certain man, lame from birth, was carried every day to the temple in Jerusalem to beg. When he saw the apostles Peter and John about to enter the temple, he asked them for alms. Peter answered, 'Silver and gold have I none; but such as I have give I thee: In the name of Jesus Christ of Nazareth rise up and walk.' The lame man stood up 'and entered with them into the temple, walking, and leaping, and praising God' (Acts, 3).

Saint Peter Martyr A Dominican friar who was so zealous in his activities against heretics that one of them attacked him on the road to Milan and split his head open with a sword. 'But Peter suffered patiently, neither grumbling nor murmuring any complaint, and commended his soul to God saying, Lord, into thy hands I commend my spirit. Then he recited the Credo', which begins, 'I believe in God'. Because he took so long to die, his assassin stabbed him to death with a knife in his side. A Dominican who accompanied Peter was also murdered. (*Golden Legend*).

Saint Peter in Prison (Liberation of Saint Peter) King Herod persecuted certain members of the church, among them

Peter, whom he arrested and imprisoned, committing him to the custody of four guards of soldiers. 'And when Herod would have brought him forth, the same night Peter was sleeping between two soldiers, bound with two chains: and the keepers before the door kept the prison. And, behold, the angel of the Lord came upon him, and a light shined in the prison: and he smote Peter on the side, and raised him up, saying, Arise up quickly. And his chains fell off from his hands. And the angel said unto him, Gird thyself, and bind on thy sandals. And so he did. And he saith unto him, Cast thy garment about thee, and follow me. And he went out, and followed him; and wist not that it was true which was done by the angel; but thought he saw a vision. When they were past the first and the second ward, they came unto the iron gate that leadeth unto the city; which opened to them of his own accord: and they went out, and passed on through one street; and forthwith the angel departed from him. And when Peter was come to himself, he said, Now I know of a surety, that the Lord hath sent his angel, and hath delivered me out of the hand of Herod, and from all the expectations of the people of the Jews' (Acts, 12).

Saint Peter Receiving the Keys, *see* Christ Gives the Keys to Saint Peter.

Saint Peter Walks on the Sea, *see* Christ Walks on the Sea.

Saint Peter's Death, *see* Death of Saint Peter.

Saint Peter's Defence in Prison When the Apostles Peter and John healed a lame man, the Jewish elders grew suspicious and imprisoned them. During their trial the following day, 'Peter, filled with the Holy Ghost, said unto them, Ye rulers of the people, and elders of Israel, if we this day be examined of the good deed done to the impotent man, by what means he is made whole; be it known unto you all, and to all the people of Israel, that by the name of Jesus Christ of Nazareth, whom ye crucified, whom God raised from the dead, even by him doth

this man stand here before you whole. This is the stone which was set at nought of you builders, which is become the head of the corner. Neither is there salvation in any other: for there is none other name under heaven given among men, whereby we must be saved' (Acts, 4).

St Paul explains St Peter's metaphor when he describes the house of God as a holy temple 'built upon the foundation of the apostles and prophets, Jesus Christ himself being the chief corner stone' (Ephesians, 2).

Saint Peter's Vision, *see* Vision of Saint Peter.

Phaethon Son of Apollo, the sun god, and a nymph. 'After much entreaty, he persuaded his father to let him drive his four-horse chariot for a single day. But he was so unequal to the task that the horses ran away with him and the earth caught fire from the heat of the sun. As Jupiter was afraid the same thing might happen to the heavens he destroyed Phaethon with a thunderbolt' (Torrentinus).

'With the flames consuming his ruddy hair he rolled headlong downward, borne through the air in a long path, as at times a star seems to fall from the serene sky' (Ovid).

Pharaoh's Dream, *see* Joseph in Egypt.

Pharisee and Publican, *see* Publican and Pharisee.

Pharisees and Saducees Jacopo da Bergamo describes the Pharisees as 'a sect or religion . . . different from others in dress and conversation. They were more austere in dress and more sparing in food. They wore patches of paper on their foreheads and left arms with the law written on them, called phylacteries, and they wore tassels tied together at the bottom by which they were stung when they walked. They never opposed their elders; and they hoped for and preached the resurrection of the dead. They were very strongly opposed to Christ our Lord and shared the guilt for his death.'

And the Saducees 'were another sect in Judaea, but not of

214

the same religion or kind as the Pharisees: they denied that there were angels, or any resurrection of the body, and thought that body and soul perished together. And because they were so severe and not social even among themselves, they called themselves Saducees, which means The Just.'

Philemon and Baucis When Jupiter and Mercury, disguised as mortals, were travelling in Phrygia, the only place where they could find hospitality was in the humble cottage of Philemon and Baucis, an old peasant couple. Baucis revived the fire from the day before and, after much preparation, served them a hot meal, with wine that miraculously replenished itself. The old couple tried to catch their only goose to feed their visitors, but it took refuge with the gods, who finally revealed their true identity.

Jupiter and Mercury decided to flood the region for its inhospitality, but offered to save Philemon and Baucis, if they would accompany them up the mountainside. 'They both agreed, and leaning on their sticks they struggled step by step up the long slope. When they were a bow's shot from the top they looked back and saw the land below them covered by a swamp.' Their cottage alone was left standing, and had been changed into a temple. The gods made them priests of the temple until their simultaneous death, when they were turned into trees, a linden and an oak, growing side by side. (Ovid).

Saint Philip Baptizing the Ethiopian Eunuch While walking in the desert, the apostle Philip met a eunuch, who was in the service of the queen of Ethiopia, returning from a pilgrimage to Jerusalem. The eunuch was sitting in his chariot and reading a passage from the prophet Isaiah which he could not understand. Philip interpreted the passage to him as a prophecy of the Crucifixion, and then told him of Christ's teaching. 'And as they went on their way, they came unto a certain water: and the eunuch said, See, here is water; what doth hinder me to be baptized? And Philip said, If thou believest with all thine heart, thou mayest. And he

215

answered and said, I believe that Jesus Christ is the Son of God. And he commanded the chariot to stand still: and they went down both into the water, both Philip and the eunuch; and he baptized him. And when they were come up out of the water, the Spirit of the Lord caught away Philip, that the eunuch saw him no more: and he went on his way rejoicing' (Acts, 8).

Philistines Struck by a Plague, *see* Return of the Ark from Captivity.

Philopoemen Recognized Philopoemen was a Greek general from Arcadia, famous for his lack of pretension. Once dressed only in rough foot soldier's clothing he arrived at a provincial household earlier than expected and the woman of the house, bustling around in preparation for his visit, mistook him for a servant and set him to chopping wood. When her husband arrived he asked Philopoemen in astonishment 'what this meant? What else, replied Philopoemen, putting on a broad rustic accent, but that I am paying the penalty for my poor appearance?' (Plutarch).

Phineus 'King of Arcadia, whose second wife persuaded him to blind his sons. On account of this he himself was blinded through the wrath of the gods, and the harpies, rapacious birds, snatched away his food, or fouled it. But later the sons of the North wind, because they were treated humanely by Phineus, put the harpies to flight' (Torrentinus).

Phocion Phocion was an Athenian general famous for his virtue and devotion to the city. When his enemies accused him of treason he was condemned to die, and a decree was passed prohibiting the Athenians from giving his body a proper burial. Someone hired for the purpose carried the body beyond the boundaries of Attica, where it was burned. Phocion's wife covered his ashes with a burial mound, and poured libations on it. Then she took his bones to her house and buried them by the hearth until, 'when events taught the people that they had lost

216

a watchful guardian of moderation and justice, they raised a bronze statue to Phocion's memory and buried his bones at public expense' (Plutarch).

Pilate Washes his Hands When Christ was brought before Pilate to be tried, Pilate questioned him and wanted to exonerate him, following the custom of releasing a Jewish prisoner every year at the Passover. When his accusers refused his amnesty, demanding the release of a murderer instead, Pilate had Christ whipped, hoping to satisfy them in that way, but they still insisted on his crucifixion.

'When Pilate saw that he could prevail nothing, but that rather a tumult was made, he took water, and washed his hands before the multitude, saying, I am innocent of the blood of this just person: see ye to it' (Matthew, 27).

'And the voices of them and of the chief priests prevailed. And Pilate gave sentence that it should be as they required. And he released unto them him that for sedition and murder was cast into prison, whom they had desired; but he delivered Jesus to their will' (Luke, 23).

Placidus, *see* Saint Benedict.

Plague at Ashdod, *see* Return of the Ark from Captivity.

Plucking Grain on the Sabbath 'And it came to pass, that he'—Christ—'went through the corn fields on the sabbath day; and his disciples began, as they went, to pluck the ears of corn. And the Pharisees said unto him, Behold, why do they on the sabbath day that which is not lawful? And he said unto them, Have ye never read what David did, when he had need, and was an hungered, he, and they that were with him? How he went into the house of God in the days of Abiathar the high priest, and did eat the shewbread, which is not lawful to eat but for the priests, and gave also to them which were with him? And he said unto them, The sabbath was made for man, and not man for the sabbath: therefore the Son of man is Lord also of the sabbath' (Mark, 2).

217

Polyphemus, *see also* Galatea, Polyphemus and Acis.

Polyphemus and Ulysses 'Polyphemus was the son of Neptune, and one of the Cyclopes, that is, a giant with one eye who lived on human flesh. When he had eaten some of Ulysses' companions, Ulysses gave him some excellent wine to drink. Then when he was thoroughly drunk and had fallen into a heavy sleep, Ulysses and his companions blinded him with their spears' (Torrentinus).

In Homer's *Odyssey*, Ulysses put out the Cyclops' eye with a long wooden shaft sharpened in the fire.

Polyxena, *see* Immolation of Polyxena.

Pomona, *see* Vertumnus and Pomona.

Potiphar's Wife, *see* Joseph in Egypt.

Prefigurations The ancient Hebrews based their expectation of the Messiah's coming on prophecies found in the Old Testament. In order to show that he was the Messiah, Christ sometimes referred these prophecies to himself. He also drew allegorical parallels between his Passion and Old Testament events that were not obviously prophetic, as Jonah, and the Brazen Serpent. After Christ's death Christians expanded this kind of interpretation, now known as typology, and regarded many passages in the Old Testament as prophecies of the events of Christ's life – for instance, the ox and the ass at the Nativity, or The Man of Sorrows, both from the prophet Isaiah. Later, prefigurations of Christ were found even in non-Hebrew history, for instance Antipater Showing His Wounds to Caesar; and St Jerome interpreted the entire Old Testament as an allegorical foretelling of the New Testament and of the lives of Christ and the Virgin.

Presentation of Christ in the Temple Forty days after his birth, Jesus' parents brought him to Jerusalem to present him in the Temple, 'and to offer a sacrifice according to that which

is said in the law of the Lord, A pair of turtledoves, or two young pigeons.

'And, behold, there was a man in Jerusalem, whose name was Simeon; and the same man was just and devout, waiting for the consolation of Israel: and the Holy Ghost was upon him. And it was revealed unto him by the Holy Ghost, that he should not see death, before he had seen the Lord's Christ. And he came by the Spirit into the temple: and when the parents brought in the child Jesus, to do for him after the custom of the law, then took he him up in his arms, and blessed God, and said, Lord, now lettest thou thy servant depart in peace, according to thy word: for mine eyes have seen thy salvation, which thou hast prepared before the face of all people; a light to lighten the Gentiles, and the glory of thy people Israel. And Joseph and his mother marvelled at those things which were spoken of him. . . .

'And there was one Anna, a prophetess . . . and she was a widow of about fourscore and four years, which departed not from the temple, but served God with fastings and prayers night and day. And she coming in that instant gave thanks likewise unto the lord, and spake of him to all them that looked for redemption in Jerusalem' (Luke, 2).

Presentation of the Virgin When the Virgin was three years old, her parents, Anne and Joachim, brought her with offerings to the Temple in Jerusalem. 'Around the Temple were 15 steps, corresponding to the 15 Gradual Psalms. When the Virgin was placed on the lowest step, she climbed all of them without any help, as though she were already full grown.' Then the priest took her in his arms and blessed her. Because Anne and Joachim had vowed to dedicate the Virgin to a life of serving God in the Temple, they left her there with the other virgins and, after making their offering, went home. (*Golden Legend*).

The Gradual Psalms were those sung on the way to Jerusalem at the time of special pilgrim feasts.

Priapus 'The unsightly divinity of gardens, son of Bacchus and Venus. His statue, with a huge male organ, was set up in

gardens. . . . They used to sacrifice donkeys to him' (Torrentinus).

Procession of Saint Gregory During a plague in Rome Pope Gregory the Great had an image of the Virgin, that had been painted by Luke the Evangelist, carried in solemn procession through the city. 'All the heavy contamination of the air gave way before the image, as though unable to stand in the presence of the Virgin, and the air became serene and pure instead.' Angelic voices were heard singing Alleluia, and Gregory 'saw an angel of the Lord wiping a bloody sword and replacing it in its sheath. And thus he understood that the plague was at an end' (*Golden Legend*).

Procris, *see* Cephalus and Procris.

Prodigal Son When the scribes and Pharisees complained that Christ welcomed sinners and ate with them, Christ told them this parable to illustrate his remark that there is more rejoicing in heaven over one repentant sinner than over ninety-nine just men who have no need of repentance.

The younger of two sons requested and received his share of his father's property, then wasted it in riotous living in a foreign country. But when he came close to starvation during a famine, he repented of his way of life and went back to his father's house to ask for work among the servants. 'And he arose, and came to his father. But when he was yet a great way off, his father saw him, and had compassion, and ran, and fell on his neck, and kissed him. And the son said unto him, Father, I have sinned against heaven, and in thy sight, and am no more worthy to be called thy son. But the father said to his servants, Bring forth the best robe, and put it on him; and put a ring on his hand, and shoes on his feet: and bring hither the fatted calf, and kill it; and let us eat, and be merry: for this my son was dead, and is alive again; he was lost, and is found. And they began to be merry.

'Now his elder son was in the field: and as he came and drew nigh to the house, he heard musick and dancing.' The elder son

reproached his father: 'Lo, these many years do I serve thee, neither transgressed I at any time thy commandment: and yet thou never gavest me a kid, that I might make merry with my friends: but as soon as this thy son was come, which hath devoured thy living with harlots, thou hast killed for him the fatted calf. And he said unto him, Son, thou art ever with me, and all that I have is thine. It was meet that we should make merry, and be glad: for this thy brother was dead, and is alive again; and was lost, and is found' (Luke, 15).

Prodigal Son Chased away by Prostitutes The Middle Ages expanded the Biblical allusion to the prodigal son's 'riotous living in a foreign country', where he wasted his inheritance 'with harlots'. In the fifteenth century *Rappresentazione del Figliuol Prodigo* he feasts and drinks at an inn where ruffians beat him at cards, and the inn-keeper arranges for him to spend the night with a serving-maid. When his money is gone, she chases him away in his nightshirt and barefoot. 'What are you doing here, you rogue?' she cries. 'Get out at once, or a good hiding is what you'll get!' The prodigal son realizes he has been taken advantage of and laments, 'Now that they've got my money and my clothes they call me buffoon and cry thief.'

Prometheus Bound 'Prometheus was the first to model in clay, which is why they say he created man. For there is a story that he climbed to heaven and stole fire in a reed, and used the fire to give life to a statue he had made. Jupiter got angry, had him tied to Mount Caucasus, and sent an eagle to eat away his heart. The meaning of this myth is that he was given to studying, and learned in astronomy' (Torrentinus).

In ancient mythology, the eagle ate away daily at his liver, which grew back again every night.

Proserpine, *see* Rape of Proserpine.

Publican and Pharisee Christ 'spake this parable unto certain which trusted in themselves that they were righteous,

and despised others: Two men went up into the temple to pray; the one a Pharisee, and the other a publican. The Pharisee stood and prayed thus with himself, God, I thank thee, that I am not as other men are, extortioners, unjust, adulterers, or even as this publican. I fast twice in the week, I give tithes of all that I possess.

'And the publican, standing afar off, would not lift up so much as his eyes unto heaven, but smote upon his breast, saying, God be merciful to me a sinner.'

Christ commented, 'I tell you, this man went down to his house justified rather than the other: for every one that exalteth himself shall be abased; and he that humbleth himself shall be exalted' (Luke, 18).

Punishment of Ananias The early Christians, under the guidance of the apostles, sold their possessions, and the proceeds were distributed to each man according to his need.

'But a certain man named Ananias, with Sapphira his wife, sold a possession, and kept back part of the price, his wife also being privy to it, and brought a certain part, and laid it at the apostles' feet. But Peter said, Ananias, why hath Satan filled thine heart to lie to the Holy Ghost, and to keep back part of the price of the land. . . . Thou hast not lied unto men, but unto God. And Ananias hearing these words fell down, and gave up the ghost' (Acts, 5).

Purification of the Virgin, *see* Presentation of Christ in the Temple.

Pyramus and Thisbe 'Pyramus was a young man of Babylon who loved the maiden Thisbe with a passion which she returned. This love they managed to conceal from their parents, who kept a close watch on them. However, they arranged to slip out one night and meet in a certain place under a certain tree. But Thisbe arrived first, and seeing a lion, fled into the woods, leaving her cloak behind. When Pyramus came and saw the cloak torn by the lion, he thought that Thisbe had been devoured, and killed himself with his sword. Thisbe

returned and, seeing him dead, she too killed herself with the same sword' (Torrentinus).

Queen of Sheba 'And when the queen of Sheba heard of the fame of Solomon concerning the name of the Lord, she came to prove him with hard questions. And she came to Jerusalem with a very great train, with camels that bare spices, and very much gold, and precious stones: and when she was come to Solomon, she communed with him of all that was in her heart. And Solomon told her all her questions: there was not any thing hid from the king, which he told her not. And when the queen of Sheba had seen all Solomon's wisdom, and the house that he had built, and the meat of his table, and the sitting of his servants, and the attendance of his ministers, and their apparel, and his cupbearers, and his ascent by which he went up unto the house of the Lord; there was no more spirit in her. And she said to the king, It was a true report that I heard in mine own land of thy acts and of thy wisdom. Howbeit I believed not the words, until I came, and mine eyes had seen it: and, behold, the half was not told me: thy wisdom and prosperity exceedeth the fame which I heard. . . .

'And she gave the king an hundred and twenty talents of gold, and of spices very great store, and precious stones. . . . And king Solomon gave unto the queen of Sheba all her desire, whatsoever she asked, beside that which Solomon gave her of his royal bounty. So she turned and went to her own country, she and her servants' (I Kings, 10).

Queen of Sheba and her Retinue, *see* Invention of the True Cross.

Quos Ego ('Whom I . . .') Juno persuaded Aeolus, king of the winds, to blow up a violent storm in an attempt to sink Aeneas and the other survivors of the Trojan War before they could reach Italy, where they were destined to found Rome. The ensuing storm 'beat upon the sail and carried the waves to the stars', and the Trojan ships were caught by the winds and flung about. Neptune, attracted by the commotion, rose from

the sea, indignant that the winds should dare to stir up a storm
without his consent. 'Quos ego . . .', he began, and then broke
off, leaving unspoken the implied threat of punishment. 'But
first let's settle the waves.' Quickly calming the sea Neptune
dispersed the clouds and brought back the sun. As he did so
Triton and a nereid dislodged the ships from the sharp rocks,
and Neptune rode away on his horse-drawn chariot. (Virgil).

Raising of the Cross Caxton's edition of Bonaventura
describes this episode of Christ's crucifixion: 'First laying the
cross on the ground they nailed him thereupon, and after with
him so hanging they lifted up the cross and fastened it down in
the earth' (trans. Nicholas Love, 1490).

In a York mystery play, the hole or mortice in which the
cross is set is too wide, and the Roman soldiers hammer in
wedges to fix it in place.

See also, **Nailing to the Cross.**

Raising of Lazarus To avoid being arrested Jesus had left
Judaea, but when Mary Magdalene and Martha sent word that
their brother Lazarus, whom he loved, was sick he decided to
return. Lazarus' sickness, he said, was 'for the glory of God,
that the Son of God might be glorified thereby'. The apostles
opposed his return to Judaea because of the danger involved,
but Thomas persuaded them to go along, 'that we may die with
him'.

When Jesus arrived in Bethany Lazarus was dead, and when
Jesus wanted the stone removed from before the tomb, Martha
said, 'Lord, by this time he stinketh: for he hath been dead four
days. Jesus saith unto her, Said I not unto thee, that, if thou
wouldest believe, thou shouldest see the glory of God? Then
they took away the stone from the place where the dead was
laid. And Jesus lifted up his eyes, and said, Father, I thank thee
that thou hast heard me. And I knew that thou hearest me
always: but because of the people which stand by I said it, that
they may believe that thou hast sent me. And when he thus had
spoken, he cried with a loud voice, Lazarus, come forth. And he
that was dead came forth, bound hand and foot with grave-

clothes: and his face was bound about with a napkin. Jesus saith unto them, Loose him, and let him go.'

This miracle was meant to strengthen men's belief, and to illustrate Christ's words, 'I am the resurrection, and the life: he that believeth in me, though he were dead, yet shall he live: and whosoever liveth and believeth in me shall never die' (John, 11).

Raising of Tabitha A miracle of St Peter: a certain disciple of his called Tabitha, a woman 'full of good works and almsdeeds', fell sick and died. Peter was summoned to view the dead body, 'and all the widows stood by him weeping, and shewing the coats and garments' which Tabitha had made. But Peter sent them out and prayed by the body and said, 'Tabitha, arise. And she opened her eyes: and when she saw Peter, she sat up. And he gave her his hand, and lifted her up', and he presented her alive to all her friends. (Acts, 9).

Raising of the Widow's son at Nain One of Christ's miracles: 'And it came to pass . . . that he went into a city called Nain; and many of his disciples went with him, and much people. Now when he came nigh to the gate of the city, behold, there was a dead man carried out, the only son of his mother, and she was a widow: and much people of the city was with her. And when the Lord saw her, he had compassion on her, and said unto her, Weep not. And he came and touched the bier: and they that bare him stood still. And he said, Young man, I say unto thee, Arise. And he that was dead sat up, and began to speak. And he delivered him to his mother. And there came a fear on all: and they glorified God, saying, That a great prophet is risen up among us; and, That God hath visited his people' (Luke, 7).

Rape of the Daughters of Leucippus Castor and Pollux were the twin sons of Jupiter and Leda, Pollux having inherited his father's immortality, but Castor being a mortal like his mother. When they saw 'Phoebe and Hilaira, the daughters of Leucippus, the first the priestess of Minerva, the second of Diana, and both very beautiful virgins, they fell in love with

them and carried them off. But the girls' fiancés armed themselves and tried to get them back.' In the battle that followed Castor was killed, but Pollux offered to share his immortality with him. They were placed among the stars and spend half their time in the underworld and the other half above the earth. (Hyginus).

Rape of Proserpine Pluto, god of the underworld, had come above ground to inspect the region around Mount Aetna for fissures that might let unwanted light into his dark kingdom. Venus, sitting on another Sicilian mountain, saw him and seized the opportunity to extend her influence to 'the third part of the world' – for she had already overcome Jupiter and Neptune, the gods of sky and sea. The second victim was to be Ceres' virgin daughter Proserpine, Pluto's niece, who had shown too strong an inclination to spurn Venus and follow the virgin goddesses Minerva and Diana. At Venus' urging Cupid chose his sharpest and surest arrow to use on Pluto.

Proserpine was picking flowers in a meadow with her companions, gathering violets and lilies in baskets and putting some into the folds of her dress, when Pluto 'saw her, and loved her, and carried her off – so hasty was his love. The frightened goddess mournfully cried out for her mother and for her friends – more often for her mother – and as she tore the top of her dress the gathered flowers fell neglected from its folds. Such was her youthful innocence that that slight loss too moved her virgin sorrow.' Pluto took her in his horse-drawn chariot to the underworld and made her his queen. Ceres wandered over land and sea sadly looking for her lost daughter. When she discovered that Pluto had taken her she begged Jupiter, Proserpine's father, to bring her back to the upper world. But Proserpine had eaten seven pomegranate seeds while in the underworld, and even Jupiter could do no more than allow her to spend half of the year above ground with her mother, and the rest of it with her husband. (Ovid).

Rape of the Sabine Women Some time after the establishment of Rome, the Romans began to look for wives among the

surrounding Italian cities, but were refused by them. As there was a serious shortage of marriageable women at Rome, they decided to take wives by guile and force. Romulus, the first king and founder of the city, held an athletic contest and invited the surrounding cities to come. The Sabines, suspecting nothing, came in great numbers with their wives and families. The guests were lost in admiration of the walls and buildings of the newly built city when, at a given signal, the Romans rushed on their guests, seized all the young Sabine women, and carried them off to their homes. The Sabine men fled in dismay, but a war soon followed. Finally, just as it appeared that the Romans and the Sabines would destroy each other in a pitched battle, the Sabine women who had been seized by the Romans rushed out and intervened between their fathers and brothers and their new found husbands. As a result, the war concluded in a treaty of alliance between the two cities. (Livy).

Rebecca at the Well, *see* Eliezer and Rebecca.

Rebellion of Korah Korah and 250 discontented leaders of the Israelites rebelled against the religious leadership of Moses and Aaron. When they offered incense to God, usurping Aaron's authority, they were punished for their rebellion by being consumed with fire. When Dathan and Abiram also complained of the power Moses wielded, they and their families were swallowed alive in an earthquake. These punishments were signs that Moses had been sent by God to lead the Israelites, and that Korah and the others had acted in defiance of God. (Numbers, 16).

Reconciliation of David and Absalom After Absalom, King David's son, had his brother murdered because he had raped their sister, he fled into exile for three years. One of David's ministers devised a way to bring the banished son home again, for he saw that David missed him, and there was a temporary reconciliation. When Absalom was summoned, 'he came to the king, and bowed himself on his face to the ground before the king: and the king kissed Absalom' (II Samuel, 14).

Red Sea, *see* Exodus.

Rest on the Flight into Egypt Joseph and Mary fled with the Christ child to Egypt to escape the slaughter by King Herod's soldiers of all children in Bethlehem two years old and under. The Middle Ages expanded the story, adding the following details.

'On the third day of their flight, Mary, tired by the intense heat of the sun, saw a palm tree and asked Joseph if she could rest for a while in its shade.' When Joseph had her comfortably seated on the ground 'she looked up at the palm fronds full of fruit and said she wished she could reach some of it. Joseph replied that he was thinking more about water, for their water skins were almost empty. . . . Then the infant Jesus, sitting in his mother's lap and with a happy look, said to the palm, Bend your branches and refresh my mother with your fruit. At the sound of his voice the palm bent its top to the soles of Mary's feet, and they gathered its fruit with which they were all refreshed.' Then Jesus told the palm to rise and 'open the course of water hidden below its roots . . . and the palm straightened itself at once and a fountain of water rose from beneath it, limpid, cool and sparkling.' They and their animals drank their fill, 'rejoicing and giving thanks to God' (*New Testament Apocrypha, Pseudo-Matthew*).

'In the course of their journey they came upon a farmer who was sowing wheat. No sooner had the Christ child put his hand in the sack and thrown out a fist full of seed than the wheat was as high and ripe as if it had been growing for a year. Herod's soldiers, looking for the child in order to kill him, came to the farmer as he was harvesting the wheat. They asked him if he had seen a woman carrying a child. Yes, he replied, when I was sowing my wheat.' The soldiers, supposing that the wheat must have been sown close to a year before, gave up their search and turned back. (*De quelques miracles que l'enfant Jésus fit en sa jeunesse*).

When they came to Egypt they found no one to give them hospitality, so went to lodge in a temple where there were 355 pagan idols. 'When Mary went into the temple with the infant

Jesus, all the idols fell to the ground and lay broken before her, thus plainly demonstrating that they were worthless. Then was fulfilled what was said by the prophet Isaiah: Behold the Lord shall come upon a light cloud and shall enter Egypt, and all the idols of the Egyptians shall be moved before his face' (*New Testament Apocrypha, Pseudo-Matthew*).

Resurrection On the morning of the third day following his burial and descent into limbo Christ rose again from the dead. An Italian mystery play describes the scene, which is set before the cave where the soldiers are guarding the tomb: 'Suddenly Christ is resurrected with earthquakes and loud thunderings, and the soldiers fall to earth as though dead. And Christ, holding the banner of the cross, with an angel on either side, says:

> 'My soul, gone down to hell three days ago, today
> is one with God, and delivered from the inferno.
> It has taken on immortal and glorious flesh. The
> beginning of a new life has been granted, which
> death can no longer deny' (*La Resurrezione*,
> anonymous, 15th century).

According to other medieval writers Christ was dressed in gleaming white. The banner he carried 'was made of the white garment in which he was mocked by Herod and of the red in which he was mocked when he was crowned with thorns'. The banner 'signifies the victory of the Resurrection and Ascension of Christ' (*Mirror of Man's Salvation* and *Golden Legend*).

Resurrection of Jairus' Daughter One of the miracles of Christ. 'And, behold, there cometh one of the rulers of the synagogue, Jairus by name; and when he saw him, he fell at his feet, and besought him greatly, saying, My little daughter lieth at the point of death: I pray thee, come and lay thy hands on her, that she may be healed; and she shall live. And Jesus went with him; and much people followed him, and thronged him' (Mark, 5).

After Christ had cured the Woman with an Issue of Blood,

229

'there cometh one from the ruler of the synagogue's house, saying to him, Thy daughter is dead: trouble not the Master. But when Jesus heard it, he answered him, saying, Fear not: believe only, and she shall be made whole.

'And when he came into the house, he suffered no man to go in, save Peter, and James, and John, and the father and the mother of the maiden. And all wept, and bewailed her: but he said, Weep not; she is not dead, but sleepeth. And they laughed him to scorn, knowing that she was dead. And he put them all out, and took her by the hand, and called, saying, Maid, arise. And her spirit came again, and she arose straightway: and he commanded to give her meat. And her parents were astonished: but he charged them that they should tell no man what was done' (Luke, 8).

Return of the Ark from Captivity The ark was a portable sanctuary in which the Jews kept historical objects from the period of their wanderings in the wilderness: a sample of the manna on which they fed for forty years, the stone tablets of the Law which Moses received from God on Mount Sinai, and the rod of Aaron which blossomed and thus indicated his election as high priest of Israel. When the Philistines defeated Israel in battle, they took the ark and kept it in the city of Ashdod. But when the Lord 'smote them in the inner parts of their buttocks' and 'the cities and houses of the region boiled up, and there was a plague of mice, and there was great confusion and death in the city', they decided to send the ark back. They consulted their priests, who told them to 'make images of your haemorrhoids, and images of mice, which have destroyed the land: and give glory to the God of Israel'. Following the priests' instructions they yoked two cows that had borne calves to a new cart on which they placed the ark and the golden images of the mice and haemorrhoids as a guilt offering. The cows, left to go where they would, spontaneously drew the cart out of Philistine territory, a sign that the plague would also leave. The Jews received the ark and sacrificed the cows to the Lord. (I Samuel, 5 and 6 (Vulgate)).

The Middle Ages found a parallel between the Return of the

Ark from Captivity and the bodily Assumption of the Virgin Mary into heaven after her death. In the *Mirror of Man's Salvation* the ark with the manna in it 'symbolizes the Virgin, for she bore the bread of heaven, that is Christ, for the world'. The Assumption was thought of as Mary's return to heaven from the exile of earth.

Return from Egypt The Holy Family fled to Egypt to avoid King Herod's slaughter in Bethlehem of all children two years old and under. 'But when Herod was dead, behold, an angel of the Lord appeareth in a dream to Joseph in Egypt, saying, Arise, and take the young child and his mother, and go into the land of Israel: for they are dead which sought the young child's life. And he arose, and took the young child and his mother, and came into the land of Israel. But when he heard that Archelaus did reign in Judaea in the room of his father Herod, he was afraid to go thither: notwithstanding, being warned of God in a dream, he turned aside into the parts of Galilee: and he came and dwelt in a city called Nazareth: that it might be fulfilled which was spoken by the prophets, He shall be called a Nazarene' (Matthew, 2).

Rich Man and Lazarus, *see* Dives and Lazarus.

Rinaldo and Armida This is an incident from Tasso's *Jerusalem Liberated*. Rinaldo was a commander in the Christian army during one of the crusades to free Jerusalem from the Saracens. Armida, skilled in all the arts of magic, was sent by the devil to entice the Christian warriors with her feminine charms and divert them from their aim. She captured Rinaldo by luring him to an island where she appeared to him, rising naked from a stream, and lulled him to sleep with a song of love. Then, binding him in chains of roses and lilies, she abducted him to her palace.

Rinaldo fell under Armida's spell and spent long hours with her, until a band of his fellow warriors came to his rescue. Tasso describes them catching sight of the lovers through the branches of the trees of Armida's magic garden:

'There sat Armida on a flowery bed;
Her wanton lap sustained the hero's head:
Her opening veil her ivory bosom showed;
Loose to the fanning breeze her tresses flowed;
A languor seemed diffused o'er all her frame,
And every feature glowed with amorous flame.'

Waiting until Rinaldo was alone, his friends showed him his image in a shield and thus wakened him from his trance. Rinaldo escaped with them and rejoined his army, and Armida, discovering his flight, destroyed her enchanted palace in a rage. (*Gerusalemme Liberata*, trans. John Hoole, 1810).

River Styx, *see* Aeneas in the Underworld.

Saint Roch A French saint and martyr. When his parents died he distributed his rich patrimony to the poor and set out as a pilgrim for Rome with the pilgrim's traditional hat, stick and sack slung over his shoulder. On his journey he came to cities devastated by the plague. Entering a lazaret he cured many of those afflicted by making the sign of the cross, and then himself received a mysterious arrow wound in his left thigh. When he finally recovered, France was at war, and when he returned he was arrested as a spy, put in prison, and left there until his death five years later at the age of thirty-two. A small tablet was found at his side which said, 'Anyone suffering from the plague who turns to the protection of St Roch will escape the contagion' (*Golden Legend*).

Roger and Angelica An incident from Ariosto's *Orlando Furioso*. Angelica, a beautiful princess from Cathay, was chained to the rocks off the coast of Ireland to be sacrificed to a dreadful sea monster who was ravaging the shore. As the monster was approaching, the young hero Roger flew by on his winged horse, wounded it with his sword and spear and, using a magic shield, stopped its advance. Releasing Angelica's chains he quickly put her behind him on his horse and, mounting in the air, flew away with her to safety.

232

Romulus and Remus The legendary founders of Rome, twins who were exposed on a mountain as infants. 'There they were found by the shepherd Faustulus, and brought up by his wife Laurentia, who was called a wolf by the shepherds because she made money from the use of her notorious body. But this is a myth; Romulus and Remus were brought up in fact by a real wolf' (Stephanus).

Wolf in Latin is a slang term for prostitute.

Saint Rosalie Rosalie is the patron saint of Palermo in Sicily. She was born in the twelfth century and was descended from Charlemagne, and though she could have spent her time with royalty she preferred a life of solitude and penance. When a mountain grotto near Palermo was excavated in the seventeenth century an inscription was found in which Rosalie declared that 'for the love of my Lord Jesus Christ I have decided to live in this cave'. When the plague broke out her body was publicly displayed and the plague ended. (*Acta Sanctorum*).

Ruth During a famine in Israel in the days when the judges ruled, Naomi, her husband, and their two sons left Israel and went to live in the country of Moab, where the sons took Moabite wives. But when her husband and both her sons died, Naomi decided to go back to her birthplace.

Ruth and Naomi. Hebrew law required a childless widow to marry her husband's brother or nearest living relative and have a son by him, who would be considered the descendant of her first husband, thus keeping his property within the family and his name alive. Because Naomi had no other sons to give her daughters-in-law, she urged them to stay in Moab with their own people. But one of them, Ruth, preferred to stay with Naomi and said, 'Intreat me not to leave thee, or to return from following after thee: for whither thou goest, I will go; and where thou lodgest, I will lodge: thy people shall be my people, and thy God my God.' Ruth thus showed her adherence to the Hebrew idea of loyalty, even though she was not Jewish herself.

Ruth and Boaz. Ruth and Naomi went to Bethlehem where

Ruth gleaned barley after the harvesters in a field owned by Boaz, a relative of her dead father-in-law. When Boaz was kind to Ruth, Naomi urged her to visit him at night at his threshing floor, where he was winnowing the barley. 'And when Boaz had eaten and drunk, and his heart was merry, he went to lie down at the end of the heap of corn: and she came softly, and uncovered his feet, and laid her down.' When Boaz awoke and found Ruth there, she pointed out to him that he had the right, as a near relative, to marry her. Boaz praised Ruth for not scorning an older man like himself in favour of a young one and said, 'Fear not; I will do to thee all that thou requirest: for all the city of my people doth know that thou art a virtuous woman.' Boaz purchased the land belonging to Ruth's dead father-in-law and married Ruth. Their grandson was Jesse, the father of King David. (The Book of Ruth).

Sabines, *see* Rape of the Sabine Women.

Sacrifice of Isaac 'And it came to pass after these things, that God did tempt Abraham, and said unto him, Abraham: and he said, Behold, here I am. And he said, Take now thy son, thine only son Isaac, whom thou lovest, and get thee into the land of Moriah; and offer him there for a burnt offering upon one of the mountains which I will tell thee of.

'And Abraham rose up early in the morning, and saddled his ass, and took two of his young men with him, and Isaac his son, and clave the wood for the burnt offering, and rose up, and went unto the place of which God had told him. Then on the third day Abraham lifted up his eyes, and saw the place afar off. And Abraham said unto his young men, Abide ye here with the ass; and I and the lad will go yonder and worship, and come again to you. And Abraham took the wood of the burnt offering, and laid it upon Isaac his son; and he took the fire in his hand, and a knife; and they went both of them together.

'And Isaac spake unto Abraham his father, and said, My father: and he said, Here am I, my son. And he said, Behold the fire and the wood: but where is the lamb for a burnt offering? And Abraham said, My son, God will provide himself a lamb

for a burnt offering: so they went both of them together. And they came to the place which God had told him of; and Abraham built an altar there, and laid the wood in order, and bound Isaac his son, and laid him on the altar upon the wood. And Abraham stretched forth his hand, and took the knife to slay his son. And the angel of the Lord called unto him out of heaven, and said, Abraham, Abraham: and he said, Here am I. And he said, Lay not thine hand upon the lad, neither do thou any thing unto him: for now I know that thou fearest God, seeing thou hast not withheld thy son, thine only son from me. And Abraham lifted up his eyes, and looked, and behold behind him a ram caught in a thicket by his horns: and Abraham went and took the ram, and offered him up for a burnt offering in the stead of his son' (Genesis, 22).

The Middle Ages commonly made Isaac 'who carried on his own shoulder the wood on which he was to be sacrificed', a prefiguration of Christ carrying the cross. (*Mirror of Man's Salvation*).

Saducees, *see* Pharisees and Saducees.

Salmacis and Hermaphroditus Salmacis was a nymph who spent most of her time in leisurely bathing in her own clear pool. One day she caught sight of the young boy Hermaphroditus and longed to possess him at once. But her too eager advances embarrassed the boy, so she pretended to give up and go away. 'Even then she kept looking back. Concealing herself quickly in a thicket of bushes she knelt down and watched him.' Hermaphroditus, not knowing he was being spied on, took off his clothes and dived into the pool. This was more than the nymph could bear, and exclaiming, 'He's mine!' she jumped naked into the water beside him. But her efforts to seduce him were unsuccessful until, as she prayed that the gods would never separate them from each other, their two bodies became as one, possessing the nature of both man and woman. (Ovid).

Salome, *see* Beheading of John the Baptist.

Samaritan Woman, *see* Woman of Samaria.

Samson Samson was a military hero of Israel and was famous for his great strength. He was a Nazarite, that is, his life was dedicated to God and therefore he never drank wine or cut his hair.

Manoah's Sacrifice. An angel told Manoah's wife, who had been barren, that she would bear a son who would deliver Israel from the Philistines, who controlled Israel at that time. 'And no razor shall come on his head: for the child shall be a Nazarite unto God from the womb. . . . So Manoah took a kid with a meat offering, and offered it upon a rock unto the Lord: and the angel did wonderously; and Manoah and his wife looked on. For it came to pass, when the flame went up toward heaven from off the altar, that the angel of the Lord ascended in the flame of the altar. And Manoah and his wife looked on it, and fell on their faces to the ground. . . . And the woman bare a son, and called his name Samson.'

Samson Rending the Lion. Although Samson was a Hebrew he wanted to marry a Philistine woman. When he was on the way to visit her 'a young lion roared against him. And the Spirit of the Lord came mightily upon him, and he rent him as he would have rent a kid, and he had nothing in his hand: but he told not his father or his mother what he had done. And he went down, and talked with the woman; and she pleased Samson well. And after a time he returned to take her, and he turned aside to see the carcase of the lion: and, behold, there was a swarm of bees and honey in the carcase of the lion. And he took thereof in his hands, and went on eating, and came to his father and mother, and he gave them, and they did eat: but he told not them that he had taken the honey out of the carcase of the lion.'

Samson's Wedding. At his wedding banquet Samson proposed a riddle to the Philistines who had been invited: 'Out of the eater came forth meat, and out of the strong came forth sweetness'. If they could guess the answer, Samson agreed to give them linen garments; if they could not, they were to give garments to Samson. His wife, with her tears, drew the answer from him: the eater was the lion, and the sweetness was the honey. She

betrayed Samson by telling this to the Philistines, who had not been able to solve the riddle themselves. In his anger Samson killed thirty men of Ascalon, a Philistine city, and gave their garments to the Philistines.

Samson Threatening his Father-in-Law. When Samson returned from the wheat harvest and wanted to sleep with his wife, his father-in-law would not let him go in to see her, and told him he had given her to the best man at the wedding. In revenge Samson burned the Philistines' crops and slaughtered many of their men.

Samson Kills a Thousand Men with the Jawbone of an Ass. When the men of Judah were treacherously about to deliver Samson bound to the Philistines, 'the Spirit of the Lord came mightily upon him, and the cords that were upon his arms became as flax that was burnt with fire, and his bands loosed from off his hands. And he found a new jawbone of an ass, and put forth his hand, and took it, and slew a thousand men therewith. And Samson said, With the jawbone of an ass, heaps upon heaps, with the jaw of an ass have I slain a thousand men.' After that Samson was thirsty and God made water flow from the hollow in the jawbone for him to drink.

Samson with the Gates of Gaza. The Philistines planned to kill Samson one morning as he was leaving a harlot's house in the Philistine city of Gaza, where he had spent the night. 'And they compassed him in, and laid wait for him all night in the gate of the city, and were quiet all the night, saying, In the morning, when it is day, we shall kill him. And Samson lay till midnight, and arose at midnight, and took the doors of the gate of the city, and the two posts, and went away with them, bar and all, and put them upon his shoulders, and carried them up to the top of an hill that is before Hebron.'

Samson and Delilah. When Samson fell in love with Delilah, the Philistines bribed her to find out the secret of his strength. Although he gave her many false answers, 'it came to pass, when she pressed him daily with her words, and urged him, so that his soul was vexed unto death; that he told her all his heart, and said unto her, There hath not come a razor upon mine head; for I have been a Nazarite unto God from my

mother's womb: if I be shaven, then my strength will go from me, and I shall become weak, and be like any other man.'

Blinding of Samson. 'And when Delilah saw that he had told her all his heart, she sent and called for the lords of the Philistines, saying, Come up this once, for he hath shewed me all his heart. Then the lords of the Philistines came up unto her, and brought money in their hand. And she made him sleep upon her knees; and she called for a man, and she caused him to shave off the seven locks of his head; and she began to afflict him, and his strength went from him. And she said, The Philistines be upon thee, Samson. And he awoke out of his sleep, and said, I will go out as at other times before, and shake myself. And he wist not that the Lord was departed from him. But the Philistines took him, and put out his eyes, and brought him down to Gaza, and bound him with fetters of brass; and he did grind in the prison house.'

Samson's Death. 'Howbeit the hair of his head began to grow again', and when the Philistines assembled to sacrifice to their god Dagon and to celebrate their victory over Samson, and brought the blind man from prison to make fun of him, 'Samson said unto the lad that held him by the hand, Suffer me that I may feel the pillars whereupon the house standeth, that I may lean upon them. . . . And Samson called unto the Lord, and said, O Lord God, remember me, I pray thee, and strengthen me, I pray thee, only this once, O God, that I may be at once avenged of the Philistines for my two eyes. And Samson took hold of the two middle pillars upon which the house stood, and on which it was borne up, of the one with his right hand, and of the other with his left. And Samson said, Let me die with the Philistines. And he bowed himself with all his might; and the house fell upon the lords, and upon all the people that were therein. So the dead which he slew at his death were more than they which he slew in his life' (Judges, 13–16).

The Middle Ages attached symbolic meaning to several incidents in Samson's life. Samson Rending the Lion became a prefiguration of Christ 'who overcame our enemy, the infernal lion'. Samson with the Gates of Gaza forshadowed Christ who 'rose in the middle of the night from the sleep of death and

broke down the doors of Hell, carrying its captives away with him'. And the blind Samson brought from prison by the Philistines to be made fun of paralleled Christ blindfolded and mocked before Caiaphas. (*Mirror of Man's Salvation*).

Saturn Devouring One of his Children 'Saturn was given the right to inherit his father's kingdom on the condition that he would expose any male children born to him, thus leaving the kingdom to the sons of his elder brother, Titan. Therefore Saturn ate his sons as soon as they were born' (Stephanus).

Satyr and Peasant The sixteenth century Antwerp poet Estienne Perret, adapting Aesop, tells this fable: A satyr lost his way in the woods and grew cold. He was rescued by a peasant who warmed his hands with his breath as he led the satyr to his house. Then, when the peasant's wife gave each a bowl of hot porridge, the peasant blew on his to cool it down. Seeing his host blow both hot and cold from the same mouth the satyr departed at once. And the poet admonishes his readers to avoid the company of hypocrites.

In La Fontaine's 17th century version of the fable, the peasant becomes a passing traveller who takes refuge from the rain with a satyr and his family, who were eating soup at the back of their cave. Although their furnishings were spare and comforts slim, they had strong appetites and held their bowls right up to their mouths. When the traveller first blew on his fingers to warm them up, and then blew on his bowl of soup to cool it down, the satyr took offence at the slur on his hospitality, and said, 'You may continue on your way – out with those who blow both hot and cold'.

Satyrs Satyrs were often in the company of Bacchus and Silenus. 'The ancients thought they were gods of the woods, similar to Sylvans and Fauns. They had a man's head, but with horns, goat's feet, and shaggy hair all over their body. They delighted in woodland retreats. But what characterized them more than anything was their wantonness, and their indulgence in sexual pleasures' (Stephanus).

239

Saul, *see also* Anointing of Saul, *and* Death of Saul, *or* Conversion of Saul.

Saul Visits the Witch of Endor King Saul sensed his weakness before the army of the Philistines. Even the protection of God seemed to have been withdrawn from him. Although Saul himself had required all witches to leave Israel, he disguised himself, and went with two of his men by night to consult one who had remained in secret, the witch of Endor. Saul asked her to call the prophet Samuel, who had anointed him king, forth from the dead. Samuel appeared as an old man covered with a mantle. In answer to Saul's plea for advice, he prophesied that the Philistines would defeat Israel and that Saul and his sons would die in the battle. (I Samuel, 28).

Scaevola and Porsenna When King Porsenna was besieging Rome, Mucius Scaevola stole out of the city with a dagger to kill the king by stealth, but killed the king's scribe by mistake. Seized by the guards and brought before the king, he demonstrated the determination of the Romans not to yield by thrusting his right hand into the fire and holding it there without flinching until it had burned away. The king was so moved that he freed Scaevola and gave up the siege. (Livy).

Saint Scholastica, *see* Conversation of Saint Scholastica.

Scylla, *see* Glaucus and Scylla.

Saint Sebastian Sebastian was an officer in the army of the Emperor Diocletian in the third century. He cured the prefect Chromatius of an illness by smashing more than two hundred 'pagan idols' – that is, classical statues of the gods. When the emperor found out that he was a Christian and would not sacrifice to the gods, he had him bound to a stake in the middle of a field and 'archers shot at him until he looked like a hedgehog. Then, thinking him dead, they went away and left him.' A Christian woman came to bury Sebastian, but finding him still alive she took him home and nursed him back to

health. A few days later he surprised Diocletian on the palace steps, reproaching him sternly for his persecution of Christians. Diocletian had him cudgelled to death and his body thrown into a latrine, but other Christians found and buried it. (*Golden Legend*).

A sixteenth century writer said of Sebastian that 'as the sores of every sick person call out for our compassion, so the many wounds and arrows of Sebastian call out to God for mercy on our behalf'(Molanus).

Seleucus, *see* Zaleucus the Judge.

Seneca, *see* Death of Seneca.

Seraphim, *see* Hierarchies of the Angels.

Seven Deadly Sins The Seven Deadly Sins are Pride, Greed, Lust, Envy, Gluttony, Wrath and Sloth.

Seven Medieval Stations of the Cross The *Mirror of Man's Salvation* describes the seven stations of the passion of Christ as the Washing of the Apostles' Feet, the Agony in the Garden and Betrayal, the Mocking before Caiaphas, the Mocking before Herod, the Flagellation and Crown of Thorns, the Condemnation and Crucifixion, and the Death of Jesus.

Seven Sorrows and Seven Joys of the Virgin The Seven Sorrows and Seven Joys of the Virgin corresponded to the Seven medieval Stations of the Cross and the Sevenfold Action of Grace worked by the Passion. Medieval Christians meditated on them to free themselves of worldly sorrow and gain eternal happiness.

The Sorrows were the Presentation in the Temple; the Flight into Egypt; Christ Among the Elders; the Betrayal and Capture of Christ; the Crucifixion; the Lamentation over the Dead Christ; and the Virgin's Exile on Earth after the Ascension of Christ into Heaven.

The Joys were the Annunciation; the Visitation; the

Nativity; the Adoration of the Magi; the Presentation in the Temple; Christ Among the Elders; and the Assumption and Coronation of the Virgin.

The Presentation in the Temple and Christ Among the Elders are both sorrows and joys, the Presentation because Mary 'had great joy in offering her Son to his Father', but also great sorrow 'when she heard the prophecy of Simeon in the Temple, A sword will pierce your own sacred soul'; and Christ Among the Elders because when Mary thought Jesus was lost she looked for him for three days before she found him, which caused her sorrow, but his obedience to her after that was a source of joy. (*Mirror of Man's Salvation*).

Seven Works of Mercy 'These are to feed the hungry, give drink to the thirsty, clothe the naked, receive the homeless, visit the sick, have compassion on and liberate prisoners, and bury the dead with proper funeral rites' (*Mirror of Man's Salvation*).

Shepherds, *see* Adoration of the Shepherds.

Shivering Venus 'An abundant harvest creates the desire for love, which is why Terence says, Without Ceres and Bacchus Venus grows cold' (Fulgentius).

Sibyl, *see* Aeneas in the Underworld, *and* Augustus and the Sibyl.

Sibyls The Sibyls were legendary female prophets of ancient Italy. Roman writers listed ten of them. 'All the Sibyls wrote of Christ's incarnation'(Torrentinus).

Silenus 'Lucian describes Silenus as an old man, bald and snub-nosed, and usually astride an ass. He was short and fat, with a pot-belly, and large pointed ears. The satyrs were his constant companions, and together they would follow along in the train of Bacchus. Some say Silenus brought up Bacchus, others that Silenus was Bacchus' foster son. He was almost

always drunk and had to be carried around on an ass because wine made him so sluggish' (Natale Conti (condensed)).

Siloam, *see* Christ Heals a Blind Man in Siloam.

Simeon, *see* Presentation of Christ in the Temple.

Simon, *see* Feast at Simon's House.

Simon Magus, *see* Flight and Fall of Simon Magus.

Simon the Zealot and Judas Thaddaeus The apostles Simon and Jude were brothers of James the Less. After Christ's death Simon preached in Egypt and Jude in Mesopotamia. Later they met in Persia where they found two magicians Matthew had driven out of Ethiopia, and put them to flight with their miracles. When they refused to sacrifice to pagan idols they were put to death. Accounts of their martyrdom vary, but the most common version is that a large group of pagan priests rushed on them and beat them to death. (*Golden Legend*).

Sisera, *see* Jael and Sisera.

Sisyphus 'The shrewdest of all the mortals of his time. He was killed by Theseus because he had infested Attica with his crimes. The poets say he was punished in the underworld by being eternally made to roll an enormous stone to the top of a mountain; then when he had almost reached the top, it would roll back again' (Calepinus).

Slaughter of the Innocents When Herod, king of Judaea, heard that the wise men had come to worship the Christ child as King of the Jews, he thought his own royal position threatened. Discovering that Bethlehem was the place of Christ's birth, he 'was exceeding wroth, and sent forth, and slew all the children that were in Bethlehem, and in all the coasts thereof, from two years old and under.... Then was

243

fulfilled that which was spoken by Jeremy the prophet, saying, In Rama was there a voice heard, lamentation, and weeping, and great mourning, Rachel weeping for her children, and would not be comforted, because they are not' (Matthew, 2).

Solomon, *see also* Judgement of Solomon.

Solomon Offering to the Idols King Solomon had 700 wives and 300 concubines, foreign women who worshipped idols, and 'it came to pass, when Solomon was old, that his wives turned away his heart after other gods: and his heart was not perfect with the Lord his God, as was the heart of David his father'. Solomon built temples to the foreign idols of his wives, and offered sacrifices to their gods. As a result, the Lord was angry with Solomon and punished him by dividing his kingdom, giving ten of the twelve tribes of Israel to Jeroboam, a foreigner. Because of the Lord's love for David, he left one tribe, the Kingdom of Judah, to Solomon's descendants. (I Kings, 11).

Sons of Zebedee, *see* First Disciples.

Spies With the Grapes of Eshcol After the Jews left Egypt and were in the wilderness on their way to the promised land, Moses sent spies ahead to investigate Canaan and bring back information about the people and the produce of the country. 'And when they had gone up they explored the land. . . . And coming to the Torrent of the Grape (Eshcol), they cut off a vine branch with its cluster, and two men carried it on a staff.' The enormous size of the grape cluster was the spies' evidence for the fertility of the promised land, a land 'truly flowing with milk and honey' (Numbers, 13 (Vulgate)).

In the *Mirror of Man's Salvation* the cluster of grapes prefigured Christ, who was led to his crucifixion by two peoples, the Jews and the Gentiles: 'Through that cluster the sons of Israel experienced the goodness of the promised land; through the teaching of Christ we contemplate the delight of heaven.'

Saint Stephen, *see* Death of Saint Stephen.

Storm on the Lake (Tempest) 'And when he was entered into a ship, his disciples followed him. And, behold, there arose a great tempest in the sea, insomuch that the ship was covered with the waves: but he was asleep. And his disciples came to him, and awoke him, saying, Lord, save us: we perish. And he saith unto them, Why are ye fearful, O ye of little faith? Then he arose, and rebuked the winds and the sea; and there was a great calm. But the men marvelled, saying, What manner of man is this, that even the winds and the sea obey him!' (Matthew, 8).

Susanna and the Elders Susanna was the beautiful wife of Joachim, a rich and respected man of Babylon. Two elders, who were often at their house, plotted to seduce her one day when she was alone in her husband's garden.

'Now when the people departed away at noon, Susanna went into her husband's garden to walk. And the two elders saw her going in every day, and walking; so that their lust was inflamed. . . . And it fell out, as they watched a fit time, she went in as before with two maids only, and she was desirous to wash herself in the garden: for it was hot. And there was no body there save the two elders, that had hid themselves, and watched her. Then she said to her maids, Bring me oil and washing balls, and shut the garden doors, that I may wash me. And they did as she bade them, and shut the garden doors, and went out themselves . . . but they saw not the elders, because they were hid. . . .

'The two elders rose up, and ran unto her, saying, Behold, the garden doors are shut, that no man can see us, and we are in love with thee; therefore consent unto us, and lie with us. If thou wilt not, we will bear witness against thee, that a young man was with thee: and therefore thou didst send away thy maids from thee. Then Susanna sighed, and said, I am straitened on every side: for if I do this thing, it is death unto me: and if I do it not, I cannot escape your hands. It is better for me to fall into your hands, and not do it, than to sin in the sight of

245

the Lord. With that Susanna cried with a loud voice: and the two elders cried out against her. Then ran the one, and opened the garden door. So when the servants of the house heard the cry in the garden, they rushed in at a privy door, to see what was done unto her. But when the elders had declared their matter, the servants were greatly ashamed: for there was never such a report made of Susanna.'

The elders publicly accused Susanna of adultery, and she was condemned. As she was being led to her death, the prophet Daniel appeared. He separated the elders and questioned them individually, and through their contradictory versions of the supposed adultery convicted them of bearing false witness. 'With that all the assembly cried out with a loud voice, and praised God, who saveth them that trust in him.' The elders were put to death and 'innocent blood was saved the same day' (History of Susanna).

Symbols of the Passion The *Mirror of Man's Salvation* gives a long catalogue of the symbols drawn from episodes in Christ's passion, some of which are: the kiss of Judas, the thirty pieces of silver, the staves and torches of his captors, and the severed ear of Malchus from the Betrayal; the white and red robes, the blindfold, the derisive tongues, the reed, crown of thorns, slaps and punches of the Mockings; the column, ropes, whips and rods of the Flagellation; Pilate's washing his hands; Peter's triple denial of Christ before the cock's crow; and finally the cross, nails, ladder, hammers, purple robe, casting of lots, reed, sponge and lance of the Crucifixion.

Syrinx, *see* Pan.

Tabitha, *see* Raising of Tabitha.

Tamar Hebrew law required a childless widow to marry her husband's brother and have a son by him who would be considered the descendant of her first husband.

Tamar was married to Judah's oldest son. After her husband's death, Judah gave her his second son in marriage.

When he died too, Tamar waited for Judah's third son to reach marriageable age, but when it became apparent that Judah did not intend to marry him to her, Tamar disguised herself as a harlot and waited for her father-in-law by the side of the road when he went out to supervise the shearing of his sheep. Seeing Tamar and not recognizing her, Judah slept with her. In payment, he was to send her a young goat. As a pledge of payment, she asked for his ring, bracelets and staff, which he gave her, and she returned to her home with them before the goat could be sent.

Tamar conceived, and when her pregnancy was discovered she was accused of harlotry. Judah condemned her to be burned for the crime, but Tamar presented him with the ring, bracelet and staff that he had given the 'harlot', and he acknowledged that 'she hath been more righteous than I; because that I gave her not to . . . my son.' Tamar bore twins, one of whom was the ancestor of David, and thus of Christ. To the Church she was an example of faithfulness. (Genesis, 38).

Tanaquil The Etruscan wife of King Tarquin of Rome. Although a foreigner, 'she had such great influence that she could bring first her husband and then her son-in-law to the throne'. Her name became proverbial for any wife who dominates her husband. (Livy).

Tempest, *see* Storm on the Lake.

Temptation of Christ After his Baptism, Jesus was tempted by the devil in the wilderness. 'And when he had fasted forty days and forty nights, he was afterward an hungered. And when the tempter came to him, he said, If thou be the Son of God, command that these stones be made bread. But he answered and said, It is written, Man shall not live by bread alone, but by every word that proceedeth out of the mouth of God.

'Then the devil taketh him up into the holy city, and setteth him on a pinnacle of the temple, and saith unto him, If thou be the Son of God, cast thyself down: for it is written, He shall

247

give his angels charge concerning thee: and in their hands they shall bear thee up, lest at any time thou dash thy foot against a stone. Jesus said unto him, It is written again, Thou shalt not tempt the Lord thy God.

'Again, the devil taketh him up into an exceeding high mountain, and sheweth him all the kingdoms of the world, and the glory of them; and saith unto him, All these things will I give thee, if thou wilt fall down and worship me. Then saith Jesus unto him, Get thee hence, Satan: for it is written, Thou shalt worship the Lord thy God, and him only shalt thou serve.

'Then the devil leaveth him, and, behold, angels came and ministered unto him' (Matthew, 4).

Ten Plagues of Egypt When Pharaoh refused to let the Israelites leave Egypt, God told Moses and Aaron to perform the following miracles, which finally persuaded Pharaoh to let them go.

1. Water turned into blood. Aaron struck the waters of the Nile with his rod and they turned to blood; the fish died, and the river stank.

2. Plague of frogs. Aaron stretched his rod over the waters of Egypt, and frogs came up into the houses, villages and fields, and onto the people.

3. Plague of gnats. Aaron struck the dust of the earth with his rod, and the dust became gnats in man and beast.

4. Plague of flies. Swarms of flies attacked the Egyptians, filled their houses and infested their land.

5. The Pestilence. A pestilence attacked the livestock of the Egyptians, and all their horses, asses, camels, oxen and sheep died.

6. Plague of boils. Moses scattered ashes toward the sky. The ashes turned to fine dust and caused festering boils on man and beast throughout Egypt.

7. Plague of hail. Moses stretched his rod toward heaven, and thunder and hail mingled with lightning struck down every Egyptian and his beast that were in the fields, and ruined the crops of barley and flax.

8. Plague of locusts. Moses stretched his hand over the land

of Egypt and the east wind brought swarms of locusts. The land was black with them and they ate all the vegetation, and the fruit of the trees.

9. Plague of darkness. Moses stretched his hand toward heaven, and a thick darkness enveloped the land of Egypt for three days.

10. Death of the first-born. At midnight, God killed all the first-born of the Egyptians and their cattle. But he spared the Israelites, whose houses he recognized and passed over, for they had marked their doorposts and lintels with the blood of a lamb as a sign for him. (Exodus, 7–11).

See also **Exodus.**

Theophilus' Son Resurrected, *see* Saint Peter Enthroned.

Thetis Dips Achilles in the Styx, *see* Death of Achilles.

Thetis and Vulcan When the Greeks seemed to be losing the Trojan War, Thetis, the mother of Achilles, went to Vulcan's forge to ask him for a favour. Her son had lost his armour, and she wanted a new set for him. Years before, when the other gods had thrown ·Vulcan out of heaven because he was a cripple, Thetis had sheltered and protected him. Remembering his debt to her, he turned the bellows on the fire and set to work with hammer and tongs. Making a large shield for Achilles he decorated it with elaborate and skilful pictures and presented it to Thetis, along with a crested helmet and shining breastplate. (Homer, *Iliad*).

In a sixteenth century version 'Vulcan said he would not give her the arms until she had slept with him. Thetis supposedly agreed to his proposition, but wanted to find out first if the armour fitted Achilles. On that basis Vulcan gave her the armour, and she put it on and fled, so fooling the lame god' (Natale Conti).

Saint Thomas Thomas was one of the twelve apostles of Christ. The *Golden Legend* says he was called Didymus (Twin) because he was aware of the Resurrection of Christ in a

two-fold manner, not only with his eyes, like the others, but also by touching Christ.

Doubting Thomas. Thomas was not with the other disciples when Christ appeared to them after his death and resurrection. 'The other disciples therefore said unto him, We have seen the Lord. But he said unto them, Except I shall see in his hands the print of the nails . . . and thrust my hand into his side, I will not believe.' When Jesus again appeared to them, he said to Thomas, 'Reach hither thy finger, and behold my hands; and reach hither thy hand, and thrust it into my side: and be not faithless, but believing. And Thomas answered and said unto him, My Lord and my God. Jesus saith unto him, Thomas, because thou hast seen me, thou hast believed: blessed are they that have not seen, and yet have believed' (John, 20).

The Virgin Mary Drops Her Girdle to Saint Thomas. Thomas told the other disciples how he had been saying mass in India and how, still wearing his priestly vestments, he had been divinely transferred to the Mount of Olives where he saw the Virgin's bodily assumption into heaven. He cried out to Mary and asked for a sign of her favour. 'Then the sash with which the apostles had girded her most sacred body was thrown down to Thomas from heaven' (*New Testament Apocrypha, Joseph of Arimathaea*).

Martyrdom of Saint Thomas. Thomas returned to India where he was imprisoned for converting the queen's sister. When the queen herself became a Christian the king in his fury tried to martyr Thomas over burning iron and then in a furnace, but the flames went out and the furnace turned cold. When the king tried to make him sacrifice to one of the pagan gods, Thomas commanded the devil inside the idol to break it to pieces, and the idol melted like wax. Then a pagan priest ran Thomas through with a sword or, as Isidore says, a spear. (*Golden Legend*).

Saint Thomas Aquinas An Italian monk of the thirteenth century who wrote many works on theology.

When his brothers wanted to make Thomas give up holy orders they kidnapped him and held him prisoner. Then 'they

sent a beautiful girl skilled in the whore's craft to his room to entice him with her looks, touches, games and whatever other device she could think of. But as the saint had already accepted the wisdom of God as his spouse,' he expelled the girl indignantly from the room and prayed God for the girdle of eternal chastity. Two angels appeared and put the girdle on him.

Once when Thomas was asleep in his cell his servant saw a brilliant star enter the window and hover above his head. Another time someone 'saw the devil in the form of an Ethiopian come into Thomas' cell to tempt him, but when the saint made the sign of the cross the devil fled screaming'.'

A monk saw the saint in church praying before a crucifix and he appeared to be hovering two cubits above the pavement. Suddenly a voice was heard from the crucifix saying, Thomas, You have written well of me. What do you wish in return for your labours? To which the saint replied, Lord, nothing except you. Then he wrote the third part of his *Summa Theologica,* on the passion and resurrection of Christ.

St Louis the king of France often sought Thomas' advice on matters of state, but the saint was so little impressed by royalty that he would often wander off into his own thoughts even in the presence of the king. Once at a banquet, after a period of absent-minded thought, he suddenly pounded the table with his fist and exclaimed, 'That's that for the Manichaean heresy'. The prior of his monastery pulled at his hood 'to bring him to his senses, saying, Remember, Master, that you are dining with the king of France', and the saint apologized. (*Acta Sanctorum*).

Three Arrows, *see* Doctrine of the Three Arrows.

Three Children in the Furnace (Nebuchadnezzar Before the Golden Image) Nebuchadnezzar, king of Babylon, made an image of gold sixty cubits high and six wide and set it up for everyone in his empire to worship. At the dedication, a herald cried to the people that it was commanded 'at what time ye hear the sound of the cornet, flute, harp, sackbut, psaltery, dulcimer, and all kinds of musick, ye fall down and worship the

golden image that Nebuchadnezzar the king hath set up: and whoso falleth not down and worshippeth shall the same hour be cast into the midst of a burning fiery furnace.' Only the Hebrews Shadrach, Meshach and Abed-nego refused to worship the image. 'Then these men were bound in their coats, their hosen, and their hats, and their other garments, and were cast into the midst of the burning fiery furnace.'

The furnace was so hot that even the men who cast them in were burned up, 'but the angel of the Lord came down into the oven . . . and made the midst of the furnace as it had been a moist whistling wind, so that the fire touched them not at all, neither hurt nor troubled them.'

And the king said, 'Lo, I see four men loose, walking in the midst of the fire, and they have no hurt; and the form of the fourth is like the Son of God'. When the three Hebrews emerged unsinged from the fire Nebuchadnezzar added, 'Blessed be the God of Shadrach, Meshach, and Abed-nego, who hath sent his angel, and delivered his servants that trusted in him' (Daniel, 3 and The Song of the Three Children).

Three Graces The Graces are Aglaia, Thalia and Euphrosyne. 'Aglaia stands for gladness, to show that benefits should be given gladly; Thalia for freshness, for the memory of a favour should be always fresh; and Euphrosyne for delight, for we should always be grateful to those who have been liberal towards us. One of them is painted facing away from us and two turned towards us, to show that a benefit received should be twice repaid. They are nude to show that kindness should be open and frank; linked arm in arm, for one good act begets another, and is a perpetual link of friendship. They are cheerful, as we should be in giving and receiving; and young, for benefits received should never grow old in gratitude, but always flower.' The fountain they wash in indicates 'that kindness should be pure and not seek payment, nor ask for anything unbecoming. Some think they are the daughters of Bacchus and Venus, and not without reason, for it is especially through the gifts of those two gods that we win the favour of the Graces' (Calepinus).

Three Kings, *see* Adoration of the Magi.

Three Marys The three Marys who came to Christ's tomb to anoint him on the Sunday after his burial were Mary Magdalene and the two sisters of the Virgin, Mary Salome and Mary Jacobi, who is sometimes called Mary Cleophas. They are often seen at the Crucifixion, Deposition, Lamentation and Burial, and other scenes from the life of Christ.
 See also **St Ann's Kith and Kin;** and **Women at the Tomb.**

Three Mighty Men, *see* David's Three Mighty Men Bring Water from the Well.

Three Wise Men, *see* Adoration of the Magi.

Titans, *see* Fall of the Titans.

Tobias, *see* Tobit.

Tobit
Tobit burying the dead. Tobit lived with his wife and son, Tobias, in Nineveh during the days of the captivity of the Jews by the Assyrians. He was a pious man, known for giving alms, and risking his life to bury secretly the bodies of his fellow Jews, killed by the Assyrians and thrown behind the walls of Nineveh.
Tobit's blindness. 'Now it happened that one day, when he was exhausted from burying, he came home and, collapsing by the wall, fell asleep. And as he was sleeping, hot dung from a swallow's nest fell on his eyes and he was made blind. However God allowed him to suffer this trial so that an example might be given to posterity of his patience, as also of holy Job.' He did not blame God for his blindness, 'but remained steadfast in the fear of God, giving thanks to God all the days of his life'.
Tobit and Anna with the kid. 'His wife Anna went out every day to do weaving, and brought back whatever she could to support them by the labour of her hands. It happened that

she was given a young kid and brought it home. But when her husband heard it bleating he said, Be careful, it might be stolen. Give it back to its owners, for it is not lawful for us to eat or touch anything that is stolen.' Angry because of Tobit's suspicions, Anna reproached him and said, 'It's clear now that your hopes were vain; this is what your charity has come to.'

Tobit lamented his blindness and longed for death. To provide for his son Tobias after his death, he sent him to collect money he had deposited with a relative in Media. He gave Tobias the receipt for the money, and told him to find a reliable guide to accompany him. 'Then Tobias went out and found a splendid young man, standing girded and as though ready for a journey.' Not knowing that 'he was the angel Raphael in disguise, Tobit hired him, thinking he was a Jew from his own tribe.

Parting of Tobias from his parents. Anna wept as she saw her son ready to leave, and said to her husband, 'You have taken away the support of our old age and sent him from us. Would that the money you sent him after had never existed.' Tobit reassured her that their son would return safely and Tobias set out with the angel, his dog following behind.

Tobias and the angel. They spent the first night by the River Tigris. When Tobias went down to the river to wash his feet, 'behold, an enormous fish jumped up to devour him'. Tobias was afraid, but the angel told him to take the fish by the gills and draw it on to dry land. 'Then the angel said to him, Take out the entrails of this fish, and lay aside his heart, his gall and his liver for yourself. For these are necessary for useful medicines' – the heart and the liver in casting out devils, the gall in curing blindness.

When they came to Media, they stayed with Raguel, a relative of Tobias, whose daughter Sarah was possessed of a demon. She had been married seven times, but each husband had been killed by the demon on the wedding night, before the marriage could be consummated. The angel urged Tobias, as her next of kin, to marry Sarah, for to keep inheritance within the tribe intact Mosaic law forbade a woman to marry outside

254

her mother's tribe; and he also told him how to free Sarah of the demon.

Tobias and his wife Sarah praying. On their wedding night, Tobias 'drew part of the fish's liver from his little box and put it on the live coals. Then the angel Raphael seized the demon and bound him in a deserted spot in Egypt.' For three successive nights Tobias and Sarah abstained from intercourse, praying together and asking God for his grace and protection. For Tobias remembered that Raphael had told him that 'those who enter marriage excluding God from their thoughts and give themselves to their own desires, like horses and mules who lack intelligence – those the devil has in his power'.

Raphael went alone to collect the money deposited with Tobit's relative and when he returned there were fourteen days of wedding festivities. Finally Tobias and Sarah left for Nineveh, accompanied by Raphael, with the dog following.

The healing of Tobit. When Anna saw Tobias coming she hurried to tell Tobit, who rose up and ran stumbling to meet him. 'Then Tobias took some of the fish's gall and anointed his father's eyes with it. After about half an hour, the whiteness like the skin of an egg began to disappear from his eyes. Then Tobias removed the gall, and at once Tobit received his sight. And they all glorified God, Tobit, his wife, and all who knew him. And Tobit said, Blessed are you, Lord God of Israel, because you have chastised me and you have saved me, and behold, I see my son Tobias.'

Tobias and his father offer half their wealth to Tobias' companion. In payment for his services as a guide, and for having cured Tobit and Sarah, Tobias and his father offered Raphael half of the animals and money they had brought back as Sarah's dowry from Media.

Departure of the angel. Raphael then revealed to them that he was one of the seven archangels and had been sent by God to test Tobit's faith by afflicting him with blindness, and later to cure him and Sarah. Tobias and his father were troubled and fell to the earth in fear. 'But the angel said to them, Do not be afraid . . . the time has come for me to return to him who sent me. . . . And as he was carried away from their sight, they

remained kneeling and giving thanks to God' (Tobit (Vulgate text)).

Tomyris 'Queen of the Massagetes, who killed Cyrus, king of the Persians. When Cyrus invaded Scythia with a vast army, Tomyris sent her young son to check his advance, but Cyrus killed him through treachery. Then the queen retreated, as though having lost heart, but really led Cyrus into an ambush where she exterminated him and his army. Then she put his head in a vase full of gore, saying, Drink your fill of the blood you thirsted for so insatiably' (Torrentinus).

To the Middle Ages Tomyris prefigured the Virgin. Cyrus, whose desire for human destruction was never satisfied, prefigured the devil. 'As Tomyris defeated Cyrus, so the Queen of Heaven overcame the devil through the martyrdom of her son, and quenched his thirst with the everlasting damnation he prepared for us' (*Mirror of Man's Salvation*).

Tower of Babel The tower was built in the land of Shinar, which belonged to the kingdom of Nimrod, the first conqueror on earth, two generations after the Flood. Augustine considered Nimrod the builder of the tower and describes him as 'a giant and a hunter against the Lord'. He was later thought of as the first of all tyrants.

'And the whole earth was of one language, and of one speech. And it came to pass, as they journeyed from the east, that they found a plain in the land of Shinar; and they dwelt there. And they said one to another, Go to, let us make brick, and burn them throughly. And they had brick for stone, and slime had they for morter. And they said, Go to, let us build us a city and a tower, whose top may reach unto heaven; and let us make us a name, lest we be scattered abroad upon the face of the whole earth.

'And the Lord came down to see the city and the tower, which the children of men builded. And the Lord said, Behold, the people is one, and they have all one language; and this they begin to do: and now nothing will be restrained from them, which they have imagined to do. Go to, let us go down, and

there confound their language, that they may not understand one another's speech. So the Lord scattered them abroad from thence upon the face of all the earth: and they left off to build the city. Therefore is the name of it called Babel; because the Lord did there confound the language of all the earth: and from thence did the Lord scatter them abroad upon the face of all the earth' (Genesis, 11).

The *Historia Scholastica* says of the tower, 'Its breadth was so great that, from close up, it appeared wider than it did high'. In the Middle Ages the confusion of tongues at Babel was contrasted with the gift of tongues at the Pentecost. Luther later allegorized Babel as 'the impiety . . . of those hypocrites who think that they alone are holy and close to God, and so want to reign on earth', and as 'the false church which always persecutes the true one'.

Trajan and the Widow The Roman Emperor Trajan was setting out with his soldiers on a military expedition when an aged widow placed herself in his path. Pointing to some of his soldiers, she accused them to the emperor of having killed her son, and called on him for justice. 'Trajan told her he would judge her case when he returned, but the widow replied, And if you don't return, what am I to do?' Hearing that, Trajan set up court at once, compensating the widow from the imperial treasury and punishing the guilty. In another version, Trajan's own son had run down the widow's son with his horse, and Trajan gave him to the widow to replace the one she had lost.

Centuries later, Pope Gregory the Great, passing through the Forum of Trajan, happened to remember the story. Considering Trajan's willingness to render prompt justice and to defend the widow, Gregory went to the Basilica of Saint Peter and wept for the soul of Trajan, who as a pagan and therefore unbaptized would be in hell. He wept so long that a divine voice finally informed him that Trajan's soul had been released from the torments of hell; but the voice also admonished him never again to pray for any one who had not been baptized. (*Acta Sanctorum*).

Transfiguration Christ took the apostles Peter, James the Greater and John the Evangelist to a high mountain to pray. As he prayed he 'was transfigured before them: and his face did shine as the sun, and his raiment was white as the light. And, behold, there appeared unto them Moses and Elias talking with him. Then answered Peter, and said unto Jesus, Lord, it is good for us to be here: if thou wilt, let us make here three tabernacles; one for thee, and one for Moses, and one for Elias.

'While he yet spake, behold, a bright cloud overshadowed them: and behold a voice out of the cloud, which said, This is my beloved Son, in whom I am well pleased; hear ye him. And when the disciples heard it, they fell on their face, and were sore afraid. And Jesus came and touched them, and said, Arise, and be not afraid. And when they had lifted up their eyes, they saw no man, save Jesus only' (Matthew, 17).

Elias is the Old Testament prophet Elijah, whom the prophet Malachi had said God would send 'before the coming of the great and dreadful day of the Lord'. Elijah's return was thus looked for as a sign of the coming of the Messiah, and his appearance here was taken as a confirmation of Christ's divinity. Bonaventura said that in the Transfiguration Christ 'showed his disciples the glory of the resurrection to come, his words being confirmed by the Law and the Prophets in the form of Moses and Elijah' (Bonaventura, *Lignum Vitae*).

See also **Lunatic Boy.**

Transfiguration of Saint Teresa Teresa was a Spanish Carmelite nun and a mystic. Visions were not uncommon to her, and she describes one in particular as having left her in a specially raptured state: a seraph appeared to her and he seemed to be all on fire. 'In his hands I saw a long golden lance, the iron spear-head pointed with a tip of fire. With it he pierced my heart to its depths.' The pain was severe but brought with it an ecstasy of her soul 'and an enormous love of God that left me all inflamed' (*Acta Sanctorum*).

Translation of Elijah 'It came to pass, when the Lord would take up Elijah into heaven by a whirlwind', that Elijah and his

disciple Elisha went to the river Jordan. Elijah struck the Jordan with his mantle and the waters parted, and they crossed over on dry ground. Elisha asked Elijah for a double portion of his prophetic spirit, and then 'there appeared a chariot of fire, and horses of fire, and parted them both asunder; and Elijah went up by a whirlwind into heaven.' Elisha 'took the mantle of Elijah that fell from him, and smote the waters, and said, Where is the Lord God of Elijah?' The waters parted 'and Elisha went over' (II Kings, 2).

The Middle Ages made Elijah's Translation to heaven a prefiguration of the Ascension.

Tree of Jesse To Christians, this prophecy of Isaiah was a description of the genealogy of Christ, who was descended from David, the son of Jesse: 'And there shall come forth a rod out of the stem of Jesse, and a flower shall grow out of his root.' An early Christian comments: 'The rod which comes from the root is the Virgin Mary, who is descended from David; the flower which grows from the rod is Mary's son, Jesus Christ, who is at the same time both flower and fruit' (Isaiah, 11 (Vulgate) and Tertullian).

Tribute Money An attempt to trick Christ into violating either the Jewish or the Roman law. If he said it was lawful to pay tribute he would violate Jewish law; if he denied tribute, he would violate Roman authority.

'Then went the Pharisees, and took counsel how they might entangle him in his talk. And they sent out unto him their disciples . . . saying, Master, we know that thou art true, and teachest the way of God in truth, neither carest thou for any man: for thou regardest not the person of men. Tell us therefore, What thinkest thou? Is it lawful to give tribute unto Caesar, or not?

'But Jesus perceived their wickedness, and said, Why tempt ye me, ye hypocrites? Shew me the tribute money. And they brought unto him a penny. And he saith unto them, Whose is this image and superscription? They say unto him, Caesar's. Then saith he unto them, Render therefore unto Caesar the

things which are Caesar's; and unto God the things that are God's. When they had heard these words, they marvelled, and left him, and went their way' (Matthew, 22).

See also **Finding the Coin in the Fish's Mouth.**

Trinity These Biblical passages suggested the later artistic tradition of the Trinity:

God the Father: 'The Ancient of days did sit, whose garment was white as snow, and the hair of his head like the pure wool' (Daniel, 7, verse 9).

Christ the Son: 'No man hath seen God at any time; the only begotten Son, which is in the bosom of the Father, he hath declared him' (John, 1, verse 18).

The Holy Ghost or Spirit: 'The heaven opened, and the Holy Ghost descended in a bodily shape like a dove' (Luke, 3, verse 22).

Voragine says, 'Power is an attribute of the Father, Wisdom of the Son, and Mercy of the Holy Ghost' (*Sermones de Sanctis*).

A Cornish miracle play expresses the idea this way:

> 'The Father of heaven is one,
> Another, Christ his Son,
> And the Holy Ghost is the third:
> Three in one and one in three,
> All worship to the Trinity.'
>
> *The Legend of the Rood*

Triumph of David, *see* David Entering Jerusalem.

Trojan Horse Worn out and discouraged after ten years of besieging Troy, the Greeks resorted to deception. Building a huge hollow wooden horse they hid their best warriors inside it and left it before the gates of the city, as though it were a votive offering to Minerva. Then they sailed away. After much debate the Trojans, persuaded the idol would bring them fortune if it were brought inside the city, even tore down part of the walls to make room for it. That night the armed Greeks

descended from their hiding place and, joined by others from the returning fleet, sacked Troy and burned the city. (Virgil).

Tuccia 'A virgin in the service of the Roman goddess Vesta. When she was accused of incest she scorned to clear her name with mortal arguments. Taking a sieve to the river Tiber she dipped it in and prayed to the goddess in these words: If I have been pious and chaste, let me carry the water in this sieve from the river to your temple. And she did so'(Stephanus).

Two Blind Men from Jericho Christ passed through Jericho just before his Entry into Jerusalem a week before the Crucifixion. 'And as they departed from Jericho, a great multitude followed him. And, behold, two blind men sitting by the way side, when they heard that Jesus passed by, cried out, saying, Have mercy on us, O Lord, thou son of David. And the multitude rebuked them, because they should hold their peace: but they cried the more, saying, Have mercy on us, O Lord, thou son of David. And Jesus stood still, and called them, and said, What will ye that I shall do unto you? They say unto him, Lord, that our eyes may be opened. So Jesus had compassion on them, and touched their eyes: and immediately their eyes received sight, and they followed him' (Matthew, 20).

Ulysses, *see* Odysseus.

Saint Ursula Ursula was the daughter of a Christian king of Brittany in the third century. The idolatrous and arrogant king of England heard of her great beauty and sent ambassadors to ask for her hand for his son. She consented on the condition that the young prince be baptized. Further, she asked the king to send her ten virgins, and another thousand virgins for each of the ten and for herself, and to give her three years to 'dedicate her virginity'.

The 11,000 virgins assembled and when Ursula had converted them all they were joined by an army of men and various bishops and set out on a pilgrimage to Rome. They sailed to Cologne, where an angel met Ursula and prophesied her

martyrdom there on her return. Leaving their ships in Basel they continued on foot to Rome where they were received with honour by Pope Cyriacus, himself a native of Brittany. Learning in a vision of the coming martyrdom, the pope resigned his position and joined the virgins on their return journey, carefully baptizing all who were still unbaptized. When they reached Cologne the army of the Huns was besieging the city and 'when the barbarians saw them, they attacked with a great clamour and, like wolves raging among sheep, massacred the whole multitude'. The prince of the Huns spared Ursula because he wanted her as his wife, but when she refused him he shot an arrow into her breast. (*Golden Legend*).

Venus, *see also* Birth of Venus.

Venus and Adonis Adonis was the son born of the incestuous love of his mother and his grandfather. While pregnant, his mother was changed into a tree and Adonis was born from a fissure in the bark, with the goddess of childbirth and the nymphs assisting.

Venus fell in love with Adonis when he had grown into a handsome young man and became his constant companion. Because he was a hunter she became a huntress and roamed the ridges and woods pursuing harmless animals like fleeing hares and deer but staying clear of the dangerous ones, the wild boars, wolves and lions. Tired by exercise she was not used to, she said, 'Look, a poplar invites us with its shade, and the turf offers a couch: let's rest here together. So she lay down on the grass, leaning against Adonis and resting her head on his breast.' She warned Adonis to show his bravery toward timid animals: 'Courage in the face of ferocious ones is not prudent. Do not be overbold or stir up beasts which nature has armed ... lest your valour be ruinous to us both.'

But later, when his hounds started a wild boar from its lair, Adonis, whose courage ran contrary to her warnings, tried to kill the boar, which mortally wounded him instead. Venus, driving through the air in her chariot drawn by winged swans, heard the groans of the dying Adonis. She leapt from her

chariot 'and tore her bosom and her hair, striking her breast with wretched hands, and complaining to the Fates'. As an everlasting reminder of her grief she changed his blood into an anemone, the flower which comes up for a brief period every spring. (Ovid).

Venus and Amor Stung by a Bee A poem of Theocritus: 'A nasty bee once stung the thieving Cupid as he was stealing honey from a hive, and punctured the tips of his fingers. He felt the pain and blew on his hand, and stamped the earth and leapt about. He showed Venus the sore spots, and complained that a bee is so tiny yet deals such awful wounds. But his mother laughed and said, Aren't you like the bees, for small as you are you too inflict cruel wounds?'

Venus Directing Aeneas to Carthage, *see* Aeneas.

Venus Disguised as a Huntress Speaking to Aeneas, *see* Aeneas.

Venus Presenting Arms to Aeneas Venus came to Vulcan's forge to ask for arms for her son Aeneas to use against the tribes of Latium when founding the city of Rome. When they were ready, Venus descended from the clouds of heaven and presented the new arms to Aeneas, laying them under an oak before him. Aeneas admired each piece in turn – the helmet, sword, breast-plate, spear and finally the shield decorated with the future history and victories of Rome. (Virgil).

Venus Shivering, *see* Shivering Venus.

Venus and the Three Graces, *see* Birth of Venus.

Veronica A medieval mystery play describes Veronica wiping Christ's face with her kerchief while he was carrying the cross to Calvary. The image of his face remained on the kerchief and Christ gave it the power to heal anyone who looked upon it.

'Veronica: Ah, ye sinful people, why fare thus?
 For sweat and blood he may not see.
 Alas, Holy prophet, Christ Jesus.
 Care-full is mine heart for thee.

'She wipes his face with her kerchief

'Jesus: Veronica, thy wiping doth me ease.
 My face is clean that was black to see:
 I shall keep them from all misease,
 That look on thy kerchief and remember
 me.'

 (Coventry Mystery).

Vertumnus and Pomona Pomona, a beautiful wood-nymph devoted to the cultivation of fruit-trees, remained inside her fenced orchard to avoid the violent approaches of her rustic wooers, in whom she had no interest. The god Vertumnus, who had the power to assume any shape he wished, was so in love with her that 'he even turned himself into an old woman with feigned white hair about his temples and an embroidered turban on his head. Leaning on a stick he entered the cultivated gardens. He admired the fruit and praised it adding, as he did so, a few kisses of a sort a real old woman would never have given. Then he sat down hunched over on the ground' and pleaded his own cause. Pointing to a vine which, in ancient fashion, Pomona had trained to grow on an elm tree, Vertumnus argued that without its 'marriage' to the elm, the vine would lie fruitless on the ground. Finally he returned to his own shape, revealing himself as a young man, and won the consent of Pomona, who fell in love with him at once. (Ovid).

Saint Vincent Ferrer Revives a Dead Child Vincent Ferrer was given hospitality in a small town in southern France. He returned from preaching a sermon to find that his host's wife, in a fit of insanity, had chopped up her son and roasted him for dinner. The saint calmed the perturbed father, and restored the child to life and health with his prayers. (*Acta Sanctorum*).

Virgin Mary The idea that the Virgin was conceived without sin and that she gave birth to Christ without losing her virginity is expressed in certain symbols associated with her. From the Song of Solomon are drawn the images of 'an enclosed garden', 'a sealed fountain', 'a well of living waters', 'the lily of an enclosed valley', and the impregnable 'tower of David built with ramparts'.

The medieval *Mirror of Man's Salvation* calls the Virgin 'the walled garden containing all fragrant spices and pleasant fruits, whose door-keeper is the true God'. It compares the virgin-birth to 'a sunbeam passing through a glass window without harming it in any way', and to the closed door of a vision of Ezekiel: 'The Lord alone passed through the door and did not break it; thus your womb did not lose its seal of virginity in the birth of Christ'.

The sun, the moon and the crown of twelve stars are attributes of the Virgin taken from the description of the Apocalyptic Woman, and are often found in representations of the Immaculate Conception.

See also **Annunciation.**

Virgin Mary Drops Her Girdle to Saint Thomas, *see* Saint Thomas.

Virgin of Mercy A Cistercian monk had a vision in which he was transported to heaven, where he saw angels, patriarchs, prophets, apostles and martyrs, and members of the various monastic orders. 'Looking about intently for members of his own order he could fine none. Then he turned to the Holy Mother of God with a sigh and said, How is it, Reverend Lady, that I don't see a single Cistercian here? Why are your servants who serve you with such devotion excluded from your celestial blessings? Seeing him troubled, the Queen of Heaven replied, I love my Cistercians so much that I shelter them under my arms. Then, opening the cloak that was about her and which was of extraordinary breadth, she showed him a great multitude of monks and lay members of the order' (Caesar of Heisterbach).

Virgin of the Milk, *see* Madonna of the Milk.

Virginia 'Daughter of the Roman centurion Virginius. When the decemvir Appius wanted to take her as his mistress, her father preferred to kill her in the middle of the forum than allow her to be led away to degrading servitude. Then he rounded up some soldiers and overthrew the arrogant domination of the decemvirs' (Stephanus).

Vision of Ezekiel Ezekiel had a vision of a cloud of fire in which he saw four animals, each with four faces and four wings. The faces were those of a man in front, a lion on the right, an ox on the left and an eagle at the back. Two of their wings were outspread and two covered their bodies. Burning coals of fire moved back and forth like torches among the animals, and beside each one were two concentric wheels. In the sky over their heads appeared the likeness of a man seated on a throne 'and there was brightness round about him. . . . Such was the appearance of the likeness of the glory of the Lord' (Ezekiel, 1 (RSV)).

Later Saint John the Evangelist had a vision of God seated on a throne surrounded by four beasts, one like a lion, one like a calf, one like a man and one like a flying eagle. These became the symbols of the four evangelists.

See also **Ezekiel's Vision of the Dry Bones.**

Vision of Saint Peter 'Peter went up upon the housetop to pray about the sixth hour: and he became very hungry, and would have eaten: but while they made ready, he fell into a trance, and saw heaven opened, and a certain vessel descending unto him, as it had been a great sheet knit at the four corners, and let down to the earth: wherein were all manner of four-footed beasts of the earth, and wild beasts, and creeping things, and fowls of the air. And there came a voice to him, Rise, Peter; kill, and eat. But Peter said, Not so, Lord; for I have never eaten any thing that is common or unclean. And the voice spake unto him again the second time, What God hath cleansed, that call not thou common.

This was done thrice: and the vessel was received up again into heaven.'

As the early Christians were Jews, they were forbidden by Jewish law to have anything to do with the uncircumcised Gentiles. But after his vision Peter was called to the house of Cornelius, a centurion in the Roman army and a Gentile. Cornelius, instructed by an angel, had sent two of his servants and a loyal soldier to fetch Peter, and when Peter arrived he converted and baptized Gentiles for the first time. For he then understood that he 'should not call any man common or unclean', and that 'on the Gentiles also was poured out the gift of the Holy Ghost' (Acts, 10).

Visitation When the archangel Gabriel appeared to the Virgin to foretell the birth of Christ he said, 'And, behold, thy cousin Elisabeth, she hath also conceived a son in her old age: and this is the sixth month with her, who was called barren. For with God nothing shall be impossible.'

'And Mary arose in those days, and went into the hill country with haste, into a city of Judah; and entered into the house of Zacharias, and saluted Elisabeth. And it came to pass, that, when Elisabeth heard the salutation of Mary, the babe leaped in her womb; and Elisabeth was filled with the Holy Ghost: and she spake out with a loud voice, and said, Blessed art thou among women, and blessed is the fruit of thy womb. And whence is this to me, that the mother of my Lord should come to me? For, lo, as soon as the voice of thy salutation sounded in mine ears, the babe leaped in my womb for joy. . . .

'And Mary abode with her about three months, and returned to her own house' (Luke, 1).

Elisabeth's child was to be John the Baptist. The *Golden Legend* says 'Christ had Mary greet Elisabeth so that the words coming from Christ in her womb might enter in through Elisabeth's ears and descend to John, thus anointing him there as a prophet'. This spirit of prophecy was then reflected at once in Elisabeth's words to Mary, saluting her as 'the mother of my Lord'.

Vulcan 'The god of fire. He was represented in painting as a blacksmith, deformed and lame, and holding a hammer in his hand. He was pushed out of heaven by the gods and fell to earth. . . . They say he made Jupiter's thunderbolts, which Jupiter's eagle carried away from earth to heaven. For that reason, along with Vulcan himself, his workshop was also painted' (Albricus).

See **Mars and Venus.**

Washing of the Feet, *see* Last Supper.

Wise and Foolish Virgins To illustrate his admonition, 'Watch therefore: for ye know not what hour your Lord doth come', Christ told his disciples this parable. 'Then shall the kingdom of heaven be likened unto ten virgins, which took their lamps, and went forth to meet the bridegroom. And five of them were wise, and five were foolish. They that were foolish took their lamps, and took no oil with them: but the wise took oil in their vessels with their lamps. While the bridegroom tarried, they all slumbered and slept. And at midnight there was a cry made, Behold, the bridegroom cometh; go ye out to meet him. Then all those virgins arose, and trimmed their lamps. And the foolish said unto the wise, Give us of your oil; for our lamps are gone out. But the wise answered, saying, Not so; lest there be not enough for us and you: but go ye rather to them that sell, and buy for yourselves. And while they went to buy, the bridegroom came; and they that were ready went in with him to the marriage: and the door was shut. Afterward came also the other virgins, saying, Lord, Lord, open to us. But he answered and said, Verily I say unto you, I know you not' (Matthew, 24 and 25).

Wise Men, *see* Adoration of the Magi.

Woman of Canaan The woman who came to Christ in this episode, being a Canaanite, was not a Hebrew. 'And, behold, a woman of Canaan came . . . and cried unto him, saying, Have mercy on me, O Lord, thou son of David; my daughter

is grievously vexed with a devil. But he answered her not a word. And his disciples came and besought him, saying, Send her away; for she crieth after us. But he answered and said, I am not sent but unto the lost sheep of the house of Israel. Then came she and worshipped him, saying, Lord, help me. But he answered and said, It is not meet to take the children's bread, and to cast it to dogs. And she said, Truth, Lord: yet the dogs eat of the crumbs which fall from their masters' table. Then Jesus answered and said unto her, O woman, great is thy faith: be it unto thee even as thou wilt. And her daughter was made whole from that very hour' (Matthew, 15).

Woman with the Issue of Blood As Christ, accompanied by the apostles Peter, James the Greater and John, was on his way to revive Jairus' daughter from the dead, 'a woman having an issue of blood twelve years, which had spent all her living upon physicians, neither could be healed of any, came behind him, and touched the border of his garment: and immediately her issue of blood stanched. And Jesus said, Who touched me? When all denied, Peter and they that were with him said, Master, the multitude throng thee and press thee, and sayest thou, Who touched me? And Jesus said, Somebody hath touched me: for I perceive that virtue is gone out of me.

'And when the woman saw that she was not hid, she came trembling, and falling down before him, she declared unto him before all the people for what cause she had touched him, and how she was healed immediately. And he said unto her, Daughter, be of good comfort: thy faith hath made thee whole; go in peace' (Luke, 8).

The law of Moses forbade a man to have contact with a woman who was menstruating or losing blood in any way. Early Christians interpreted this miracle and Christ's words to the woman as indicating that with Christ's coming, faith in God had replaced the strict observance of Old Testament law. Bonaventura identified this woman with Martha, the sister of Mary Magdalene and Lazarus.

Woman of Samaria On his way through Samaria, Jesus rested at Jacob's well.

'There cometh a woman of Samaria to draw water: Jesus saith unto her, Give me to drink. (For his disciples were gone away unto the city to buy meat.) Then saith the woman of Samaria unto him, How is it that thou, being a Jew, askest drink of me, which am a woman of Samaria? for the Jews have no dealings with the Samaritans. Jesus answered and said unto her, If thou knewest the gift of God, and who it is that saith to thee, Give me to drink; thou wouldest have asked of him, and he would have given thee living water. The woman saith unto him, Sir, thou hast nothing to draw with, and the well is deep: from whence then hast thou that living water? . . . Jesus answered and said unto her, Whosoever drinketh of this water shall thirst again: but whosoever drinketh of the water that I shall give him shall never thirst; but the water that I shall give him shall be in him a well of water springing up into everlasting life.'

Christ told her that God is a spirit, and revealed himself to her as the Messiah. As the disciples returned, surprised to find him talking to the woman, she left her water-jug and returned to Samaria with Christ's message. (John, 4).

Woman Taken in Adultery The scribes and the Pharisees tried to catch Christ in a dilemma. If he did not condemn the woman to be stoned, he would be violating the law of Moses; and if he did condemn her, he would be renouncing his principle of forgiveness.

'And early in the morning he came again into the temple, and all the people came unto him; and he sat down, and taught them. And the scribes and Pharisees brought unto him a woman taken in adultery; and when they had set her in the midst, they say unto him, Master, this woman was taken in adultery, in the very act. Now Moses in the law commanded us, that such should be stoned: but what sayest thou? This they said, tempting him, that they might have to accuse him. But Jesus stooped down, and with his finger wrote on the ground, as though he heard them not. So when they continued asking him,

he lifted up himself, and said unto them, He that is without sin among you, let him first cast a stone at her. And again he stooped down, and wrote on the ground. And they which heard it, being convicted by their own conscience, went out one by one, beginning at the eldest, even unto the last: and Jesus was left alone, and the woman standing in the midst. When Jesus had lifted up himself, and saw none but the woman, he said unto her, Woman, where are those thine accusers? hath no man condemned thee? She said, No man, Lord. And Jesus said unto her, Neither do I condemn thee: go, and sin no more' (John, 8).

An old tradition said that Christ was writing the sins of the accusers in the dust. (Bonaventura).

Women of Jerusalem As Christ was being led to his crucifixion, 'there followed him a great company of people, and of women, which also bewailed and lamented him. But Jesus turning unto them said, Daughters of Jerusalem, weep not for me, but weep for yourselves, and for your children. For, behold, the days are coming, in the which they shall say, Blessed are the barren, and the wombs that never bare, and the paps which never gave suck. Then shall they begin to say to the mountains, Fall on us; and to the hills, cover us. For if they do these things in a green tree, what shall be done in the dry?' (Luke, 23).

Christ's metaphor is explained by St Peter's words, 'If the righteous scarcely be saved, where shall the ungodly and the sinner appear?' (I Peter, 4).

See also **Destruction of Jerusalem.**

Women at the Tomb After Christ's Burial, 'Mary Magdalene, and Mary the mother of James, and Salome' (that is, Mary Salome), 'had bought sweet spices, that they might come and anoint him. And very early in the morning the first day of the week, they came unto the sepulchre at the rising of the sun. And they said among themselves, Who shall roll us away the stone from the door of the sepulchre? And when they looked, they saw that the stone was rolled away: for it was very great. And entering into the sepulchre, they saw a young man

sitting on the right side, clothed in a long white garment; and they were affrighted. And he saith unto them, Be not affrighted: Ye seek Jesus of Nazareth, which was crucified: he is risen; he is not here: behold the place where they laid him. But go your way, tell his disciples and Peter that he goeth before you into Galilee: there shall ye see him, as he said unto you. And they went out quickly, and fled from the sepulchre; for they trembled and were amazed: neither said they any thing to any man; for they were afraid' (Mark, 16).

According to Luke there were two angels, and Matthew says there was only one other woman with Mary Magdalene. As the women left to find the disciples, 'Jesus met them, saying, All hail. And they came and held him by the feet, and worshipped him. Then said Jesus unto them, Be not afraid: go tell my brethren that they go into Galilee, and there shall they see me' (Matthew, 28).

Wrath of Achilles Achilles was the greatest of the Greek heroes who besieged Troy. His famous 'deadly wrath, that brought great sorrow upon the Greeks', began when Agamemnon, the commander of the Greek army, took from him the girl Briseis, who had been part of his booty in a successful looting expedition. 'Within his proud breast Achilles' heart pondered two possibilities: either to draw his sharp sword, thrust those before him aside, and kill Agamemnon, or else to restrain his furious anger and let it subside. As he was weighing these two courses in his mind, and drawing his great sword from its sheath, the goddess Minerva came down from the heavens.' Standing behind Achilles, and visible to him alone, Minerva took him by his tawny hair and persuaded him to put away his sword.

From then on Achilles refused to go out to battle, sulking in his tent instead. In his absence the course of the war turned disastrously against the Greeks and many of them were killed. But when the Trojan hero Hector killed Achilles' closest comrade, Patroclus, Achilles' grief and his desire for revenge were so great he put aside his wrath and ended his feud with Agamemnon. Patroclus received a magnificent funeral, and

Agamemnon had Ulysses bring Briseis, 'in looks like golden Venus', back to Achilles, with propitiatory gifts of bronze tripods, cauldrons and horses. (Homer).

Saint Yves St Yves lived in Brittany in the thirteenth century, and studied first theology and then law. As both lawyer and priest he became a protector of the poor, living in ever greater poverty until his death. His good name was commemorated in a popular Latin jingle:

> Sanctus Ivo erat Brito
> Advocatus et non latro
> Res miranda populo.

(St Yves was a Breton, a lawyer and not a thief – a cause of astonishment to all.(He is the patron saint of lawyers. (*Acta Sanctorum*).

Zacharias and the Annunciation of the Birth of John the Baptist Zacharias, a temple priest, and his wife Elisabeth were a childless couple, and advanced in years. One day Zacharias was burning incense in the temple. 'And there appeared unto him an angel of the Lord standing on the right side of the altar of incense. And when Zacharias saw him, he was troubled, and fear fell upon him. But the angel said unto him, Fear not, Zacharias: for thy prayer is heard; and thy wife Elisabeth shall bear thee a son, and thou shalt call his name John. And thou shalt have joy and gladness; and many shall rejoice at his birth. For he shall be great in the sight of the Lord, and shall drink neither wine nor strong drink; and he shall be filled with the Holy Ghost, even from his mother's womb. And many of the children of Israel shall he turn to the Lord their God. And he shall go before him in the spirit and power of Elias, to turn the hearts of the fathers to the children, and the disobedient to the wisdom of the just; to make ready a people prepared for the Lord.

'And Zacharias said unto the angel, Whereby shall I know this? for I am an old man, and my wife well stricken in years.

And the angel answering said unto him, I am Gabriel, that stand in the presence of god; and am sent to speak unto thee, and to shew thee these glad tidings. And, behold, thou shalt be dumb, and not able to speak, until the day that these things shall be performed, because thou believest not my words, which shall be fulfilled in their season.

'And the people waited for Zacharias, and marvelled that he tarried so long in the temple. And when he came out, he could not speak unto them: and they perceived that he had seen a vision in the temple: for he beckoned unto them, and remained speechless' (Luke, 1).

See **Birth of John the Baptist.**

Zaleucus the Judge Zaleucus was a legislator from the Greek city of Locris. 'When his son was condemned of adultery, he was sentenced to lose both his eyes, according to one of Zaleucus' own laws. But the whole city wanted to remit the son's punishment out of respect for the father. For some time Zaleucus opposed them but, finally defeated by the entreaties of the people, he first put out one of his own eyes and then one of his son's. Thus each of them retained the power of sight, but Zaleucus rendered the due measure of the law, balancing himself with admirable restraint between the merciful father and the just legislator' (Valerius Maximus).

Zama, *see* Hannibal.

Saint Zenobius Zenobius was a Florentine of the fourth century. His pagan parents wanted him to marry, but he refused and was baptized instead. Later he converted his parents and baptized them himself, and was finally made bishop of Florence. He performed many miracles of healing, reviving the dead, curing the blind and liberating the possessed from demons. At his funeral – in winter time – the bier touched a bare elm tree which put out leaves and blossomed at once. (*Acta Sanctorum*).

Authors and books cited

Acta Sanctorum, a collection of early lives of the saints compiled by a group of Jesuits known as the Bollandists. The collection was begun in the early seventeenth century and is not yet completed.

AESOP, a Greek slave from Asia Minor who wrote his famous *Fables* in the sixth century BC.

ALBRICUS, an English mythographer who wrote a Latin book on the *Images of the Gods (Liber Ymaginum Deorum)* at the end of the fifteenth century.

APULEIUS, a second century writer from Africa who wrote *Cupid and Psyche,* a mythological tale included in his larger work, *The Golden Ass.*

ARATUS, a Greek poet of the third century BC who wrote a poem on astronomy called *Phaenomena.*

ARIOSTO, an Italian poet of the sixteenth century who wrote *Orlando Furioso,* a medieval romance.

ATHANASIUS, a fourth century bishop of Alexandria.

AUGUSTINE, a fifth century bishop and theologian.

AULUS GELLIUS, a Roman prose writer of the second century AD. His *Attic Nights* is a collection of miscellaneous anecdotes on ancient life.

Bible. Most of the quotations are from the Authorized Version. For clarity's sake the Revised Standard Version (RSV) has sometimes been used, and in two cases the Catholic edition of the Revised Standard Version (RSVCE) when it includes verses from the Latin Vulgate not included in the other English versions. Where the Vulgate differs significantly from all the English versions we have used our own translation from the Latin text. In one case we have used the Old Latin text that the Vulgate replaced.

BOCCACCIO, a fourteenth century Florentine whose most famous work is the *Decameron,* a collection of short stories.

BONAVENTURA, a thirteenth century Franciscan. When Bonaventura is given as a source, the work referred to is the

Meditations on the Life of Christ, except in the articles on St Francis where the reference is to his *Life of St Francis*. He also wrote mystical theological works including the *Tree of Life* (*Lignum Vitae*).

CAESAR OF HEISTERBACH, a thirteenth century Cistercian monk who wrote a collection of anecdotes about miraculous occurrences, the *Dialogus Miraculorum*.

CALEPINUS, an Italian cleric, published a Latin dictionary in 1502 that included articles on historical and mythological characters.

CARTARI, a sixteenth century Italian whose *Imagini dei Dei degli Antichi* discussed the ways of representing the ancient gods.

CAXTON, a fifteenth century translator and printer, who published English versions of the *Golden Legend* and of Bonaventura's *Meditations on the Life of Christ*.

CELANO, a thirteenth century Franciscan who wrote two lives of Saint Francis.

La Conversione di Maria Maddalena, an anonymous Italian mystery play of the fifteenth century.

CORNISH MIRACLE PLAY, *The Legend of the Rood*, written down in the fifteenth century.

COVENTRY MYSTERIES, a fifteenth century cycle of religious dramas.

DIODORUS SICULUS, a first century BC Sicilian who wrote a history of the world in Greek.

DIOGENES LAERTIUS, a writer of the third century AD, who wrote in Greek about the lives of the Greek philosophers.

Fioretti, The Little Flowers of St Francis, anonymous, perhaps by a fourteenth century Franciscan.

FULGENTIUS, a fifth century bishop in Africa who wrote three books in Latin on ancient mythology.

GEORGE OF MONTEMAJOR, a sixteenth century Spanish novelist who wrote *Diana*, a popular pastoral romance.

GIRALDI, a sixteenth century Italian mythographer whose *History of the Gods* (*De Deis Gentium*) influenced similar works by Natale Conti and Cartari.

Golden Legend, or *The Lives of the Saints,* by Jacopo da Voragine, archbishop of Genoa in the thirteenth century. This was one of the most popular works of the Middle Ages.

HESIOD, a Greek poet who lived in the seventh century BC and wrote on mythology and farming.

Historia Scholastica, a twelfth century retelling of the Bible, with interpretative additions, by a French cleric named Petrus Comestor.

HOMER, the earliest Greek poet, who lived in the eighth century BC. His two long epic poems are the *Iliad* and the *Odyssey.*

HONORIUS D'AUTUN, a twelfth century monk who wrote mystical theological works.

HYGINUS, a second century AD Latin mythographer.

ISIDORE OF SEVILLE, a seventh century Spanish bishop, philologist and encyclopedist.

JACOPO DA BERGAMO, a sixteenth century Italian who wrote an encyclopedic history of the world starting with creation, and a book on famous women.

JEAN MICHEL, wrote the fifteenth century French mystery play, *Mystère de la Passion.*

JOHN OF HILDESHEIM, a fourteenth century German Carmelite monk.

JONSON, BEN, an English dramatist of the sixteenth century.

LA FONTAINE, a seventeenth century French poet who wrote versified fables, often based on Aesop.

LIVY, a first century BC Roman historian.

LUTHER, a sixteenth century German monk whose criticisms of the Catholic Church helped to start the protestant Reformation in 1517.

Mirror of Man's Salvation (Speculum Humanae Salvationis), a fourteenth century retelling of the life of Christ with Old Testament parallels, in rhymed Latin prose, probably by a Dominican monk.

MOLANUS, a sixteenth century Belgian professor of theology who also wrote books explaining religious art.

MYSTERY PLAYS, religious dramas of the Middle Ages, on Old and New Testament themes and lives of the saints, performed by the various town guilds. They began as early as

the ninth century, as dramatizations of church services, especially at Easter.

NATALE CONTI, a sixteenth century Italian mythographer whose *Mythologia* is an explanation of the ancient myths.

New Testament Apocrypha, a collection of early Christian and medieval gospels, acts, epistles and revelations in Greek, Latin and oriental languages. Theologians generally considered these works spurious and they were not included in the New Testament. Many are found in English in M. R. James, *The Apocryphal New Testament.*

Oberammergau Passion Play, a mystery play on the passion of Christ first written down in Bavaria in the seventeenth century.

Old Testament Apocrypha. Most of these books of the Bible were considered authentic until the sixteenth century and are still printed in Catholic bibles. They include the *History of Susanna,* the *Book of Esther, Bel and the Dragon,* the *Song of the Three Children, Tobit,* and the *Book of Judith.*

OVID, a Roman poet who died early in the first century AD. All references in this book are to the *Metamorphoses,* unless otherwise stated.

PERRET, ESTIENNE, a sixteenth century Antwerp poet whose popular animal fables, in French, were first published in 1578, and later translated into Dutch.

PLINY THE ELDER, a Roman historian and naturalist who wrote an encyclopedia called *Natural History.*

PLUTARCH, a Greek writer of the first century AD. His *Lives* are biographies of famous Greeks and Romans.

QUINTUS CURTIUS RUFUS, a first century AD Roman rhetorician who wrote a history of Alexander the Great.

Rappresentazione del Figliuol Prodigo, a fifteenth century Italian mystery play by Castellano Castellani.

La Resurrezione, a fifteenth century anonymous Italian mystery play.

ROSS, a seventeenth century Scottish schoolmaster who wrote a classical dictionary called the *Mystagogus Poeticus,* in English.

RSV, Revised Standard Version of the Bible.

RSVCE, Catholic edition of the Revised Standard Version of the Bible.

Sermones de Sanctis, see Voragine.

SERVIUS, a fourth century Roman commentator on Virgil.

STEPHANUS. Charles Stephanus was a French mythographer of the sixteenth century who, with his brother Robert, expanded the classical dictionary of Torrentinus in successive editions.

TACITUS, a Roman historian of the first century AD.

TASSO, a sixteenth century Italian poet whose *Gerusalemme Liberata (Jerusalem Delivered)* is a long poem on one of the Crusades.

TERTULLIAN, a Christian writer from Carthage who died in the third century. He was one of the early church fathers.

THEOCRITUS, a third century BC Greek poet from Sicily, who wrote pastoral poetry.

TORRENTINUS, a fifteenth century Dutch professor who wrote a Latin *Elucidarius*, or classical dictionary.

VALERIUS MAXIMUS, a Roman historian of the first century AD. His *Memorabilia* is a collection of historical anecdotes arranged under moral or philosophical headings.

VIRGIL, a Roman poet of the late first century BC. Besides pastoral and agricultural poems he wrote the *Aeneid*. All references in this book are to the *Aeneid*.

VORAGINE, the thirteenth century author of the *Golden Legend*. He also wrote a collection of sermons on saints called *Sermones de Sanctis*.

VULGATE, Jerome's fourth century Latin translation of the Bible.

WADDING, a seventeenth century Irish Franciscan who compiled the early annals of the Francisan Order.

York Mystery Plays, a cycle of 48 plays written down in the fourteenth century.

Bibliographical notes

Balaam. The reading 'man' in Balaam's prophecy is the one commonly found in medieval picture Bibles.

Doctrine of the Three Arrows. The French manuscript is cited from Paul Perdrizet, *La Vierge de la Miséricorde*, Paris, 1908.

Saint Livinus. The source is printed in Migne, *Patrologia Latina*, volume 87.

Madonna of the Milk. The Christmas carol is quoted from Louis Réau, *Iconographie de l'art Chrétien*, Paris, 1955.

Rest on the Flight into Egypt. *De quelques miracles que l'enfant Jésus fit en sa jeunesse* is quoted from Emile Mâle, *L'art religieux du xiii^e siècle en France*, Paris, 1923.

The Virgin Mary. Quotations from the Song of Solomon are from the Vulgate.

Saint Yves. The Latin verses are quoted from the *Bibliotheca Sanctorum* published by the Istituto Giovanni XXIII in the Lateran.